DATE DUE

PRINTED IN U.S.A.

Authors
& Artists
for Young
Adults

ISSN 1040-5682

12

Authors & Artists for Young Adults

VOLUME 19

Thomas McMahon
Editor

GALE

DETROIT • NEW YORK • TORONTO • LONDON

Thomas McMahon, *Editor*

helly Andrews, Joanna Brod, Sheryl Ciccarelli, Alan Hedblad,
o Huthwaite, Gerard J. Senick, Diane Telgen, Kathleen Witman,
Contributing Editors

Diane Andreassi, Barbara Bigelow, Ken Cuthbertson, Marian C. Gonsior, Janet L.
Hile, Kevin Hillstrom, David P. Johnson, Ronie-Richele Garcia-Johnson, J. Sydney
Jones, Tom Pendergast, Nancy Rampson, Megan Ratner, Susan Reicha, Pamela L.
Shelton, Kenneth R. Shepherd, Tracy J. Sukraw,
Sketch Contributors

Victoria B. Cariappa, *Research Manager*
Cheryl L. Warnock, *Project Coordinator*
Tamara C. Nott and Michele P. Pica, *Research Associates*
Alicia Noel Biggers, Julia C. Daniel, and Michelle Lee, *Research Assistants*

Marlene S. Hurst, *Permissions Manager*
Margaret A. Chamberlain, Maria Franklin, and Kimberly F. Smilay,
Picture Permissions Specialists
Diane Cooper, *Permissions Associate*

Mary Beth Trimper, *Production Director*
Deborah Milliken, *Production Assistant*

Randy Bassett, *Image Database Supervisor*
Sherrell Hobbs, *Macintosh Artist*
Robert Duncan and Mikal Ansari, *Imaging Specialists*
Pamela A. Hayes, *Photography Coordinator*

The paper used in this publication meets the minimum requirements of American National Standard for Information Sciences—Permanence Paper for Printed Library Materials, ANSI Z39.48-1984.

Library of Congress Catalog Card Number 89-641100
ISBN 0-8103-9943-1
ISSN 1040-5682

10 9 8 7 6 5 4 3 2 1

Printed in the United States of America

Contents

Introduction

Authors and Artists for Young Adults is a reference series designed to serve the needs of middle school, junior high, and high school students interested in creative artists. Originally inspired by the need to bridge the gap between Gale's *Something about the Author,* created for children, and *Contemporary Authors*, intended for older students and adults, *Authors and Artists for Young Adults* has been expanded to cover not only an international scope of authors, but also a wide variety of other artists.

Although the emphasis of the series remains on the writer for young adults, we recognize that these readers have diverse interests covering a wide range of reading levels. The series therefore contains not only those creative artists who are of high interest to young adults, including cartoonists, photographers, music composers, bestselling authors of adult novels, media directors, producers, and performers, but also literary and artistic figures studied in academic curricula, such as influential novelists, playwrights, poets, and painters. The goal of *Authors and Artists for Young Adults* is to present this great diversity of creative artists in a format that is entertaining, informative, and understandable to the young adult reader.

Entry Format

Each volume of *Authors and Artists for Young Adults* will furnish in-depth coverage of twenty to twenty-five authors and artists. The typical entry consists of:

—A detailed biographical section that includes date of birth, marriage, children, education, and addresses.

—A comprehensive bibliography or filmography including publishers, producers, and years.

—Adaptations into other media forms.

—Works in progress.

—A distinctive essay featuring comments on an artist's life, career, artistic intentions, world views, and controversies.

—References for further reading.

—Extensive illustrations, photographs, movie stills, cartoons, book covers, and other relevant visual material.

A cumulative index to featured authors and artists appears in each volume.

Compilation Methods

The editors of *Authors and Artists for Young Adults* make every effort to secure information directly from the authors and artists through personal correspondence and interviews. Sketches on living authors and artists are sent to the biographee for review prior to publication. Any sketches not personally reviewed by biographees or their representatives are marked with an asterisk (*).

Highlights of Forthcoming Volumes

Among the authors and artists planned for future volumes are:

Rudolfo A. Anaya
Maya Angelou
T. Ernesto Bethancourt
Janet Bode
Kenneth Branagh
Gwendolyn Brooks
James Fenimore Cooper
Stephan Crane
Farrukh Dhondy
Philip K. Dick
John Donovan
Michael Dorris

Anne Fine
Robert Frost
Kristin Hunter
Brian Jacques
Robin Klein
R. R. Knudson
Maya Lin
John Marsden
William Mayne
Carson McCullers
Carolyn Meyer
Jim Murphy

Georgia O'Keeffe
Uri Orlev
Marjorie Kinnan Rawlings
Jon Scieska
Pamela Service
Mary Shelley
Jan Slepian
Lane Smith
Robert Swindells
Mark Twain
Kate Wilhelm
Jacqueline Woodson

Contact the Editor

We encourage our readers to examine the entire *AAYA* series. Please write and tell us if we can make AAYA even more helpful to you. Give your comments and suggestions to the editor:

BY MAIL: The Editor, *Authors and Artists for Young Adults*, Gale Research, 835 Penobscot Building, 645 Griswold St., Detroit, MI 48226-4094.

BY TELEPHONE: (800) 347-GALE

BY FAX: (313) 961-6599

BY E-MAIL: CYA@Gale.com@Galesmtp

Authors & Artists for Young Adults

Jane Austen

■ Personal

Born December 16, 1775, in Steventon, Hampshire, England; died (probably of Addison's disease), July 18, 1817, in Winchester, Hampshire, England; daughter of George (an Anglican priest) and Cassandra (a homemaker; maiden name, Leigh) Austen. *Education:* Studied briefly as a child with Mrs. Anne Cawley of Oxford, 1782; attended Abbey School, 1784-86; also educated at home with assistance of father and older brothers. *Religion:* Church of England. *Hobbies and other interests:* Playing piano, listening to music, dancing.

■ Career

Author.

■ Writings

Sense and Sensibility: A Novel, 3 volumes, T. Edgerton (London), 1811; Modern Library (New York), 1995.

Pride and Prejudice: A Novel, 3 volumes, T. Edgerton, 1813; edited by James Kinsley, introduction by Isobel Armstrong, notes by Frank W. Bradbrook, Oxford University Press, 1995.

Mansfield Park: A Novel, 3 volumes, T. Edgerton, 1814; Modern Library, 1995.

Emma: A Novel, 3 volumes, John Murray (London), 1816, 2 volumes, M. Carey (Philadelphia), 1816; edited by James Kinsley, introduction by Terry Castle, Oxford University Press, 1995.

Northanger Abbey and Persuasion, 4 volumes, John Murray, 1818, published separately as *Northanger Abbey*, Modern Library, 1995, and *Persuasion: Authoritative Text, Backgrounds, and Contexts Criticism*, edited by Patricia Meyer Spacks, W.W. Norton (New York), 1995.

Lady Susan and The Watsons, George Munro (New York), 1882, published separately as *The Watsons*, Leonard Parsons (London), 1923, and *Lady Susan*, preface by A. Walton Litz, Garland Publishing (New York), 1989.

Love & Friendship and Other Early Works, Now first printed from the original MS, Chatto & Windus (London), 1922, Frederick A. Stokes (New York), 1922.

Fragment of a Novel Written by Jane Austen January-March 1817 [Sanditon], edited by R.W. Chapman, Clarendon Press (Oxford), 1925.

Plan of a Novel according to Hints from Various Quarters, edited by Chapman, Clarendon Press, 1926.

Two Chapters of Persuasion, Printed from Jane Austen's Autograph, Clarendon Press, 1926.

Volume the First (juvenilia), edited by Chapman, Clarendon Press, 1933.

Volume the Third (juvenilia), edited by Chapman, Clarendon Press, 1951.

Volume the Second (juvenilia), edited by B. C. Southam, Clarendon Press, 1963.

Catherine and Other Writings, edited by Margaret Anne Doody and Douglas Murray, Oxford University Press, 1993.

The Beautifull Cassandra (juvenilia), illustrated and afterword by Juliet McMaster, Sono Nis (Victoria, BC), 1993.

The History of England: From the Reign of Henry the 4th to the Death of Charles the 1st, Algonquin Books of Chapel Hill, 1993.

The Sayings of Jane Austen, edited by Maggie McKernan, Duckworth (London), 1993.

The Complete Novels, Oxford University Press, 1994.

LETTERS

Jane Austen's Manuscript Letters in Facsimile: Reproductions of Every Known Extant Letter, Fragment, and Autograph Copy, edited by Jo Modert, Southern Illinois University Press, 1990.

My Dear Cassandra: The Letters of Jane Austen, selected and with introduction by Penelope Hughes-Hallet, Clarkson Potter (New York), 1991.

Jane Austen's Letters, collected and edited by Deirdre Le Faye, Oxford University Press, 1995.

■ Adaptations

Pride and Prejudice was adapted for film by MGM, 1940, and serialized for television by the British Broadcasting Corporation (BBC), 1979 and 1995. *Persuasion* was adapted as a television mini-series, 1971, and as a screenplay by Nick Dear; the film version was released by Sony Classics, 1995. *Sense and Sensibility* was adapted as a screen play by British actress Emma Thompson; the film version was released by Columbia Pictures, 1995; the screenplay, which won the American Academy for Motion Picture Arts and Sciences award, or "Oscar," for best screenplay, was published as *The Sense and Sensibility Diaries and Screenplay: The Making of the Film Based on the Jane Austen Novel,* Newmarket Press, 1996. *Emma* was adapted as a screenplay by Douglas McGrath; the film version was released by Miramax, 1996.

■ Sidelights

"It is a truth universally acknowledged," wrote Jane Austen in the opening sentence of *Pride and Prejudice,* "that a single man in possession of a good fortune, must be in want of a wife." With this statement one of the great English novelists and most superb prose stylists of the nineteenth century established her subject: marriage. Austen's fiction dwells exclusively on social relations among the landed gentry and rural professionals of her own social class. Her wry depictions of gentlemen and gentlewomen in pursuit of fortune, romance, and love were popular in her day, and continue to be widely read and enjoyed. Her books have been adapted for film and television, and recent writers have even been inspired to attempt sequels to Austen's novels. Critics, too, have appreciated Austen's work, and call attention to the structural clarity and narrative sophistication of her best writing. In her attention to the details of daily life, Austen's affection for the society she represented is obvious. As an artist, however, her attitude toward that society was ultimately ironic and critical. "A world which so often ends in a suitable marriage is not a world to wring one's hands over," wrote Virginia Woolf, explaining the enduring appeal of *Pride and Prejudice,* "On the contrary, it is a world about which we can be sarcastic; into which we can peer endlessly, as we fit the jagged pieces one into another."

The seventh of eight children, and second of two girls, Jane Austen was born on December 16, 1775, in the village of Steventon, Hampshire, England. Austen's father, the Reverend George Austen, was an Anglican priest, who, despite being orphaned as a young child, had graduated from St. John's College, Oxford. Jane's mother, Cassandra Leigh Austen, was of higher social standing than George Austen, and only his education and prestige as a clergyman made the courtship possible. The Austen family's first home was the rectory of St. Nicolas's Church in Steventon. The reverend's income was meager for a family of ten, but the Austens' prestige in the village was higher than income alone could dictate, and they lived comfortably. The family was close, and the children especially dear to one another.

The Austen boys (with the exception of the second son, George, who was handicapped and spent much of his life institutionalized), all went on to distinguished careers. The eldest, James, like his

father, attended St. John's College, Oxford, and was ordained in the Church of England. He eventually succeeded his father as rector at Steventon. While at Oxford he and his younger brother, Henry, edited and issued a literary magazine, *The Loiterer*. Scholars speculate that Jane Austen's first published piece was a letter to the editor of *The Loiterer*, printed in 1788. Henry, who was Jane's favorite among her brothers, also graduated from St. John's College, but postponed entering the church. Following a brief stint in the army, he became a prosperous banker. Later, as Jane began circulating manuscripts for publication, he acted as her agent. In 1816 Henry's bank failed, after which he earned his living as a country clergyman.

The third son, Edward Austen, was adopted by a wealthy, childless cousin of George Austen's, Thomas Knight, and eventually inherited his adopted father's estate, Godmersham, Kent. The younger brothers, Francis and Charles, entered the navy and fought in the Napoleonic Wars. Both were highly decorated veterans, and each attained the rank of admiral.

Austen's Education

Education and careers such as those pursued by the Austen men, however, were closed to women. The only prospect for financial security for the Austen girls, Jane and Cassandra, two years her elder, was marriage. Both had expectations for men who died abruptly, and neither ever married. Inseparable as children, Cassandra and Jane were to become constant companions during Jane's brief life. Cassandra was Jane's confidant and most trusted critic. The two were rarely out of communication, and during brief periods of separation routinely exchanged long letters. While Jane battled the illness that would eventually take her life, Cassandra served as her nurse.

The girls' formal education was sporadic. When Jane was seven she and Cassandra were sent, with their cousin Jane Cooper, to Oxford to study with Mrs. Anne Cawley. Not long after their arrival in Oxford, Mrs. Cawley took the girls on an outing to Southampton, where all three contracted typhus. The girls recovered to health, but Jane Cooper's mother, Mrs. Austen's sister, succumbed to the disease while tending the girls and died. For the next two years Jane and Cassandra remained at home in Steventon.

Jane and Cassandra resumed their education at the Abbey School in Reading. There was little emphasis on academics at the Abbey School. Instead, the girls learned etiquette and received training in the practical arts that were considered important to women at the time, including sewing and embroidery. The girls were recalled from school in December of 1786, when the family could no longer afford their tuition.

Their formal studies thus concluded, the girls returned to Steventon to begin their education in earnest. George Austen owned a considerable number of books (more than five-hundred volumes), which he placed at his children's disposal. The father and sons took an active interest in tutoring Jane and Cassandra. For the most part, the girls read fiction. Jane was steeped in English literature, including the works of William Shakespeare, John Milton, Alexander Pope, and Samuel Johnson. Her favorite novel, one which she reread into adulthood, was Samuel Richardson's *Sir Charles Grandison* (1754). She also admired the poetry of William Cowper. Both Richardson and Cowper were advocates of the gentry, a sympathy which allowed Austen to identify with their work. Austen also read the books of Frances Burney, a female author whose novels, *Evelina* (1778), *Cecilia* (1782), and *Camilla* (1796) advanced themes initiated by Richardson. Significantly, women play the principal roles in Burney's fiction, and her later work employed narrative techniques which Austen adopted in her mature writing.

The Austens were a family of readers. They frequented private lending libraries, and occasionally subscribed to publishers for the most recent editions of books by favorite authors. Reading, and in particular the reading of current fiction, was both a social and political activity during Austen's era, noted Gary Kelly in the *Dictionary of Literary Biography*. Through popular literature, the Austens were connected to the political debates shaping their nation. These debates became particularly heated in England following the French Revolution. While political commentary is never explicit in Austen's writing, her novels confront these issues, such as women's right to property, through the lives of her characters.

As a pastime, the Austens frequently read aloud. Jane excelled at this, and as an adult, read aloud for Cassandra's pleasure. The family also took pleasure in drama, and the Austen brothers staged

The country home at Chawton, where Austen lived with her mother and sister, is where she did most of her finest writing.

plays in the family barn when Jane was young. The practice continued, and before long, the entire family was involved. The productions often became quite elaborate and they increased in popularity among the friends and family who attended the performances. Jane contributed scripts to the family theater, and it was in the context of providing family entertainment that she began to write seriously. Her experience with amateur drama was transformed in a famous episode in Austen's *Mansfield Park.*

Although reading was their primary form of education, the girls cultivated other talents. Jane learned to play piano. She practiced regularly and performed for her small circle of acquaintances. She also loved to dance. Cassandra took up drawing. She made the only two authenticated portraits of Jane (one of which is a view of Jane from behind).

What survives of Austen's early writing was transcribed by her later in life. The works filled three notebooks, and are, with the exception of some

poetry, short satires of popular literary forms of her day. One of the better known pieces from this juvenilia is *The History of England: From the Reign of Henry the 4th to the Death of Charles the 1st,* a farce, at the beginning of which Austen declares herself entirely ignorant of her subject. Following this disclaimer, she advances, in comic tone, the political loyalties of her family.

Austen's family recognized her potential as a writer. With their encouragement, Jane continued to write for their entertainment until some time around 1795. Then, without their knowledge, she began to write seriously with the intention of publishing her work. She completed the first-draft of an epistolary novel (a form where the story is told through an exchange of letters authored by the characters), which she tentatively titled "Elinor and Marianne." Two years later she completed a second epistolary novel, "First Impressions."

In 1797, George Austen attempted to have "First Impressions" published by Thomas Cadell and

William Davies of London, but the manuscript was refused. After completing "First Impressions," Austen abandoned the epistolary form. In 1798 and 1799 she began "Susan," a novel which was bought by the publisher Richard Crosby in 1803. The book, however, was not published during Austen's lifetime; it was finally released in 1817, under the title *Northanger Abbey*. During the years 1798 to 1799 Austen resumed work on "Elinor and Marianne," which she rewrote as third person narrative. Despite the momentum she developed as a writer at the close of the eighteenth century, Austen wrote little for nearly the next decade.

In 1795, Austen, who was now twenty years old, fell in love with Thomas Lefroy. A young graduate of Trinity College, Dublin, Lefroy was in Steventon to visit relatives who happened to be friends of the Austens. When Lefroy's aunt sensed her nephew's affection for Jane, she feared that marriage to the youngest daughter of a poor churchman might ruin his career in the law. She insisted that he leave Steventon immediately, and thus put an end to Austen's first romance.

Move to Bath

In 1800, Austen's father suddenly resigned his position in the church and announced he was moving the family to the city of Bath in southwestern England. Austen is reported to have fainted when she received the news. Bath—built by the Romans as a spa around natural hot springs—had become a fashionable resort for the English gentry. Austen quickly recovered from the initial shock of the move, and, for a while at least, enjoyed the company of the family's new circle of social acquaintances.

The following year Austen embarked on the second of her three ill-fated romances. While away from Bath on a family vacation, Austen fell in love with a young churchman, who it was expected would propose marriage to her. He had received permission from the family to join them later in their holiday, but as they were awaiting his arrival, they received news that he had died unexpectedly.

While visiting friends in 1802 Jane briefly accepted the marriage proposal of Harris Bigg-Wither, who stood to inherit his family's estate Manydown Park, Hampshire. Although she did not love Bigg-

Wither, a wedding would deliver her from Bath, which she was beginning to find intolerable. Moreover, as the lady of an estate, Austen would be able to support her mother and sister in the event of her father's death. The morning after accepting Bigg-Wither's proposal, however, Austen called off the engagement. "She would rather remain single," Laura Dabundo concluded in *Concise Dictionary of British Literary Biography*, "than enter a loveless union with a man who was not her intellectual equal."

Shortly after this, Austen began work on *The Watsons*, a work that she never completed. Reflecting the insecurity of her own life, the bleak novel

Two sisters find true love despite class conflict and a confusion of relationships in this 1811 story of reason (sense) versus responsiveness (sensibility).

probes the lives of three sisters apparently doomed to poverty. In 1805 Austen's father died, and the church, as was the custom, stopped paying his pension. For the Austen women, the specter of poverty that had hung about them as long as the daughters remained unmarried became all too real.

The Austen brothers pooled their resources to provide for the virtually penniless women. With their close friend Martha Lloyd, the Austen women lived comfortably in Bath for the remainder of the year. In 1806 Jane, Cassandra, and their mother left Bath to live with Francis Austen, who had recently married. As an officer of the British Navy, Francis was often away at sea, and the women of the house led a quiet life. They occasionally visited Edward Austen, who had adopted his stepfather's surname of Knight. Following his wife's death in 1808, Edward wanted his sisters and mother to be closer to his own bereaved family, and offered them one of his country homes. In 1809, the Austen women relocated for the final time, to Chawton, Kent, near their old home in Steventon.

At Chawton, Jane was restored to the English countryside she had been deprived of since the family's move to Bath. Here, Jane resumed writing, and in 1810 she completed revisions to the work which had begun as "Elinor and Marianne." Austen submitted the manuscript, with brother Henry acting as intermediary, to the London publisher Thomas Edgerton. The book was accepted, and released in 1811, as *Sense and Sensibility*.

Sense and Sensibility

The novel develops the conflicting themes of sense, or reason, and sensibility, or emotion, through the romantic entanglements of the Dashwood sisters. Recently widowed, Mrs. Dashwood and her daughters must vacate their home when it is inherited by Mr. Dashwood's son from a previous marriage. The displaced Dashwood women occupy a cottage on the grounds of an estate owned by Sir John Middleton, a wealthy relative. While the aristocratic affectations of the Middleton household conflict with the conservative values of the Dashwoods, the Middleton estate quickly becomes the center of their social world.

Elinor, the eldest daughter, is a portrait of prudence. She suspects she has fallen in love with her sister-in-law's brother, Edward Ferrars. Mild-mannered Edward, who is his family's heir and has a promising career in the church, cannot afford to confess his love for Elinor. With her feelings for Edward unconfessed and her affection unrequited, Elinor represses her frustration and politely carries out her social obligations. The second sister, Marianne, is governed by emotions and romantic expectations. She attracts the attention of Colonel Brandon, but she refuses his advances because he lacks the gallantry she has come to expect from the novels she has read. Marianne prefers the dashing and somewhat dangerous Willoughby, also a guest in the neighborhood of the Middletons. The youngest daughter, Margaret, still an adolescent, is spared these romantic distractions.

Things are further complicated by the introduction of the Steele sisters to Middleton. The younger of the two, Lucy, confesses to Elinor that she and Edward Ferrars have become secretly engaged. Elinor becomes indignant when the intrigue is revealed, and resolves to have nothing more to do with the inhabitants and guests of Middleton. The action is then relocated to London, where the lives of Dashwood sisters begin a downward spiral. Willoughby abandons Marianne and marries a wealthy woman he does not love. Elinor cannot maintain hope that Edward might experience a change of heart, after his engagement to Lucy is revealed, and he is disinherited in favor of his younger brother Robert. Following these disappointments, Marianne falls seriously ill.

While Marianne is incapacitated, Willoughby returns and admits that he truly loved her, but can do nothing to alter the conditions of his unhappy marriage. Shortly after Marianne's recovery, Elinor receives news that a Mr. Ferrars has married Lucy Steele. Seemingly, the thing she has dreaded most has come to pass. The Mr. Ferrars in question, however, proves to be Robert, not Edward. Freed from obligations to his family estate, Edward at last acknowledges his love for Elinor. The two are engaged, while a wiser, mature Marianne recognizes the sober Colonel Brandon's merits and marries him.

Sense and Sensibility raised issues that were important to women in a format that was seen as non-confrontational. The novel presented women as an economic underclass who were nonetheless essential to the moral stability of Britain. Elinor's pa-

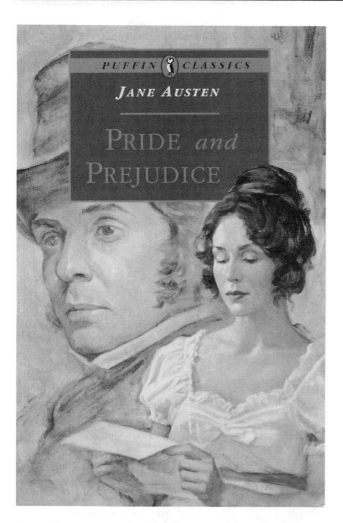

In her popular second novel, Austen interweaves the romantic fate of five sisters.

tience and Marianne's newfound wisdom in the face of circumstances beyond their control, presented society with a model for reform based on "feminine" virtues, asserted Gary Kelly in *Dictionary of Literary Biography*.

In his essay, "Regulated Hatred: An Aspect of the Work of Jane Austen," D. W. Harding claimed that the full implications of Austen's criticism may not have been realized because it could be dismissed as so much caricature. "She found people eager to laugh at faults they tolerated in themselves and their friends," Harding concluded, "so long, that is, as the assault on society could be regarded as a mock-assault and not genuinely disruptive."

Sense and Sensibility was popular with the reading public, and sales from the book earned Austen a considerable sum of money. She avoided celebrity by refusing to acknowledge authorship of the book. On the title page she was merely identified as a "lady." With her second publication, *Pride and Prejudice*, she was referred to as the author of *Sense and Sensibility*. The practice of identifying her only as the author of her previous novel continued throughout her career.

Pride and Prejudice

Begun as "First Impressions," Austen's second novel also focuses on a pair of sisters as they pursue prospects for marriage. There are five Bennet sisters in all: Jane, Elizabeth, Mary, Kitty, and Lydia. They, along with their mother, will be forced off their father's small estate in the event of his death. Lacking a male heir, Mr. Bennet's property has been willed, or entailed, to his nearest male relative, the Reverend William Collins. This arrangement has made Mrs. Bennet increasingly anxious to marry off her daughters. When the wealthy Mr. Bingley moves into a nearby estate with his sister and another young gentleman, the scheming Mrs. Bennet perceives the opportunity to find a husband for at least one of her daughters.

The reserved Jane and dispassionate Mr. Bingley seem to be a match. His haughty companion, Fitzwilliam Darcy, runs afoul of Elizabeth by pronouncing her "tolerable" looking and refusing to ask her to dance. The comment stirs-up the resentment of both Elizabeth and her mother. The younger sisters, Lydia and Kitty, are intent on attracting the attention of some young military officers stationed in the area. One of these men, Wickham, expresses an interest in Elizabeth, to whom he relates a mysterious tale of his unjust treatment at the hands of Darcy.

Attempting to make amends for the conditions of the entail, Reverend Collins arrives at the Bennet house intent on taking one of the daughters as a wife. Finding Jane already in love with Mr. Bingley, Collins proposes to Elizabeth. She rejects him, and is shocked when her close friend Charlotte Lucas accepts a proposal from Collins, whom she clearly does not love, merely to attain the security of marriage. When Bingley and his party return to London, Elizabeth concludes that Bingley has been persuaded by Darcy and his sister to abandon Jane, and her distrust for Darcy deepens.

Thinking him out of her life for good, Elizabeth runs into Darcy while visiting Charlotte at Reverend Collins's home, which is on the grounds of an estate owned by Darcy's Aunt. During their chance encounter, Darcy unexpectedly proposes marriage to Elizabeth. She rejects him, and accuses him of keeping Jane and Mr. Bingley apart, as well as cheating Wickham out of an inheritance. The following day Elizabeth receives a letter from Darcy in which he exposes the rakish Wickham as a liar. At this point, Elizabeth realizes that her prejudice against Darcy, which is the unfortunate result of their first meeting and a subsequent series of misunderstandings, has caused her to misjudge both Wickham and Darcy. Similarly, Darcy must overcome the arrogance and condescension which precipitated the stand-off.

When Lydia elopes with Wickham, who has no intention of marrying her, Darcy finds the couple and pressures Wickham into honoring his commitment. His gallantry in this episode preserves the Bennet family's good name. As Elizabeth's estimation of Darcy increases, his aunt, Lady Catherine de Bourgh, confronts her and commands her not to accept any offer of marriage from Darcy. When Darcy catches wind of this affair, he undermines his aunt by proposing to Elizabeth. This time she accepts. Jane and Bingley also resume their romance and are engaged. By the novel's conclusion, Mrs. Bennet has inadvertently accomplished more than she set out to do.

Pride and Prejudice exceeded *Sense and Sensibility* in popularity. "For all its little smugness and blind spots, despite something airless and narrow," wrote Martin Amis in *Atlantic Monthly*, "*Pride and Prejudice* is Jane Austen's most sociable book—and strangely, her most socially idealistic." This sense of optimism fades in Austen's later novels, Amis concluded. The intricate plotting of the work has also attracted critical attention. In *Jane Austen: A Biography* Elizabeth Jenkins remarked: "In *Pride and Prejudice* this interlacing of characters forms, as it were, the steel structure upon which the work, with its amazing buoyancy, is sprung. Every important fact in the story is shown to be the inevitable consequence of something that has gone before."

Although she was obstinate about maintaining her anonymity, knowledge that Austen was the author of *Sense and Sensibility* and *Pride and Prejudice* began to spread. Austen became somewhat reclusive in the face of her potential celebrity. She rose early in the morning to write undisturbed. When the hinges on the door in the adjacent room squeaked (Austen would not allow them to be oiled), she knew she had just enough time to hide her manuscript in her writing desk. Later in her career Austen tolerated the company of her housemates in the parlor as she worked. After her writing session was concluded, the remainder of the day was devoted to domestic upkeep and occasional visits.

Mansfield Park

In 1814 Austen published her third novel, *Mansfield Park*. After her father's death the novel's heroine, taciturn Fanny Price, is sent to live with her mother's wealthy sister. Soon after Fanny's arrival at Mansfield Park it becomes clear that her aunt, Lady Bertram, has little concern for the wellbeing of her impoverished niece. A second maternal aunt, Mrs. Norris, proves no better. She and Lady Bertram neglect Fanny in favor of her wealthy cousins, Tom, Maria, Julia, and Edmund. Edmund, who plans on entering the clergy, becomes Fanny's lone companion at Mansfield Park and takes it upon himself to provide her with an education. To this end he supervises Fanny's reading, and acts as her tutor. Fanny cherishes Edmund's attention, and the two seem to be falling in love.

Their happiness is disrupted by the arrival from London of the Crawford siblings, Henry and Mary. The provincial Bertrams are fascinated by the quick wit and easy sophistication of the worldly Crawfords. The vain Henry Crawford attempts to win the affections of both Julia and Maria, in spite of Maria's previous engagement to a wealthy neighbor. Similarly, Mary attracts the admiration of both Edmund and his older brother, Tom, the Bertram heir. Fanny, although disconcerted by Edmund's gravitation toward Mary, remains a disinterested observer, content in her ability to see through the Crawfords' superficial charms.

Under the direction of Tom's friend, Yates, the Bertrams and the Crawfords decide to produce a play. They choose *The Lovers' Vows*, Elizabeth Inchbald's English translation of August von Kotzebue's *Das Kinde der Liebe*. With its frank confessions of love, the play will allow the young

inhabitants of Mansfield Park to enact roles they could not acceptably play otherwise. Even the self-righteous Mrs. Norris becomes involved in the production. Fanny alone protests, and refuses to take part. Before the performance, however, Sir Thomas Bertram returns from abroad and calls a halt to the rehearsals.

Searching for a distraction from the company of the cousins, Henry focuses his attentions on Fanny. Much to his surprise, he falls genuinely in love with her, and proposes marriage. When she declines, her relatives are outraged, and demand that she return to her mother's home in Portsmouth. Upon returning home, Fanny finds that she is just as uncomfortable and unfamiliar there as she was at Mansfield Park. Henry continues to pursue her but, just as she seems to soften, he elopes with the recently married Maria. When Mary finds her brother's adultery merely socially inconvenient (and not morally objectionable), Edmund realizes how mistaken he has been concerning her character. With the path between them cleared, Edmund and Fanny resume their romance and become engaged.

While *Mansfield Park* was not as well-received as her previous two novels, Austen's readership included some of the most influential members of British society. The prince regent, the future King George IV, greatly admired Austen's novels. Following the publication of *Mansfield Park,* the prince dispatched his librarian, James Stanier Clarke, to Chawton with the task of getting Austen to dedicate her next novel to the prince.

Emma

Austen agreed (with some reservations) and the novel thus dedicated was *Emma,* often ranked as Austen's greatest literary accomplishment. The novel traces the emotional development of Emma Woodhouse, who is young, beautiful, and, unlike Austen's other female protagonists, rich. Emma is not only liberated from financial concern, but from the burden of meddling adults as well. Her father is a widower, her governess has recently married and moved away, and her older sister lives with her husband in London. Emma is absolutely free to do as she pleases, and she indulges her desire to arrange the lives of her acquaintances in the village of Highbury.

She begins with Harriet Smith, a woman of illegitimate birth who has her sights set on Robert Martin, a young farmer whose family lives on land belonging to Emma's friend and counselor, Mr. Knightley. Emma imagines that Harriet's father must have been a nobleman. She communicates this fantasy to Harriet, then attempts to arrange a marriage between Harriet and Mr. Elton, a young clergyman. Mr. Elton, however, mistakes Emma's curiosity for affection and proposes to her. Emma is seriously taken aback by this, and she explains to Mr. Elton that he ought to be pursuing Harriet instead. Mr. Elton is outraged by Emma's plotting. He proclaims that he considers Harriet his social inferior and would not even

The Penguin English Library

JANE AUSTEN
EMMA

Dedicated to the Prince Regent at his request, this 1816 masterpiece revolves around an unusual heroine—conniving, opinionated, domineering—but lovable.

If you enjoy the works of Jane Austen, you may also want to check out the following books and films:

Joan Aiken's sequels to Austen's novels, including *Jane Fairfax*, 1990.

Stephanie Barron, *Jane and the Unpleasantness at Scargrave Manor* (first in a mystery series featuring Jane Austen as a detective), 1996.

Samuel Richardson, *Sir Charles Grandison* (an Austen favorite), 1754.

Anne Telscombe, *Sandition*, 1975.

Clueless, 1996.

consider marrying her. He then departs for Bath in search of a wife.

Undeterred by her initial failure at matchmaking, Emma continues to manipulate Harriet's affections. She first considers Frank Churchill, the wealthy son of her governess's husband, as a suitable partner for Harriet. These designs fade when Mr. Elton (who has returned to Highbury with his new wife) refuses to dance with Harriet at a ball, and the gallant Mr. Knightley steps in to rescue her honor. She unfortunately misunderstands his motives. When Harriet confesses her ambition of marrying Mr. Knightley to Emma, Emma realizes that she loves Mr. Knightley, and that her plotting has gone thoroughly awry. Finally, Emma's ambitions for Harriet are put to rest when Knightley admits that he has loved Emma all along. Harriet resumes her romance with Robert Martin, which she had not altogether given up, and the two are engaged.

Emma was an immediate success and has received abundant critical attention since. Although still guarded about revealing her identity, Austen was not insensitive to the opinions of others concerning her work, and she kept a list of friends' reactions to *Emma*. Early reviewers were content to praise the book's meticulous plotting and subtle evocation of daily life. "*Emma*, in point of construction, stands without a rival. The story relates the fortunes of a match-making heroine in a quiet country town. A more restricted subject or sphere cannot be imagined," wrote William John Courthope in 1879, "yet, so admirably are the involvements of the situation contrived, that the interest of the reader never flags." More recent criticism has fo-

cused on the character of Emma herself. Emma's dalliances have been variously interpreted as a young woman's awakening to sexual desire, as an expression of artistic imagination and independence, and as a conflict between society and the individual.

In 1817, after completing her sixth novel, *Persuasion*, Austen became seriously ill with symptoms of what appears to have been Addison's disease. She died on March 18 of that year, in Winchester, Hampshire, where Cassandra had taken her to see a physician. As was the custom, Cassandra was not allowed to attend Jane's funeral. With the posthumous publication of *Northanger Abbey* and *Persuasion*, Austen's popularity as a novelist was briefly maintained. Her work then fell out of fashion until the end of the century, when a group of appreciative critics known as "Janites" rediscovered her novels. Jane Austen's books have since become part of the canon of English literature.

Their literary importance notwithstanding, Austen's novels are cherished by scores of readers unconcerned with critical analyses. It is a testament to Austen's artistry that her books, nearly two hundred years old, are still read just for pleasure. Attempting to explain the contemporary fascination with Jane Austen and her novels, Edward Rothstein of the *New York Times* wrote, "Her characters learn through ambiguity and pained disclosure, through error and misjudgment. It may be that we are now looking toward them, in hope of doing the same."

■ Works Cited

Amis, Martin, "Miss Jane's Prime," *Atlantic Monthly*, February, 1990, pp. 100-102.

Courthope, John William, "The Reflection of English Character in Art," *The Quarterly Review*, January, 1879, pp. 81-112.

Dabundo, Laura, "Jane Austen," *Concise Dictionary of British Literary Biography*, Volume 3: *Writers of the Romantic Period, 1789-1832*, Gale, 1992, pp. 3-29.

Harding, D.W., "Regulated Hatred: An Aspect of the Work of Jane Austen, *Scrutiny*," March, 1940, pp. 346-62.

Jenkins, Elizabeth, *Jane Austen: A Biography*, Gollancz, 1968.

Kelly, Gary, "Jane Austen," *Dictionary of Literary Biography*, Volume 116: *British Romantic Novelists*, Gale, 1992.

Rothstein, Edward, "Jane Austen Meets Mr. Right," *New York Times*, December, 10, 1995, pp. E1, E14.

Woolf, Virginia, "Phases of Fiction, Part 2," *The Bookman*, May, 1929, pp. 269-79.

■ For More Information See

BOOKS

Austen-Leigh, William and Richard Arthur, *Jane Austen, A Family Record*, revised and enlarged by Deirdre Le Faye, British Library, 1989.

Bloom, Harold, editor and author of introduction, *Jane Austen* (collection of critical essays), Chelsea House Publishers, 1986.

Duckworth, Alistair M., *The Improvement of the Estate: A Study of Jane Austen's Novels*, Johns Hopkins University Press, 1994.

Gard, Roger, *Jane Austen's Novels: The Art of Clarity*, Yale University Press, 1992.

Harris, Jocelyn, *Jane Austen's Art of Memory*, Cambridge University Press, 1989.

Honan, Park, *Jane Austen: Her Life*, St. Martin's, 1988.

Johnson, Claudia L., *Equivocal Beings: Politics, Gender, and Sentimentality in the 1790's: Wollstonecraft, Radcliffe, Burney, Austen*, University of Chicago Press, 1995.

Lane, Maggie, *Jane Austen and Food*, Hambledon Press, 1995.

Looser, Devoney, editor, *Jane Austen and Discourses of Feminism* (collection of critical essays), St. Martin's Press, 1995.

McMaster, Juliet and Bruce Stovel, editors, *Jane Austen's Business: Her World and Her Profession*, St. Martin's Press, 1996.

Roberts, Warren, *Jane Austen and the French Revolution*, Athlone, 1995.

Stewart, Maaja, *Domestic Realities and Imperial Fictions: Jane Austen's Novels in Eighteenth-Century Contexts*, University of Georgia Press, 1993.

Stout, Janis P., *Strategies of Reticence: Silence and Meaning in the Works of Jane Austen, Willa Cather, Katherine Anne Porter, and Joan Didion*, University Press of Virginia, 1990.

Tanner, Tony, *Jane Austen*, Harvard University Press, 1986.

Tucker, George Holbert, *Jane Austen: The Woman; Some Biographical Insights*, St. Martin's Griffin, 1995.

Wiltshire, John, *Jane Austen and the Body: The Picture of Health*, Cambridge University Press, 1992.

PERIODICALS

Library Journal, January, 1993, p. 170.

Newsweek, August 14, 1995, p. 70.

New Yorker, January 8, 1996, pp. 31-35.

People Weekly, December 25, 1995.*

—Sketch by Ronie-Richele Garcia-Johnson

Marion Dane Bauer

of Minnesota Continuing Education for Women, 1978-85, and Institute of Children's Literature, 1982-85; Carnival Press, Minneapolis, editor, 1982-88; instructor at The Loft, 1986-93; Vermont College, Montpelier, VT, instructor in writing for children, 1997—. *Member:* Authors Guild, Authors League of America, Society of Children's Book Writers and Illustrators.

■ Personal

Born November 20, 1938, in Oglesby, IL; daughter of Chester (a chemist) and Elsie Hempstead (a kindergarten teacher) Dane; married Ronald C. Bauer (an Episcopal priest), June 25, 1959 (divorced December 27, 1987); children: Peter Dane, Elisabeth Alison. *Education:* La Salle-Peru-Oglesby Junior College, A.A., 1958; attended University of Missouri, 1958-59; University of Oklahoma, B.A., 1962. *Politics:* Democrat. *Religion:* Episcopalian. *Avocational interests:* Camping, theater, cats.

■ Addresses

Home—8861 Basswood Rd., Eden Prairie, MN 55344-7407.

■ Career

High school English teacher in Waukesha, WI, 1962-64; Hennepin Technical Center, Minneapolis, MN, instructor in creative writing for adult education program, 1975-78; instructor at University

■ Awards, Honors

Notable Children's book citation, American Library Association, 1976, for *Shelter from the Wind*; Golden Kite Honor Book, Society of Children's Book Writers, 1979, for *Foster Child*; Jane Addams Children's Book Award, Jane Addams Peace Association and Women's International League for Peace and Freedom, Teachers' Choice Award, National Council of Teachers of English, both 1984, both for *Rain of Fire*; Notable Children's Book citation, American Library Association, *School Library Journal's* Best Books of 1986, *Booklist* Editors' Choice, 1987, Newbery Honor Book, 1987, Flicker Tale Children's Book Award, 1989, and Golden Archer Award, 1989, all for *On My Honor*; Children's Book of Distinction, *Hungry Mind Review*, 1992, for *Face to Face*; Notable Children's Book citation, American Library Association, 1992, for *What's Your Story?: A Young Person's Guide to Writing Fiction*; Pick of the Lists citation, American Booksellers Association, and *School Library Journal's* Best Books of 1994 citation, both for *A Question of Trust*; Best Book for Young Adults and Recommended Book

for Young Adult Readers citations, American Library Association, Minnesota Book Award for older children, and Gay-Lesbian-Bisexual Book Award for Literature, 1995, all for *Am I Blue?: Coming Out from the Silence*; Kerlan Award, Kerlan Collection, University of Minnesota, 1996.

■ Writings

JUVENILE FICTION

Shelter from the Wind, Clarion Books (Boston, MA), 1976.
Foster Child, Clarion Books, 1977.
Tangled Butterfly, Clarion Books, 1980.
Rain of Fire, Clarion Books, 1983.
Like Mother, Like Daughter, Clarion Books, 1985.
On My Honor, Clarion Books, 1986.
Touch the Moon (novella), Clarion Books, 1987.
A Dream of Queens and Castles, Clarion Books, 1990.
Face to Face, Clarion Books, 1991.
Ghost Eye (novella), Scholastic (New York City), 1992.
A Taste of Smoke, Clarion Books, 1993.
A Question of Trust, Scholastic, 1994.
(Editor and contributor) *Am I Blue?: Coming Out from the Silence* (short stories), HarperCollins (New York City), 1994.
When I Go Camping with Grandma, illustrated by Allen Garns, BridgeWater Books (Mahwah, NJ), 1995.
Alison's Wings, illustrated by Robert Roth, Hyperion (New York City), 1996.

Contributor to *Funny You Should Ask: The Delacorte Book of Original Humorous Short Stories*, edited by David Gale, Dell (New York City), 1992; *Don't Give Up the Ghost: The Delacorte Book of Original Ghost Stories*, edited by Gale, Delacorte (New York City), 1993; *But That's Another Story: Famous Authors Introduce Popular Genres*, edited by Sandy Asher, Walker and Company (New York City), 1996.

JUVENILE NONFICTION

What's Your Story?: A Young Person's Guide to Writing Fiction, Clarion Books, 1992.
A Writer's Story: From Life to Fiction, Clarion Books, 1995.
Our Stories: A Fiction Workshop for Young Authors, Clarion Books, 1996.

OTHER

Author of *God's Tears: A Woman's Journey*, a chancel drama performed as a one-woman show. Contributor of stories and articles to periodicals, including *Cricket, Horn Book, ALAN Review, Writers' Journal, School Library Journal*, and *Boys' Life*.

■ Adaptations

Shelter from the Wind was adapted into an "ABC Afterschool Special" called *Rodeo Red and the Runaway*.

■ Work in Progress

Two early readers: *Alison Wants a Puppy* and *Alison's Fierce and Ugly Halloween*, for Hyperion; *If You Were Born a Kitten* (picture book) for Simon & Schuster.

■ Sidelights

Like most kids their age, the characters in Marion Dane Bauer's novels have problems: Stacy, in *Shelter from the Wind*, doesn't get along with her stepmother, who, to make matters worse, is pregnant and is getting all of Stacy's father's attention. Stacy has thought about running away, yet when she actually does one day, it's on the spur of the moment when she's unprepared, both for her trek and for the surprising things she learns while out on her own. In *Rain of Fire*, Steve finds himself telling lies right and left. Sometimes it's to impress his friends or the new neighborhood bully, sometimes it's to protect his preferred notions about his older brother Matthew, a war veteran with "uncool" ideas about peace. Joel, in *On My Honor*, must find a way to live with the tragic consequences of foolish decisions he and his buddy Tony make during an afternoon of good-natured bickering and dare-devil challenges.

Family, friends, home, school: troubles come with the territory, and Bauer, by taking up some of the trails through adolescence, ends up walking a stretch alongside her young readers. Though her characters rarely find definite solutions, they always learn a few things along the way: Running away gets you nowhere if you're carrying the problem inside you. Honesty is a pretty good

policy. Kids can make choices and the consequences matter. The truth is usually more than one thing.

"My stories are meant to ask unanswerable questions, to share pain, to test insights, and most of all, to make connections," Bauer once explained in *Contemporary Authors.* "I am always writing toward that moment when a reader will say, 'But I thought I was the only one who ever felt that, thought that, wanted that'; and when the moment comes, my story has found its reason for being." The author of seventeen books for young people, she has received numerous awards over the course of her twenty-year career as a published writer— including a 1987 Newbery Honor Book award for *On My Honor*—attesting to the successful connection her books make with readers' lives. Bauer believes that storytelling responds to a basic hu-

man need. In the introduction to her book *What's Your Story?: A Young Person's Guide to Writing Fiction*, she states: "We are born hungry. We are hungry for food, for warmth, for a loving touch, and for something else as well. We are hungry to understand, to make sense of the world around us. Almost as soon as we begin to talk, we ask a single question, over and over again. 'Why?' And we are still asking that same question when we say, only slightly later, 'Tell me a story.'"

Balance between Child and Adult

Marian Dane Bauer was born in 1938 in the small north-central Illinois town of Oglesby. Her father, Chester Dane, was a chemist who, because of job scarcity during the Great Depression, worked for many years in a cement plant; only later in life did he find a job in his chosen field, working for an area chemical company until his retirement. Her mother, Elsie Hempstead Dane, was a schoolteacher. Bauer recalls that the housing on the edge of the small mill town where she and her older brother Willis spent their childhood was fairly isolated and that she had few friends her own age to play with. "I was very much alone, but in those early years never lonely," she wrote in an essay in the *Something about the Author Autobiography Series (SAAS)*. She received early encouragement from teachers at school and—though her parents weren't religious—through the Episcopal Church, which she attended with her dance teacher's family.

Her preteen years were a painful time, made more so when she transferred to a school in nearby Peru, Illinois, where she felt out of place and found it hard to make friends. "Twelve- and thirteen-year-old girls move in packs. I was totally devoid of pack instinct," she declared in *SAAS.* "I would never, I told myself, never have come near such creatures if I weren't forced to be one of them myself. Which makes it curious, I suppose, that the main characters in my stories are almost always twelve and that now, as an adult, I find that particular age, balanced between childhood and adulthood, the most appealing. Undoubtably, part of the energy of my stories comes from the fact that I am still finding it necessary to redeem that time in my own life."

Always a dreamer of sorts, Bauer knew at a young age that she liked to write. "Though I

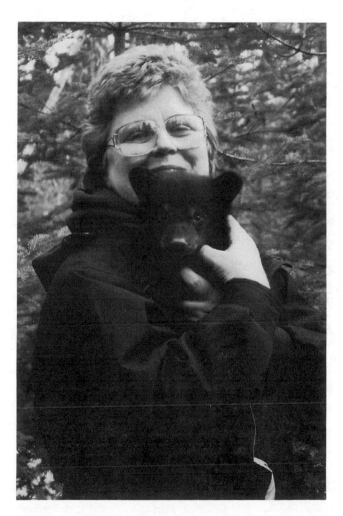

Bauer, best known for her young adult fiction, has also written picture books for preschoolers and nonfiction works on writing.

made up endless stories in my head, stories in which I always played the starring role, I saw little relationship between that activity and writing," she remembers in *SAAS*. "Instead, I wrote journals, long letters to relatives, school assignments, whatever came my way, always confident that the day would come when I would be writing fiction instead."

An aunt who wrote poetry and edited a poetry column for a newspaper in Ohio was an early role model. Bauer continues, "That example, the example of someone who loved writing and found doing it both good and important, probably influenced me more deeply than any other."

After graduating from high school, where she had enjoyed working on the yearbook staff, Bauer attended a local junior college, and then, as a junior, transferred to the University of Missouri to study journalism, "determined to make writing my career," according to her *SAAS* account. She soon discovered, however, that she was more interested in her literature courses than her journalism ones. "The world of the novel felt like the one I lived in. The newspaper dealt with that outer world I had never known and had never wanted to know." That summer, in 1959, she married Ron Bauer, a Korean War veteran. They moved to Norman, Oklahoma, and attended the University of Oklahoma. Bauer had switched majors, from journalism to English literature; then, realizing she needed to be better prepared to find a job—since her husband hoped to be ordained a priest in the Episcopal Church and would be going on to seminary after graduation—decided to study language arts so that she could be an English teacher.

For about the next ten years, Bauer put her professional writing aspirations on the back burner. Her husband's theological studies and parish ministry took them to Wisconsin, Texas, Kansas, Missouri, and Minnesota. She kept busy teaching English, then raising their two children, Peter Dane and Elisabeth Alison, and taking on numerous volunteer activities in the community and church, including foster parenting, teaching Sunday school, and working with troubled youth. "By then I saw my writing as my secret vice, the one thing I did that served no one but myself," she explained in *SAAS*. She recalls that it was not until both her children were in school that she finally came to the realization that dreaming of becoming a writer wasn't going to make it happen. She needed to take action. She made a deal with her husband, who wanted her to go back to work: she would take the next five years to work at her writing as if it were a full-time job. If, after that time, she hadn't gotten anywhere, she would go back to being a teacher.

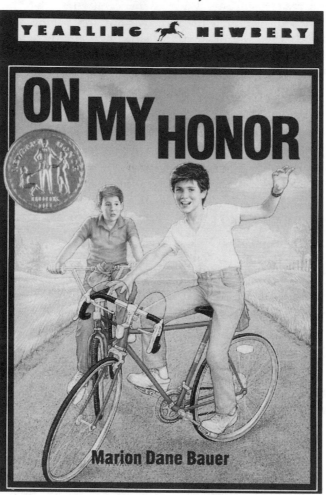

Winner of a 1987 Newbery Honor Book Award, this story of a thirteen-year-old who feels responsible for a friend's death but doesn't tell anyone was based on a true incident.

As a mother of young children, Bauer was familiar with what seemed to be the simple stories in children's books, so she tried her hand at children's stories first and soon found how difficult the work was. She went to the local library for inspiration, where she came upon the shelves of contemporary novels for children and young adults, a genre she hadn't known about. Reading

these books brought her a happy discovery, which she described in *SAAS*: ". . . I didn't have to make compromises or hold back any part of my power in order to write for children. I could write about anything which could touch a child's life, as long as I wrote it well and with compassion and intelligence." Just a little more than three years later, in 1976, her first book, *Shelter from the Wind*, was published.

Early Success

Most aspiring writers dream about the lucky break that will get them recognized—and published. For Bauer, that break came at a writer's conference in St. Paul, Minnesota, where she received public praise from Newbery Award-winning writer Maia Wojciechowska (*Shadow of a Bull*) for her manuscript *Foster Child*. It was her first novel-writing attempt, based on some of her experiences as a foster parent. Her confidence buoyed by this recognition, Bauer got right to work and, in less than a year, completed *Shelter from the Wind*, her first published novel. (*Foster Child* was revised and published a year later.) The American Library Association (ALA) named *Shelter* a Notable Children's Book for 1976, and it was eventually adapted into an *ABC Afterschool Special* called "Rodeo Red and the Runaway."

Shelter from the Wind is about young Stacy and the eye-opening experiences she has after she runs away from home. She wanders about on the Oklahoma prairie for a day and a night, fairly lost, until two white German shepherds find her. She follows the dogs home to a remote cabin belonging to an equally independent soul, Old Ella. The old woman's steely acceptance of a hard but long and worthy life causes Stacy to confront some of her own personal pains. The climax comes when Ella is injured in a fall just as one of the dogs begins giving birth—with difficulty—to a litter of puppies. Stacy is uncertain, angry, and afraid, but nonetheless takes charge.

Foster Child explores other childhood pains and longings. In the book, a social worker deposits twelve-year-old Renny in a foster home after her beloved grandmother becomes too ill to care for her any longer. There Renny has to cope with four foster brothers and sisters and the fallout from their equally difficult family lives. She learns about the strict rules and rituals laid out by foster fa-

ther Pop Beck, who disguises his own misconduct with religious zeal. Finally, she struggles to give up her own fantasies about her grandmother's recovery and about being rescued by a father figure she has never known. *Foster Child* received a 1979 Golden Kite honor book citation from the Society of Children's Book Writers.

Bauer earned further recognition for her fourth novel, *Rain of Fire* (1983), which attempts to illustrate the complexities of war through a microcosmic focus on an escalating conflict between neighborhood children. Set in a Midwestern mill town (not unlike Bauer's childhood home) at the conclusion of World War II, *Rain of Fire* gets its title from an account of the war-ending atomic bombing of Hiroshima, given by twelve-year-old Steve's older brother Matthew, who was among the troops occupying Japan. Matthew is disturbed by his war experiences, and Steve finds it hard to understand the changes in his brother and in their relationship. When a tough-talking new kid on the block wins over Steve's best friends and then challenges Matthew's honor, Steve finds himself telling lies and plotting revenge of various sorts, all of which cycles out of control and ends in accidental violence. In order to learn the book's ultimate lesson, Steve has to negotiate his way among friends and enemies and shifting loyalties; rash actions and drastic consequences; truth and lies and the gray areas in between.

Though some reviewers believed the novel's message about war was heavy-handed, they also noted how deftly Bauer had drawn her young characters—particularly the unusual yet genuine-seeming camaraderie between Steve and his friend Becca—and the sometimes humorous, sometimes painful situations in which they found themselves: "Bauer has the notable ability to relate a story so that it never deviates from the viewpoint of a child," a critic in *Publishers Weekly* stated. A reviewer in *Booklist* observed that the author's "characters and the dilemmas she creates for them grow in power as [*Rain of Fire*] . . . builds to its riveting conclusion." *Rain of Fire* earned the Jane Addams Children's Book Award from the Jane Addams Peace Association and Women's International League for Peace and Freedom in 1984. "To have hope [children] must believe that the choices they make matter, that they have the power to change human history," Bauer stated in "Peace in Story, Peace in the World," an article published in *Horn Book*.

The Book that Transformed a Career

On My Honor, published in 1986, came out at a time when the author was going through difficult transitions in her personal life, including a divorce after twenty-eight years of marriage. In the end, however, the book brought Bauer widespread recognition and helped her to become a self-sufficient writer. Among numerous awards and citations, *On My Honor* received the prestigious Newbery Honor Book citation in 1987. "It is quite amazing how one book can transform a career," Bauer remarked in *SAAS*. Bauer has said that her attempt in *On My Honor* was different than anything she had written before. "It came as a gift, one of those gifts writers always hope for and receive only rarely. I, who ordinarily find my way through a first draft slowly, methodically, circling back many, many times to start over, wrote the first draft of *On My Honor* from beginning to end in two weeks," she remembered in *SAAS*.

Based on a real event she heard about as a child, *On My Honor* concerns one boy's involvement in a tragedy. Lifelong pals Joel and Tony set out one summer day on a difficult bike trek to a site where Tony wants to do some dangerous rock-climbing, a scheme that Joel agrees to against his better judgment. Knowing that Tony can't resist a challenge, Joel suggests that they stop along the way to swim in the river, with hopes that it will divert Tony from their original plan. Little does he know that the intrepid Tony is a poor swimmer who soon gets pulled under. Joel repeatedly dives in search of his friend, until he is exhausted and himself threatened by the swift current. He has to give up the search and accept the terrible reality that his friend has drowned. In shock and not knowing what to do, Joel returns home, telling no one what has happened. "To make a mistake, even to have participated in someone else's mistake which ended fatally! How did a person learn to live with that?" questioned Bauer in *SAAS*. "We all have had moments when we have done something, perhaps not meaning to at all, which hurt another person. Times when we would have given anything to start a day over and make a different set of choices," Bauer surmised.

Rights, Responsibilities, Relationships

Most of Bauer's novels ask such moral questions about rights and responsibilities . . . and about relationships, too. In *A Dream of Queens and Castles* (1990) twelve-year-old Diana arrives with her mother, a hard-working college professor with whom she has lately been at odds, to a small English village for a year's exchange. Entertaining a fantasy about meeting Princess Diana—who young Diana imagines will overrule her mother's wishes and send her home to her friends and school in Minnesota—she puts her trust in an eccentric old gentleman she meets in the village who doesn't question her dream. He has a dream of his own: to get a royal medal for his heroic war service. Diana disobeys her mother and takes a train trip with the old man to London, where her high hopes seem momentarily attainable but soon begin to unravel. She discovers that she is stranded in a strange city and responsible for an old man whose memory isn't stable. According to a review by Kristiana Gregory in the *Los Angeles Times Book Review*, "*A Dream of Queens* offers a quality story for 9- to 12-year-olds who will appreciate a broader and almost tender view of the world."

In *Face to Face* (1991), "a powerful though understated novel . . . about inner torment," according to Maeve Visser Knoth in *Horn Book*, thirteen-year-old Michael is reunited with his father at a whitewater rafting camp in Colorado. He is thrilled to get away from a stepfather with whom he doesn't get along and kids at school who make fun of him. Michael's idealization of the father who abandoned his mother and him years ago soon shatters as he discovers that his father is not an admirable person. Anger and depression threaten to overcome him. Elaine S. Patterson in *KLIATT* called *Face to Face* "an excellent read" that discusses a common problem for children of divorced parents: "unrealistic ideas about an absent parent and the inability to accept stepparents."

Bauer again takes up the problems of a broken family in *A Question of Trust* (1994). Brothers Brad and Charlie, whose parents have recently separated, refuse to talk to or visit their mother, hoping it will force her to come home. Meanwhile, in a parallel subplot, a stray cat has kittens in their shed and, when she inexplicably kills one of them, the boys secretly defend and care for the remaining kitten, even though their father won't allow pets. "From the first page, Bauer writes with an intensity and honesty that propel readers through the story, stirring their feelings, too. She makes them see how love and hate are intertwined," Ilene Cooper wrote in *Booklist*.

Bauer's stories recognize that relationships, particularly family ones, are complicated and never static and always affected by outside forces. Such relationships both help and hinder the formation of personal identity. Because most of Bauer's characters are at an age when they are attempting to discover and assert an independent identity, a process clouded by the heightened emotional drama of adolescence, it seems inevitable that they commonly find themselves trying to sort out family conflict. "I am convinced that we all spend our lives trying to solve the problems of our original families. In adulthood, the problems change form, but the underlying issues remain the same. I find I have little interest artistically in the later changed forms, only in the early origins," Bauer remarked in *SAAS.* "If I were not a children's fic-

Original stories by C. S. Adler, Marion Dane Bauer, Francesca Lia Block, Bruce Coville, Nancy Garden, James Cross Giblin, Ellen Howard, M. E. Kerr, Jonathan London, Lois Lowry, Gregory Maguire, Lesléa Newman, Cristina Salat, William Sleator, Jacqueline Woodson, and Jane Yolen

This 1994 collection of short stories for young people on growing up gay or lesbian, or with lesbian or gay friends or parents, was envisioned by the editor to celebrate our common humanity.

tion writer, I would probably be a psychotherapist, helping people to explore their childhoods in order to understand their present lives," she continued. "When I write for children, I have built-in perspective. When I write for adults, I tend to try to use my very immediate present as material. And thus I end up writing too close to the bone and lose the perspective art requires."

While best known for her young adult novels, Bauer's writing has in recent years branched out into other genres: She has had several picture books for young children published, as well as two nonfiction books about the literary life: *What's Your Story? A Young Person's Guide to Writing Fiction* (1992) and *A Writer's Story: From Life to Fiction* (1995), an autobiographical follow-up. Described as "a model of lucid organization, written as elegantly as [her] YA novels" by Cathi Dunn MacRae in the *Wilson Library Bulletin, What's Your Story* is a how-to book for aspiring young writers that provides practical suggestions on planning and focusing story ideas, creating good beginnings and endings, developing plot, characters, and dialogue, and final revision. Reviewers Susan Murphy and Joyce Graham concluded in the *Journal of Reading:* "Interspersing examples from her own work with examples constructed to illustrate her points, Bauer skillfully introduces the subtle elements of good fiction writing. Her tone is encouraging, but she frankly addresses the common traps beginning writers fall into."

"Am I Blue?"

One of Bauer's most recent works for young adults is an effort very different from her previous ones, and it may be her most personal to date. As editor of the anthology *Am I Blue?: Coming Out From the Silence,* Bauer brought together stories by fifteen different authors, all of them focused on gay and lesbian themes. "Ten years ago, an anthology of short stories dealing with gay and lesbian themes probably would not have been considered by any major young adult publisher," Bauer wrote in the introduction to *Am I Blue?* "It is my dream that ten years from now such an anthology will not be needed, that gay and lesbian characters will be as integrated into juvenile literature as they are in life." Why embark on such a project? As Bauer explained in *Am I Blue?:* "One out of ten teenagers attempts suicide. One out of three of those does so because

If you enjoy the works of Marion Dane Bauer, you may also want to check out the following books and films:

Francesca Lia Block, *Weetzie Bat,* 1989.
Paula Fox, *The Slave Dancer* (a Bauer favorite), 1973.
Nancy Garden, *Annie on My Mind,* 1984.
M. E. Kerr, *Deliver Us from Evie,* 1994.
Richard Peck, *Unfinished Portrait of Jessica,* 1991.
Sounder, Twentieth Century-Fox, 1972.

of concern about being homosexual. . . . The intention of this anthology is to tell challenging, honest, affecting stories that will open a window for all who seek to understand themselves or others."

Dedicated to "all young people in their search for themselves," with a portion of the proceeds from its sales earmarked for the national support group, Parents Families and Friends of Lesbians and Gays (P-FLAG), the collection has been widely praised. A reviewer in *Publishers Weekly* commended the work for its "stellar list of popular children's and YA authors," and Stephanie Zvirin in *Booklist* found *Am I Blue?* "wonderfully diverse in tone and setting . . . [with] stories [that] cut across color and class lines." Cyrisse Jaffee, in the *Women's Review of Books,* wrote that "this is a brave, extraordinary collection, sure to raise the hackles of reactionaries everywhere—but equally destined to find its way to teenagers everywhere, brimming with questions, desires and hopes." And author Katherine Paterson, reviewing *Am I Blue?* in the *Washington Post Book World,* concluded, "When a book that sets out to do good turns out to be as good as this one, we are all the winners."

A sampling of the book's offerings: In "Holding," by Lois Lowry, one young man finds he can finally be honest with a friend about his father's homosexuality. Francesca Lia Block writes in "Winnie and Teddy" about the up-and-down weekend during which a girl finds out that her boyfriend is gay. "Blood Sister," by Jane Yolen, strings together myth, song, and academic theorizing to tell a girl's coming-of-age story set in an imaginary world. Gregory Maguire's "The Honorary Shepherds" uses a music video storytelling style to give a glimpse into two young men's growing relationship and self-awareness as they work together on a film class project devoted to retelling the Christmas story from a non-traditional point of view. And, in the title story, "Am I Blue?" by Bruce Coville, a young man grappling with sexual confusion gets a fairy godfather with flair, who turns everyone with some degree of homosexual orientation a shade of blue for the day, illustrating that, regardless of what his charge discovers about himself, he will not be alone. Bauer ends the collection with her own story, "Dancing Backward," about two young women in a private school who do not discover what they unconsciously already know about their closeness until they experience the accusatory and harsh reaction of the nuns in charge. Describing the story as "entirely true and mostly made up," Bauer writes in an endnote to the story that it took her thirty years of adult life before "I finally recognized what direction I had been facing all along. When I was four years old I understood what it has taken me all these years to discover. It's not the audience's perspective that matters, or their applause. It's the dance."

As various as Bauer's fiction is, at least one common theme emerges that applies to adolescents as well as adults: self-discovery is a journey, not a destination. Bauer now lives in Minneapolis, Minnesota (her mother's home state), writing, teaching, and lecturing, and has said that she is as happy as she has ever been. Referring to the early days of her writing career, Bauer concludes in *SAAS,* "The writing became work, good work but nonetheless work. In the years since then I have discovered that the books, after all, are only a by-product. The true creation of my life is me, what I become."

■ Works Cited

Review of *Am I Blue?: Coming Out from the Silence, Publishers Weekly,* May 2, 1994.

Bauer, Marion Dane, "Peace in Story, Peace in the World," *Horn Book,* November/December, 1987.

Bauer, Marion Dane, comments in *Contemporary Authors,* New Revision Series, Volume 26, Gale, 1989.

Bauer, Marion Dane, essay in *Something About the Author Autobiography Series,* Volume 9, Gale, 1990.

Bauer, Marion Dane, *What's Your Story: A Young Person's Guide to Writing Fiction,* Clarion Books, 1992.

Bauer, Marion Dane, *Am I Blue?: Coming Out from the Silence*, HarperCollins, 1994.

Cooper, Ilene, review of *A Question of Trust*, *Booklist*, January 15, 1994.

Review of *Face to Face*, *KLIATT*, July, 1993.

Gregory, Kristiana, review of *A Dream of Queens and Castles*, *Los Angeles Times Book Review*, April 22, 1990.

Jaffee, Cyrisse, "A World of Words," *Women's Review of Books*, November, 1994.

Knoth, Maeve Visser, review of *Face to Face*, *Horn Book*, November/December, 1991.

MacRae, Cathi Dunn, review of *What's Your Story: A Young Person's Guide to Writing Fiction*, *Wilson Library Journal*, June, 1993.

Murphy, Susan and Joyce Graham, *What's Your Story: A Young Person's Guide to Writing Fiction*, *Journal of Reading*, October, 1992.

Paterson, Katherine, "Easing Troubled Hearts," *Washington Post Book World*, September 8, 1994.

Review of *Rain of Fire*, *Booklist*, September 15, 1983.

Review of *Rain of Fire*, *Publishers Weekly*, Volume 234, number 22, p. 64.

Zvirin, Stephanie, review of *Am I Blue?: Coming Out from the Silence*, *Booklist*, May 1, 1994.

■ **For More Information See**

PERIODICALS

Booklist, February 15, 1990, p. 1157; September 15, 1992, p. 148; January 1, 1995, p. 824.

Bulletin of the Center for Children's Books, October, 1991, p. 30; January, 1994, p. 147; March/April, 1996, p. 221.

Horn Book, July/August, 1990, pp. 452-53; January/February, 1994, p. 68-69; July/August, 1994, pp. 448-49.

Locus, January, 1994, p. 51.

Publishers Weekly, March 16, 1990, p. 70; April 20, 1992, p. 58; November 16, 1992, p. 25; September 27, 1993, p. 64; February 7, 1994, p. 88.

Quill & Quire, January, 1992, p. 34.

School Library Journal, February, 1984, p. 65; October, 1992, p. 112; April, 1993, p. 80; March, 1994, p. 220; February, 1995, pp. 32-33; August, 1996, pp. 115-6.

Voice of Youth Advocate, February, 1994, p. 364; April, 1994, p. 22; August, 1994, p. 141.

Wilson Library Bulletin, June, 1993, pp. 69-70, 104-5.

—*Sketch by Tracy J. Sukraw*

Jose Luis Borges

numerous universities in the United States and throughout the world, including University of Texas, 1961-62, University of Oklahoma, 1969; University of New Hampshire, 1972, and Dickinson College, 1983; Harvard University, Cambridge, MA, Charles Eliot Norton Professor of Poetry, 1967-68. Editor at various Argentine journals and magazines.

■ Personal

Also wrote under pseudonym Francisco Bustos and joint pseudonyms Honorio Bustos Domecq, B. Lynch Davis, and B. Suarez Lynch; born August 24, 1899, in Buenos Aires, Argentina; died of liver cancer, June 14, 1986, in Geneva, Switzerland; buried in Plainpalais, Geneva, Switzerland; son of Jorge Guillermo Borges (a lawyer, teacher, and writer) and Leonor Suarez (a translator; maiden name, Acevedo); married Elsa Astete Millan, September 21, 1967 (divorced, 1970); married Maria Kodama, April 26, 1986. *Education:* Collége Calvin, Geneva, Switzerland, 1918; Cambridge University.

■ Career

Writer. Miguel Cane branch library, Buenos Aires, Argentina, municipal librarian, 1937-46; National Library, Buenos Aires, director, 1955-73. Teacher of English literature at several private institutions and lecturer in Argentina and Uruguay, 1946-55; University of Buenos Aires, Buenos Aires, professor of English and North American literature, beginning 1956. Visiting professor or guest lecturer at

■ Awards, Honors

Buenos Aires Municipal Literary Prize, 1928, for *El idioma de los argentinos;* Gran Premio de Honor, Argentine Writers Society, 1945, for *Ficciones, 1935-44;* Gran Premio Nacional de la Literatura (Argentina), 1957, for *El Aleph;* Prix Formentor (shared with Samuel Beckett), International Congress of Publishers, 1961; named as an honorary fellow, Modern Language Association of America, 1961; Commandeaur de l'Ordre des Lettres et des Arts (France), 1962; named as an honorary fellow, American Association of Teachers of Spanish and Portuguese, 1965; Ingram Merrill Foundation Award, 1966; Matarazzo Sobrinho Inter-American Literary Prize, Bienal Foundation, 1970; nominated for Neustadt International Prize for Literature, *World Literature Today* and University of Oklahoma, 1970, 1984, and 1986; Jerusalem Prize, 1971; named an honorary member, American Academy of Arts and Letters and National Institute of Arts and Letters, 1971; Alfonso Reyes Prize (Mexico), 1973; Gran Cruz del Orden al merito Bernardo O'Higgins

from Government of Chile, 1976, Gold Medal From French Academy, Order of Merit, Federal Republic of Germany, and Icelandic Falcon Cross, all 1979; Miguel de Cervantes Award (Spain) and Balzan Prize (Italy), both 1980; Ollin Yoliztli Prize (Mexico), 1981; T.S. Eliot Award for Creative Writing, Ingersoll Foundation and Rockford Institute, 1983; Gold Medal of Menendez Pelayo University (Spain), La Gran Cruz de la Orden Alfonso X, el Sabio (Spain), and Legion d'Honneur (France), all 1983; Knight of the British Empire. Recipient of honorary degrees from numerous colleges and universities, including University of Cuyo (Argentina), 1956, University of the Andes (Colombia), 1963, Oxford University, 1970, University of Jerusalem, 1971, Columbia University, 1971, Michigan State University, 1972, and Harvard University, 1981.

■ Writings

SHORT STORIES

Historia universal de la infamia, Tor (Buenos Aires), 1935, revised edition published as *Obras completas*, Volume 3, Emecé, 1964, translation by di Giovanni published as *A Universal History of Infamy*, Dutton, 1972.

El jardín de senderos que se bifurcan (also see below; titled means "Garden of the Forking Paths"), Sur, 1941.

(With Adolofo Bioy Casares, under joint pseudonym H. Bustos Domecq) *Seis problemas para Isidro Parodi*, Sur, 1942, translation by di Giovanni published under authors' real names as *Six Problems for Don Isidro Parodi*, Dutton, 1983.

Ficciones, 1935-44 (includes *El jardin de senderos que se bifurcan*), Sur, 1944, revised edition published as *Obras completas*, Volume 5, Emecé, 1956, reprinted, with English introduction and notes by Grodon Brotherson and Peter Humle, Harrap, 1976, translation by Anthony Kerrigan and others published as *Ficciones*, edited and with an introduction by Kerrigan, Grove, 1962 (published in England as *Fictions*, John Calder, 1965), reprinted, Limited Editions Club (New York), 1984.

(With Bioy Casares, under joint pseudonym H. Bustos Domecq) *Dos fantasías memorables*, Oportet & Haereses, 1946, reprinted under authors' real names with notes and bibliography by Horacio Jorge Becco, Edicom (Buenos Aires), 1971.

El Aleph, Losada, 1949, revised edition, 1952, published as *Obras completas*, Volume 7, Emecé, 1956, translation and revision by di Giovanni in collaboration with Borges published as *The Aleph and Other Stories, 1933-1969*, Dutton, 1970.

(With Luisa Mercedes Levinson) *La hermana de Eloísa* (title means "Eloisa's Sister"), Ene (Buenos Aires), 1955.

(With Bioy Casares) *Crónicas de Bustos Domecq*, Losada, 1967, translation by di Giovanni published as *Chronicles of Bustos Domecq*, Dutton, 1976.

El informe de Brodie, Emecé, 1970, translation by di Giovanni in collaboration with Borges published as *Dr. Brodie's Report*, Dutton, 1971.

El matrero, Edicom, 1970.

El congreso, El Archibrazo, 1971, translation by di Giovanni in collaboration with Borges published as *The Congress* (also see below), Enitharmon Press, 1974, translation by Alberto Manguel published as *The Congress of the World*, F.M. Ricci (Milan), 1981.

El libro de arena, Emecé, 1975, translation by di Giovanni published with *The Congress* as *The Book of Sand*, Dutton, 1977.

(With Bioy Casares) *Nuevos cuentos de Bustos Domecq*, Libreria de la Ciudad, 1977.

Rosa y azul (contains "La rosa de Paraceleso" and "Tigres azules") Sedmay (Madrid), 1977.

Veinticinco agosto 1983 y otros cuentos de Jorges Luis Borges (includes interview with Borges), Siruela, 1983.

POETRY

Fervor de Buenos Aires (title means "Passion for Buenos Aires"), Serantes (Buenos Aires), 1923, revised edition, Emecé, 1969.

Luna de enfrente (title means "Moon across the Way") Proa (Buenos Aires), 1925.

Cuaderno San Martín (title means "San Martin Copybook"), Proa, 1929.

Poemas, 1923-1943, Losada, 1943, 3rd enlarged edition published as *Obra poética, 1923-1964*, Emecé, 1964, translation published as *Selected Poems, 1923-1967* (bilingual edition; also includes prose), edited, with an introduction and notes, by Norman Thomas di Giovanni, Delacorte, 1972.

El hacedor (prose and poetry; Volume 9 of *Obras completas*; title means "The Maker"), Emecé, 1960, translation by Mildred Boyer and Harold Morland published as *Dreamtigers*, University of Texas Press, 1964, reprinted, 1985.

Seis poemas escandinavos (title means "Six Scandinavian Poems"), privately printed, 1966.

Siete poemas (title means "Seven Poems"), privately printed, 1967.

El otro, el mismo (title means "The Other, the Same"), Emecé, 1969.

Elogio de la sombra, Emecé, 1969, translation by di Giovanni published as *In Praise of Darkness* (bilingual edition), Dutton, 1974.

El oro de los tigres (also see below; title means "The Gold of Tigers"), Emecé, 1972.

Siete poemas sajones/Sevon Saxon Poems, Plain Wrapper Press, 1974.

La rosa profunda (also see below; title means "The Unending Rose"), Emecé, 1975.

La moneda de hierro (title means "The Iron Coin") Emecé, 1976.

Adrogue (prose and poetry), privately printed, 1977.

Historia de la noche (title means "History of the Night"), Emecé, 1977.

The Gold of Tigers: Selected Later Poems (contains translations of *El oro de los tigres* and *La rosa profunda*), translated by Alastair Reid, Dutton, 1977.

La cifra, Emecé, 1981.

(With Kodama) *Atlas* (prose and poetry), Sudamericana, 1984, translation by Kerrigan published as *Atlas*, Dutton, 1985.

Les conjures (originally published as *Los conjurados* in 1985), translated by Silvia Baron Supervielle (Geneva), Jacques T. Quentin, 1990.

ESSAYS, LITERARY CRITICISM, AND LECTURES

Inquisiciónes (title means "Inquisitions"), Proa, 1925.

El tamaño de mi esperanza (title means "The Measure of My Hope"), Proa, 1926.

El idioma de los argentinos (title means "The Language of the Argentines"), M. Gleizer (Buenos Aires), 1928, 3rd edition (includes three essays by Borges and three by Jose Edmundo Clemente), Emecé, 1968.

Figari, privately printed, 1930.

Las Kennigar, Colombo (Buenos Aires), 1933.

Historia de la eternidad (title means "History of Eternity"), Viau y Zona (Buenos Aires), 1936, revised edition published as *Obras completas*, Volume 1, Emecé, 1953, reprinted, 1978.

Nueva refutacion del tiempo (title means "New Refutation of Time"), Oportet y Haereses, 1947.

Aspectos de la literature gauchesca, Numero (Montevideo), 1950.

(With Delia Ingenieros) *Antiguas literaturas germanicas*, Fondo de Cultura Economica (Mexico), 1951, revised edition with Maria Esther Vazquez published as *Literaturas germánicas medievales*, Falbo, 1966, reprinted, Emecé, 1978.

Otras inquisiciónes, Sur (Buenos Aires), 1952, published as *Obras completas*, Volume 8, Emecé, 1960, translation by Ruth L. C. Simms published as *Other Inquisitions, 1937-1952*, University of Texas Press, 1964.

(With Margarita Guerrero) *El Martín Fierro*, Columba, 1953, reprinted, Emecé, 1979.

(With Bettina Edelberg) *Leopoldo Lugones*, Troquel, (Buenos Aires), 1955.

(With Guerrero) *Manual de zoología fantástica*, Fondo de Cultura Economica, 1957, translation published as *The Imaginary Zoo*, University of California Press, 1969, revised Spanish edition with Guerrero published as *El libro de los seres imaginarios*, Kier (Buenos Aires), 1967, translation and revision by di Giovanni and Borges published as *The Book of Imaginary Beings*, Dutton, 1969.

La poesia gauchesca (title means "Gaucho Poetry"), Centro de Estudios Brasileiros, 1960.

(With Vasquez) *Introducción a la literatura inglesa*, Columba, 1965, translation by L. Clark Keating and Robert O. Evans published as *An Introduction to English Literature*, University Press of Kentucky, 1974.

(With Esther Zemborain de Torres) *Introducción a la literatura norteamericana*, Columba, 1967, translation by Keating and Evans published as *An Introduction to American Literature*, University Press of Kentucky, 1971.

Borges on Writing (lectures), edited by Norman Thomas di Giovanni, Daniel Halpern, and Frank MacShane, Dutton, 1973, Ecco, 1994.

(With Alicia Jurado) *Qué es el budismo?* (title means, "What Is Buddhism?"), Columba, 1976, Emecé, 1991.

Borges oral (lectures), edited by Martin Mueller, Emecé, 1979.

Siete noches (lectures), Fondo de Cultura Economica, 1980, translation by Weinberger published as *Seven Nights*, New Directions, 1984.

Nuevos ensayos dantescos (title means "New Dante Essays") Espasa-Calpe, 1982.

Textos cautivos: Ensayos y resenas en "El Hogar" (1935-39) (title means "Captured Texts: Essays and Reviews in 'El Hogar' [1936-39]"), edited by Rodriguez Monegal and Enrique Sacerio-Gari, Tusquets, 1986.

El aleph borgiano (chiefly book reviews which appeared in journals, 1922-84), edited by Juan Gustavo Cobo Borda and Martha Kovasics de Cubides, Biblioteca Luis-Angel Arango (Bogota), 1987.

Testimony to the Invisible & Other Essays on Swedenborg, Swedenborg Foundation, 1995.

TRANSLATIONS

Virginia Woolf, *Orlando,* Sur, 1937.

(Also author of prologue) Franz Kafka, *La metamorfosis,* [Buenos Aires], 1938, reprinted, Losada, 1976.

Henri Michaux, *Un barbaro en Asia,* Sur, 1941.

(Also author of prologue) Herman Melville, *Bartleby, el escribiente,* Emecé, 1943, reprinted, Marymar (Buenos Aires), 1976.

William Faulkner, *Las palmeras salvajes,* Sudamericana, 1956.

(Also editor and author of prologue) Walt Whitman, *Hojas de hierba,* Juarez (Buenos Aires), 1969.

OMNIBUS VOLUMES

La muerte y la brújula (stories; title means "Death and the Compass"), Emecé, 1951.

Obras completas, nine volumes, Emecé, 1953-1960, revised edition edited by Carlos V. Frías, published as one volume, 1974.

Cuentos (title means "Stories"), Monticello College Press, 1958.

Antología personal (prose and poetry), Sur, 1961, translation published as *A Personal Anthology,* edited and with foreword by Kerrigan, Grove Press, 1967.

Labyrinths: Selected Stories and Other Writings, edited by Donald A. Yates and James E. Irby, preface by Andre Maurois, New Directions, 1962, augmented edition, 1964, reprinted, Modern Library, 1983.

Nueva antología personal, Emecé, 1968.

Prologos, con un prólogo de prólogos (title means "Prologues, with a prolougue of prologues"), Torres Aguero (Buenos Aires), 1975.

(With others) *Obras completas en colaboracion* (title means "Complete Works in Collaboration"), Emecé, 1979.

Narraciones (stories), edited by Marcos Ricardo Bamatan, Catedra, 1980.

Borges: A Reader (prose and poetry), edited by Emir Rodriguez Monegal and Reid, Dutton, 1981.

Ficcionario: Una antologia de sus textos, edited by Rodriguez Monegal, Fondo de Cultura Economica, 1985.

Biblioteca personal: Prólogos (Alianza, 1988).

OTHER

(Author of afterword) Ildefonso Pereda Valdes, *Antología de la moderna poesia uruguaya,* El Ateneo (Buenos Aires), 1927.

Evaristo Carriego (biography), M. Gleizer, 1930, revised edition published as *Obras completas,* Volume 4, Emecé (Buenos Aires), 1955, translation by di Giovanni published as *Evaristo Carrigo: A Book about Old Time Buenos Aires,* Dutton, 1984.

Discusión, Gleizer (Buenos Aires), 1932, revised edition, Alianza (Madrid), Emecé, 1976.

(Editor with Pedro Henriquez Urena) *Antología clasica de la literatura Argentina,* Kapelusz (Buenos Aires), 1937.

(Editor with Bioy Casares and Silvina Ocampo) *Antología de la literatura fantastica,* with foreword by Bioy Casares, Sudamericana, 1940, enlarged edition with postscript by Bioy Casares, 1965, translation of revised version published as *The Book of Fantasy,* with introduction by Ursula K. Le Guin, Viking, 1988.

(Author of prologue) Bioy Casares, *La invencion de Morel,* Losada, 1940, reprinted, Alianza, 1981, translation by Simms published as *The Invention of Moral and Other Stories,* University of Texas Press, 1964, reprinted, 1985.

(Editor with Bioy Casares and Ocampo and author of prologue), *Antología poetica argentina,* Sudamericana, 1941.

(Compiler and translator with Bioy Casares) *Los mejores cuentos policiales* (title means "The Best Detective Stories"), Emecé, 1943, reprinted, Alianza, 1972.

(Editor with Silvina Bullrich) *El compadrito: Su destino, sus barrios, su música* (title means "The Buenos Aires Hoodlum: His Destiny, His Neighborhoods, His Music"), Emecé, 1945, 2nd edition, Fabril, 1968.

(With Bioy Casares, under joint pseudonym B. Suarez Lynch) *Un modelo para la muerte* (novel; title means "A Model for Death"), Oportet & Haereses, 1946.

(Compiler and translator with Bioy Casares) *Los mejores cuentos policiales: Segunda serie,* Emecé, 1951.

(Editor and translator with Bioy Casares) *Cuentos breves y extraordinarios: Antología,* Raigal (Buenos

Aires), 1955, revised and enlarged edition, Losada, 1973, translation by Kerrigan published as *Extraordinary Tales*, Souvenir Press, 1973.

(With Bioy Casares) *Los orilleros* [and] *El paraiso de los creyentes* (screenplays; titles mean "The Hoodlums" and "The Believers' Paradise"; "Los orilleros" produced by Argentine director Ricardo Luna, 1975), Losada, 1955, reprinted, 1975.

(Editor and author of prologue, notes, and glossary with Bioy Casares) *Poesia gauchesca* (title means "Gaucho Poetry"), two volumes, Fondo de Cultura Economica, 1955.

(Editor with Bioy Casares) *Libro del cielo y del infierno* (anthology; title means "Book of Heaven and Hell"), Sur, 1960, reprinted, 1975.

(Editor and author of prologue) *Macedonio Fernandez*, Culturales Argentinas, Ministerio de Educacion y Justicia, 1961.

Para las seis cuerdas: Milongas (song lyrics: title means "For the Six Strings: Milongas"), Emecé, 1965.

Dialogo con Borges, edited by Victoria Ocampo, Sur, 1969.

(Compiler and author of prologue) Evaristo Carriego, *Versos*, Universitaria de Buenos Aires, 1972.

(With Bioy Casares and Hugo Santiago) *Les Autres: Escenario original* (screenplay; produced in France and directed by Santiago, 1974), C. Bourgois (Pairs), 1974.

(Author of prologue) Carlos Zubillaga, *Carlos Gardel*, Jucar (Madrid), 1976.

Cosmogonias, Libreria de la Ciudad, 1976.

Libro de suenos (Transcripts of Borges's and others' dreams; title means "Book of Dreams"), Torres Aguero, 1976.

(Author of prologue) Santiago Daove, *La muerte y su traje*, Calicanto, 1976.

Borges—Imagenes, memorias, dialogos, edited by Vazquez, Monte Avula, 1977.

Borges para millones, Corregidor (Buenos Aires), 1978.

(Editor with Maria Kodama) *Breve antologia anglosajona*, Emecé, 1979.

(Compiler) Paul Groussac, *Jorge Luis Borges selecciona lo mejor de Paul Groussac*, Fraterna (Buenos Aires), 1981.

(Compiler and author of prologue) Francisco de Quevedo, *Antología poetica*, Alianza, 1982.

(Compiler and author of introduction) Leopoldo Lugones, *Antología poetica*, Alianza, 1982.

(Compiler and author of prologue) Pedro Antonio de Alarcon, *El amigo de la muerte*, Siruela (Madrid), 1984.

En voz de Borges (interviews), Offset, 1986.

Dialogos (interviews), edited by Osvaldo Ferrari, Sudamericana, 1986, Seix Barral, 1992, published as *Dialogos ultimos*, Sudamericana, 1987.

A/Z, Siruela (Madrid), 1988.

Borges, el otro: diccionario arbitrario (philosophy), compiled by Napoleon de Armas, Cordillera (Venezuela), 1991.

Borges: un dialogo sobre cine y los venidos a menos, prologo de Roberto Alifano, Camilo Cappelletto (Buenos Aires), 1992.

(With Thiago de Mello) *Borges na luz de Borges* (interviews), Pontes, 1992.

Borges en la Escuela Freudiana de Buenos Aires, Agalma (Buenos Aires), 1993.

(Author of introduction) Rene Burri, *Gauchos*, Takarajima, 1993.

Also founding editor of *Prisma* magazine, 1921, and *Proa* magazine, 1921, 1924-25, and a publisher of *Martín Fierro*. Editor at *Crítica*, weekly arts supplement section, beginning 1933; *El Hogar*, "Foreign Books and authors," 1936-39; (with Bioy Casares) *Destiempo* magazine, 1936; *Los Anales de Buenos Aires* journal, 1946-48.

■ Sidelights

Although Ireneo Funes, a Uruguayan teenager, was paralyzed and confined to his chair, he "knew by heart the forms of the southern clouds at dawn on the 30th of April, 1882, and could compare them in his memory with the mottled streaks on a book in Spanish binding he had only seen once." Funes remembered every moment of his life, and he had spent entire days recreating his past with his memory. His remarkable memory also allowed him to master English, French, Portuguese, and Latin.

Funes's amazing memory was accompanied by fantastic perception. "We, at one glance, can perceive three glasses on a table; Funes, all the leaves and tendrils and fruit that make up a grape vine." While Funes's gifts intensified or enriched his sedentary existence, they also troubled him at times. Funes found it difficult "to comprehend that the generic symbol *dog* embraces so many unlike individuals of diverse size and form; it bothered him that the dog at three fourteen (seen from the side) should have the same name as the dog at three fifteen (seen from the front)." Funes dis-

tracted himself by giving names like *"meat blanket"* and *"sulphur"* to numbers from one beyond twenty-four thousand ("In place of five hundred, he would say *nine*"). When Funes wanted to go to sleep, he had to struggle to ignore his perceptions and memories.

Ireneo Funes, and his millions of memories, existed only in the mind of Jose Luis Borges, who wrote a fabricated memoir describing this fictional character as if he'd really known him. Because of his Borges's talent for writing innovative, thought-provoking narrative fiction like that found in the short story "Funes the Memorious," Borges is widely recognized as one of the most influential intellectuals of the twentieth century. A master of metaphors, Borges artfully addressed ancient questions about time, memory, history, and mortality. As Octavio Paz, the great Mexican writer, observed in the *New Republic,* Borges "ceaselessly explored" a "single theme" in his work: "man lost in the labyrinth of a time made of changes that are repetitions, man preening before the mirror of unbroken eternity, man who has found immortality and has conquered death but neither time nor old age."

In addition to gem-like short stories which indulged the fantastic, mystic, and metaphysic in strict literary form, Borges wrote insightful essays and symbolist poetry. He was known for transcending the borders of traditional genres; some of his short stories feature scholarly footnotes and references to imaginary books and fictional people, and many of his essays and stories seem poetic in composition and style. In the *New Republic,* Paz explained that, for Borges, the "division" between genres was "arbitrary. His essays read like stories; his stories are poems; and his poems make us think, as though they were essays. The bridge connecting them is thought."

While Borges demonstrated his unique talent in his essays and poetry, many critics agree that, in the words of John Updike in his book *Picked-Up Pieces,* the "great achievement" of Borges's "art is his short stories." Julio Cortázar, an Argentine writer known for his own fantastic short stories, described the intrigue created by Borges's work in *Books Abroad:* "What some literary critics admire above all in Borges is a genius of geometrical invention, a maker of literary crystals whose condensation responds to exact mathematical laws of logic. Borges has been the first to insist on that

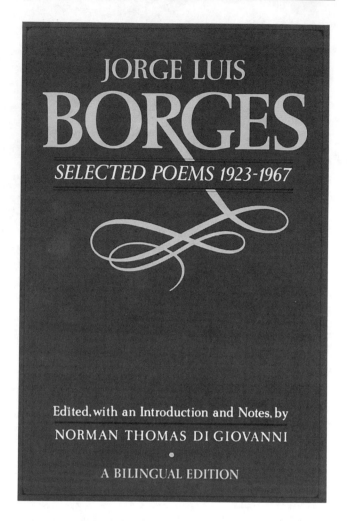

This 1972 work collects more than 100 of Borges's poems, chosen by the author himself and translated by such writers as Alastair Reid, W. S. Merwin, John Updike, and Robert Fitzgerald.

rigorous construction of things which tend to appear, on the surface, as absurd and aleatory. The fantastic, as it appears in Borges's stories, makes one think of a relentless geometrical theorem." Borges, as James Gardner explained in the *New Criterion,* "never attempted a novel." He "was always a miniaturist. None of his works extends beyond roughly six thousand words. . . . Perhaps he realized that his stories were primarily the treatment of a single imaginative impulse; perhaps he felt (no doubt rightly) that their jewel-like concision could not fill out a larger form."

Although he was born in Argentina on the eve of the twentieth century, Borges incorporated American, English, German, French, and Spanish nineteenth-century literature and esoteric philosophy

in his own writing. He counted Edgar Allan Poe, Samuel Taylor Coleridge, Edmund Spenser, Rudyard Kipling, G. K. Chesterton, Paul Valery, Walt Whitman, Franz Kafka, and Arthur Schopenhauer among his precursors and engaged the work of these authors in an intertextual dialogue. According to James E. Irby in the introduction to *Labyrinths*, "Borges is always quick to confess his sources and borrowings, because for him no one has claim to originality in literature; all writers are more or less faithful amanuenses of the spirit, translators and annotators of pre-existing archetypes."

The English translation of Borges's *Ficciones* brought him international exposure in the early 1960s, and he began to serve as a precursor to younger writers around the world. Borges won numerous international prizes and distinctions for his contribution to literature (with the exception of the coveted Nobel prize). He was presented with honorary degrees from some of the world's most prestigious universities and soon became known as one of literature's most charming and distinguished personalities.

Despite his international appeal and impact, some literary critics argue that Borges was, at heart, Latin American. As Octavio Paz asserted, "Europeans were amazed by the universality of Borges," but "none of them observed that his cosmopolitanism was not, and could not have been, anything but the point of view of a Latin American. . . . The Latin American can regard the West as a totality, and not with the fatally provincial vision of a Frenchman, a German, an Englishman, or an Italian."

Others suggest that Borges's essential contribution was to Latin American literature, which "boomed" in the 1960s and 70s with the "magical realism" found in the work of Colombian Gabriel García Márquez and Julio Cortázar. According to James Neilson in *Encounter*, "Borges is the genius who stripped away ornate Hispanic rhetoric from their [Latin American writers] written language . . . and who freed them from the obligation to compile 'realistic' committed novels about their own societies. Since Borges showed them that fantasy was respectable, few serious Latin American writers have looked back: for the last twenty years fantasy has been the predominant mode and it is the principal characteristic of most translated Latin American works."

Borges Is Born to Write

Jorge Luis Borges was born in Buenos Aires on August 24, 1899, to a family that cherished literature. His father, Jorge Guillermo Borges, was a lawyer, professor, and amatuer writer who regretted the fact that he had not devoted his life to writing. His mother, Leonor Acevedo de Borges, was a translator. Borges' paternal grandmother, an Englishwoman, taught Borges to read English before he could read Spanish. The family expected Borges to become a writer, and he was encouraged to explore his father's library. He was still a child when he read some of the great works of the Americans Mark Twain, Henry Wadsworth Longfellow, and Poe. Borges also began to write as a child; when he was just nine years old his Spanish translation of "The Happy Prince," by Oscar Wilde, was published in a local newspaper. He was thirteen years old when his first original story, "El rey de la selva," was published.

If Borges's intellect was shaped by his family's rapacious appetite for literature, it was also influenced by the people and culture of Buenos Aires. When Borges was a young boy, Argentina was still a young nation; its first years were bloody and highly politicized. Borges came to know his country's political history intimately. Through his maternal grandmother, Borges was related to Colonel Isidoro Suárez, a figure in the Argentine war of independence, and the patriot Francisco Narciso de Laprida. Borges's father's grandfather, Colonel Francisco Borges, was killed during the Argentine civil wars. There was violence to be found in tales about *gauchos* (the cowboys of the Argentine pampas immortalized in the Argentine classic *Martin Fierro*), and in stories of urban knife-fights.

As critics have suggested, these two themes that animated Borges's childhood, intellectual contemplation and physical violence, were expressed in his writings as an adult. Recalling that Borges "suffered from an attraction to the darkness and the violence of America," Octavio Paz asserted in the *New Republic* that the "law of spiritual gravity governs Borges's work: the macho Latin faces the metaphysical poet. The contradiction that informs his intellectual speculations and his fictions— the struggle between the metaphysical and the skeptical—reappears violently in the field of feelings. . . . It appears again and again in his writings. It was perhaps a vital and instinctive response to his skepticism, his civilized tolerance."

Borges left Argentina and his childhood in 1914, when his family began a tour of Europe and got stuck in Geneva, Switzerland. As Borges once recalled for *New York Times Book Review* contributor Amelia Barili, "We were so ignorant that we did not know that was the year of the First World War." Jorge and his sister, Norah, were sent to study at the Collége Calvin in Geneva, where Borges was expected to learn his lessons in French and study Latin. He eagerly learned both languages and familiarized himself with French and German literature and philosophy. Borges's time in Geneva not only gave him the opportunity to experience and imbibe European culture, it made him forever loyal to Switzerland. As he told Barili, "I am Swiss."

When Borges graduated from college in 1918 and the war ended, he traveled to Spain. There, the young man joined a group of avant-garde poets known as the *ultraístas*. Led by writers like Rafael Cansinos Assens, Guillermo de Torre, and Gerardo Diego, and influenced by Dadaism, Imagism, and German Expressionism, the *ultraístas* attempted to construct abstract poetry with emphasis on the use of the metaphor.

Constructing A Cosmopolitan Literature in Buenos Aires

When the Borges family returned to Argentina in 1921, Borges brought the modern expressionism he had learned in Spain from the *ultraístas* with him and led the Argentine *ultraísmo* movement. He began collaborative relationships with writers Silvina Ocampo and Adolfo Bioy-Cesares that lasted for decades. With such writers, Borges published *Prisma*, a literary magazine which made its debut in 1921, and continued the publication of two other literary journals, *Proa* and *Martín Fierro*.

These publications, and the essays Borges wrote for them, were marked by a cosmopolitan intellectual discourse and by attempts to construct bridges linking Argentine and European literature. As James Gardner noted in the *New Criterion*, "the Argentine writers of Borges's youth were conscious of their standing apart from the distant wellsprings of European literature," but there was "a general sense among them of trying to keep up with developments abroad, consciously cultivating a cosmopolitan environment through allusions to the most recent European writers and painters,

and delighting to fill their pages with quotations in French, German, and English." The contribution to Argentine literature that Borges made with his essays was one of style as well as content. According to Paz in the *New Republic*, Borges's essays are still "memorable, mainly for their orginality, their diversity, and their style. Humor, sobriety, acuity—and suddenly, an unusual twist. Nobody else had written that way in Spanish."

Borges published three collections of poetry during these early years, *Fervor de Buenos Aires* (1923), *Luna de enfrente* (1925), and *Cuaderno San Martin* (1929). In *Fervor de Buenos Aires*, urban themes, colorful descriptions of Buenos Aires, and praise for Borges's native city dominate. In *The New Criterion*, Gardner noted that the poems in this collection "usually alternate between the traditional eleven-syllable line of Spanish verse and lines of arbitrary length." According to Gardner, the poems in *Luna de enfrente* and *Cuaderno San Martín* were largely inspired by the works of Walt Whitman and the French Symbolists. Gardner asserts that, as early as "1923 we can hear the soft-spoken clarity of voice and the tenacious sense of place that would characterize" Borges's "poetry for sixty years to come."

Borges increasingly began to devote his time to short, narrative fiction, and the first of these pieces were collected in *Historia universal de la infamia* (1935). Each of these realistic stories portrays a fictional or historical character—a knife fighter, rogue, or criminal—with imaginary facts and fabricated details. Although Borges would later write other detective pieces, like "Death and the Compass" (published in *Ficciones*) and more realistic stories, like "Emma Zunz" (in *El Aleph*), by the late 1930s Borges's stories were increasingly embedded in the realm of the philosophical or fantastic.

Borges was working at a branch of the Buenos Aires municipal library in 1938 when he suffered emotional and physical trauma. First, his father, who had been blind for some time, died. Then, while walking up a dark staircase, Borges hit his head on a window pane and suffered septicemia. Worried that he would not be able to write as he once had, Borges attempted to write an unusual story that would not reveal any mental defects he may have suffered. The story, about a man who sets out to write, word for word, Cervantes's classic novel *Don Quixote* three hundred years after

Cervantes, was published in *El Sur*, Argentina's foremost literary journal. "Pierre Menard, Author of the *Quixote*," became one of Borges' well-known pieces, sent Borges' work in a new direction and eventually influenced the course of Latin American and western literature. This story, along with others, was published in *El jardín de senderos que se bifurcan* (1942) and later in *Ficciones, 1935-44* (1944).

Borges's Transcendent Short Stories

"From a formal point of view," wrote Alberto Julián Pérez in the *Dictionary of Literary Biography*, "it is the fantastic story, as conceived by Poe, that

Short stories, essays, and poems are gathered in this 1964 work.

is the generic source most evident in Borges's stories. But . . . [fantastic literature] is for him (as it is for other writers and thinkers, such as Voltaire, Jonathan Swift, and Franz Kafka) not an end but rather a means to an end . . . to create a literature of ideas, capable of commenting on the questions and broodings of the cultural world." Borges addressed such "questions and broodings" with a surprisingly small number of literary devices used alone or in combinations. According to James E. Irby in an introduction to *Labyrinths*, "Borges once claimed that the basic devices of all fantastic literature are only four in number: the work within the work, the contamination of reality by dream, the voyage in time, and the double."

Like a jeweler transforming a coarse rock into a brilliant, multifaceted gem with just a few cuts, Borges created stories that suggest a myriad of meanings. "Pierre Menard, autor del *Quijote*," to cite one example, is just a few pages long, but scholars have written countless papers and pages offering different interpretations of it. David I. Grossvogel explained in his book *Mystery and Its Fictions: From Oedipus to Agatha Christie* that, because the only difference between Cervantes's *Don Quixote* and Menard's *Don Quixote* is "the way in which Borges's reader reads them," the reader is forced to "become a fictional character." "Within the infinite recession of the dream dreaming the dreamer dreaming . . . the reader is thrust through the fiction into a confrontation with the unknowable that creates the existential sense that the fiction is investigating."

In the *Dictionary of Literary Biography*, Pérez offered the idea that Borges "succeeds in satirizing the intellectual habit of the symbolist writers and their conception of the writer as an aesthete and scholar," as well as in laughing "at himself" in "Pierre Menard, autor del *Quijote*." According to John Stark in his book, *The Literature of Exhaustion*, Borges's "bias against historical literature appears under the surface of 'Pierre Menard, Author of the *Quixote*.' This fiction implies that if a man living in a later century can exactly reproduce *Don Quixote*, the original version cannot have been linked in any way with its historical era."

Some of the most discussed and analyzed stories among Borges's works appear in *Ficciones, 1935-1944*. In "Tlön, Uqbar, Orbis Tertius," a story that reads like an essay and cites imagined works sup-

posedly written by actual scholars and writers, a narrator mentions an imaginary world, Tlön; readers gradually find that Tlön, a "labyrinth" created by men, is not only "real," it is gradually replacing the dimensions of the present and past world. The narrator realizes that "English and French and mere Spanish will disappear from the globe. The world will be Tlön. I pay no attention to all this and go on revising, in the still days at the Androgué hotel, an uncertain Quevedian translation (which I do not intend to publish) of Browne's *Urn Burial*."

The narrator in the short story "La lotería en Babilonia" explains how a company conducting a lottery restructured the Babylonians' existence with a completely controlled system of randomness and uncertainty. "La muerte y la brújula," a detective

The title work of this 1978 collection describes a stone which encompasses infinite power.

story set in Buenos Aires, features the literary devices of the double and the labyrinth. In "The Garden of Forking Paths," a spy must solve a riddle of a book with that title in order to complete his mission.

Other well-known stories by Borges were collected in *El Aleph*, published in 1949. "El Aleph" reports the existence of a stone which encompasses and represents the potential of the infinite universe. "El Zahir" is the story of a coin that moves its possessors to dwell on its image and to perceive it as an object that will help them systematically understand and comprehend that space. In "La Espera," a man dreams his assassins are coming to get him. As he was able to kill his assassins in a recurring dream, he thought perhaps that he could kill his "real" ones as well. But he could not be sure that he was not already dead and dreaming of waiting to kill or be killed. "Emma Zunz" follows a woman as she finds out that her father, who had been betrayed by his boss, has taken his own life. In order to get revenge, Emma has to arrange her own violation.

In its numerous permutations, Borges's "literature basically is about literature," as John Stark explained in his book, *The Literature of Exhaustion*. According to Stark, this idea is emphasized in "The Library of Babel." "The library described in the story oppresses a viewer because of its regularity: made of hexagonal cubicles, and having five shelves on each wall, thirty-two books on each shelf, 410 pages in each book, forty lines on each page, eight letters in each line. . . . In this story the universe is a library, and the books, both individually and collectively, mean nothing substantive. The only meaning in the universe derives from its relentless order or, in other words, its artifice."

Ficciones Brings Borges International Acclaim

Although Borges lived through some turbulent political times that affected his personal life, as Joseph Epstein explained in *Commentary*, "there was his politics and there was his writing and, insofar as he could control them, never did the twain meet. . . . Borges's stories do appear drained of all political content: questions of good and evil do not arise in his stories and neither can he ever be said to seek to persuade his readers to any conclusions. He wished to entertain and

If you enjoy the works of Jorges Luis Borges, you might also want to check out the following books:

G. K. Chesterton, *The Father Brown Stories*, 1974.
Franz Kafka, *The Metamorphosis, The Penal Colony, and Other Stories*, 1988.
Edgar Allan Poe, *Collected Works of Edgar Allan Poe*, 1969-1978.
Gabriel García Márquez, *One Hundred Years of Solitude*, 1967.

move them, but to move them in a particular direction—toward wonder and wonderment over life's mysteries." As a result of his approach to politics in his work, James E. Irby observed in the introduction to *Labyrinths*, "save for the admiration of a relatively small group," Borges was "criticized as non-Argentine, as an abstruse dweller in an ivory tower."

When Borges finally did receive "belated recognition as a major writer of our time," according to Irby in his introduction to *Labyrinths*, it came "more from Europe" than from Borges's "native America." International and domestic politics, Borges's English heritage, and his disdain for totalitarianism further precluded his potential popularity at home and abroad during World War II and the decade following it. In the early 1940s, while many Argentines sympathized with the Germans, Borges's loyalty was with the Allies. Borges disliked the mass-supported Colonel Juan Domingo Perón, a populist leader who came to power as a dictator in Argentina in 1946 and who put Borges' mother in jail. After Borges signed an anti-Perón document, Perón attempted to humiliate Borges by designating him as the national poultry inspector of market chicken and rabbits. Borges did not accept the insulting appointment, and he left his job at the municipal library. He began to work as a teacher at the Instituto Superior de Cultura Inglesa and the Colegio Libre de Estudios Superiores and moved into a downtown Buenos Aires apartment with his mother.

After the fall of Perón in 1955, the new government appointed Borges as the director of the Biblioteca Nacional. Borges became a professor of English literature at the Facultad de Filosofia y Letras. *Ficciones, 1935-44* was finally translated into English in the early 1960s, and Borges won the Prix Formentor (the International Publishers Prize) in 1961, with Samuel Beckett. That year, Borges finally acquired international fame: in the words of James Neilson, writing in *Encounters*, Borges's "reputation overflowed Buenos Aires and penetrated into every city in the Western world."

Borges was invited to teach and lecture around the world. In addition, according to Neilson, "inevitably, imitators soon began to appear, busying themselves with turning out enigmatic tales concerning labyrinths, mirrors, tigers, resumés of nonexistent treatises, and all the other features of the Borgesian universe," while Borges "abandoned" his "private world" and "took refuge in Argentina's past or in Anglo-Saxon verse and Icelandic sagas."

This change in Borges's status as a writer at home and abroad coincided with the descent of darkness, or at least a yellow hue, over Borges's perception of the world. (He told Robert Alifano in *Twenty-Four Conversations with Borges* that yellow was the only color he could see). By 1956, the man who lived to read and write could no longer see. But Borges did not let blindness stop his work. He enlisted his mother, who served as his secretary, to read to him, and he dictated his writing to her. He also called upon friends to read to him, listen to him recite poetry, converse with him, and guide him on walks around Buenos Aires and tours around the world.

Until his very last years, Borges was surrounded by people who were happy to visit with him. Alfred J. MacAdam, the editor of *Review*, recalled that Borges was polite ("a nineteenth-century man adrift in the late twentieth century"), and that his wit was sharp and clever. Christopher Hitchens wrote in the *Spectator* that Borges "was always searching for a mutually agreeable topic" during conversations," and "seemed at times to fear that it was he, lonely, sightless and claustrated, who might be the dull partner in chat. When he found a subject that would please, he began to bubble and grin, and even to tease."

Blindness and Alienation

At a time when readers around the world were just gaining exposure to Borges stories, Borges

began to invest more time in his poetry, which appeared in *El hacedor* (1960, translated as *Dreamtigers)*, and *Antología personal* (1961). Stuart Evans, writing in *Dictionary of Literary Biography Yearbook 1986*, reminded critics that Borges thought of himself as a poet and quoted Borges in the foreword to his *Selected Poems, 1923-67:* "In the long run, perhaps, I shall stand or fall by my poems."

According to Miguel Enguídanos in the introduction to *Dreamtigers*, this collection demonstrates Borges's devotion to poetry because, as a collection, it is a poem. *Dreamtigers*, then, is not just an assortment of "odd poems, stories, parables, sketches, fragments, and apocryphal quotations. . . . Actually this juxtaposing of fragments, bits, and snippets corresponds to a poetic criterion of an extremely high order: that of creating a book—*the* book—which is the mirror of life."

Evan's brief survey of Borges's poetry recalls its most frequent themes: otherness, oblivion, and death. Evans explained that Borges's poems about death "became increasingly involved with his perplexities concerning time and a sort of Nietzschean sense of continuity, somewhat at odds with his brooding over loss of identity and his growing sense of oblivion." Despite his preoccupation with such themes, wrote Evans, Borges was not a "gloomy poet." Instead, he was a "'literalist of the imagination,' who is, if sometimes melancholy, never morbid. Throughout his work there is a powerful element of delight in his discoveries: his exploration of Buenos Aires, his study of other languages and literature's, his interest in philosphy and metaphysic . . . , his discovery of himself through ancestors, loves, his poetry and fiction, and eventually in his blindness." Evans cited the "Poem of the Gifts" as an example of Borges's "surpassing courage and goodwill."

Borges also demonstrated his courage and goodwill during the 1960s by continuing to take advantage of offers to teach and lecture abroad despite his increasing age and his blindness. According to a *New Yorker* story, "Many who had read him came to hear him, and carried away, as a talisman, an image of him that added affection to awe: frail, soft-spoken in both English and Spanish, his hands clasping a walking stick in front of him, he mesmerized his listeners with his careful phrasing, his modesty, his wit, the warm and often mischievous humor of his spoken asides."

This 1981 work is the first collaboration between Borges and his long-time friend, Adolfo Bioy-Casares.

Borges married Elsa Astete Millán in September, 1967, and they lived together while Borges taught at Harvard. In 1970, the couple divorced, and Borges took up residence with his elderly mother once more. That same year, *El informe de Brodie* appeared and received mixed reviews. "In this book he recovers many of the favorite themes of his youth (the adventures of hoodlums and knife duels)," wrote Pérez in *Dictionary of Literary Biography*, "but the author who mastered so well the poetics of the fantastic tale could not apply to his work the poetics of realism with equal success." Thomas O. Bente assured readers in *Américas* that "although the subject matter and thrust of many of the stories are modified, their essence is still very much within the Borges vein, and the reader should not be alarmed with the new configurations the stories take." *El libro de arena* (1975) marked a return to the fantastic for Borges, who

was in his seventies when it was published. According to Pérez, this collection is "equal to his best works of the 1940s."

Borges was teaching abroad when, in 1973, Perón returned from exile to serve as an elected president in Argentina. When Perón died, his inexperienced widow came to power. When the country seemed threatened by the onset of chaos, the military decided to take control of the government. Intent on destroying the Peronist movement and left-wing organizations, it clandestinely kidnapped, imprisoned, and killed countless Argentine citizens.

Unlike some of Latin America's most famous writers, Borges was not passionately involved in contemporary politics. Nevertheless, as a public figure who commanded respect from people around the world, Borges was expected to take a stand and to decry the military and its methods. But, as Jaime Alazraki explained in the *Dictionary of Literary Biography Yearbook 1986*, Borges identified the generals with the fathers of Argentine Independence and believed that the military were "the only gentlemen left capable of saving the country." Borges "believed that the military should intervene in the nation's political life and seize power by force."

As Alazraki wrote, because Borges sided "with the torturers and assassins of his own nation," he lost contact with many of his friends, family members, and beloved writers. The military government, on the other hand, seemed to favor Borges. Writing in 1982 in *Encounter*, Neilson noted that a general described Borges as a "national monument," and Borges was "regularly raised aloft like a martial trophy by Argentines who rarely read any books but who are infuriated by the Swedish Academy's refusal to give their man the Nobel Prize." Ultimately, Borges published a poem expressing his discontent with the Falklands war Argentina's military government had provoked with England in the newspaper *Clarin*.

It was around this time that Borges grew very ill. He was diagnosed with cancer of the liver and was told that he was going to die. Borges was noted for saying that, instead of fearing death, he welcomed it. William D. Montalbano quoted Borges in the *Los Angeles Times*, "I believe that if they told me that I would die tonight, I would feel relieved, but one knows so little of oneself that perhaps I would be terrified. I don't know, but I feel rather impatient. I have lived too long."

Borges kept his terminal prognosis a secret and began to plan his final months. If, as Alazraki explained in the *Dictionary of Literary Biography Yearbook 1986*, Borges felt as though Argentina "had been lost to him, he believed that Switzerland offered him a peace he could not find in his native land." According to Alazraki, Borges decided to "die in the country of his adolescence, in that 'tower of reason' where life is as private as its aloof citizens and runs as serene as the Rhone waters. That environment was much closer to his intellectual constructs and labyrinthian artifices." Borges traveled to Geneva with María Kodama, his former student, secretary, and collaborator. There they were married. Kodama stayed by Borges's side as he endured medical tests, took walks, suffered the failure of his body, recited his last poems, and finally died on June 14, 1986. He was eighty-seven years old.

Catholic and Protestant eulogies for Borges were held at the Saint Pierre Cathedral in Geneva, and his body was buried in Plainpalais, an exclusive cemetery. Alazraki remembered that the writer's best friends, family members, and writers were not present at the funeral. Nevertheless, in Argentina, President Raul Alfonsin announced a formal decree of mourning, and writers and readers of great literature around the world lamented Borges' passing.

While Borges may have been ready to pass on, his friends and admirers were not ready to lose him. Alfred J. MacAdam, for one, wrote in *Review*, "For most of us Borges had always been there, and we simply assumed he always would be. He was immortal." Some would say that the great writer *is* immortal—he lives on, like his character Ireneo Funes, in his works. Borges was well aware of this potential for his literal recreation. According to the *New Yorker*, he once remarked: "When writers die, they become books, which is, after all, not too bad an incarnation."

■ Works Cited

Alazraki, Jaime, "Jorge Luis Borges," *Dictionary of Literary Biography Yearbook 1986*, Gale Research, 1987, pp. 206-209.

Bente, Thomas O., "Borges Revisited," in *Américas*, November-December, 1973, pp. 36-40.

Borges, Jorge Luis, "Borges on Life and Death," in an interview with Amelia Barili, in *New York Times Book Review*, July 13, 1986, pp. 1, 27-9.

Borges, "Funes the Memorious," translated by James E. Irby, in *Labyrinths*, edited by Donald A. Yates & James E. Irby, Modern Library, 1983, pp. 59-66.

Borges, "Tlön, Uqbar, Orbis Tertius," translated by James E. Irby, in *Labyrinths*, edited by Donald A. Yates & James E. Irby, Modern Library, 1983, pp. 3-18.

Borges, Jorge Luis, and Roberto Alifano, *Twenty-Four Conversations with Borges, Including a Selection of Poems: Interivews by Roberto Alifano, 1981-83*, Lascaux, 1984.

Cortázar, Julio, "The Present State of Fiction in Latin America," translated by Margery A. Safir, *Books Abroad*, Summer, 1976, pp. 533-40.

Enguídanos, Miguel, introduction to *Dreamtigers* by Jorge Luis Borges, translated by Mildred Boyer and Harold Morland, University of Texas Press, 1985.

Epstein, Joseph, "Señor Borges's Portico," *Commentary*, April, 1987, pp. 55-62.

Evans, Stuart, "The Poetry of Jorge Luis Borges," *Dictionary of Literary Biography Yearbook 1986*, Gale Research, 1987, pp. 209-213.

Gardner, James, "Jorge Luis Borges, 1899-1986," *New Criterion*, October, 1986, pp. 16-24.

Grossvogel, David I., "Borges: The Dream Dreaming the Dreamer," *Mystery and Its Fictions: From Oedipus to Agatha Christie*, The Johns Hopkins University Press, 1979, pp. 127-46.

Hitchens, Christopher, "Jorge Luis Borges," *Spectator*, June 21, 1986, pp. 12-13.

Irby, James E., introduction to *Labyrinths: Selected Stores & Other Writings* by Jorge Luis Borges, edited by Donald A. Yates and James E. Irby, New Directions, 1964, pp. xv-xxiii.

MacAdam, Alfred J., "Jorge Luis Borges: 1899-1986," in *Review*, January-June, 1986, p. 4.

Montalbano, William D., "Borges, Dean of Latin American Writers, Dies," *Los Angeles Times*, June 15, 1986.

Neilson, James, "In the Labyrinth: The Borges Phenomenon," *Encounter*, June-July, 1982, pp. 47-58.

Paz, Octavio, "In Time's Labyrinth," translated by Charles Lane, *The New Republic*, November 3, 1986, pp. 30-4.

Pérez, Alberto Julián, "Jorge Luis Borges," translated by Virginia Lawreck, *Dictionary of Literary Biography*, Volume 113, Gale Research, 1992, pp. 67-81.

Stark, John, "Jorge Luis Borges," *The Literature of Exhaustion*, Duke University Press, 1974, pp. 20-2.

"The Talk of the Town," *New Yorker*, July 7, 1986, pp. 19-20.

Updike, John, *Picked-Up Pieces*, Alfred A. Knopf, 1975, p. 183.

■ For More Information See

BOOKS

Agheana, Ion Tudro, *Reasoned thematic dictionary of the prose of Jorge Luis Borges*, Ediciones del Norte, 1990.

Aizenberg, Edna (editor), *Borges and His Successors: the Borgesian Impact on Literature and the Arts*, University of Missouri Press, 1990.

Alazraki, Jaime, *Jorge Luis Borges*, Taurus, 1976,

Alazraki, *Critical Essays on Jorge Luis Borges*, G. K. Hall, 1987.

Alazraki, *España en Borges*, Ediciones El Arquero (Madrid), 1990.

Balderston, Daniel, *Out of Context: Historical Reference and the Representation of Reality in Borges*, Duke University Press, 1993.

Bell-Villada, Gene H., *Borges and His Fiction: A Guide to His Mind and Art*, The University of North Carolina Press, 1981.

Bugin, Richard, *Conversations with Jorge Luis Borges*, Holt, Rinehart & Winston, 1969.

Canto, Estela, *Borges: An Intimate Portrait*, translated by Elaine Kerrigan, Chronicle, 1992.

Carrizo, Antonio, *Borges, el memorioso: Conversaciones de Jorge Luis Borges con Antonio Carrizo*, Fondo de Cultura Económica, 1982.

Cheselka, Paul, *The Poetry and Poetics of Jorge Luis Borges*, Peter Lang, 1987.

Chiappini, Julio, *Borges y Kafka*, Editorial Zeus (Argentina), 1991.

Cozarinsky, Edgardo, *Borges In/and/on Film*, translated by Gloria Waldman and Ronald Christ, Lumen Books, 1988.

Fishburn, Evelyn, and Psiche Hughes, *A Dictionary of Borges*, forewords by Mario Vargas Llosa and Anthony Burgess, Duckworth, 1990.

Foster, David William, *Jorge Luis Borges: An Annotated Primary and Secondary Bibliography*, Garland, 1984.

Henriksen, Zheyla, *Tiempo sagrado y tiempo profano en Borges y Cortázar*, Editorial Pliegos (Madrid), 1992.

Hernandez, B., Manuel, *Borges, de la ciudad al mito*, Ediciones Uniandes (Colombia), Universidad de los Andes, 1991.

Hernandez Martin, Jorge, *Readers and Labyrinths: Detective Fiction in Borges, Bustos Domecq, and Eco*, Garland, 1995.

Jaen, Didier Tisdel, *Borges' Esoteric Library: Metaphysics to Metafiction*, University Press of America, 1992.

Lennon, Adrian, *Jorge Luis Borges*, Chelsea House, 1992.

Lindstrom, Naomi, *Jorge Luis Borges: A Study of the Short Fiction*, Twayne, 1990.

Maier, Linda S., *Borges and the European Avant-Guarde*, P. Lang, 1992.

Malloy, Sylvia, *Signs of Borges*, translated and adapted by Oscar Montero in collaboration with the author, Duke University Press, 1994.

Merrell, Floyd, *Unthinking Thinking: Jorges Luis Borges, Mathematics, and the New Physics*, Purdue University Press, 1991.

Monegal, Emir Rodriguez, *Jorge Luis Borges: A Literary Biography*, E.P. Dutton, 1978.

Sarlo Sabajanes, Beatriz, *Jorge Luis Borges: A Writer on the Edge*, edited by John King, Verso, 1993.

Stabb, Martin S., *Jorge Luis Borges*, Frederick Ungar, 1980.

Stabb, *Borges Revisited*, Twayne, 1991.

Sucre, Guillermo, *Borges el poeta*, U.N.A.M., 1967.

Wheelock, Carter, *The Mythmaker: A Study of Motif and Symbol in the Short Stories of Jorge Luis Borges*, University of Texas Press, 1969.

PERIODICALS

Booklist, January 1, 1987, p. 689; December 15, 1988, p. 681.

Book World, August 9, 1992, p. 9.

Los Angeles Times Book Review, January 20, 1985, p. 8.

Modern Fiction Studies, Summer, 1990, pp. 149-66.

New York Times Book Review, November 3, 1985, p. 46.

Publishers Weekly, September 13, 1985, p. 122.

World Literature Today, Winter, 1992, pp. 21-26.

■ Obituaries

PERIODICALS

London Review of Books, August 7, 1986, pp. 6-7.

National Review, July 18, 1986, pp. 20-21.

New York Review of Books, August 14, 1986, p. 11.

North American Review, September, 1986, pp. 75-78.

Washington Post, June 15, 1986.*

—Sketch by Ronie-Richele Garcia-Johnson

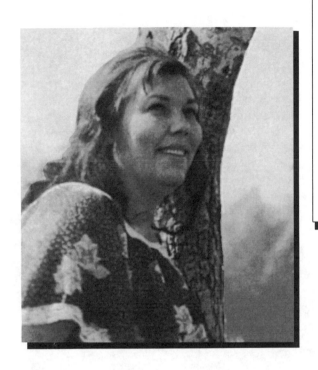

Robbie Branscum

and 1982, for *The Murder of Hound Dog Bates: A Novel*; "Best of the Best 1966-1978," *School Library Journal*, 1979, for *Johnny May*; Edgar Allan Poe Award, 1983, for *The Murder of Hound Dog Bates: A Novel*.

■ Personal

Born June 17, 1937, in Big Flat, AR; daughter of Donnie H. (a farmer) and Blanch (Balitine) Tilly; married Duane Branscum, c. 1952 (divorced, 1969); married Lesli J. Carrico, July 15, 1975 (divorced); children: Deborah. *Hobbies and other interests:* Reading, gardening, cooking.

■ Addresses

Home—P.O. Box 629, Lucerne, CA 95458.

■ Career

Children's book author; farmer.

■ Awards, Honors

Friends of American Writers Award, 1977, for *Toby, Granny, and George;* outstanding book of the year citations, *New York Times*, 1977, for *The Saving of P.S.*, 1978, for *To the Tune of a Hickory Stick*,

■ Writings

Me and Jim Luke, Doubleday, 1971.
Johnny May, Doubleday, 1975.
The Three Wars of Billy Joe Treat, McGraw, 1975.
Toby, Granny, and George, illustrated by Glen Rounds, Doubleday, 1976.
The Saving of P.S., Doubleday, 1977.
Three Buckets of Daylight, Lothrop, 1978.
To the Tune of a Hickory Stick, Doubleday, 1978.
The Ugliest Boy, illustrated by Michael Eagle, Lothrop, 1978.
For Love of Jody, Lothrop, 1978.
Toby Alone, Doubleday, 1978.
Toby and Johnny Joe, Doubleday, 1978.
The Murder of Hound Dog Bates: A Novel, Viking, 1982.
Spud Tackett and the Angel of Doom, Viking, 1983.
Cheater and Flitter Dick: A Novel, Viking, 1983.
The Adventures of Johnny May, illustrated by Deborah Howland, Harper, 1984.
The Girl, Harper, 1986.
Johnny May Grows Up, illustrated by Bob Marstall, Harper, 1987.
Cameo Rose, Harper, 1989.
Old Blue Tilley, Macmillan, 1991.

■ Sidelights

In many ways Robbie Branscum's impoverished beginnings were a blessing: not only did she gain valuable experiences she later turned into stories for teens and children, but she also learned the magic that books can contain. Most writers credit their local library with igniting their interest in reading and writing; for Branscum, it was a full-scale love affair. She continues to sing the praises of just such libraries any chance she gets and is pleased to address gatherings of librarians as a featured speaker. Branscum creates stories that evoke the Arkansas hills where she grew up, detailing the struggles and joys of a life filled with hardship. Her characters are the tough, individualist survivors of difficulties who never forget the power of family and community.

Born June 17, 1937, in Big Flat, Arkansas, Branscum was one of five children. The family lived on a farm until she was about four. At this time her parents, eager to provide a better life for their children, moved the family to Colorado. Branscum's father soon found work as a lumberjack, and it was at this new job that his appendix burst; the site was too far to reach medical help and he died. Following this tragedy, Branscum's mother sent the children to live on their grandparents' small sharecropping farm in a remote part of the state of Arkansas. The lack of indoor plumbing and electricity, in addition to the plentitude of chores, brought Branscum and her siblings closer, and found them often assuming responsibility for each other. They did their best to steer clear of their grandmother, who ensured they were clothed and fed, but whose child rearing included arbitrary slapping and pinching. Their grandfather's more accepting nature made him popular among the children, though he too burdened them with lots of work.

Branscum began her first school experience at the nearby one-room schoolhouse. Though she doesn't remember learning to read, she recalled that the school's meager materials included two orange crates full of books. As she wrote in an essay for *Something about the Author Autobiography Series* (*SAAS*), "I read like a starving person eats. I read every book over and over during the seven years I went to that school, and hungered for more of them." The Bible was the only book available at home, but the house was papered in old newspapers and Branscum remembers reading through

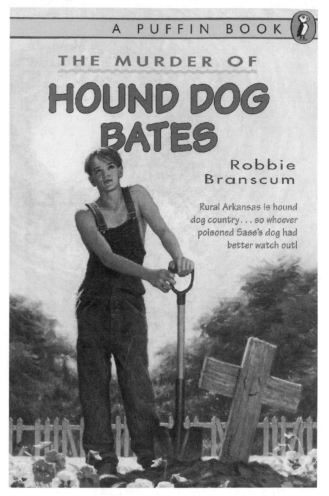

This 1982 mystery, about a twelve-year-old boy investigating the death of his beloved hound dog, received the Edgar Allan Poe Award.

every room, using a chair to raise herself close enough to the ceiling to read the words there, too. From early on, words had a strong hold on her and she would repeat each new phrase to herself again and again.

Eight years after they had been separated, Branscum's mother came to reclaim her children. At thirteen, Branscum started anew in Colorado, where her mother had remarried and begun another family. During her time with her grandparents, Branscum had grown particularly close to her brother Ovallee, two years her senior, and although the other three children eventually returned to their grandparents, she and Ovallee remained. Branscum's mother and stepfather encouraged her to finish school, but the transplanted teenager felt awkward and uncomfortable. When her fellow students jeered at her because she

didn't fit in, Branscum played dumb and finally stopped going to school altogether—one of her teachers even pronounced her unteachable. Luckily, she had stumbled on the local library and she continued to read. And she also eventually overcame her awkwardness and began to hang out with a group of small town teens.

Among her new friends was Duane Branscum, whom she married at the age of fifteen. A few years older, her husband worked on the railroad or as a lumberjack. By the time their daughter Deborah was born in 1960, though, their marriage was already shaky. As Branscum noted in *SAAS,* "My husband was rarely home, which disturbed me. I knew he wasn't happy with the marriage but I didn't know what to do about it. . . . I grieved over it, but my child, church, and home kept me going." Her church had a subscription to a Southern Baptist newspaper and when Branscum submitted an article titled "Men Who Walked with God" they not only published it but asked for more. Thrilled, she found that her husband didn't share her excitement. "All my married life I'd done whatever he wanted me to do, but now I couldn't, I just couldn't. Writing was part of me; if he took it away, I'd be crippled for the rest of my life. I thought I couldn't be more unhappy than I was and kept writing."

Partial Manuscript Leads to Series

Another library, this one in the San Francisco Bay Area (where Branscum and her daughter moved after her marriage fell apart), gave the writer the tools she needed to continue her new writing career. When she mentioned to a librarian that she was having trouble finding places to send her stories, the librarian checked out a copy of the *Writer's Market* in Branscum's name. The agent to whom Branscum sent work arranged to meet with her and brought along a successful playwright. Both men encouraged her and the playwright gave her a list of 185 books to read; she read them all in the course of a year. As she admitted in *SAAS,* "I didn't understand many of them very well, like Shakespeare. But bits and pieces stuck in my mind, and I kept writing."

By now, she and Deborah were getting by mostly on welfare and the money Branscum earned babysitting neighborhood children. She could only afford to send half the manuscript of *Me and Jim*

Abandoned by their mother, an eleven-year-old girl and her four siblings are forced to live with their abusive grandmother and uncle in this 1986 tale.

Luke, her first novel, but when the publisher wrote back to ask for the rest she borrowed the postage. A story her grandfather told of finding a dead revenuer is the starting point for the book, which tells the tale of two young white southern men who discover a body in a hollow tree while possum hunting one night.

Four years later, in 1975, Branscum published *Johnny May,* the first in a series of stories about a young girl in rural Arkansas. The ten-year-old protagonist is suspicious of the man her aunt is seeing; she's convinced that he killed his first four wives. The story concerns her tireless efforts to reveal the suitor as a cad, while at the same time describing Johnny May's sexual awakening.

The series picked up again almost ten years later, when Branscum published *The Adventures of Johnny*

May. Eleven-year-old Johnny May narrates her story of keeping her grandparents fed and of trying to celebrate Christmas with them in spite of their desperate poverty. Aside from her own problems, she has also witnessed a mysterious shooting, which she believes to have been fatal. A *Bulletin of the Center for Children's Books* reviewer noted that the book provides a "convincing picture of rural life in the Arkansas hills," as well as "a heavy hand with dialect and idiom." Branscum's decision to include a shooting that amounts to one of the characters taking the law into his own hands led a *Booklist* contributor to conclude that "the story's finish could be used to spark a hearty discussion. Whether one considers

If you enjoy the works of Robbie Branscum, you may also want to check out the following books and films:

Mary Downing Hahn, *The Dead Man in Indian Creek,* 1990.
Patricia Pendergraft, *Brushy Mountain,* 1989.
Judy Carole Rhodes, *The King Boy,* 1991.
Alana White, *Come Next Spring,* 1990.
Where the Lilies Bloom, MGM, 1974.

it flawed or not, the story will prove quite absorbing." Branscum's ability to write vividly is highlighted by Lucy V. Hawley in the *School Library Journal,* who commented that many readers "will be introduced to a place and way of life unimaginably different from their own. But they will easily recognize the pain and confusion a young person experiences when she first must compromise ideals for reality."

In the third book of the series, *Johnny May Grows Up,* the protagonist is a chubby thirteen-year-old who is in love with her longtime friend Aron. Johnny May continues to do the farm work for her grandparents but wishes she could afford to get more education—and that she'd lose some weight. In the end she manages to reach all her goals. A *Publishers Weekly* contributor praised Branscum for a "moving novel about a girl's struggle to grow up and at the same time be true to herself." Although criticizing the solution to Johnny May's financial problem as "contrived," Zena Sutherland went on to add in her *Bulletin of the Center for Children's Books* review that "the brisk pace of the story and the vivid depiction of

farm life will appeal to many readers." And in the *School Library Journal,* Eleanor K. MacDonald noted that "the sympathetic portrayal of a tough but vulnerable heroine should appeal to young readers."

Despite publication and good reviews, Branscum's life was far from trouble-free, as financial difficulties continued to plague her. As she wrote in *SAAS:* "The welfare department called me in and said they'd never before had an author with her own agent on welfare and didn't know quite what to do with me." Back injuries from an accident when Deborah was a baby left Branscum too disabled to wait tables or cook, her only options other than writing. Fortunately, the officials decided to keep her on welfare for the time being.

When *Toby, Granny, and George* was published in 1976, it initiated another series, set once again in the backwoods of Arkansas. Thirteen-year-old Toby traces her parentage and investigates two suspicious drownings; as she uncovers the truth about the deaths, she also finds out who her mother was. Focusing on Branscum's new character, a *Horn Book* reviewer described Toby as "remarkable and winning," while a *Kirkus Reviews* contributor judged her to be "as rugged and matter-of-fact as her hand-me-down bib overalls." The subsequent book, *Toby Alone,* describes Toby's attempts to come to terms with the death of her grandmother and to hold onto her boyfriend. In the third book, *Toby and Johnny Joe,* the protagonist marries and has sex for the first time, and then finds herself coping with the loss of her unborn child and the anxiety of waiting for her husband who has gone to war. A reviewer for the *School Library Journal* applauded the book for its "original blend of mystery, humor, and homelessness."

In her 1978 novel *To the Tune of a Hickory Stick,* Branscum shifted her focus from one protagonist to two: a brother and sister are sent to live on their aunt and uncle's farm in the Arkansas hills following the death of their father. In addition to the abuse their uncle dishes out, the siblings soon discover that the money their mother sends is squandered by their guardians. A *School Library Journal* reviewer pointed out that the characters are "earthy and tough when necessary." And a *Horn Book* contributor commented that "the basic plot of children triumphing over adversity gives the first-person narrative the appeal of the universally popular orphan story."

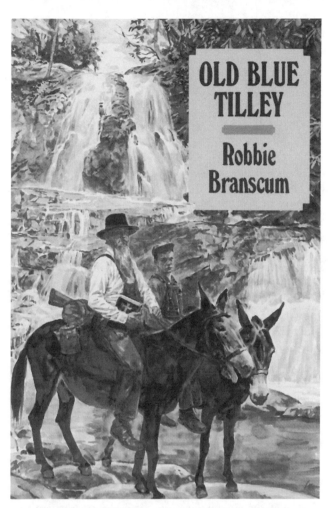

In this 1991 novel, fourteen-year-old Hambone travels through the Ozark Mountains with his guardian, a preacher named Old Blue Tilley.

Branscum continued to support herself and her daughter with the money she earned from her books, but it wasn't until Deborah became an exchange student in Sweden that the writer was able to do without welfare assistance. Branscum's 1982 novel *The Murder of Hound Dog Bates* was cited as a *New York Times* outstanding book of the year and also won the Edgar Allan Poe Award in 1983. The twelve-year-old protagonist of this story lives with his three maiden aunts on their Arkansas farm. Finding his cherished dog lying dead in the hot summer sun, the boy is convinced that one of his aunts has done the deed. Because he assumes that he'll be the next victim, the boy delves into his aunts' pasts to find out why they all remained single. An ex-cop joins the search, but appears to be more interested in courting one of the aunts. Only after the family escapes a tor-

nado is the real killer revealed. "Colloquial imagery and dialogue convey the regional setting, but the tone suggests . . . a time recalled," concluded Mary M. Bush in her *Horn Book* review.

Challenging Readers to Make Moral Choices

Branscum doesn't make life easy for her characters, nor does she shy away from difficult subjects. Though not strictly autobiographical, her books reflect the struggles she endured during her youth and beyond. *The Girl,* which she published in 1986, is the sometimes harrowing story of an unnamed girl and her four siblings who are shunted to their grandparents' Arkansas farm when their mother abandons them following the death of her husband. The children work hard and learn to accept the fact that their grandmother uses the monthly welfare check for gifts for her son, their Uncle Les. At the same time that she suffers physical abuse from her grandmother, the girl is tormented by Uncle Les's "inappropriate touching." Through the intervention of her older brother and the wisdom of her beloved great-grandmother, the girl eventually puts a stop to Uncle Les's molesting and finds a way out.

In a *Voice of Youth Advocates* review of *The Girl* Jean Kaufman noted that "Branscum has again painted a poignant view of another way of life," adding that books like hers offer readers a view of lives different from theirs, "yet the universal human constants are so clear. Wonderful!" Reviewing the book for *School Library Journal,* Heide Piehler found that the "full human complexity" of the characters and relationships make for a "memorable novel . . . made even more powerful by the careful construction and skillful use of understated drama." A *Publishers Weekly* critic deemed *The Girl* "a disturbing, beautifully evoked novel" that "might be better suited to an adult list." And writing in the *Bulletin of the Center for Children's Books,* Sutherland asserted: "Branscum draws a brutal and convincing picture of child abuse."

In *Cameo Rose,* the eponymous protagonist is an orphan who lives with her grandfather. When one of the least-liked residents of their small town is shot, Cameo Rose resolves to find the murderer. But when she discovers that the killer is a woman she loves and admires, the young woman must make a judgment call. A *Publishers Weekly* reviewer

noted that Cameo Rose's reactions may seem "either devastatingly naive or calculatingly immoral. Readers will have to make up their own minds; this brief novel raises ethical questions without easy answers." Bruce Ann Shook, writing in *School Library Journal*, found that Cameo Rose "emerges as a feisty, likable character who is both naive and wise," but went on to add that she found the ending "troubling."

In Branscum's *Old Blue Tilley*, published in 1991, fourteen-year-old Hambone lives with an Ozark mountain preacher. Set just before World War II, the story details the duo's springtime journey to the revival meeting. Although several critics found the story too easily resolved—a *Publishers Weekly* contributor termed the ending "neither believable nor satisfying"—*Voice of Youth Advocates* contributor Allan A. Cuseo remarked that Branscum's characters are "mostly delightfully rounded, the 'bad ones' have positive virtues, the 'good ones' are sinners." Writing in *Booklist*, Randy Meyer praised Branscum for her facility with her characters' way of life: "She shines a soft light on the social problems of the area (no schools, little health care, alcoholism, teenage pregnancy) while showing us its simple earnest residents. . . . Branscum's presentation of mountain life makes for an interesting cultural study."

Again and again, reviewers highlight Branscum's talent for depicting reality far removed from most modern readers' experiences. By relying on her intimate knowledge of the hard life in rural Arkansas, its dialect and way of life, she has created compelling narratives peopled with unusual characters. In her *SAAS* essay Branscum described her initial urge to write: "I daydreamed of books I wanted to write. I wanted to give other people the enjoyment that books gave me." Her accomplished, prolific storytelling has made her a popular writer and speaker—and allowed her to fill a few library shelves of her own.

■ Works Cited

Review of *The Adventures of Johnny May, Booklist*, January 1, 1985, p. 638.

Review of *The Adventures of Johnny May, Bulletin of the Center for Children's Books*, March, 1985, p. 121.

Branscum, Robbie, essay in *Something about the Author Autobiography Series*, Volume 17, Gale, 1994, pp. 17-26.

Bush, Mary M., review of *The Murder of Hound Dog Bates, Horn Book*, December, 1982, p. 647.

Review of *Cameo Rose, Publishers Weekly*, December 23, 1988, p. 83.

Cuseo, Allan A., review of *Old Blue Tilley, Voice of Youth Advocates*, June, 1991, pp. 92-93.

Review of *The Girl, Publishers Weekly*, September 26, 1986, p. 83.

Hawley, Lucy V., review of *The Adventures of Johnny May, School Library Journal*, December, 1984, pp. 88-89.

Review of *Johnny May Grows Up, Publishers Weekly*, November 13, 1987, p. 71.

Kaufman, Jean, review of *The Girl, Voice of Youth Advocates*, December, 1986, p. 212.

MacDonald, Eleanor K., review of *Johnny May Grows Up, School Library Journal*, December, 1987, p. 83.

Meyer, Randy, review of *Old Blue Tilley, Booklist*, March 1, 1991, p. 1383.

Review of *Old Blue Tilley, Publishers Weekly*, April 12, 1991, pp. 58-59.

Piehler, Heide, review of *The Girl, School Library Journal*, October, 1986, p. 187.

Shook, Bruce Ann, review of *Cameo Rose, School Library Journal*, March, 1989, p. 198.

Sutherland, Zena, review of *The Girl, Bulletin of the Center for Children's Books*, December, 1986, p. 62.

Sutherland, review of *Johnny May Grows Up, Bulletin of the Center for Children's Books*, November, 1987, p. 43.

Review of *To the Tune of a Hickory Stick, Horn Book*, December, 1978, pp. 638-39.

Review of *To the Tune of a Hickory Stick, School Library Journal*, December 1978, p. 50.

Review of *Toby and Johnny Joe, School Library Journal*, October, 1976, p. 98.

Review of *Toby, Granny, and George, Horn Book*, October, 1976, p. 498.

Review of *Toby, Granny, and George, Kirkus Reviews*, May 1, 1976, p. 533.

■ For More Information See

BOOKS

Twentieth-Century Young Adult Writers, 1st edition, edited by Laura Standley Berger, St. James Press, 1994.

Gallo, Donald R., compiler and editor, *Speaking for Ourselves*, National Council of Teachers of English, 1990.

PERIODICALS

Horn Book, August, 1983, p. 440; December, 1983,
p. 707; January/February 1985, p. 49.
School Library Journal, March, 1991, p. 192.
Writer's Digest, July, 1980, p. 64.*

—Sketch by Megan Ratner

Joseph Bruchac

■ **Personal**

Surname is pronounced Brew-shack; born October 16, 1942, in Saratoga Springs, NY; son of Joseph E. (a taxidermist) and Flora (Bowman) Bruchac; married Carol Worthen, June 13, 1964; children: James Edward, Jesse Bowman. *Education:* Cornell University, A.B., 1965; Syracuse University, M.A., 1966; graduate study at State University of New York at Albany, 1971-73; Union Graduate School, Ph.D., 1975. *Religion:* Animist.

■ **Addresses**

Home—P.O. Box 308, Greenfield Center, New York, 12833. *Office*—Greenfield Review Press, Greenfield Center, NY 12833. *Agent*—Barbara Kouts, P.O. Box 558, Bellport, NY 11713.

■ **Career**

Writer, 1966—. Keta Secondary School, Ghana, West Africa, teacher of English and literature, 1966-69; Skidmore College, Saratoga Springs, NY, instructor in creative writing and in African and black literatures, 1969-73; teacher of creative writing at Great Meadows Institute, Comstock Prison, 1972-74; Greenfield Review Press, Greenfield Center, NY, publisher and editor of *Greenfield Review,* 1969—; director, Greenfield Review Literary Center, 1981—. *Member:* Poetry Society of America, PEN, National Association of Metis Indians, National Wildlife Federation.

■ **Awards, Honors**

New York State Arts Council grant, 1972; Vermont Arts Council grant, 1972; monthly poetry prize from Poetry Society of America, February, 1972; New York State CAPS poetry fellowship, 1973, 1982; poetry fellowship, National Endowment for the Arts, 1974; editors' fellowship, Coordinating Council of Literary Magazines, 1980; Rockefeller Foundations Humanities fellowship, 1982-83; American Book Award, Before Columbus Foundation, 1984, for *Breaking Silence: An Anthology of Contemporary Asian American Poets;* American Library Association Notable Books for Children citations, 1996, for *A Boy Called Slow: The True Story of Sitting Bull* and *The Boy Who Lived with the Bears and Other Iroquois Stories;* Knickerbocker Award for Juvenile Literature, New York Library Association, 1996; Mountains & Plains Booksellers Association Regional Book Award, 1996, for *A Boy Called Slow: The True Story of Sitting Bull;* Cherokee Nation Prose Award; *Scientific American* Award for Young Readers; *Boston Globe-Horn Book* Honor Book in

Nonfiction, 1996, for *The Boy Who Lived with the Bears and Other Iroquois Stories.*

■ Writings

Turkey Brother and Other Tales, Crossing Press, 1976.

The Dreams of Jesse Brown (novel), Cold Mountain Press, 1977.

Stone Giants and Flying Heads: More Iroquois Folk Tales, illustrated by Kahionhes Brascoupe and Clayton Brascoupe, Crossing Press, 1978, published as *Stone Giants and Flying Heads: Adventure Stories of the Iroquois*, 1979.

Iroquois Stories; Heroes and Heroines, Monsters and Magic, Crossing Press, 1985.

The Wind Eagle and Other Abenaki Stories, illustrated by Kahionhes Brascoupe, Bowman Books, 1985.

No Telephone to Heaven (novel), Cross-Cultural Communications, 1986.

The Faithful Hunter: Abenaki Stories, Greenfield Review Press, 1988.

(With Michael J. Caduto) *Keepers of the Earth: Native American Stories and Environmental Activities for Children*, illustrated by Carol Wood and John K. Fadden, Fulcrum, 1988, paperback edition published as *Native American Stories*, 1988, selections published as *Native American Animal Stories*, 1992.

The Return of the Sun: Native American Tales from the Northeast Woodlands, Crossing Press, 1989.

Hoop Snakes, Hide Behinds, and Side-Hill Winders: Tall Tales from the Adirondacks, Crossing Press, 1991.

(With Michael J. Caduto) *Keepers of the Animals: Native American Stories and Wildlife Activities for Children*, Fulcrum, 1991.

Turtle Meat and Other Stories, Holy Cow! Press, 1992.

Dawn Land (novel), Fulcrum, 1993.

The First Strawberries: A Cherokee Stories, Dial, 1993.

Flying with the Eagle, Racing the Great Bear: Stories from Native North America, BridgeWater Books, 1993.

Fox Song, Philomel, 1993.

The Native American Sweat Lodge: History and Legends, Crossing Press, 1993.

(With Gayl Ross) *The Girl Who Married the Moon: Stories from Native North America*, BridgeWater Books, 1994.

Gluskabe and the Four Wishes, illustrated by Christine Nyburg Shrader, Cobblehill Books/Dutton, 1994.

The Great Ball Game: A Muskogee Story, illustrated by Susan L. Roth, Dial, 1994.

(With Michael J. Caduto) *Keepers of Life: Discovering Plants through Native American Stories and Earth Activities for Children*, Fulcrum, 1994, selections published as *Native Plant Stories*, 1995.

A Boy Called Slow: The True Story of Sitting Bull, illustrated by Rocco Baviera, Philomel, 1995.

The Boy Who Lived with the Bears and Other Iroquois Stories, illustrated by Murv Jacob, HarperCollins, 1995.

(With Gayl Ross) *The Story of the Milky Way: A Cherokee Tale*, illustrated by Virginia A. Stroud, Dial, 1995.

(With Michael J. Caduto) *Keepers of the Night: Native American Stories and Nocturnal Activities for Children*, Fulcrum, 1995.

Dog People: Native Dog Stories, illustrated by Murv Jacob, Fulcrum, 1995.

The Earth under Sky Bear's Feet, illustrated by Thomas Locker, Philomel, 1995.

Four Ancestors, illustrated by the author and others, BridgeWater Books, 1995.

Long River: A Novel (sequel to *Dawn Land*), Fulcrum, 1995.

Between Earth and Sky: Legends of Native American Sacred Places, illustrated by Thomas Locker, Harcourt, 1996.

Children of the Longhouse, Dial, 1996.

The Man Who Loved Buffalo, illustrated by Rocco Baviera, Harcourt, 1997.

POETRY

Indian Mountain and Other Poems, Ithaca House, 1971.

The Buffalo in the Syracuse Zoo, Greenfield Review Press, 1971.

Flow, Cold Mountain Press, 1975.

The Road to Black Mountain, Thorp Springs Press, 1976.

This Earth Is a Drum, Cold Mountain Press, 1977.

Entering Onondaga, Cold Mountain Press, 1978.

There Are No Trees Inside the Prison, Blackberry Press, 1978.

Ancestry, Great Raven, 1980.

Translator's Son, Cross-Cultural Communications, 1981.

Remembering the Dawn, Blue Cloud, 1983.

Tracking, Ion Books, 1986.

Walking with My Sons and Other Poems, Landlocked Press, 1986.

Near the Mountains: New and Selected Poems, White Pine Press, 1987.

Long Memory and Other Poems, Wurf (Munster), 1989.

Talking Book Box B: Multiethnic (Native American, African Interest, Latin American) Poetry, Cross-Cultural Communications, 1989.

(With Jonathan London) *Thirteen Moons on Turtle's Back: A Native American Year of Moons*, Philomel, 1992.

The Circle of Thanks, illustrated by Murv Jacob, BridgeWater Books, 1996.

Also author of *Mu'ndu Wi Go: Mohegan Poems*, 1978.

EDITOR

(With William Witherup) *Words from the House of the Dead: An Anthology of Prison Writings from Soledad*, Greenfield Review Press, 1971.

The Last Stop: Writings from Comstock Prison (anthology), Greenfield Review Press, 1974.

(With Roger Weaver) *Aftermath: An Anthology of Poems in English from Africa, Asia, and the Caribbean*, Greenfield Review Press, 1977.

The Next World: Poems by Thirty-Two Third-World Americans (anthology), Crossing Press, 1978.

Songs from This Earth on Turtle's Back: Contemporary American Indian Poetry (anthology), Greenfield Review Press, 1983.

The Light from Another Country: Poetry from American Prisons (anthology), Greenfield Review Press, 1984.

Breaking Silence: An Anthology of Contemporary Asian American Poets, Greenfield Review Press, 1984.

(With others) *North Country: An Anthology of Contemporary Writing from the Adirondacks and the Upper Hudson Valley*, Greenfield Review Press, 1985.

New Voices from the Longhouse: An Anthology of Contemporary Iroquois Writing, Greenfield Review Press, 1989.

(With Stanley H. Barkan) *Native American Writers*, Cross-Cultural Communications, 1991.

Raven Tells Stories: An Anthology of Alaska Native Writing, Greenfield Review Press, 1991.

Returning the Gift: Poetry and Prose from the First North American Native Writers Festival, University of Arizona, 1994.

Aniyunwiya/Real Human Beings: An Anthology of Contemporary Cherokee Prose, Greenfield Review Press, 1995.

Native Wisdom, HarperCollins West (San Francisco), 1995.

Smoke Rising: The Native North American Literary Companion, Visible Ink Press, 1995.

OTHER

The Poetry of Pop (essays), Dustbooks, 1973.

(Translator from the Iroquois) *The Good Message of Handsome Lake*, Unicorn Press, 1979.

How to Start and Sustain a Literary Magazine: Practical Strategies for Publications of Lasting Value, Provision House Press, 1980.

Survival This Way: Interviews with Native American Poets, University of Arizona Press, 1987.

Also author of *Peter Davis*, an album of songs which has been recorded. Contributor of poetry to over four hundred periodicals, including *New Letters, Paris Review, Akwesasne Notes, Hudson Review, American Poetry Review*, and *Contact II*. Assistant editor, *Epoch*, 1964-65; contributing editor, *Nickel Review*, 1967-71, and *Studies in American Indian Literature*, 1983—; contemporary music editor, *Kite*, 1971—; editor, *Prison Writing Review*, 1976—.

■ Sidelights

It is the time when the snows are deep and the wind's voice circles the big Bear Clan longhouse. It is Tsiotorkowa, the Coldest Moon, when the nights are the longest. . . .

This evening people have come crowding in from the other four longhouses that are also part of this village surrounded by cornfields. Almost all the people of the clans of the Turtle, the Wolf, the Snipe, and the Eel have come as guests. . . . They are here because of the man in his late middle years who sits now by the fire, looking around the circle of expectant faces. His name is Crosses Many Rivers. . . . Wherever he travels, his name precedes him and every longhouse opens its door to him, for he is a story teller.

Like Crosses Many Rivers, introduced in *The Boy Who Lived with the Bears and Other Iroquois Stories*, Joseph Bruchac has earned a reputation as one of the foremost storytellers working in America. The total body of his works span a variety of genres, including poetry and fiction as well as Native American folktales and legends. "Much of my writing and my life relates to the problem of being an American," he writes in *Something about the Author*. "While in college I was active in Civil Rights work and in the anti-war movement. . . . I went to Africa to teach—but more than that to be taught. It showed me many things. How much we have as Americans and take for granted. How

much our eyes refuse to see because they are blinded to everything in a man's face expect his color. And most importantly, how human people are everywhere—which may be the one grace that can save us all."

Bruchac was raised in Greenfield Center, New York, in the Adirondack mountains, by his mother's parents. His grandmother was a lawyer. His grandfather, Bruchac states in his introduction to *The Boy Who Lived with the Bears and Other Iroquois Stories*, was "a gentle man whose Native ancestry was Abenaki." "The surname is from my father's people," Bruchac writes in *I Tell You Now: Autobiographical Essays by Native American Writers*. "It was shortened from *Bruchacek*—'big belly' in Slovak." The author adds that he also has some English blood. "Yet my identity has been affected less by middle European ancestry and Christian teachings (good as they are in their seldom-seen practice) than by that small part of my blood which is American Indian."

Building a Literary Career

The author originally harbored ambitions to be "something like a park ranger, or one of those interpretive naturalists who goes and gives tours

Bruchac was raised and still lives here at Bowman's Store in New York state, originally the home and business of his grandparents.

in national parks and explains what things are," he tells *Publishers Weekly* interviewer Kit Alderdice. Instead, he began to feel drawn toward literature and toward his Native American heritage. He graduated from Cornell University in 1965 and then attended Syracuse University on a writing fellowship. In the following year Bruchac and his wife Carol moved to Ghana in West Africa and they taught there for three years. They returned to upstate New York, settled in Bruchac's grandparents' old home, and in 1971 began publishing the literary magazine *Greenfield Review*. The magazine continued publication until 1990. Bruchac continues to publish books and the North American Native Authors Catalog through the Greenfield Review Press.

Bruchac published his first volume of poetry the same year that he and his wife launched the *Greenfield Review*. His writings have since appeared in about five hundred journals and anthologies. He has also earned a reputation as an editor, giving multiethnic literature and works by prison inmates nationwide exposure. Bruchac taught creative writing and African and Black literatures at Skidmore College in neighboring Saratoga Springs, New York, from 1969 to 1973. He also launched a creative writing program for inmates at Great Meadows Correctional Facility. In 1984, his *Breaking Silence: An Anthology of Contemporary Asian American Poets* won the American Book Award from the Before Columbus Foundation.

The author returned to exploring his Native American heritage through stories when his sons were young. "When the boys were very little," he explains to Alderdice, "I started telling them stories. And the stories I chose to tell were the traditional stories that I had grown up with, read in books and then, as an adult, been hearing from elders." Finally, Bruchac began to exhaust his own supply of stories and, he states, "I began seeking out more stories, so I could share them with the kids." "Before long," he concludes in his introduction to *The Boy Who Lived with the Bears*, "I found myself telling the stories to other children and to adults, and I began traveling as those old storytellers did long ago. I crossed many rivers and found myself as welcomed as they were."

Many of these tales appeared in Bruchac's first collection, a book entitled *Turkey Brother and Other Tales*. The stories in this collection were taken from the traditions of the Haudenosaunee, the five al-

lied tribes who occupied most of modern New York State before the coming of the Europeans. Bruchac begins by explaining how legends came into the world. "The first three tales feature Turtle," writes Denise M. Wilms in *Booklist*, "a trickster not unlike the Ashanti Anansi figure." Yet Turtle also proves capable of tricking himself in "Turtle Makes War on Men." Other stories in the collection feature animals, such as bears and porcupines, that were important to Native Americans, explaining how they came into the world, why they look as they do, and why they relate to mankind the way they do.

Bruchac followed *Turkey Brother* with another collection, *Stone Giants and Flying Heads: Adventure Stories of the Iroquois*. The second book introduces the Iroquois trickster Skunny-Wundy and concentrates on moral lessons, emphasizing proper behavior: "virtues such as bravery, obedience, or goodness rewarded," explains a reviewer for *Booklist*. Critics recognized that both books provided exceptional resources for storytellers and celebrated Bruchac's accomplishment in preserving these tales for later generations.

A Career in Storytelling

Soon Bruchac found himself in demand as a speaker at primary schools. The stories he told proved just as popular with other children as they had with his sons. With *Keepers of the Earth: Native American Stories and Environmental Activities for Children* and its sequels *Keepers of the Animals: Native American Stories and Wildlife Activities for Children*, *Keepers of Life: Discovering Plants through Native American Stories and Earth Activities for Children*, and *Keepers of the Night: Native American Stories and Nocturnal Activities for Children*— written in conjunction with Michael Caduto— Bruchac began weaving his Native American traditions into activity books for use in children's classrooms. The authors also provided collections of stories related to the activities, including *Native American Animal Stories* and *Native Plant Stories*. These works, writes Frances Bradburn in the *Wilson Library Bulletin*, contain "a variety of activities to take part in with children, each illustrating an environmental or cultural principle discussed within the chapter."

Bruchac has also written his own stories that echo but do not copy ancient Native American legends.

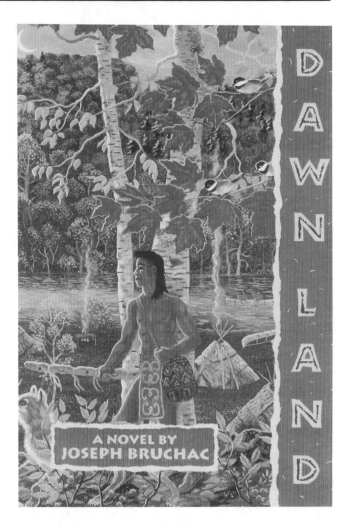

In this haunting 1993 myth created by an Abenaki storyteller, the balance of native lifestyles with nature is dramatized and commemorated.

Turtle Meat and Other Stories is a collection of original tales by the author and ranges in time from the distant past to modern times. In one story, Indians battle the Ice Hearts, who later turn out to be Europeans in armor. After most of the invaders are driven off, the Native Americans choose to adopt and civilize some of their captives. Another tells of how the Dutch mayor of Albany, New York, Peter Schuyler, is fooled by an Indian. "In one of the most skillful stories," declares a *Publishers Weekly* reviewer, "two Indians from different tribes are recruited during World War II to sneak information past the Germans by talking 'Native American.'" The two turn out to be from different tribes, and they discover that they can only communicate in badly-pronounced German—so badly pronounced that they alone can understand it.

"Several common themes run through these fictions," writes *Bloomsbury Review* contributor Carl L. Bankston: "the past and present of Native American peoples, the sacredness of the natural world, and humanity's ruptured relations with untamed animals." "Fox Den," for example, shows how a family of foxes survives the invasion of farmers into their territory. "Throughout," states a *Kirkus Reviews* contributor, "Bruchac questions the boundaries between animals and men, remembering the distant past when Iroquois women nursed orphaned beaver kits at the breast and, more recently, when farm people kept wild animals as pets." "This is a good blend of well-crafted stories that are deserving of careful analysis," declares Yvonne Frey in *School Library Journal*. "Even on the printed page," the *Publishers Weekly* contributor concludes, "Bruchac's tales ring of the oral tradition he helps preserve. His stories are often poignant, funny, ironic—and sometimes all three at once."

Stories of Ancient and Modern Times

Not all of Bruchac's works are collections of stories. *Dawn Land* is a novel about the imagined history of the people of the American Northeast—what is now New England and the Maritime Provinces of Canada. The story takes place shortly after the end of the Ice Age, and tells how Young Hunter leaves his home in Only People Village to find the technology that will help him defeat the terrible Cannibal Giants. "Finally," explains a *Kirkus Reviews* contributor, ". . . Young Hunter reaches the new land and the People of the Long Lodges. He discovers, classically, that the other is not always the enemy, and returns with 'too great a weapon to be used by people whose minds might not be straight.'" Young Hunter's time is a semimythical period in which many people have superhuman powers and share close relationships with their animal companions. "Told in the cadence of a storyteller's voice," states Judy Sokoll in *School Library Journal*, "the tale weaves together Native American history, traditions, values, and beliefs, central to which is the sacredness and interrelation of all things."

Fox Song is also about relationships, but on a more personal level. It tells how a little girl named Jamie comes to terms with the death of her great-grandmother, an Abenaki Indian. She "remembers and describes some of the special times they

shared," explains Patricia Dooley in *School Library Journal*. Grama Bowman and Jamie have gathered berries, birch bark, and sap for crafts—activities that have brought them closer to nature and, at the same time, closer to each other. Before her death, Grama tells Jamie to look for the tracks of a fox; when the girl sees the fox, the old woman says, the little girl will remember her. "When Jamie finally gets up," writes Sara Stein in the *New York Times Book Review*, "she goes to their favorite place under a sugar maple tree and bravely sings an Abenaki song of welcome. A fox comes, sits, yawns and in a moment is gone again." The moment of memory begins the little girl's healing process.

Although many of the themes and patterns Bruchac uses in his work are universal—death and

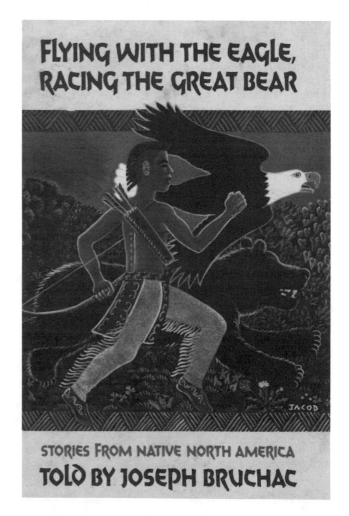

In this 1993 collection, Iroquois, Creek, Navajo, and Inuit tales of the rites of passage to maturity are gathered together.

loss in *Fox Song*, growth and discovery in *Dawn*—the author also makes a point of respecting and honoring diversity. In many of his collections, the stories come from different Native American cultures, each of which has its own traditions and folktales. "There are more than 400 different living American Indian cultures in North America," Bruchac tells Alderdice. "No one knows them all. And what I can say is that I know a bit, to some detail, about a couple of them."

Tales to Grow Men and Women

Flying with the Eagle, Racing the Great Bear: Stories from Native North America is one example of the types of stories told by the different North American Indian cultures. The tales in the collection tell about the ways young men relate to the world around them. The Cherokee story "How the Game Animals Were Set Free" explains why men have to hunt and work hard for a living. The Lakota story of "The Light-Haired Boy" tells about the origins of the great Oglala warrior Crazy Horse. "Many of the stories I've been given," the author continues in his introduction to the book, "are tales designed not only to help the boy find his way to full manhood but also to help the man remember the boy within himself, so that he can be sympathetic and helpful to the coming generations. . . . I offer them as a few examples of the ways in which the many different tribal nations of North America recognized the need to guide and gently channel young men as they grew."

Native American cultures also recognized the importance of a girl's entrance into womanhood. *The Girl Who Married the Moon: Stories from Native North America* collects some of the stories from different Indian traditions about the ways girls become women. "Some are ancient stories that speak of the paths from youth to maturity, from foolishness to wisdom, from selfishness to caring," Gayle Ross writes in her introduction to the collections. "Though times change, and people and societies change with them, the wisdom of the traditional tale is everlasting." In "The Girl Who Married the Moon," for example, the wife of the Moon, like the wife of the pirate Bluebeard, learns that some doors are better left unopened. Unlike the pirate's wife, however, the Moon accepts his wife's curiosity and invites her to participate in his nightly work. "And so," Ross concludes, "we offer these stories both to honor the generations

of grandmothers who have gone before us and to reach the daughters and granddaughters who will come after."

"Few words have been as often used or as frequently misunderstood in recent years as *multiculturalism*," Bruchac writes in *Horn Book* magazine. "Whether we are speaking of literature for children or education in general, the word *multiculturalism* is as omnipresent (and, to some, as ominous) as the proverbial Damoclean sword that hung by a thread over an ancient king, reminding him how tenuous life—and power—can be." Multiculturalism, the author explains, means respect for *all* cultures, including European, Asian, African, and all different Native American cultures. "For the Native peoples of North America," he adds, "multiculturalism simply means *people*. Not some people; *all* people. *Wli dogo wongan* is how we say it in Abenaki, a phrase which might be translated as 'good relatives,' and means 'all our relations' in a figurative sense." "My firm belief," Bruchac concludes, "is that when perceived properly, when presented and used with sensitivity and balance, ideas of multiculturalism can empower all our children."

Bruchac emphasizes these values in his stories, and he believes that they help to account for the popularity of his work. "I really think that what people are seeing are those basic values: of family, of environment and community and storytelling," he tells Alderdice. "Values that all come together so clearly in the Native American traditions. But these are basic human values. And you don't have to be an Indian, or even interested . . . in American Indian culture to appreciate a book like *Between Earth and Sky*."

"Some writers have a single story they tell over and over again, in the same voice, renaming the characters and rearranging the events," Bankston

If you enjoy the works of Joseph Bruchac, you may also want to check out the following books and films:

Will Hobbs, *Bearstone*, 1989.
James Houston, *Drifting Snow: An Arctic Search*, 1992.
Jan Hudson, *Sweetgrass*, 1989.
Barbara Kingsolver, *The Bean Trees*, 1988.
Dances with Wolves, Orion, 1990.

explains. "Others, the true storytellers, change constantly, adopting a new tone for each tale, submerging themselves in their characters, producing the unexpected in each new narrative." "Joseph Bruchac," he concludes, "is one of the true storytellers."

■ Works Cited

Alderdice, Kit, "Joseph Bruchac: Sharing a Native-American Heritage," *Publishers Weekly*, February 19, 1996, pp. 191-92.

Bankston, Carl L. III, review of *Turtle Meat and Other Stories*, *Bloomsbury Review*, May-June, 1993, p. 5.

Bradburn, Frances, review of *Native American Animal Stories Told by Joseph Bruchac*, *Wilson Library Bulletin*, June, 1993, pp. 103, 133.

Bruchac, Joseph, comments in *Something about the Author*, Volume 42, Gale, 1986, pp. 52-53.

Bruchac, Joseph, essay in *I Tell You Now: Autobiographical Essays by Native American Writers*, edited by Brian Swann and Arnold Krupat, University of Nebraska Press, 1987.

Bruchac, Joseph, introduction to *Flying with the Eagle, Racing the Great Bear: Stories from Native North America*, BridgeWater Books, 1993.

Bruchac, Joseph, "All Our Relations," *Horn Book*, March/April, 1995, pp. 158-62.

Bruchac, Joseph, *The Boy Who Lived with the Bears and Other Iroquois Stories*, HarperCollins, 1995.

Review of *Dawn Land*, *Kirkus Reviews*, March 15, 1993, pp. 316-17.

Dooley, Patricia, review of *Fox Song*, *School Library Journal*, February, 1994, p. 78.

Frey, Yvonne, review of *Turtle Meat and Other Stories*, *School Library Journal*, December, 1992, p. 137.

Ross, Gayle, introduction to *The Girl Who Married the Moon: Stories from Native North America*, BridgeWater Books, 1994.

Sokoll, Judy, review of *Dawn Land*, *School Library Journal*, August, 1993, p. 205.

Stein, Sara, "The Little Foxes," *New York Times Book Review*, November 14, 1993, p. 24.

Review of *Stone Giants and Flying Heads: Adventure Stories of the Iroquois*, *Booklist*, April 1, 1979, p. 1217.

Review of *Turtle Meat and Other Stories*, *Kirkus Reviews*, October 1, 1992, p. 1201.

Review of *Turtle Meat and Other Stories*, *Publishers Weekly*, October 19, 1992, p. 73.

Wilms, Denise M., review of *Turkey Brother and Other Tales*, *Booklist*, March 1, 1976, p. 974.

■ For More Information See

BOOKS

Native North American Literature, edited by Janet Witalec, Gale, 1994.

Notable Native Americans, Gale, 1995.

PERIODICALS

Albany Times Union, June 1, 1980.

Bloomsbury Review, March-April, 1988, pp. 7, 26.

Booklist, December 15, 1978, p. 667; July, 1993, p. 1969; November 15, 1993, p. 632.

Books in Canada, September, 1991, p. 47.

Bulletin of the Center for Children's Books, July/August, 1996, pp. 364-65.

Choice, July-August, 1979, p. 662; April, 1980, p. 218.

Horn Book, November/December, 1993, pp. 770-73; November/December, 1995, p. 750; May/June, 1996, pp. 341-42.

Kliatt, January, 1993, pp. 25-26; March, 1993, pp. 21-22; July, 1996, p. 32.

Los Angeles Times Book Review, November 1, 1992, p. 11; January 10, 1993, p. 9; June 20, 1993, p. 6; October 23, 1994, p. 12.

Publishers Weekly, April 26, 1976, p. 60; March 15, 1993, p. 68; July, 1993, p. 254; October 2, 1995, p. 74; April 15, 1996, p. 67; June 10, 1996, p. 100.

School Library Journal, April, 1979, p. 53; July, 1992, p. 67; September, 1993, p. 222; September, 1995, p. 132.

Western American Literature, November, 1984, p. 243; winter, 1985, pp. 322-23.

Wilson Library Bulletin, September, 1993, p. 87.*

—*Sketch by Kenneth R. Shepherd*

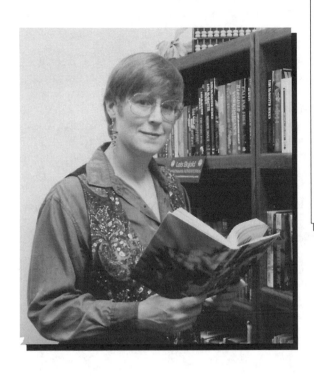

Lois McMaster Bujold

■ Personal

Surname is pronounced "*boo*-jhold"; born November 2, 1949, in Columbus, OH; daughter of Robert Charles (an engineering professor) and Laura Elizabeth (a homemaker; maiden name, Gerould) McMaster; married John Fredric Bujold, October 9, 1971 (divorced, 1992); children: Anne Elizabeth, Paul Andre. *Education:* Attended Ohio State University, 1968-72.

■ Addresses

Agent—Eleanor Wood, Spectrum Literary Agency, 111 Eighth Ave., Suite 1501, New York, NY 10011.

■ Career

Homemaker, 1971—; Ohio State University Hospitals, pharmacy technician, 1972-78; writer, 1982—. Writing workshop instructor at Thurber House, spring, 1988, and Ohio State University, summers, 1990-92. *Member:* Science Fiction Writers of America, Novelists, Inc.

■ Awards, Honors

Nebula Awards, Science Fiction Writers of America, 1988, for novel *Falling Free,* and 1989, for novella "The Mountains of Mourning"; Hugo Awards, World Science Fiction Society, 1989, for novella "The Mountains of Mourning," 1991, for novel *The Vor Game,* 1992, for novel *Barrayar,* and 1995, for novel *Mirror Dance;* Locus Award for best novel, *Locus* Magazine, 1992, for *Barrayar,* 1995, *for Mirror Dance.*

■ Writings

SCIENCE FICTION; "VORKOSIGAN" SERIES

Shards of Honor, Baen Books, 1986.
Ethan of Athos, Baen Books, 1986.
The Warrior's Apprentice, Baen Books, 1986.
Falling Free, Baen Books, 1988.
Brothers in Arms, Baen Books, 1989.
Borders of Infinity (novellas; includes "The Mountains of Mourning"), Baen Books, 1989.
The Vor Game, Baen Books, 1990.
Vorkosigan's Game (contains *Borders of Infinity* and *The Vor Game*), Science Fiction Book Club, 1990.
Barrayar, Baen Books, 1991.
Mirror Dance, Baen Books, 1994.
Cetaganda, Baen Books, 1995.
Memory, Baen Books, 1996.

OTHER

The Spirit Ring (fantasy), Baen Books, 1992.
(Editor with Roland J. Green) *Women at War* (science fiction), Tor Books, 1995.

Contributor to periodicals, including *American Fantasy, Analog Science Fiction/Science Fact, Columbus Dispatch, Far Frontiers, New Destinies,* and *Twilight Zone.*

■ Adaptations

Bujold's short story "Barter" was adapted for the syndicated television program *Tales from the Darkside,* 1986.

■ Sidelights

A disabled military genius from an aristocratic family who is also a mercenary, a planet where only men live and children are hatched in artificial incubators, and a space station where genetically engineered "quaddies" with four hands instead of the normal set of two hold a revolution—these are examples of the kind of science fiction stories Lois McMaster Bujold conjures up in her novels. But her science fiction is not known only for its creative universes. Bujold is considered a master at character development and the nuances of human interaction—qualities not always found in modern science fiction. Although best known as the creator of Miles Vorkosigan, the disabled military genius and mercenary, Bujold has written many other critically acclaimed science fiction novels—and has even written a well-received fantasy book.

Bujold has been writing science fiction since 1982. In 1985, she had the almost unheard of feat of receiving contracts to publish three novels in one year. Her first novel was published in 1986. In *Shards of Honor* (1986), she introduces the characters and universe that would lead to many more stories. In this novel, Cordelia Naismith is the leader of a scientific survey group sent to the strategically located planet Sergyar from the peaceful Beta Colony. Her group is routed in military skirmishes, and she and the remaining survivor are captured by Captain Aral Vorkosigan, a man known throughout the galaxy as the "Butcher ofKomarr." During the 200-kilometer journey back to Vorkosigan's camp, Naismith and Vorkosigan begin to warm up to each other as Cordelia learns the truth behind the Barrayaran's reputation. Yet, despite her changing feelings, Naismith escapes her captor and returns home.

Naismith is given the command of a freight ship that is forced into the conflict surrounding the planet Escobar. She is once again captured by Barrayarans, this time by the sadistic Admiral Vorrutyer. She helps to organize a mutiny, escapes her captors and somehow manages to be honored by the Barrayans for Vorrutyer's death. Because of this, her home world becomes suspicious of her, and she flees to Barrayar to join Vorkosigan. "Bujold has a nice hand with the complications" of the story, asserted Tom Easton in *Analog Science Fiction/Science Fact.* Although he noted that the plot suffered from "conventionality and predictability," he praised Bujold for her sensitive treatment of lovers separated by war. Margrett J. McFadden similarly hailed the story in *Voice of*

Bujold at age seventeen, when she was not yet a writer but already an avid science fiction reader.

Youth Advocates, indicating that "the story can be read on different levels; as pure entertainment, [or] as a study in leadership." McFadden also commented on Bujold's exceptional development of "engaging, interesting, [and] complicated protagonists."

In Bujold's next novel, *The Warrior's Apprentice* (1986), she introduced her most popular character, zooming ahead to the time when Naismith and Vorkosigan's son, Miles, becomes a man. Because his mother was exposed to a toxin while still pregnant, Miles was born deformed and remains his aristocratic father's only chance for an heir. Miles is fighting to prove himself as a warrior and worthy successor on Barrayar, an extremely militaristic and conservative planet. Despite opposition from those in power, Miles decides to apply to the Imperial Service Academy, passes both the oral and written exams, but fails the physical exam miserably when both his legs, brittle since birth, are broken in an ill-advised jump. Despondent and wanting to prove himself, Miles takes a trip to his mother's home planet of Beta; through a series of well-intentioned actions, he creates his own mercenary fleet and becomes an arms dealer for an enemy planet. At the same time, he ends up performing a valuable service for the Barrayaran empire and finds his own niche within it. Eleanor Klopp commented in *Voice of Youth Advocates* that "this is an unusually good book." "Bujold may be a new voice among science fiction writers," Martha A. Bartter wrote in *Fantasy Review*, "but she knows how to make a story work," praising in particular the author's ability to develop character through humor.

No Girls Allowed

In Bujold's third novel published in 1986, *Ethan of Athos*, she departed a little from the story of Miles. Relating a mission performed by one of Miles's mercenaries, this satirical novel has an unusual premise. The inhabitants of Athos are all homosexual men; they reproduce their population through the use of artificial uteruses and real ovarian cultures. The main character, Ethan Urquhart, is one of the planet's obstetricians. When the planet gets low on ovarian cultures, he must travel off planet to replace their stocks, a journey that has complex consequences. *Booklist* reviewer Roland Green called *Ethan of Athos* a "remarkable novel" with a "compellingly attractive" hero.

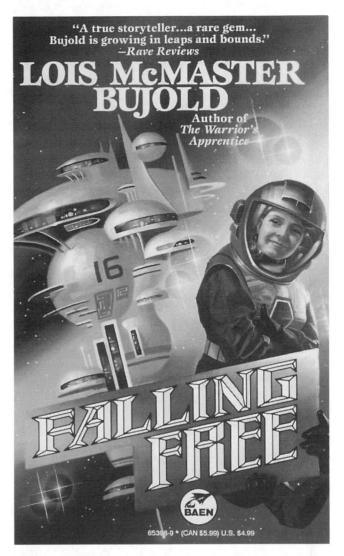

"A true storyteller...a rare gem... Bujold is growing in leaps and bounds." —*Rave Reviews*

LOIS McMASTER BUJOLD

Author of *The Warrior's Apprentice*

FALLING FREE

BAEN

65398-9 * (CAN $5.99) U.S. $4.99

In this 1988 science fiction adventure, a giant corporation genetically creates hundreds of four-handed children to work on a gravity-less planet until they are no longer useful.

Set in the Vorkosigan universe 200 years before Miles's birth, Bujold's 1988 novel, *Falling Free*, posed the question of what can happen when genetic engineering is used to satisfy corporate greed. A middle-aged engineer named Leo Graf is sent to the Cay Habitat, a space station without artificial gravity, to teach welding to the staff. What he finds there are a few humans and over a thousand "quaddies"—genetically engineered humans who have an extra set of arms and hands, instead of legs, to be useful in a zero-gravity situation. Soon after he lands, artificial gravity is invented and the quaddies become useless to their inventors. The corporation that invented them concocts a plot to eliminate them.

Graf becomes friends with the quaddies and eventually leads them into a revolt where they escape the corporation and live on their own. *Booklist*'s Green praised Bujold for her insightful wit, "nearly flawless" characterization, and technical detail, and called *Falling Free* a "superior novel."

Falling Free won a Nebula Award, science fiction's most prestigious honor, an event which generated some controversy. In the collection *Nebula Awards 24: SFWA'S Choices for the Best Science Fiction and Fantasy, 1988,* Ian Watson called the work "an out-and-out juvenile" and asked, "Do members of SFWA [Science Fiction Writers of America] *really* wish this to be seen as their pinnacle, their height of achievement?" Bartter, rebutting his argument in *Twentieth-Century Science Fiction Writers,* stated, "Watson makes two peculiar assumptions here: first, that juveniles don't represent high achievement, and second, that *Falling Free* is a juvenile." She observed that "the protagonist, Graf, is a middle-aged engineer; willing and unwilling sex plays a major role; and the plot revolves not around achieving adulthood but around definitions of slavery and what it takes to achieve freedom responsibly." In *Nebula Awards 24,* Bujold herself responded to Watson by stating that the novel concerned adult issues like "teaching, building, nurturing, making moral choices, and taking personal responsibility for the welfare of fellow human beings."

In the 1989 release *Brothers in Arms,* Bujold once again returned to her valiant crusader, Miles Vorkosigan. Miles has just finished a stint as Admiral Naismith, his gun-running, mercenary alias, and has gone to Earth for some business. While on Earth, he discovers there is a plot to kill him and must switch between his two identities to find and thwart the assassins. In the meantime, someone has cloned Miles, an act that wreaks havoc with Vorkosigan's compatriot and lover, Elli Quinn, and could cause unlimited amounts of trouble on Barrayar. Even though Miles is the one kidnapped by the plotters, his peculiar Barrayarian sense of honor requires him to rescue his newly discovered "brother." Green of *Booklist* once again hailed the author's "superb characterization" and "rare wit," and deemed *Brothers in Arms* "an essential purchase."

Borders of Infinity (1989) contains three novellas about Miles Vorkosigan. In one tale, he undertakes a mission on Barrayar that is particularly mean-

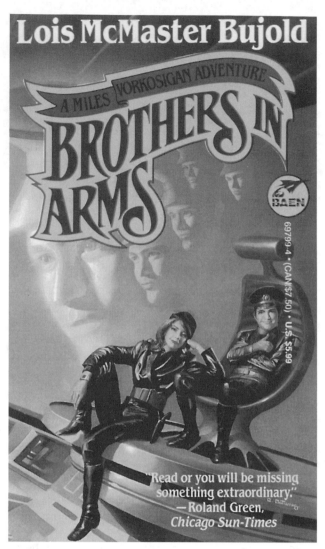

In this 1989 tale, Miles Vorkosigan, also known as the mercenary Admiral Naismith, discovers a plot to kill him, but he is not sure which of his identities is at risk.

ingful to him because of his own deformity—investigating the death of a poor woman's daughter, thought to have been killed because of a cleft palate. In another story, he finds himself befriending an unusual being who has been genetically engineered. And, in the final story, he organizes a prison break from a supposedly escape-proof prison. In *The Vor Game* (1990), Bujold travels back in time to when Miles has, despite his many physical problems, just graduated from the Imperial Military Academy on Barrayar. His adventures take him to an isolated Arctic military post where he finds himself in conflict with the jaded and cruel commander; he later encounters Barrayar's runaway Emperor Gregor in a detention center

and must return him home without letting any of Barrayar's many enemies discover his absence. *The Vor Game* won the respected Hugo Award in 1990; in *Voice of Youth Advocates*, Judy Kowalski called Miles "an audacious, witty character."

Barrayar (1991) looks back at the events that happened during Cordelia Naismith's pregnancy with Miles. Shortly after Cordelia and Aral Vorkosigan are married, the Emperor of Barrayar dies and the highly-ranked Aral Vorkosigan is appointed regent of the planet. This puts the couple in a very dangerous position because there are many pretenders to the throne. Vordarian, one of these pretenders, ambushes the couple with a soltoxin gas bomb. The antidote to the poison also kills fetal tissue. Cordelia makes the unprecedented move of transplanting her unborn child into a uterine replicator, a device common on her planet, but virtually unknown on Barrayar. She and the young Emperor Gregor flee into the mountains while her husband fights with Vordarian. Soon after, Vordarian steals the uterine replicator with Miles in it, and Cordelia ignores her husband's wishes and arranges for the replicator to be taken in a raid. Mary K. Chelton commented in *Voice of Youth Advocates* that "Bujold has a genius for blending technological speculation, the conventions of classic military science fiction, and cultural anthropology" to create "wonderfully plotted stories." Bartter, writing in *Twentieth-Century Science Fiction Writers*, observed that "Bujold doesn't preach; her characters must make hard choices, and pay the price for them." Faren Miller declared in *Locus* that "in many respects her new book, *Barrayar*, is the best yet," adding, "This is sf fully equipped with brains, humor, and heart." *Barrayar* won Bujold another Hugo Award for best science fiction novel.

This 1990 work packages together the Hugo Award-winning *The Vor Game* and *Borders of Infinity*, which includes a Nebula Award-winning novella.

Close Cloning Encounter

Mirror Dance (1993) also won a Hugo Award for science fiction. In this novel, Miles has more in-depth encounters with his clone, Mark. Despite the fact that they are made from the same basic genetic materials, the two are very different. Unbeknownst to Miles, Mark has taken his place as Admiral Naismith, head of a fleet of mercenaries, in order to stage a raid on a cloning facility whose products are scheduled to become brain-transplant hosts. Unfortunately, his lack of experience and his tendency for introspection are hampering him. When Miles finds out about his plan, the more impulsive "brother" rushes to get in on the action. However, Miles is killed by a stray bullet, put into cryogenic freeze, and then dropped in an anonymous mail chute with little hope of his friends finding his correct shipping address. Mark then goes to visit Miles's parents to tell them of the news, and finds that they are willing to accept and love him as if he had been born to them. In this book, Mark finally gets a chance to find out who he really is.

A critic in *Publishers Weekly* claimed *Mirror Dance* is "peopled with introspective but genuine heroes who seize the reader's imagination and intellect." Calling the plot "as good a story as ever was offered as science fiction," *Booklist* reviewer Green asserted that the book "deserves the highest recommendation and a horde of eager readers."

The 1991 Hugo Award winner, *Barrayar* returns to Vorkosigan's prebirth days, revealing the deadly forces that drove his parents and shaped his destiny.

Miller, reviewing the work in *Locus*, observed that while *Mirror Dance* is "often darker than anything Bujold has achieved before," it still contains her trademark "wit and style"; the critic concludes by encouraging readers to "go discover this impressive book for yourself: you're in for some surprises, but I don't think you'll be disappointed."

After years of focusing on the world of Miles Vorkosigan and company, Bujold created an entirely different world with the publication of *The Spirit Ring* (1992). Here, she travels to Renaissance Italy, which in this novel is changed into a fantasy world. The novel focuses on Fiametta Beneforte, the teenage daughter of the powerful Magician Prospero. Fiametta begs her father to

teach her his magical talents, but he refuses because of her gender. Their duchy is invaded and the Duke killed, and as Fiametta and her father flee, he drops dead from cardiac arrest. His body is taken back to the occupied castle to be used in an act of unspeakable black magic that will bind his soul. With the help of Thur Ochs, a man who fits Fiametta's true-love ring perfectly, they overtake the castle's invaders and free her father's spirit. Although peopled with ghosts and demons, *The Spirit Ring* "is solidly grounded in human psychology and the ways of the real world," Miller claimed in his *Locus* review. Susan Rice wrote in *Voice of Youth Advocates* that Bujold had made the transfer from science fiction to fantasy quite readily, claiming that "with this new setting and characters, Bujold is the best yet," and concluding to the reader: "Don't miss this one, it's a keeper."

The 1995 release *Cetaganda* returns once again to the world of Miles Vorkosigan, prior to his temporary death in the last series novel. In this adventure, he calls upon his diplomatic skills in a trip to the planet Cetaganda, where he is to attend the funeral of the empress. Miles has scarcely disembarked from his spacecraft when he and his handsome, woman-chasing cousin Ivan experience mysterious events and have to consider the political implications. As Miles becomes embroiled in a plot to find a copy of the software that houses the Cetagandan genome, which the empresses use to reproduce, he also must deal with his own feelings towards a beautiful but forbidden Cetagandan empress. Although he is a man and a foreigner, the matriarchal planet lets Miles help them find the guilty governor and clear his own name. A reviewer in *Publishers Weekly* commented that this novel, "like its predecessors, blends high adventure with wry commentary," while *Voice of Youth Advocates* contributor Kim Carter said the novel "dances with Bujold's engaging narrative, deftly drawn characters, and intricate plot development."

The follow-up to the Hugo-winning *Mirror Dance, Memory* takes place after Miles's resurrection and explores the physical and emotional consequences of his near-death experience. Although he has not fully recovered from his injuries, Miles undertakes an important mission for the Barrayan secret service; unfortunately, he suffers a seizure during the action and accidentally disables the very man he's come to rescue. When he tries to cover up the

If you enjoy the works of Lois McMaster Bujold, you might also want to check out the following books and films:

David Brin, *Startide Rising*, 1983.
C. J. Cherryh, *Cyteen*, 1989.
Joan D. Vinge, "Cat" series: *Psion* (1982), *Catspaw* (1988), and *Dreamfall* (1996).
Timothy Zahn, *Deadman Switch*, 1988.
Blade Runner, Warner Brothers, 1982.

incident, he is discovered by his superior Simon Illyan, and is dismissed from the Imperial Service. Since his government position had been a way for him to prove himself as more than just his famous father's son, Miles is crushed by this turn of events. He doesn't have much time to brood over his failures, however, for Illyan begins to experience his own mental troubles, and only Miles has the knowledge to save the empire from potential disaster. Although the Vorkosigan books "started out as fairly lightweight space opera," according to a *Publishers Weekly* critic, "Bujold has matured as a writer over the years"; the skill in characterization she demonstrates in *Memory*, the writer concluded, makes the novel a "compelling" one.

Bujold once commented on her reasons for writing: "I see science fiction as psychological allegory for our times. . . . My interest in science fiction dates back to age nine. I picked up the taste from my father, a professor of welding engineering at Ohio State University, who used to buy the sf magazines to read on the plane on consulting trips." A veteran of the field, Bujold has long been cited for her exceptional character development. Chelton observed in *Voice of Youth Advocates* that Bujold's "characters are so vivid and easily beloved that they master the plot and the reader simultaneously. It is an honor to have read her work, and a debt of honor repaid to encourage others to introduce her to kids." Bujold remarked in *Twentieth-Century Science Fiction Writers* that character development is one of her main considerations: "I try to write the kind of book I most like to read: character-centered adventure." Chelton concluded that Bujold's "people wear their civilization on the inside. And can she write about it! But then, science fiction has always been about that. Bujold just does it better than almost anybody else."

■ Works Cited

Bartter, Martha A., review of *The Warrior's Apprentice, Fantasy Review,* October, 1986, p. 20.

Bartter, Martha A., "Lois McMaster Bujold," *Twentieth-Century Science Fiction Writers*, 3rd edition, edited by Noelle Watson and Paul E. Schellinger, St. James Press, 1991, pp. 92-94.

Bujold, Lois McMaster, "Free Associating about *Falling Free*," *Nebula Awards 24: SFWA'S Choices for the Best Science Fiction and Fantasy, 1988*, edited by Michael Bishop, Harcourt, 1990, pp. 24-29.

Bujold, Lois McMaster, comments in *Twentieth-Century Science Fiction Writers*, 3rd edition, edited by Noelle Watson and Paul E. Schellinger, St. James Press, 1991, pp. 92-94.

Carter, Kim, review of *Cetaganda, Voice of Youth Advocates*, June, 1996, pp. 106-107.

Review of *Cetaganda, Publishers Weekly*, December 11, 1995, p. 61.

Chelton, Mary K., "A Debt of Honor Repaid: The Science Fiction Novels of Lois McMaster Bujold—'My Word On It'," *Voice of Youth Advocates*, December, 1991, pp. 295-97.

Chelton, Mary K., review of *Barrayar, Voice of Youth Advocates*, February, 1992, pp. 378-79.

Easton, Tom, review of *Shards of Honor, Analog Science Fiction/Science Fact*, January, 1987, pp. 179-80.

Green, Roland, review of *Ethan of Athos, Booklist*, February 1, 1987, p. 822.

Green, Roland, review of *Falling Free, Booklist*, March, 1, 1988, p. 1098.

Green, Roland, review of *Brothers in Arms, Booklist*, December 1, 1988, p. 618.

Green, Roland, review of *Mirror Dance, Booklist*, January 1, 1994, p. 811.

Klopp, Eleanor, review of *The Warrior's Apprentice, Voice of Youth Advocates*, February, 1987, p. 290.

Kowalski, Judy, review of *The Vor Game, Voice of Youth Advocates*, February, 1991, p. 361.

McFadden, Margrett J., review of *Shards of Honor, Voice of Youth Advocates*, December, 1986, p. 233.

Review of *Memory, Publishers Weekly*, September 23, 1996, p. 60.

Miller, Faren, review of *Barrayar, Locus*, September, 1991, pp. 15, 17.

Miller, Faren, review of *The Spirit Ring, Locus*, August, 1992, pp. 17, 55-56.

Miller, Faren, review of *Mirror Dance, Locus*, January, 1994, p. 15.

Review of *Mirror Dance, Publishers Weekly*, January 3, 1994, p. 76.

Rice, Susan, review of *Spirit Ring, Voice of Youth Advocates,* April, 1993, p. 36.

Watson, Ian, "Themes and Variations: A View on the SF and Fantasy of 1988," *Nebula Awards 24: SFWA'S Choices for the Best Science Fiction and Fantasy, 1988,* edited by Michael Bishop, Harcourt, 1990, pp. 1-23.

■ **For More Information See**

BOOKS

Encyclopedia of Science Fiction, edited by John Clute and Peter Nicholls, St. Martin's, 1993, p. 171.

St. James Guide to Science Fiction Writers, 4th edition, edited by Jay P. Pederson, St. James Press, 1996, pp. 124-26.

PERIODICALS

Sol Rising, May, 1991.

Starlog, May, 1990.

Sun-Times (Chicago), October, 1991; November, 1992.

Washington Post Book World, July 30, 1989.

Voice of Youth Advocates, June, 1996, p. 112.

—Sketch by Nancy Rampson

Betsy Byars

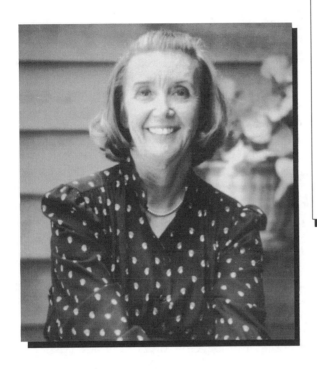

■ Personal

Born August 7, 1928, in Charlotte, NC; daughter of George Guy (a cotton mill executive) and Nan (a housewife; maiden name, Rugheimer) Cromer; married Edward Ford Byars (a professor of engineering), June 24, 1950; children: Laurie, Betsy Ann, Nan, Guy. *Education:* Attended Furman University, 1946-48; Queens College, B.A., 1950; attended West Virginia University. *Hobbies and other interests:* Gliding, antique airplanes, reading, traveling, music, needlepoint, crosswords.

■ Addresses

Home—4 Riverpoint, Clemson, SC 29631.

■ Career

Children's book author.

■ Awards, Honors

Book of the Year selection, Child Study Association of America, 1968, for *The Midnight Fox*, 1969, for *Trouble River*, 1970, for *The Summer of the*

Swans, 1972, for *The House of Wings*, 1973, for *The Winged Colt of Casa Mia* and *The 18th Emergency*, 1974, for *After the Goat Man*, 1975, for *The Lace Snail*, 1976, for *The TV Kid*, and 1980, for *The Night Swimmers*; Notable Book selection, American Library Association, 1969, for *Trouble River*, 1972, for *The House of Wings*, 1974, for *After the Goat Man*, 1977, for *The Pinballs*, 1981, for *The Cybil War*, and 1982, for *The Two-Thousand-Pound Goldfish*; Lewis Carroll Shelf Award, 1970, for *The Midnight Fox*; Newbery Medal, 1971, for *The Summer of the Swans*; Best Books for Spring selection, *School Library Journal*, 1971, for *Go and Hush the Baby*; Book List selection, *Library Journal*, 1972, and National Book Award finalist, 1973, both for *House of Wings*; *New York Times* Outstanding Book of the Year, 1973, for *The Winged Colt of Casa Mia* and *The 18th Emergency*, 1979, for *Good-bye Chicken Little*, and 1982, for *The Two-Thousand-Pound Goldfish*; Book List selection, *School Library Journal*, 1974, for *After the Goat Man*; Dorothy Canfield Fisher Memorial Book Award, Vermont Congress of Parents and Teachers, 1975, for *The 18th Emergency*; Horn Book Honor List, Woodward Park School Annual Book Award, Child Study Children's Book Award, Child Study Children's Book Committee at Bank Street College of Education, all 1977, Hans Christian Andersen Honor List for Promoting Concern for the Disadvantaged and Handicapped, Georgia Children's Book Award, both 1979, Charlie May Simon Book Award, Arkansas Elementary School Council, Surrey School Book of the Year Award, Surrey School Librarians of Surrey, British Colum-

bia, Mark Twain Award, Missouri Association of School Librarians, William Allen White Children's Book Award, Emporia State University, Young Reader Medal, California Reading Association, all 1980, Nene Award runner up, 1981 and 1983, and Golden Archer Award, Department of Library Science of the University of Wisconsin—Oskosh, 1982, all for *The Pinballs; Boston Globe—Horn Book* fiction honor, Best Book of the Year, *School Library Journal,* both 1980, and American Book Award for Children's Fiction (hardcover), 1981, all for *The Night Swimmers;* Notable Children's Book, *School Library Journal,* 1981, Children's Choice, International Reading Association, 1982, Tennessee Children's Choice Book Award, Tennessee Library Association, 1983, and Sequoyah Children's Book Award, 1984, all for *The Cybil War;* Parents' Choice Award for Literature, Parents' Choice Foundation, Best Children's Books, *School Library Journal,* both 1982, CRABbery Award, Oxon Hill Branch of Prince George's County Library, 1983, and Mark Twain Award, 1985, all for *The Animal, the Vegetable, and John D. Jones;* Notable Book of the Year, *New York Times,* and IBBY Award (Finland), both 1982, both for *The Two-Thousand-Pound Goldfish;* *Horn Book* Honor List, Parents' Choice Award for Literature, both 1985, South Carolina Children's Book Award, 1987, William Allen White Children's Book Award, Emporia State University, and Maryland Children's Book Award, both 1988, all for *Cracker Jackson;* Parents' Choice Award for Literature, 1986, for *The Not-Just-Anybody Family;* Regina Medal, Catholic Library Association, 1987; Charlie May Simon Award, 1987, for *The Computer Nut;* Edgar Award, 1992, for *Wanted . . . Mud Blossom.*

■ Writings

JUVENILE FICTION

Clementine, illustrated by Charles Wilton, Houghton, 1962.

The Dancing Camel, illustrated by Harold Berson, Viking, 1965.

Rama, the Gypsy Cat, illustrated by Peggy Bacon, Viking, 1966.

The Groober (self-illustrated), Harper, 1967.

The Midnight Fox, illustrated by Ann Grifalconi, Viking, 1968.

Trouble River, illustrated by Rocco Negri, Viking, 1969.

The Summer of the Swans, illustrated by Ted CoConis, Viking, 1970.

Go and Hush the Baby, illustrated by Emily A. McCully, Viking, 1971.

The House of Wings, illustrated by Daniel Schwartz, Viking, 1972.

The 18th Emergency, illustrated by Robert Grossman, Viking, 1973.

The Winged Colt of Casa Mia, illustrated by Richard Cuffari, Viking, 1973.

After the Goat Man, illustrated by Ronald Himler, Viking, 1974.

The Lace Snail (self-illustrated), Viking, 1975.

The TV Kid, illustrated by Cuffari, Viking, 1976.

The Pinballs, Harper, 1977.

The Cartoonist, illustrated by Cuffari, Viking, 1978.

Good-bye, Chicken Little, Harper, 1979.

The Night Swimmers, illustrated by Troy Howell, Delacorte, 1980.

The Cybil War, illustrated by Gail Owens, Viking, 1981.

The Animal, the Vegetable, and John D. Jones, illustrated by Ruth Sanderson, Delacorte, 1982.

The Two-Thousand-Pound Goldfish, Harper, 1982.

The Glory Girl, Viking, 1983.

The Computer Nut, illustrated with computer graphics by son Guy Byars, Viking, 1984.

Cracker Johnson, Viking, 1985.

The Blossoms Meet the Vulture Lady, illustrated by Jacqueline Rogers, Delacorte, 1986.

The Not-Just-Anybody Family, illustrated by Rogers, Delacorte, 1986.

The Golly Sisters Go West, illustrated by Sue Truesdell, Harper, 1986.

A Blossom Promise, illustrated by Rogers, Delacorte, 1987.

The Blossoms and the Green Phantom, illustrated by Rogers, Delacorte, 1987.

Beans on the Roof, illustrated by Melodye Rosales, Delacorte, 1988.

The Burning Questions of Bingo Brown, illustrated by Cathy Bobak, Viking, 1988.

Bingo Brown and the Language of Love, illustrated by Bobak, Viking, 1989.

Bingo Brown, Gypsy Lover, Viking, 1990.

Hooray for the Golly Sisters!, illustrated by Truesdell, Harper, 1990.

The Seven Treasure Hunts, illustrated by Jennifer Barrett, HarperCollins, 1991.

Wanted . . . Mud Blossom, illustrated by Rogers, Delacorte, 1991.

The Moon and I (autobiography), J. Messner, 1991.

Bingo Brown's Guide to Romance, Viking, 1992.

Coast to Coast, Delacorte, 1992.

McMummy, Viking, 1993.

The Golly Sisters Ride Again, illustrated by Truesdell, HarperCollins, 1994.

The Dark Stairs: A Herculeah Jones Mystery, Viking, 1994.

(Compiler) *Growing Up Stories,* illustrated by Robert Geary, Kingfisher, 1995.

Tarot Says Beware, Viking, 1995.

The Joy Boys, illustrated by Frank Remkiewicz, Dell, 1995.

My Brother, Ant, illustrated by Marc Simont, Viking, 1996.

Dead Letter: A Herculeah Jones Mystery, Viking, 1996.

OTHER

Contributor of the afterward to *The Five Little Peppers and How They Grew,* by Margaret Sidney, Dell, 1985, and of the preface to *For Reading Out Loud,* by Margaret M. Kimmel, Dell, 1987. Also contributor of articles to numerous magazines, including *Signal, Saturday Evening Post, TV Guide,* and *Look.* Byars' writings have been translated into nine language. Byars' manuscripts are housed at Clemson University, South Carolina.

■ Adaptations

The following were adapted for ABC-TV as episodes of the *ABC Afterschool Special:* "Pssst! Hammerman's After You," adapted from *The 18th Emergency,* 1973; "Sara's Summer of the Swans," adapted from *The Summer of the Swans,* 1974; "Trouble River," adapted from book of same title, 1975; "The Winged Colt," adapted from *The Winged Colt of Casa Mia,* 1976; "The Pinballs," adapted from book of same title, 1977; and "Daddy, I'm Their Mamma Now," adapted from *The Night Swimmers,* 1981. *The Summer of the Swans* was adapted into the videocassette *Sara's Summer of the Swans,* Martin Tahse Productions, 1976; *The TV Kid* was adapted into a record/cassette, 1977; *The Lace Snail* was adapted as a filmstrip with cassette by Viking; several works are available on record or cassette.

■ Sidelights

"I used to think, when I first started writing, that writers were like wells, and sooner or later we'd use up what had happened to us and our children and our friends and our dogs and cats, and

there wouldn't be anything left," reveals Betsy Byars in an essay for *Something about the Author Autobiography Series (SAAS).* "I imagine we would if it weren't for that elusive quality—creativity. I can't define it, but I have found from experience that the more you use it, the better it works."

This creativity is scattered profusely throughout the children's and young adult books of Byars' prolific career. Among these creative works are her strong, realistic award-winning novels *The Midnight Fox, The Summer of the Swans, The Pinballs,* and *The Night Swimmers.* In these works, as well as several others, Byars presents "real" lonely or alienated children and young adults coping with believable problems. And she often adds just the right amount of humor to relieve the serious situations her characters are facing. "Byars' understanding of the traumatic impact of ordinary, often minor crises, upon the child's developing character is central to the success of her best writing," maintains Rosanne Fraine Donahue in *Twentieth-Century Children's Writers.* And Ina Robertson writes in *Language Arts* that Byars is "viewed as an artist who can create vivid characters, use deft dialogue, inject just enough humor into situations, fashion plots that are convincing and tightly structured as well as entertaining, and make a comment on today's world. She is a thoughtful, sensitive writer with extraordinary ability to help her readers view those portions of society captured in her books."

While growing up in both the city and countryside of Charlotte, North Carolina, Byars never once had ambitions to be a writer. "In all of my school years—from grade one through high school, not one single teacher ever said to me, 'Perhaps you should consider becoming a writer,'" she recalls in *SAAS,* adding: "Anyway, I didn't want to be a writer. Writing seemed boring. You sat in a room all day by yourself and typed." This lack of interest in becoming a writer herself did not affect Byars' love of books. The earliest childhood memory she has is of her father sitting next to her on the couch while reading *The Three Bears* aloud. Much to Byars' dismay, though, her father began changing certain parts of the story as he went along. She recalls in *SAAS* that "this infuriates me. I am hitting my father, trying by brute force to make him read correctly. It works. He does indeed read it right for a few lines. Then, as soon as I relax, and lose myself in the story, the mama bear says, 'Somebody's been sleeping

on my Beauty Rest mattress.' More fury. More hits. A great first memory for an author. Already I had respect for the written word."

Byars describes her father as a stern man possessing a good sense of humor and a strong work ethic. Her mother, she recalls in *SAAS*, "was very pretty and lively" and had strong interests in acting and speech that continued throughout her life. These interests led to Byars' enrollment at the age of five in Expression preschool lessons. "I enjoyed my Expression lessons a lot," she explains in *SAAS*. "I cannot recall any of the poems I memorized, but there was a comic one that allowed me to roll my eyes and make a lot of faces. My mother suffered through my comic recitation for a while, but plainly it was not what she had in mind for me. I had not inherited her dramatic charm, and I soon was diplomatically shifted to piano lessons."

"As a writer, I have a good way of shedding . . . old childhood concerns—I pass them on to the characters in my books."

—*Betsy Byars*

Although the majority of Byars' childhood was spent in the city of Charlotte on 915 Magnolia Avenue, she did spend a few years in the country town of Hoskins. The scarcity of jobs for civil engineers forced Byars' father to take a job in the office of the cotton mill for which the town was named. Young Byars found this country life enjoyable because of her love of animals, and only later realized how hard it must have been on her mother to live in an area that offered so little in the form of culture. During this time, for example, a birthday party was thrown for Byars' sister Nancy. "At Hoskins," relates Byars in her autobiographical essay, "no one went to a store and bought a birthday present. Everyone just looked around their house until they found something that did not look too bad, and they wrapped it up and came to the party. My sister got the oddest assortment of gifts that I had ever seen, and I, who loved odd things, was green with envy."

Childhood Concerns

The move back to the city took place when Byars was in fourth grade, and she lived at 915 Magnolia Avenue until she graduated from college. "No other house will ever hold so much of my life," she states in *SAAS*. At this time, Byars was also spending time in the houses of her grandparents, who she recalls as having little interest in her, allowing her to do as she pleased without getting caught. This offered Byars the opportunity to look at her Grandaddy Rugheimer's rare coins, stamps, and books and explore his beautiful woodworking shop.

The one book from this collection that she still remembers contained Bible stories with graphic, dark illustrations. "Noah's ark was no happy scene with the animals clomping into the ark, two by two," describes Byars in *SAAS*. "The ark was already afloat, in the distance. In the front of the picture was the last mountain top where the remaining desperate people and animals struggled for survival. . . . I'm sure I asked my mother about it later, concealing where I had come across such a picture, but I never got a satisfactory answer." Another similar unsatisfactory childhood incident occurred when Byars accompanied her Grandaddy Cromer to pay his respects to his friend Mr. Joe. As he lifted Byars to see inside the coffin, her knee hit the side and Mr. Joe's mouth popped open. "As a writer, I have a good way of shedding these old childhood concerns—I pass them on to the characters in my books."

The main focus of Byars' concerns shifted greatly when she entered high school in 1943—"the important thing—the only important thing—was to look exactly like everybody else," she relates in *SAAS*. Makeup was an essential, as were saddle shoes, pleated skirts, and very large sweaters. "I spent a good part of my school day arranging to accidentally bump into some boy or other," reveals Byars in *SAAS*. "I would rush out of science, tear up three flights of stairs, say a casual 'Hi' to a boy as he came out of English, and then tear back down three flights of stairs, rush into home ec and get marked tardy. I was tardy a lot." The only memories associated with actual classes that Byars has are from a math class in which the numbers of Pi matched her phone number (giving her instant fame); she also remembers getting caught cheating in the same class.

Following this high school career Byars went away to college at Furman University in 1946. In keeping with her father's wishes, and following in her sister's footsteps, she started as a math major. All was well until she hit calculus during her sophomore year. "This—no matter how hard I tried, and I tried hard—I could not get," recalls Byars in *SAAS*. "It was a desperate semester for me. My father was paying hard-earned money for me to go to college and he expected me to do well. I had discovered early in life that things were easier all around if I lived up to my father's expecta-

"Some writers are acclaimed for their literary talents, and some are popular with kids. Betsy Byars is one of that select circle who is both." —Ilene Cooper

tions. Even in high school when I was flitting through the halls, chasing boys, I made sure I never got a grade lower than B." While home for a weekend, Byars finally mustered up enough courage and broke the terrible news to her father that she could not be a mathematician and was switching to English. "There was not the terrible explosion that I had feared," Byars continued in *SAAS*. "To be honest, there usually wasn't."

Byars continued her focus on English at Queens College, and it was during her senior year that she met the man she would later marry. "I was . . . just months away from getting out into the adult world where nobody could tell me what to do or what time I had to be in, and I had just met the man I wanted to marry," relates Byars in her autobiographical essay. "The sole cloud on the horizon of my life was that he might not ask me." Edward Byars had already graduated from college and was teaching engineering at Clemson College when Byars met him. "And, as if that weren't enough, he had a Stinson 1931 antique airplane. I was madly in love," exclaims Byars in *SAAS*. By that spring the couple was engaged; they were married on June 24, 1950, exactly three weeks after Byars' graduation from college. "It is no longer fashionable to admit this, but I was very happy

to be getting married instead of looking for a job," reveals Byars in *SAAS*. "I had no work ambition. I had always wanted marriage and a family."

The next five years were spent at Clemson, where Byars enjoyed her new marriage and her roles as faculty wife and new mother. In 1955, Byars' husband decided to attend graduate school at the University of Illinois, so the family packed up their belongings, rented their house, and set out for their new home. "When we pulled up two days later in front of the barracks where we would be living for the next two-and-a-half years, my excitement faded a little," describes Byars in *SAAS*. "When we went inside and I saw the barracks furniture, it faded even more." It only took about a week for Byars to fix the place up, so she then set out to make new friends. "As it turned out," she explains in *SAAS*, "every other wife in the barracks complex either worked or was going to school. The last thing any of them wanted was to come to my house to chat. I got lonelier and lonelier."

Writing Rookie

This loneliness resulted in Byars' first creative writing attempts. "Now up until this point in my life, while I had never done any creative writing, I had always thought that I could write if I wanted to," she relates in *SAAS*. "I thought it couldn't be as hard as people say it is. I thought probably the reason professional writers claim it's so hard is because they don't want any more competition." For the next two years Byars wrote constantly, using an old typewriter that remained by her place at the table. Aiming first at the magazine market, Byars scanned national magazines and then wrote something similar to what was already published; her first sale was a short article to the *Saturday Evening Post*. "I had known all along there was nothing to writing! Seven months passed before I sold a second article," writes Byars in *SAAS*, adding: "I was learning what most other writers have learned before me— that writing is a profession in which there is an apprenticeship period, oftentimes a very long one. In that, writing is like baseball or piano playing. You have got to practice if you want to be successful."

Moving back to Clemson, Byars set up her typewriter on a card table in her bedroom; writing

was now a very important part of her life. And despite several rejections, she did not give up. "In Illinois—out of necessity—I developed a kind of tough, I'll-show-them attitude that I have maintained to this day," asserts Byars in *SAAS*. "Sort of—All right, you don't like that one, wait till you see this one. All right, you turned that down and you'll be sorry. I am now going to do the best book in the entire world." Byars goes on to add: "And the truth was that each time I believed it really was going to be the best book in the world. It never occurred to me that complete and total success was not just one manuscript away."

During this time it was hard for Byars to understand why she could not get a children's book published. At first, she attempted children's books because they looked easy, but then she really started to work on them and still could not get published. "In 1962, seven years after I rolled my first sheet of paper into that ancient typewriter, my first children's book was published," states Byars in *SAAS*. "It had been turned down by nine publishers, so it was not exactly the book the world was waiting for, but I was absolutely wild with excitement." This excitement soon faded when Byars read her first reviews of *Clementine*, which were not good. Two more children's books later, *The Dancing Camel* and *The Groober*, she continued to receive poor reviews. "About this time I signed up for a course in children's literature at West Virginia University, and this was one of the turning points in my career," maintains Byars in *SAAS*. "For the first time I saw the realistic children's novel. There had not been any of those when I was growing up. . . . I had never even considered anything realistic."

Discovers Realism

This new-found element of realism was added to Byars' next book, *Rama, the Gypsy Cat*, the story of a pioneer cat, and the author received her first critical praise. By this point in her career, Byars was also receiving invaluable help from several editors, whose advice she always followed. "As a writer, I have always been aware of the enormity of the gap between the brain and a sheet of paper," she explains in *SAAS*. "You write something that you think is hilarious; on paper it isn't funny at all. You write something sad; it's not. You write a story and you know exactly what the finished

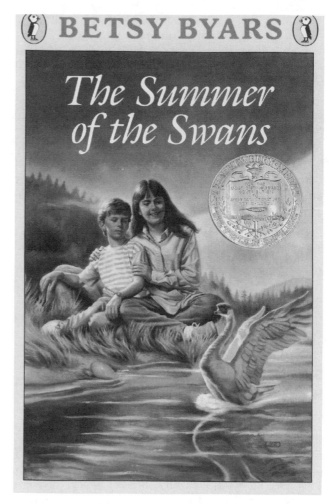

This novel, winner of the 1971 Newbery Medal, depicts the relationship between fourteen-year-old Sara and her mentally impaired younger brother, Charlie.

story should be; and it turns out to be something else." The first story that actually turned out the way Byars envisioned it was *The Midnight Fox*. Tom, the narrator, is left at an aunt and uncle's farm for the summer while his parents bicycle through Europe. Considering himself a disappointment to his parents because he is unathletic, Tom is miserable as he finds the farm animals and surrounding wilderness very frightening. But as the summer progresses he becomes fascinated by a black fox and her cub, and is able to show just how much he has grown when he courageously frees the fox from a trap set by his uncle.

What makes *The Midnight Fox* different from other books with similar themes "is the simplicity and beauty of the writing and the depth of characterization," asserts Diane Farrell in *Horn Book*. Zena Sutherland, writing in *Saturday Review*, praises the

realistic aspects of *The Midnight Fox,* stating that Byars' "writing really sounds like the vocabulary and phrasing of a small boy, and the story develops with ease and pace." And Elizabeth Segel maintains in the *Dictionary of Literary Biography (DLB)* that the "bold mix of humor and sensitivity to the intense emotions of childhood" found in *The Midnight Fox* "is the keystone of Betsy Byars's originality." Byars herself considers this book to be another major turning point in her career. "It gave me the confidence I had not had before," she states in *SAAS.* "I knew now that I was going to be able to do some of the things I wanted to do, some of the things I had not had the courage and skill to try. For this reason, and others, it remains my favorite of my books."

The same year that *The Midnight Fox* was published, Byars participated in a volunteer program to help children with learning difficulties. "This was a stunning experience for me," she relates in *SAAS.* "Up until this time I had never been around kids who were having real problems in learning. I had not been aware of how much they suffered, not only because they had learning difficulties, but—more importantly—because of the way the other kids treated them." The character of Charlie in *The Summer of the Swans* was not based on the children Byars worked with, but she could not have written the book without having known them. Instead, she based Charlie on three case studies she read in the Medical Library of West Virginia University. "All the details of his life were from those three case histories. I made nothing up," Byars states in *SAAS.*

The Summer of the Swans takes place during the fourteenth summer of Sara's life; she is just beginning to experience all the awkwardness associated with being a teenager. In addition to her own problems, she has to deal with her beautiful older sister Wanda and the dependency of her mentally impaired younger brother Charlie. Having lived with her aunt since her mother's death, Sara has always watched over and felt responsible for Charlie. So, despite her newfound problems, she takes him to see the swans that have appeared on the lake near their home. Later that same night, Charlie disappears as he goes in search of the swans for himself. While looking for her brother, Sara pushes aside her own selfish concerns and concentrates on Charlie, feeling elation and relief when she finds him.

Swans Wins Newbery

"I worked hard on the book and I was proud of it," writes Byars of *The Summer of the Swans* in *SAAS.* "It was published in April of 1970 to a sort of resounding thud. It didn't sell well, it didn't get great reviews; in some papers it didn't get reviewed at all." This brought on a very discouraging period for Byars as she wondered if she would ever make it as a writer. Coming to the conclusion that she should do something else, she enrolled at West Virginia University to get her master's degree in special education. When Byars received a phone call on her way to class one day in January of 1971 she was stunned to hear that *The Summer of the Swans* had won the Newbery Medal. "The announcement of the Newbery Award literally changed my life over-

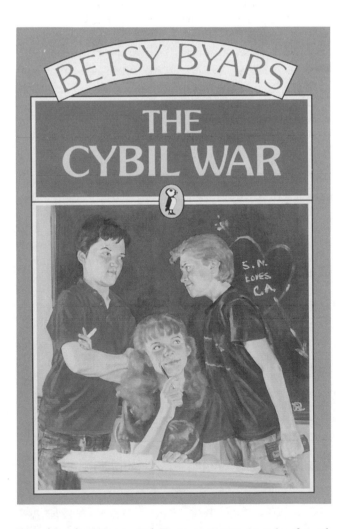

Best friends Simon and Tony compete to win the affection of schoolmate Cybil Ackerman in this realistic 1981 work.

night," she remembers in *SAAS.* "Up until this time I had had a few letters from kids. Now we had to get a bigger mailbox. I got tapes, questionnaires, invitations to speak, invitations to visit schools, requests for interviews. For the first time in my life, I started feeling like an author."

The Newbery Medal also brought much more favorable reviews of *The Summer of the Swans.* "The book has a tender quality and has enough action to balance the quiet unfolding of a situation," describe Zena Sutherland and May Hill Arbuthnot in *Children and Books.* Ethel L. Heins writes in *Horn Book* that *The Summer of the Swans* is "a subtly told story, echoing the spoken and unspoken thoughts of young people." And a *Top of the News* contributor asserts: "Throughout this realistic, tender, and sometimes humorous story there is an authentic emotional tension which characterizes the interactions between family and friends. . . . Betsy Byars, a sensitive writer with an ear and heart attuned to the subtleties of growing up, has created a story of extraordinary understanding and warmth."

Since the publication of *The Summer of the Swans* Byars has published several other realistic novels which have similar structures, situations, and characters. Using a mixture of humor and sympathy, she addresses the emotions of her troubled, loner characters through their relationships with often eccentric adults and through their own troubling experiences as they grow toward maturity. And despite the similarities in her books, Byars manages to fill them with "originality and inventiveness, lack of repetition, wit and good sense, a succinct prose style with terse, vivid perceptions and ironical observations of life," maintains David Rees in *Painted Desert, Green Shade: Essays on Contemporary Writers of Fiction for Children and Young Adults.* Segel similarly states that Byars' "well-developed comic sense is refreshing. Writing about children under stress, she uses her wit to grapple unsentimentally with subjects ordinarily considered too painful for young readers. Her energy and enjoyment of life, together with her belief in the sensitivity and resilience of ordinary children, endow her books with a fundamental hopefulness."

Among Byars' resilient characters are several young boys, including Mouse Fawley in *The 18th Emergency* and Simon Newton in *The Cybil War.* It is these characters that "ring so true," asserts I. V. Hansen in *Children's Literature in Education.*

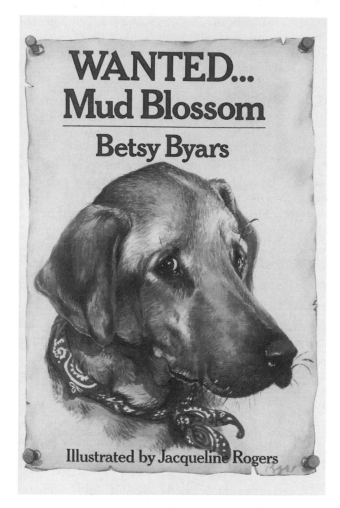

In this 1991 tale, Mud, the Blossom family's dog, becomes the prime suspect when Junior's hamster is missing.

In *The 18th Emergency* Mouse and his friend Ezzie spend their time fantasizing about life's great emergencies, such as the approach of mad elephants and being choked by a boa constrictor, and how they would deal with them. Their fantasies become reality when the eighteenth emergency, how to escape from the school bully Marv Hammerman, comes true. Inspired by a series of lessons on honor, Mouse confronts Marv in the end, and although he is beaten up, he proudly maintains his honor. *The Cybil War* centers around Simon and his friend Tony, who end up competing against each other to win the affection of fellow classmate Cybil Ackerman. Despite the fact that Simon has been in love with Cybil since the first time he saw her, Tony proceeds to tell outrageous lies to keep the two apart. Simon eventually discovers the truth, confronts Tony, and wins Cybil.

The 18th Emergency and *The Cybil War* "have much in common, passages of totally natural dialogue, shrewd observations of the world of the child, set comic pieces . . ., young heroes coping with themselves, the technique of memories 'like the time when,'" points out Hansen. Segel also acknowledges the broad humor and realistic situations in *The Cybil War*, asserting that "Cybil is an appealing enough heroine to be worth the epic battle Simon engages in, and the fourth-grade social dynamics are deftly captured." *The 18th Emergency*, continues Hansen, "is a wry, sometimes uproariously humorous story, and yet the medieval vision Mouse has slips easily into its fabric." In conclusion, Hansen states: "Yet with both titles we should be grateful to Byars for her portraits of small boys in a sometimes bewildering and unfair world; her light touch is the secret of her accessibility."

Resilient Young Heroes

A group of three children trying to make their way in an unfair world can be found in both *The Pinballs* and *The Night Swimmers*. The first group consists of three abused foster children brought together in one home after their own parents fail them in varying ways. Carlie, Thomas J, and Harvey find good and tolerable foster parents in the Masons, as well as finding new friends in each other and new hope that they can control their own destinies. The Anderson children in *The Night Swimmers* are siblings who are also without parents most of the time; their mother passed away and their father is a traveling country and western singer. Retta takes care of her younger brothers Johnny and Roy and is determined to be a good mother, so she takes them to swim after dark in the pool of a wealthy neighbor. When Johnny starts to rebel against her and make new friends, Retta develops a hatred for her brother. It is only the near drowning of Roy that finally alerts the absent father and makes him realize that he needs to be more responsible for his children. At this point Retta is able to accept her new role as a child and lose some of the resentment she feels for her brothers.

In her *Horn Book* review of *The Pinballs*, Ethel L. Heins describes: "The stark facts about three ill-matched, abused children living in a foster home could have made an almost unbearably bitter novel; but the economically told story, liberally

spiced with humor, is something of a tour de force." Lance Salway remarks in the *Times Literary Supplement* that "despite the incidental comedy in this story and the deceptive simplicity of its telling, Betsy Byars has written a serious book about a disturbing subject, investing it with the insight, sympathy and sense of comedy that have distinguished her more recent work. *The Pinballs* is a book to remember." *The Night Swimmers* utilizes similar elements of sympathy and comedy; Elaine Moss asserts in the *Times Literary Supplement* that with this book Byars "has written a short novel that makes the reader hold his breath, cry and laugh; not for one moment are the emotions disengaged." And Sutherland and Arbuthnot state: "In *The Night Swimmers* Byars again explores a situation and a turning point in a child's life with insight, again writes with tenderness and grace, again creates a memorable character."

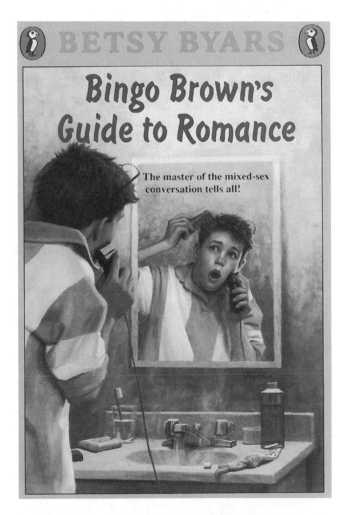

In this 1992 novel, the title character must deal with the adolescent traumas associated with young love.

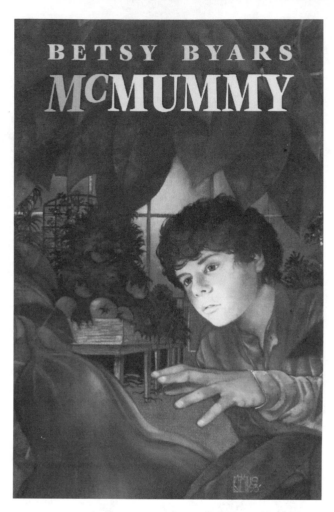

Young Mozie believes a human-sized pod creature is attempting to communicate with him in this 1993 novel.

The memorable characters in *The Night Swimmers* were originally supposed to become involved in a mystery—Byars intended for them to see something mysterious in their neighbor's house while they were swimming. Unable to come up with what the children would actually see, Byars found herself stuck, at least until she came across the diary her daughter kept when she was ten. Inside the diary, Byars discovered page after page describing how much her daughter hated her sister. This brought up memories from her own childhood in which her mother had to draw a chalk line down the middle of the bedroom she shared with her sister to keep them from killing each other. "That diary and that memory changed *The Night Swimmers* from a mystery to a book about brothers and sisters who get to the point where they hate each other," relates Byars in *SAAS*. "They made me realize that not only can

brothers and sisters hate each other, but it may be the strongest hate they will ever feel in their lives. Certainly it was the only time in my own life that someone had to draw a chalk line to keep me from murder."

Bingo Brown's World

Bingo Brown, one of Byars' more recent creations, does not have any siblings to contend with in his first appearance. *The Burning Questions of Bingo Brown,* published in 1988, introduces this somewhat ordinary sixth grader as he tackles such problems as first love, a class protest, and the strange behavior of a favorite teacher, keeping track of all the questions these situations raise in a journal. Later adventures, found in *Bingo Brown and the Language of Love, Bingo Brown, Gypsy Lover,* and *Bingo Brown's Guide to Romance,* show Bingo's growing level of maturity as he is faced with his mother's unplanned pregnancy, a long-distance relationship, buying a present for his first girlfriend, the premature birth of his baby brother, and all the other common traumas associated with adolescence.

"Bingo Brown is one of Byars's most ingenious and likable male characters," states a *Publishers Weekly* reviewer. Christine Behrmann, writing in *School Library Journal,* also finds Bingo very likable and interesting, adding that "Byars brings to immediate life Bingo's thoughts and feelings, and gently comments on them as well." Pointing out the humor that also runs through the Bingo Brown series, Fannie Flagg maintains in the *New York Times Book Review:* "If there is such a thing as a typical American kid, Bingo Brown is it. He is funny and bright and lovable without being precocious, and Betsy Byars has demonstrated a special creative genius in pulling off this delicate balancing act. . . . Although her themes may be contemporary, her charm lies in the fact that she deals with them in an old-fashioned and lighthearted way—a rare talent indeed."

Throughout the course of her writing career Byars' talents have been increasingly praised and appreciated. "Some writers are acclaimed for their literary talents, and some are popular with kids. Betsy Byars is one of that select circle who is both," asserts Ilene Cooper in *Booklist.* Past successes do not make the writing process any different for Byars, though; it is still hard work.

If you enjoy the works of Betsy Byars, you may also want to check out the following books and films:

Ellen Conford, *If This Is Love, I'll Take Spaghetti,* 1983.
Barbara Corcoran, *Annie's Monster,* 1990.
Lois Metzger, *Barry's Sister,* 1992.
Lee Wardlaw, *Seventh Grade Weirdo,* 1992.
The Outsiders, Warner Bros., 1983.

"Every time I sit down to write a book, I feel like that character in the old fairy tale who, in order to survive, has to spin straw into gold," she describes in an speech quoted in the *School Librarian.* "What I know about spinning straw is nil and I have learned from hard reality that no little man in a funny suit is going to pop out of the woodwork to strike a deal." Byars goes on to conclude: "We authors write the best we can, with what skills we have, what tricks we've learned, and then if we are lucky, very lucky, the straw actually will be turned into gold, for a fleeting moment by the miraculous mind of a child."

■ **Works Cited**

Behrmann, Christine, review of *Bingo Brown, Gypsy Lover, School Library Journal,* June, 1990, p. 117.

Review of *The Burning Questions of Bingo Brown, Publishers Weekly,* April 8, 1988, p. 95.

Byars, Betsy, essay in *Something about the Author Autobiography Series,* Volume 1, Gale, 1986, pp. 53-68.

Byars, Betsy, "Spinning Straw into Gold," *School Librarian,* March, 1986, pp. 6-13.

Cooper, Ilene, "The Booklist Interview: Betsy Byars," *Booklist,* January 15, 1993, pp. 906-07.

Donahue, Rosanne Fraine, essay on Betsy Byars in *Twentieth-Century Children's Writers,* 3rd edition, edited by Tracy Chevalier, St. James Press, 1989, pp. 166-68.

Farrell, Diane, review of *The Midnight Fox, Horn Book,* February, 1969, p. 52.

Flagg, Fannie, review of *Bingo Brown and the Language of Love, New York Times Book Review,* October 8, 1989, p. 34.

Hansen, I. V., "A Decade of Betsy Byars' Boys," *Children's Literature in Education,* Spring, 1984, pp. 3-11.

Heins, Ethel L., review of *The Summer of the Swans, Horn Book,* February, 1971, pp. 53-54.

Heins, Ethel L., review of *The Pinballs, Horn Book,* August, 1977, p. 437.

Moss, Elaine, "Dreams of a Surrogate Mother," *Times Literary Supplement,* July 18, 1980, p. 806.

Rees, David, "Little Bit of Ivory: Betsy Byars," *Painted Desert, Green Shade: Essays on Contemporary Writers of Fiction for Children and Young Adults,* Horn Book, 1984, pp. 33-46.

Robertson, Ina, "Betsy Byars—Writer for Today's Child," *Language Arts,* March, 1980, pp. 328-34.

Salway, Lance, "Against the Odds," *Times Literary Supplement,* October 21, 1977, p. 1247.

Segel, Elizabeth, essay on Betsy Byars in *Dictionary of Literary Biography,* Volume 52: *American Writers for Children since 1960: Fiction,* Gale, 1986, pp. 52-66.

Review of *The Summer of the Swans,* "Betsy Byars: Newbery 1971," *Top of the News,* April, 1971, pp. 240-41.

Sutherland, Zena, review of *The Midnight Fox, Saturday Review,* November 9, 1968, pp. 64-65.

Sutherland, Zena, and May Hill Arbuthnot, "Modern Fiction: Books for the Middle Group," *Children and Books,* 7th edition, Scott, Foresman, 1986, pp. 340-57.

■ **For More Information See**

BOOKS

Children's Literature Review, Gale, Volume 1, 1976; Volume 16, 1989.

Contemporary Literary Criticism, Volume 35, Gale, 1985.

Usrey, Malcolm, *Betsy Byars,* Twayne, 1995.

PERIODICALS

Booklist, October 1, 1985, pp. 267-69; May 1, 1990, p. 1699.

Bulletin of the Center for Children's Books, January, 1985, p. 81; March, 1986, p. 123; October, 1986, pp. 22-23; November, 1986, p. 44; April, 1987, p. 143; November, 1987, p. 44; November, 1988, pp. 66-67; June, 1989, p. 244; June, 1990, p. 234; April, 1991, pp. 185-86; March, 1992, p. 77; December, 1992, p. 107; June, 1996, p. 328.

Horn Book, September/October, 1989.

Junior Bookshelf, February, 1992, p. 26.

New York Times Book Review, December 15, 1991, p. 29.

Publishers Weekly, May 12, 1989, p. 294; October 12, 1992, p. 79; July 18, 1994, p. 246; July 17, 1995, p. 140.

School Library Journal, May, 1986, p. 88-89; December, 1986, p. 122; November, 1987, pp. 103-04; May, 1988, p. 95-96; November, 1988, p. 84; July, 1989, pp. 81-82; January, 1990, p. 56; September, 1990, p. 194; June, 1991, p. 74; July, 1991, p. 72; April, 1992, p. 112; September, 1994, p. 214.

Voice of Youth Advocates, August-October, 1986, p. 140; December, 1986, p. 213; April, 1987, p. 29; December, 1987, p. 46; August, 1991; December, 1992, p. 275.*

—Sketch by Susan Reicha

Robert Cormier

Personal

Also wrote under pseudonym John Fitch IV; born Robert Edmund Cormier, January 17, 1925, in Leominster, MA; son of Lucien Joseph (a factory worker) and Irma Margaret (Collins) Cormier; married Constance B. Senay, November 6, 1948; children: Roberta S., Peter J., Christine J., Renee E. *Education:* Attended Fitchburg State College, 1943-44. *Religion:* Roman Catholic.

Career

Freelance writer, 1966—. Radio station WTAG, Worcester, MA, writer, 1946-48; *Telegraph & Gazette,* Worcester, reporter and columnist, 1948-55, writing consultant, 1980-83; *Fitchburg Sentinel* (now *Fitchburg-Leominster Sentinel and Enterprise*), Fitchburg, MA, reporter, 1955-59, wire editor, 1959-66, columnist and associate editor, 1969-78. Member of board of trustees of Leominster (MA) Public Library, 1978—. *Member:* L'Union St. Jean Baptiste d'Amerique.

Addresses

Home—1177 Main St., Leominster, MA 01453. *Agent*—Curtis Brown Ltd., 575 Madison Ave., New York, NY 10022.

Awards, Honors

Prize for Best News Writing, Associated Press in New England, 1959, 1973; Bread Loaf Writers Conference Fellowship, 1968; Best Newspaper Column, K. R. Thomson Newspapers, Inc., 1974; *New York Times* Outstanding Book of the Year Award, 1974, for *The Chocolate War,* 1977, for *I Am the Cheese,* and 1979, for *After the First Death;* American Library Association's Best Books for Young Adults citations, 1974, for *The Chocolate War,* 1977, for *I Am the Cheese,* 1979, for *After the First Death,* 1983, for *The Bumblebee Flies Anyway,* 1988, for *Fade,* and 1996, for *In the Middle of the Night;* Maxi Award, *Media & Methods,* 1976, Lewis Carroll Shelf Award, 1979, and one of *School Library Journal's* "Best of the Best Books 1966-1978," 1979, all for *The Chocolate War;* Doctor of Letters, Fitchburg State College, 1977; Woodward Park School Annual Book Award, 1978, for *I Am the Cheese.*

Eight Plus One was selected a Notable Children's Trade Book in the Field of Social Studies, National Council for Social Studies and the Children's Book Council, 1980; ALAN (Assembly on Literature for Adolescents) Award, National Council of Teachers

of English, 1982, for significant contributions to the field of adolescent literature; Carnegie Medal nomination, 1983, for *The Bumblebee Flies Anyway;* Readers Choice Award, 1983, for short story, "President Cleveland, Where Are You?" (contained in *Eight Plus One); The Chocolate War, I Am the Cheese,* and *After the First Death* were each chosen one of American Library Association's "Best of the Best Books, 1970-1983," 1984; *New York Times Notable Books* citation, 1985, and "Honor List" citation, *Horn Book,* 1986, for *Beyond the Chocolate War;* Young Adult Service Division "Best Book for Young Adults" citation, American Library Association, 1988, for *Fade;* World Fantasy Award nomination, 1989, for *Fade;* Margaret A. Edwards Award (formerly *School Library Journal*/Young Adult Services Division Author Achievement Award), American Library Association, 1991, for *The Chocolate War, I Am the Cheese,* and *After the First Death;* American Library Association's Quick Pick for Reluctant YA Readers citation, 1996, for *In the Middle of the Night.*

■ Writings

YOUNG ADULT NOVELS

The Chocolate War, Pantheon, 1974.
I Am the Cheese, Pantheon, 1977.
After the First Death, Pantheon, 1979.
The Bumblebee Flies Anyway, Pantheon, 1983.
Beyond the Chocolate War, Knopf, 1985.
Fade, Delacorte, 1988.
Other Bells for Us to Ring, Delacorte, 1990, published in England as *Darcy,* Gollancz, 1991.
We All Fall Down, Delacorte, 1991.
Tunes for Bears to Dance To, Delacorte, 1992.
In the Middle of the Night, Delacorte, 1995.

OTHER

Now and at the Hour (adult novel) Coward, 1960.
A Little Raw on Monday Mornings (adult novel), Sheed, 1963.
Take Me to Where the Good Times Are (adult novel), Macmillan, 1965.
Eight Plus One (short stories), Pantheon, 1980.
I Have Words to Spend: Reflections of a Small-Town Editor (autobiographical essays), edited by wife, Constance Senay Cormier, Doubleday, 1991.

Contributor to anthologies, including *Celebrating Children's Books: Essays in Honor of Zena Sutherland,* edited by Betsy Hearne and Marilyn Kay, Lothrop, 1981; *Sixteen: Short Stories by Outstanding Writers for Young Adults,* Delacorte, 1984; and *Trust Your Children: Voices against Censorship in Children's Literature,* edited by Mark I. West, Neal-Schuman, 1987.

Author of book review column "The Sentinel Bookmark," *Fitchberg Sentinel,* 1964-1978, and of human interest column, "And So On," under pseudonym John Fitch IV, 1969-78; also author of monthly human interest column "1177 Main Street," for *St. Anthony Messenger,* 1972-82. Author of weekly column for *Worcester (MA) Telegram.* Contributor of articles and short stories to periodicals, including *McCalls, Redbook,* and *Woman's Day.*

■ Adaptations

I Am the Cheese, a motion picture adapted from Cormier's novel of the same name, was released in 1983 by the Almi Group, starring Robert Wagner, Hope Lange, Robert MacNaughton, and featuring Cormier in the role of Mr. Hertz; *The Chocolate War* was released as a movie of the same title by Management Company Entertainment Group in 1989, directed by Keith Gordon and starring John Glover, Ilan Mitchell-Smith, and Wally Ward. *The Chocolate War, I Am the Cheese,* and *After the First Death* were all released as records and cassettes by Random House/Miller Brody in 1982.

■ Overview

"Terrorism, suicide, child murder, betrayal, personality destruction, and governmental and religious corruption." They might seem more like topics for television movies-of-the-week than themes for young adult novels, but this is the list of subjects covered in Robert Cormier's novels that Joe Stines compiled for his *Dictionary of Literary Biography* essay on the author. Cormier's works defy young adult fiction stereotypes and offer teens hard-as-nails novels often dominated by a feeling of despair. Since *The Chocolate War,* his breakthrough first novel for young audiences, appeared in 1974, critical debate on Cormier's books often focuses on his themes and subject matter and their appropriateness for young readers. Cormier, however, remains firm in his desire to provide books for his youthful audience that will take them beyond

the happily-ever-after fairy tales of childhood and the easy solutions of television action shows. "Why should I have to create happy endings?," he asked Tony Schwartz in *Newsweek*. "My books are an antidote to the TV view of life, where even in a suspenseful show you know before the last commercial that Starsky and Hutch will get their man. That's phony realism. Life isn't like that."

With a background in both advertising and journalism, Cormier began his career as a novelist writing for adults. After publishing three novels in the 1960s, it took almost a decade before *The Chocolate War* appeared. Publication of the young adult novel was delayed by requests from four publishers to change the downbeat ending, which Cormier refused to do. Eventually, Cormier found a publisher who accepted his vision of the book; it was published as Cormier had written it and enthusiastically read by young people throughout the country. Over the next eleven years, Cormier went on to write four more critically acclaimed novels for young adults, including *I Am the Cheese*, *After the First Death*, and *Beyond the Chocolate War*. Together they form what Patricia Campbell in *Presenting Robert Cormier* calls "undoubtedly Cormier's mature masterpieces." Most of Cormier's works take place in and around the small town of Monument, much like his home town of Leominster, Massachusetts. His novels are noted for their complex structures and thought-provoking endings. While writing, Cormier keeps his young adult audience in mind, but he is not condescending. "He is unafraid to bring a story to its aesthetically inevitable conclusion," wrote Geraldine DeLuca in *The Lion and the Unicorn*, "and his lucid prose style, which is easily accessible to adolescents, seems natural rather than contrived to catch the interests of that audience."

Like many of Cormier's novels, *The Chocolate War* grew out of an incident in Cormier's life that he looked at and said, "What if?" In this case, his teenage son came home from school one day with chocolates to sell as a fund-raiser. After much discussion, the boy decided not to participate in the sale, and returned the chocolates to the school the following day. While his son's refusal brought no retaliation, the author wondered how differently things could have turned out. What Cormier came up with is the story of Jerry Renault, a freshman student at Trinity High School, who refuses to participate in the school's annual chocolate sale. Trinity is a Catholic boy's school caught in a

DELL• U.S.$4.50
CAN.$5.99

THE CHOCOLATE WAR

ROBERT CORMIER

Cormier's controversial 1974 classic tells of a boarding school student who tries to rebel against the system, loses the battle, and lets injustice prevail.

power struggle between the acting headmaster, the cruel Brother Leon, and the Vigils, a secret society of students run by the villainous Archie Costello. "They murdered him," the first line of the novel reads, introducing us to Trinity's bleak world where evil usually triumphs over good and, in fact, where goodness seems nearly non-existent.

The book shocked many reviewers who objected the most to the book's ending in which Jerry, after being brutally beaten by one of the Vigils, suggests that maybe it would have been better if he had just sold the chocolates like everyone else. Also receiving criticism were the sexual references and graphic language used by some of the characters. Those with negative reviews felt that the

ending would make already sensitive teens feel that life was indeed hopeless and that any aspirations to true individualism were bound to fail. Among the critics were Betsy Hearne, whose comments in *Booklist* were surrounded by a thick, black border usually reserved for obituaries, and British reviewer D. A. Young, who in *Junior Bookshelf* called the novel "a thoroughly nasty book about a thoroughly nasty American private school." Despite such criticism, *The Chocolate War* appeared on important lists of best books for young adults compiled that year and found vocal supporters among other reviewers, teachers, and young adults themselves. Among those writing positive reviews was Theodore Weesner, who in the *New York Times Book Review* deemed the book "masterfully structured" and "well crafted," and young adult novelist Richard Peck, who claimed in *American Libraries* that "anyone banning this book for its locker-room-realistic language is committing a crime against the young."

Other Controversial Works

Cormier's next novel, *I Am the Cheese,* also features a young male protagonist trying to rebel against the system. Like Jerry, his efforts end in defeat. Cormier wrote the novel after reading about the witness relocation program run by the U.S. government to protect those whose testimony in high-profile criminal cases puts them in danger. In the novel's first scene the reader meets fourteen-year-old Adam Farmer who is on his bike "pedaling furiously" on a trip from Monument to Rutterberg, Vermont, to take a gift to his father. In subsequent chapters it is learned that Adam's name was Paul Delmonte until he was three years old. At that time, he and his parents were given new identities by the government in order to protect them after Adam's journalist father produced damaging evidence in testimony given to a special Senate committee investigating organized crime. Alternating with first-person descriptions of Adam's bike trip are chapters containing what appear to be transcripts of Adam trying to remember his past with the help of a psychiatrist, and third-person commentary. Piecing together the narratives, the reader slowly unravels the book's mystery. The bike ride actually takes place in the the boy's mind. The interviews are taking place in an institution where Adam has been held since his parents died in a car accident apparently arranged by a government agent who was supposed

to be helping them. The novel ends with Adam again "pedaling furiously" as the book's first paragraph is also its last.

Critics, like Newgate Callendar in the *New York Times Book Review,* praised Cormier's intricate technique and slow revelation of the truth in the book. "Everything builds and builds to a fearsome climax," Callendar noted. *Horn Book*'s Paul Heins also commented on Cormier's skillful layering of psychological suspense. According to Heins, Cormier entwines the three narratives in order to "build the necessary dynamic structure to encompass the onward-pacing story full of tension, mysteries, and secrets." Some reviewers wondered if the complex structure of the novel might be beyond the comprehension of adolescent readers. During the writing of the novel Cormier had also wondered about the appropriate age for the book's audience. "*The Chocolate War* had just seen some success and, for the first time, I really had a lot of literary and financial success," he told Dieter Miller of *Authors and Artists for Young Adults.* "Then I wrote *I Am the Cheese* and said to my editor, 'I think I'm leaving the young adult field behind.' He said, 'Why not stretch their minds?' I agreed. You've got to stretch." Again, Cormier had produced a successful book by challenging teens instead of coddling them. "Beside it," commented *Times Literary Supplement* reviewer Lance Salway, "most books for the young seem as insubstantial as candyfloss."

Told in a complicated structure reminiscent of *I Am the Cheese, After the First Death* appeared two years later. It is the story of three teenagers: Miro Shantas, a sixteen-year-old terrorist; Ben Marchand, whose father is in charge of a secret government anti-terrorist agency, Inner Delta; and Kate Forester, who is doing her sick busdriver uncle a favor by driving a busload of very young children to their day camp outside of town. Miro and Artkin, his mentor, take over the bus at gunpoint and force Kate to drive to a deserted bridge where the terrorists demand $10 million in ransom, freeing of all political prisoners and the break-up of Inner Delta. They also threaten to kill a child for each one of their own group that is killed. Through chapters told from various viewpoints, including that of each of the teenagers, the reader follows the agonizing playing out of the drama: the death of one of the children after one of the terrorists dies, Ben's father's decision to send his son as a messenger into the midst of the

stand-off, and Miro's killing of Kate when she offers him comfort after Artkin is killed. The part of the narration told through Ben's eyes is highly experimental with the thoughts of the adolescent seeming to fuse with those of his father. Ben is, the reader learns, already dead, driven to suicide, having been in great mental anguish ever since the incident. Ben was tormented by the realization that his father had put patriotism over his own son's well-being.

Critics pointed out that *After the First Death* was a natural progression of the author's interest in exploring both the sources and consequences of

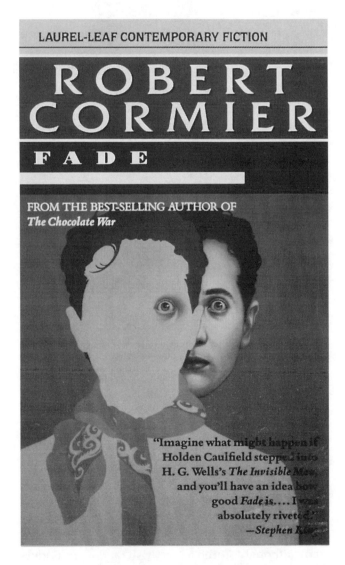

LAUREL-LEAF CONTEMPORARY FICTION

ROBERT CORMIER

FADE

FROM THE BEST-SELLING AUTHOR OF
The Chocolate War

"Imagine what might happen if Holden Caulfield stepped into H. G. Wells's *The Invisible Man*, and you'll have an idea how good *Fade* is.... I was absolutely riveted."
—Stephen King

In a break from realism, this 1988 work features a boy who can make himself invisible and thus able to discover the heinous secrets of others—and hide his own.

power. "Subtly, with all his artistry in building plot and portraying character in a brilliant style, Cormier once again gives us a sinister world," noted Rebecca Lukens in the *ALAN Review*. "This time it is not the microcosm of a school dominated by evil in *The Chocolate War*, or of a wider American world controlled by the mobs in *I Am the Cheese*, but the international macrocosm of terrorism motivated by patriotism." In *School Library Journal* Roger Sutton wrote that Cormier's first three novels for young adults "all tell compellingly of a universe where the good guys lose. But under the grim, no-win surface lies a very conventional, respectable morality: wrong may triumph over right, but the reader is certainly shown which is which." In the *New York Times Book Review*, Stanley Ellin called the book "a marvelously told story" and claimed "*After the First Death* more than sustains the reputation its author has won with *The Chocolate War* and *I Am the Cheese*; it adds luster to it."

In 1985 *Beyond the Chocolate War*, Cormier's long-awaited sequel to *The Chocolate War*, was published. In it Cormier continues his story of the Vigils and Trinity High School, revisiting many of the characters from the first book and introducing a few new ones. In an interview with Anita Silvey in *Horn Book*, Cormier admitted that he resisted the idea of writing a sequel, doing so only because he had so many requests over the years from his readers for more information about the characters in the first book. Enthusiastic reviews greeted the novel, including a *Horn Book* essay by Mary M. Burns who called it "one of Cormier's finest books to date." "The pacing is breathlessly irresistible," Campbell noted in *Presenting Robert Cormier*. "Unanswered questions and unresolved tensions layer from scene to scene as the characters collide in a rich choreography of shifting expectations, allegiances, and perceptions."

While *Beyond the Chocolate War* covered territory familiar to both Cormier and his readers, *Fade* was Cormier's first entry in the fantasy/science fiction genre. The "fade" of the title is the ability to become invisible possessed by thirteen-year-old Paul Moreaux. This peculiar trait has passed from uncle to nephew in his family for several generations. The first part of the novel is Paul's account of family life in the Frenchtown community of Monument (based on the French Hill area where Cormier grew up), including encounters with his Uncle Adelard, who also can make himself invis-

ible. The second part takes place in 1988 when Susan Roget, Paul's distant cousin, reveals that Paul became a famous writer and left the first part of the book as a manuscript with his former agent. The agent has tried to determine if the manuscript is fiction or fact and has sent a copy of it to Susan's grandfather for his advice. While the grandfather's report scoffs at the idea of a fade, the agent gives Susan another portion of the manuscript to read in which Paul confronts a formerly unknown teenage nephew who also has the fade but who is using it to commit heinous acts of violence. As the novel ends, Susan is becoming increasingly convinced of the truth of Paul's story. *Fade* was marketed for both young adults and adults, but some critics felt its subject matter made it most suitable for older young adult readers. *Horn Book* reviewer Ann A. Flowers found "the story itself gripping," noting that "despite the violence and overt sexual episodes, the book is another thought-provoking and endlessly debatable novel by an outstanding author."

■ Update

In the 1990s Cormier continues to steadily produce new fiction for young adults that are similar in many ways to his prior works—the familiar setting in small town Massachusetts, an emphasis on the dark side of life, and multi-voiced narratives. His skills as a storyteller have not diminished as reviewers continue to lavish praise on his latest works. In 1991, he received the prestigious Margaret A. Edwards Award (formerly known as the *School Library Journal*/Young Adult Services Division Author Achievement Award). Previously given to distinguished writers S. E. Hinton and Richard Peck, the award is given "to those authors whose books or book have provided young adults with a window through which they can view the world, and which will help them to grow and understand themselves and their role in society." *The Chocolate War, I Am the Cheese*, and *After the First Death* were especially acknowledged.

Cormier began the decade with *Other Bells for Us to Ring* (published as *Darcy* in England). The book aimed at less mature audiences than *Fade* had been but, according to *Horn Book* reviewer Mary M. Burns, was nonetheless a novel "that defies simplistic categorization by the age of the audience." Unlike Cormier's previous books, it is told in a straightforward manner with only one narra-

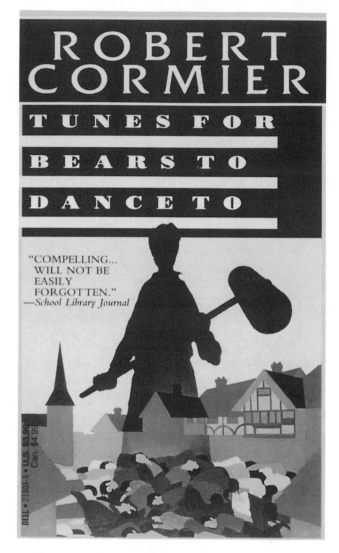

Another tale of youth being manipulated by adults, this 1992 novel repeats the unspoken message of *The Chocolate War*: Good doesn't always win.

tor. The story takes place during World War II, in the Frenchtown area to which eleven-year-old Darcy Webster has recently arrived, brought there when her father is stationed at Fort Delta after finishing basic training. Although Darcy is used to moving—the bad economic times of the Depression have forced her family to relocate often—she feels particularly isolated in Frenchtown where the inhabitants are mostly French-Canadian Roman Catholics. Darcy is neither. Things look better when she is befriended by Kathleen Mary O'Hara, who, although Catholic, is Irish and can understand Darcy's feelings of being different. Kathleen Mary takes Darcy under her wing, saying, "You and me against the Canucks, the Micks, everybody in the whole, wide world."

Kathleen Mary entertains her friend with colorful explanations of unfamiliar Catholic beliefs. As Darcy notes, "Kathleen Mary delighted in explaining the strange practices of Catholics, which gave her an opportunity to make more speeches." In a playful mood, Kathleen Mary one day sprinkles her friend with holy water from the font at the local church and declares that this baptism has made Darcy a Roman Catholic. Darcy is confused by her friend's actions and wonders if she is, indeed, now a Catholic. Soon, Darcy has other matters to worry about as Kathleen Mary and her family mysteriously disappear from Frenchtown. Later, Darcy's soldier father is reported missing in action in Europe. Not knowing where to turn in her sorrow, Darcy seeks out a nun famous for miraculous cures whom she and Kathleen Mary had watched one day when they were exploring around the convent next to Kathleen Mary's church. Darcy eventually learns both the fate of her father and her lost friend, and a Christmas miracle closes the novel.

Though some reviewers found the book's characters incompletely drawn, Burns, writing in *Horn Book*, called *Other Bells for Us to Ring* "one of those rare and brilliant gems for all seasons and for all those who would be possessed by its honest poignancy and superb craftsmanship." Both a *Junior Bookshelf* reviewer and Maurice Saxby in *Magpies* praised Cormier's characterization of Darcy. "Delight is not a word I would have expected to use of a book by Robert Cormier," noted the *Junior Bookshelf* reviewer, "but [*Other Bells for Us to Ring*] is delightful, moving and wise. Not many men writers have penetrated so surely to the heart of a small girl." Even reviewers who criticized aspects of the novel found something to praise: both Janice Del Negro in *School Library Journal* and a *Publishers Weekly* contributor wrote admirably of Cormier's ability to recapture the World War II-era setting of his novel. "Cormier captures the sounds, smells, and mood of wartime America with deft strokes," the *Publishers Weekly* critic claimed; while Del Negro observed, "Cormier effectively evokes the streets and tenements of Darcy's World War II Frenchtown."

A Violent Love Story

Cormier's next novel, *We All Fall Down*, marked a return to the intensity of his earlier books. Like *The Chocolate War*, violence pervades the novel

from the start. The book's first few lines read: "They entered the house at 9:02 p.m. on the evening of April Fools' Day. In the next forty-nine minutes, they shit on the floors and pissed on the walls and trashed their way through the seven-room Cape Cod cottage." Before the second page ends, four teenage vandals have smashed televisions, emptied dressers, and taken a hammer to a piano. They have also left Karen Jerome, the fourteen-year old daughter of the family who lives in the home and who unexpectedly interrupts their crime spree, at the bottom of the cellar stairs near death. The action is abruptly stopped and the reader sees the scene again, this time told from the vantage point of a mysterious character named the Avenger who has been watching the house from the bushes. In subsequent pages the reader meets Karen's older sister, Jane, trying to cope with the aftermath of the mayhem, and then re-lives the trashing, this time through the eyes of Buddy Walker, one of the young intruders. Although Buddy is appalled by what Harry Flowers, the leader of the gang, and his other friends have done, especially when it comes to hurting the girl, he goes along with them to fit in. During the rampage he is also quite drunk, as he frequently turns to alcohol to help him through the emotional turmoil caused by the breakup of his parents' marriage. The story continues, told by various narrators, each one filling in details unknown to the others. Jane, who knows nothing of Buddy's involvement with the vandalism, meets him and falls in love. Buddy tries to keep his alcoholism and his knowledge of the trashing secret from Jane, but she learns of both. In the end, after surviving a kidnapping by the psychotic Avenger, Jane completely rejects Buddy.

Cormier commented on the novel, *We All Fall Down*, in a pre-publication interview with Roger Sutton in *School Library Journal*. Cormier said the book would be different from his other works in that the action would be set outside his usual setting of Monument and that it contained his "first love story." He also dicussed why he chose to include graphic violence in the novel. "When violence happens to adults, its bad," Cormier told Sutton, "but when it happens to young people they're even more vulnerable, and I find it more intriguing to write about from that point of view. I'm hoping it's a successful psychological suspense story, a thriller." Critics seemed to find much to praise in the novel. Nancy Vasilakis, reviewing *We All Fall Down* in *Horn Book*, called it "a gripping

page-turner." She added, "The black hole down which the novelist draws the reader is both repellent and enthralling." In *Voice of Youth Advocates*, Joyce Hamilton also referred to Cormier's success at building suspense in the novel. "A sense of foreboding prevails throughout the book," she observed, "building to a chilling and suspenseful scene when the Avenger finally undertakes his plan of revenge." Similarly a *Junior Bookshelf* reviewer commented, "The vivid portrayal of the sleazy side of human nature allied with the convolutions of the tightly drawn plot makes riveting reading and the interest is held throughout." While admitting that the book is violent and might possibly be controversial, *School Library Journal* contributor Michael Cart argued that teenage readers "will recognize and embrace the authenticity of the achingly awful adolescent world that Cormier has created."

In Cormier's next novel, *Tunes for Bears to Dance To,* he once again looked to the past for the setting, as he had in *Fade* and *Other Bells for Us to Ring. Tunes for Bears to Dance To* takes place in the early 1950s and tells the story of eleven-year-old Henry Cassavant who lives with his parents in Wickburg, a city twenty miles away from Monument. Henry was originally from the Frenchtown area of Monument, but his parents decided to move after their young son, Eddie, died from injuries suffered in a car accident. When Henry and his mother visit Eddie's grave every Sunday, Henry feels like "Eddie's death had obliterated all the good times they had known in Frenchtown." Unable to forget the tragedy, Henry's father becomes severely depressed; his mother works long hours as a waitress just to make ends meet. Henry works after school and on Saturday mornings at Hairston's Corner Market to help pay the family's bills. Hairston is an evil, bigoted man whose "favorite pastime was standing at the window near the big brass cash register, watching people passing by on the street, and making comments about them." Henry also discovers that Hairston beats his young daughter.

When Henry is not in school or working, he wanders through the neighborhood, "homesick for the people and streets of Frenchtown." He meets Jacob Levine, a survivor of a Nazi concentration camp, whose village was destroyed during World War II. The boy follows Levine to the municipal arts-and-crafts center where he watches the elderly gentleman meticulously carve a miniature replica

of his hometown, complete with cottages and life-like people. In rapid succession Henry learns that his father is going to be away for a while getting therapy for depression at a nearby hospital, that Hairston plans to fire him at the end of the week, and that the miniature village has been awarded first prize in a city-wide contest and will soon be put on display at the City Hall in a glass case. Unexpectedly, Hairston promises to let Henry keep his job, influences Henry's mother's employer to give her a raise, and arranges to have a special headstone put on the unmarked grave of Henry's brother—if he will destroy Levine's magnificent village. Although Henry says he doesn't want to carry out Hairston's demands, he goes to the arts center, raises a mallet, and is suddenly surprised by a rat scurrying by. As the mallet falls forward, it smashes the village and, terrified at what has happened, Henry runs away from the scene. As

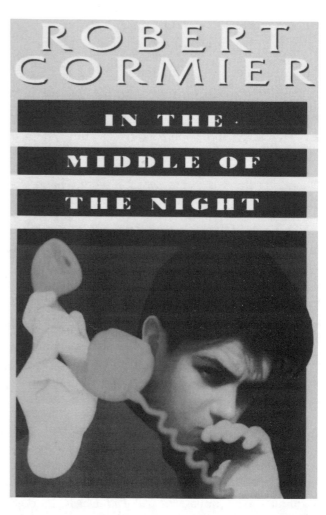

A boy, tormented by his father's past, rebels and suffers the chilling consequences in this 1995 work.

the novel ends, Henry and his family are moving back to Monument and Levine is repairing the damage. Before leaving, Henry tells Hairston's daughter to "stand up to" her father.

Reviewers noted that *Tunes for Bears to Dance To* covers familiar thematic ground for Cormier. A *Junior Bookshelf* critic described the novel as "a powerful distillation of his favourite theme—the corruption of the innocent." The same theme appears in a scene from *The Chocolate War*, in which Brother Leon badgers a student until someone in the classroom tells him to stop. Brother Leon then says those who didn't protest the mental abuse of the student in front of his peers had "turned this classroom into Nazi Germany." In *Tunes for Bears to Dance* Cormier ends the scene in which Henry destroys Levine's handiwork with the boy's thoughts, "*I didn't want to do it.*" However, the very next line reveals the sad truth: "But, he had done it after all." Referring to the grocer, Hazel Rochman noted in her *Booklist* critique of the novel, "Since Archie in *The Chocolate War* . . ., Cormier has been interested in satanic figures of pure, calculating evil." Some reviewers felt that Cormier's handling of the plot and his characters was hampered by his desire to make a particular point. Lucinda Snyder Whitehurst, for example, writing in *School Library Journal*, found that the characters in the book "simply embody the concepts Cormier is exploring." Similarly, Rochman maintained that "the conflict here is set up for the message." Cormier's method of building suspense, however, redeemed the novel for Rochman, who conceded, "Cormier's a compelling storyteller, and the pace [of the action] is inexorable."

The Third Decade Begins

Cormier's tenth novel for young adults, *In the Middle of the Night*, was published in 1995, coinciding with the beginning of his third decade as a young adult novelist. *In the Middle of the Night* is the story of sixteen-year-old Denny Colbert who is the same age his father was when a terrible tragedy changed his life. John Paul Colbert was assistant manager and head usher at the Globe Theater in Wickburg, Massachusetts, the night the balcony collapsed and twenty-two underprivileged children perished in the midst of a Halloween magic show. For the novel, Cormier uses multivoiced narration. The reader hears the story of the tragedy is told first in the prologue through the

If you enjoy the works of Robert Cormier, you might also want to check out the following books and films:

The works of Grahame Greene (Cormier's favorite author), including *The Power and the Glory*, 1940, and *The Comedians*, 1966.
Charlotte Herman, *A Summer on Thirteenth Street*, 1991.
Kathryn Lasky, *Prank*, 1984.
Alice McDermott, *That Night*, 1987.
Lord of the Flies, Continental, 1963.
Three Days of the Condor, Paramount, 1975.

eyes of the brother of Lulu, one of the survivors of the incident. Later, John Paul recalls, as an adult, what his younger self saw on that fateful day. Later, Denny's mother shares her memories of the accident with her son. Although John Paul was exonerated of any wrong doing, he and his family have been subjected to threatening phone calls and letters throughout the twenty-five years since the incident. Now, as the twenty-fifth anniversary of the tragedy approachs, Denny decides he can no longer stand his father's decision to make no comment on the events of that day. Breaking a long standing rule in his household not to answer the telephone, Denny decides to pick up the receiver. "Emergency or not, he had to stop the ringing. More than that: he wanted to start a war, do something." What he hears is the seductive voice of one of the survivors. He feels strangely drawn to her. The caller's name is Lulu, and Denny makes plans near the end of the novel to meet her, not realizing that her only motive is revenge.

Calling the book "one of the eeriest of Cormier's thrillers," a *Publishers Weekly* reviewer greeted the novel as another powerful addition to the Cormier canon. Critics particularly noted familiar touches that made the novel an outstanding example of Cormier's work. "This account of vengeance and obsession," the *Publishers Weekly* reviewer commented, "provides the brand of suspense that has earned him so many fans." In *School Library Journal* Joel Shoemaker found the novel to be "parallel in plot and theme to Cormier's previous YA titles," while, according to Patty Campbell in *Horn Book*, "Cormier aficionados will find *In the Middle of the Night* very Cormieresque not only in style and content but in many characteristic details and

references to his life and other works." Campbell pointed out three areas in which the book is reminiscent of Cormier's first novel for young adults, *The Chocolate War.* She notes that in both novels a teenage boy meets a beautiful girl at a bus stop, the theme of the individual against collective evil is explored, and the language is "clipped and spare." As with *The Chocolate War,* Cormier had managed to put together all the various elements of the novel together to form a story not quickly forgotten by his readers. "The taut plot, authentic characters, and psychological exploration," according to Maeve Visser Knoth in *Horn Book,* "all work together in Cormier's suspenseful and ultimately poignant novel." Campbell concluded that whatever the title "a new book by Robert Cormier is an exciting event." She continued: "For readers, there is the pure joy of abandonment to a gripping story, and for critics, the even purer pleasure of peeling the plot down to its gleaming bones of structure and plucking out the metaphors and hidden resonances."

■ Works Cited

Burns, Mary M., review of *Beyond the Chocolate War, Horn Book,* July-August, 1985, pp. 451-53.

Burns, Mary M., review of *Other Bells for Us to Ring, Horn Book,* November-December, 1990, pp. 742-43.

Callendar, Newgate, "Boy on the Couch," *New York Times Book Review,* May 1, 1977, p. 26.

Campbell, Patricia J., *Presenting Robert Cormier,* updated edition, Twayne, 1989.

Campbell, Patty, "The Sand in the Oyster," *Horn Book,* May/June, 1995, pp. 365-69.

Cart, Michael, review of *We All Fall Down, School Library Journal,* September, 1991, p. 277-78.

Cormier, Robert, *The Chocolate War,* Pantheon, 1974.

Cormier, Robert, *Other Bells for Us to Ring,* Delacorte, 1990.

Cormier, Robert, *We All Fall Down,* Delacorte, 1991.

Cormier, Robert, *Tunes for Bears to Dance To,* Delacorte, 1992.

Cormier, Robert, *In The Middle of the Night,* Delacorte, 1995.

Review of *Darcy, Junior Bookshelf,* August, 1991, pp. 172-73.

Del Negro, Janice M., review of *Other Bells for Us to Ring, School Library Journal,* November, 1990, p. 137.

DeLuca, Geraldine, "Taking True Risks: Controversial Issues in New Young Adult Novels," *The Lion and the Unicorn,* winter, 1979-80, pp. 125-48.

Ellin, Stanley, "You Can and Can't Go Home Again: 'After the First Death'," *New York Times Book Review,* April 29, 1979, pp. 30-31.

Flowers, Ann A., review of *Fade, Horn Book,* January/February, 1989, p. 77.

Hamilton, Joyce, review of *We All Fall Down, Voice of Youth Advocates,* December, 1991, p. 308.

Hearne, Betsy, "Whammo, You Lose," *Booklist,* July 1, 1974, p. 1199.

Heins, Paul, review of *I Am the Cheese, Horn Book,* August, 1977, pp. 427-28.

Review of *In the Middle of the Night, Publishers Weekly,* May 8, 1995, p. 297.

Knoth, Maeve Visser, review of *In the Middle of the Night, Horn Book,* May/June, 1995, p. 335.

Lukens, Rebecca, "From Salinger to Cormier: Disillusionment to Despair in Thirty Years," *ALAN Review,* fall, 1981, pp. 38-40.

Miller, Dieter, interview with Robert Cormier, in "Robert Cormier," *Authors and Artists for Young Adults,* Volume 3, Gale, 1990, pp. 65-76.

Review of *Other Bells for Us to Ring, Publishers Weekly,* November 16, 1990, p. 57.

Peck, Richard, "Delivering the Goods," *American Libraries,* October, 1974, p. 492-94.

Rochman, Hazel, review of *Tunes for Bears to Dance To, Booklist,* June 15, 1992, p. 1825.

Salway, Lance, "Death and Destruction," *Times Literary Supplement,* December 2, 1977, p. 1415.

Saxby, Maurice, review of *Davey, Magpies,* November, 1991, p. 33.

Schwartz, Tony, "Teen-Agers' Laureate," *Newsweek,* July 16, 1979, pp. 87-88.

Shoemaker, Joel, review of *In the Middle of the Night, School Library Journal,* May, 1995, p. 118.

Silvey, Anita, "An Interview with Robert Cormier," Part 1, *Horn Book,* March/April, 1985, pp. 145-55.

Stines, Joe, "Robert Cormier," *Dictionary of Literary Biography,* Volume 52: *American Writers for Children since 1960: Fiction,* Gale, 1986, pp. 107-14.

Sutton, Roger, "A Conversation with Robert Cormier; 'A Kind of Funny Dichotomy,'" *School Library Journal,* June, 1991, pp. 28-33.

Review of *Tunes for Bears to Dance To, Junior Bookshelf,* August, 1993, p. 161.

Vasilakis, Nancy, review of *We All Fall Down, Horn Book,* November/December, 1991, p. 742-43.

Review of *We All Fall Down, Junior Bookshelf,* October, 1992, pp. 214-15.

Weesner, Theodore, review of *The Chocolate War, New York Times Book Review,* May 5, 1974, p. 15.

Whitehurst, Lucinda Snyder, review of *Tunes for Bears to Dance To, School Library Journal*, September, 1992, pp. 274, 277.

Young, D. A., review of *The Chocolate War, Junior Bookshelf*, June, 1975, pp. 194-95.

■ For More Information See

BOOKS

Children's Literature Review, Volume 12, Gale, 1987.

Contemporary Literary Criticism, Gale, Volume 12, 1980, Volume 30, 1985.

Contemporary Authors, New Revision Series, Volume 23, Gale, 1988.

Twentieth-Century Children's Writers, 4th edition, St. James Press, 1994.

PERIODICALS

Bulletin of the Center for Children's Books, October, 1991, p. 35; September, 1992, p. 8.

Horn Book, March/April, 1988, pp. 166-73.

New York Times Book Review, May 5, 1985, p. 37; July 16, 1995, p. 27.

Publishers Weekly, October 7, 1983, pp. 98-99; July 29, 1988, p. 134; September 30, 1988, p. 69; September 7, 1992, p. 97.

School Library Journal, October, 1988, p. 160.*

—Sketch by Marian C. Gonsior

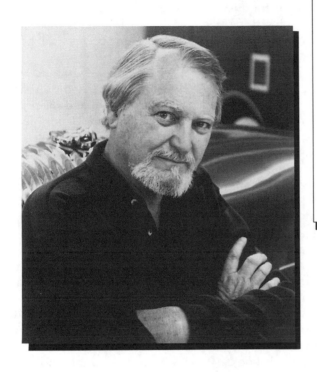

Clive Cussler

■ Personal

Born July 15, 1931 in Aurora, IL; son of Eric E. and Amy (Hunnewell) Cussler; married Barbara Knight, August 28, 1955; children: Teri, Dirk, Dana. *Education:* Attended Pasadena City College, 1949-50, and Orange Coast College, California. *Politics:* Non-partisan. *Religion:* None. *Hobbies and other interests:* Collecting automobiles, searching for historic shipwrecks.

■ Addresses

Home—Telluride, CO, and Paradise Valley, AZ. *Agent*—Peter Lampack, The Lampack Agency, 551 Fifth Ave., New York, NY 10017.

■ Career

Writer. Bestgen & Cussler Advertising, Newport Beach, CA, owner, 1961-65; Darcy Advertising, Hollywood, CA, creative director, 1965-68; Mefford Advertising, Denver, CO, vice president and creative director, 1970-75; Aquatic Marine Dive Equip-

ment, Newport Beach, member of sales staff. *Military service:* U.S. Air Force, 1950-54; served as aircraft mechanic, became sergeant. *Member:* National Underwater & Marine Agency (Washington, DC; founder and chairman), Classic Car Club of America, Royal Geographic Society (London; fellow), Explorers Club of New York (fellow).

■ Awards, Honors

Ford Foundation Consumer Award, 1965-66, for best promotional campaign; first prize, Chicago Film Festival, 1966, for best thirty-second live action commercial; International Broadcasting Awards, 1964, 1965, 1966, 1972, 1973, for year's best radio and TV commercials; first place award, Venice Film Festival, 1972, for sixty-second live commercial; Clio Awards, 1972, 1973, 1974, for TV and radio commercials; Lowell Thomas Award, Explorers Club of New York, for underwater exploration; numerous honors for work in shipwreck discoveries and marine archaeology.

■ Writings

The Mediterranean Caper, Pyramid Publications, 1973.
Iceberg, Dodd, 1975.
Raise the Titanic, Viking, 1976.
Vixen 03, Viking, 1978.
Night Probe, Bantam, 1981.

Pacific Vortex!, Bantam, 1983.
Deep Six, Simon & Schuster, 1984.
Cyclops, Simon & Schuster, 1986.
Treasure, Simon & Schuster, 1988.
Dragon, Simon & Schuster, 1990.
Sahara, Simon & Schuster, 1992.
Inca Gold, Simon & Schuster, 1994.
Shock Wave, Simon & Schuster, 1996.
(With Craig Dirgo) *The Sea Hunters* (nonfiction), Simon & Schuster, 1996.

■ Adaptations

The film *Raise the Titanic,* an adaptation of Cussler's novel of the same title, was released by AFD in 1980; all of Cussler's books are available on audiotape.

■ Sidelights

"I look upon myself more as an entertainer than merely a writer," Clive Cussler told Connie Lauerman of the *Chicago Tribune.* "It's my job to entertain the reader in such a manner that he or she feels that they received their money's worth when they reach *the end* of the book." Cussler began his career in advertising, where he collected numerous awards for his copywrting. In 1969, he embarked on a series of underwater adventure novels. Their huge success, predicated on his willingness to take risks at every level, has allowed him to write full-time ever since. Cussler and his alter-ego hero, Dirk Pitt, have a devoted following—the author has sold over seventy million copies in thirty-five languages and 105 countries.

An only child, Cussler was born in Illinois and raised in Alhambra, California. His father was a German-born accountant, his mother a homemaker. "I detested school," Cussler told Walt Jayroe in *Publishers Weekly,* "I was always the kid who was staring out the window. While the teacher was lecturing on algebra, I was on the deck of a pirate ship or in an airplane shooting down the Red Baron." Though he was disenchanted with formal learning, Cussler was reading six or more books a week. He was admitted to Pasadena City College, then dropped out to enlist in the Air Force in 1950. Flying supply missions in the Pacific, Cussler missed out on the combat he was eager to see, but over his four years of active duty he learned to scuba dive, an ongoing interest he later expanded to shipwreck exploration. In 1954, he and a friend went in on a gas station in East Los Angeles. Devising successful promotional campaigns for his new business, Cussler decided to try advertising. He enjoyed great success; his campaigns and spots garnered many prizes and honors.

In the meantime, Cussler had married Barbara Knight, an art student. While she worked evenings for the Costa Mesa, California, police department, he started writing fiction. He credits his advertising background with giving him a marketing slant and with encouraging him to do plenty of research. Before launching his own project, he read widely, everything from the sleuthing chronicles of Edgar Allen Poe's Monsieur Dupin to Ian Fleming's James Bond. When he wrote his first manuscripts reviving the suspense-adventure format, Cussler got little more than discouragement. Publishing professionals told him no one would buy an ongoing series with a single hero and that his adventure story style was passé. Cussler admits that he wasn't convinced that his first manuscript—eventually revised and published as his sixth book, *Pacific Vortex*—was publishable. In fact, it got rejected several times before he decided to try a second novel, determined to see this one published. He canvassed friends for a list of literary agents and gathered a list of about twenty.

The Winthrop Connection

Cussler solved his rejection problem by creating a fictional character: his new agent, Charles Winthrop. Using his father's address in Laguna Hills, California, Cussler printed up letterhead in the name of the Winthrop Agency and sent a letter to the first name on his list, Peter Lampack. Lampack had just started working for the William Morris Agency at the time, and on "Charlie Winthrop's" recommendation, he requested Cussler's two manuscripts.

Ten days later Winthrop/Cussler was startled to get another letter: Lampack wanted to sign Clive Cussler. It took Lampack another four years—until 1973—to get Cussler's *Mediterranean Caper* into print; the William Morris Agency wanted to let Cussler go but Lampack persisted, convinced that he had real potential. Cussler said that it was only six years (and two books later) that he finally had the pluck to tell Lampack about his

ruse. "When I finished, he looked kind of blank, then he laughed himself under the table. When he recovered, he said, 'I always thought Charlie Winthrop was someone I met at a cocktail party,'" as Cussler told Jayroe. He has remained with Lampack, who now heads his own agency.

With *Iceberg*, his second book, Cussler introduced the complex plots that have become his trademark. Air Force Major Dirk Pitt and oceanographer Dr. Bill Hunnewell spot a strange vessel encased in an iceberg, apparently on hold for use by a group of entrepreneurs ready to take over the world. In this novel, Cussler firmly established Pitt as an audacious and witty character, whose lady-killer looks and derring-do allow him to trump every villain and consistently save the day. Even Cussler describes Pitt as "corny." "He still helps old ladies across the street. He always wins," the author said to *People*'s Pam Lambert. *Armchair Detective* reviewer Ronald C. Miller made the following assessment: "Dirk Pitt has the archeological background of Indiana Jones and the boldness of James Bond. He is as skilled and comfortable underwater as Jacques Cousteau, and, like Chuck Yeager, he can fly anything with wings." Like Cussler, Pitt collects antique cars and looks for shipwrecks—and works for the National Underwater and Marine Agency, though in Cussler's case the fictional version preceded the real NUMA, which is a private, non-profit organization unlike the government agency Pitt works for.

It was Cussler's third effort, *Raise the Titanic*, that really took off—its publication in 1976 preceded by about a decade the discovery of the wreckage of the ill-fated ocean liner, which sank off the coast of Newfoundland on April 15, 1912, after hitting an iceberg. The United States government learns that a rare element, "byzanium," was stowed in the hold of the *Titanic*. In order to use this for a state-of-the-art missile-defense system, Dirk Pitt embarks on an effort to raise the ship, hampered not only by Russians eager to get their hands on it too, but by an unforeseen hurricane as well. A contributor in *Publishers Weekly* hailed the book as "a great adventure thriller," though a Newgate Callendar in the *New York Times Book Review* groused that "seldom has a book with such an exciting idea been so poorly written. Cussler is the cliché expert nonpareil." But the book sold more than 150,000 copies and remained on the *New York Times* bestseller list for twenty-six weeks. Cussler began getting fan letters from readers as

young as nine and decided to eliminate overt references to sex and to avoid four-letter words—cigarettes are out as well, though Pitt still drinks alcohol. *Raise the Titanic* was filmed in 1980 with Alec Guinness and Jason Robards. Its lack of success has made Cussler reluctant to get involved with Hollywood again. "I don't care if they cut the book, that doesn't bother me," he told Jayroe. "But I mean the direction was bad, the screenwriting was dreadful, and they didn't put all the money into it they said they did. So I took all [my] books off the Hollywood market."

In *Night Probe*, Cussler imagined what might happen if the United States had to annex Canada in order to avoid an energy and financial crisis. *Quill and Quire*'s John North pronounced Cussler a "master magician," and found that he had once again "proved himself an enthralling storyteller who is master of both sustained action and the misleading clue." In *Deep Six*, published in 1984, the author returned to maritime adventure. *Armchair Detective*'s Andy East praised Cussler for balancing "high-tech sea fare, the mysteries of the deep, superbly drawn characters and a credibly haunting plot set against a future aquatic background," and stated that he created a thriller that covers "every possible perimeter in the marine mystery to the extent that the genre is exclusively his own." The complex plot has much of the Washington power structure (including the President) kidnapped by terrorists, deadly chemicals in sunken ships, and an evil consortium of Russian and Asian interests behind it all. Reviewing the work in the Toronto *Globe and Mail*, Douglas Hill was underwhelmed by the writing and the "improbable plot," but noted that "it's a good few hours of entertaining silliness." In the *Los Angeles Times Book Review*, Chris Wall chided Cussler for "clumsy" writing, but said that he "manages to keep the pages turning despite a plot so ludicrous it makes 'The Man From U.N.C.L.E.' look like classified files from the CIA."

Bestselling Master of the Underwater Thriller

Hidden treasure plays a part in Cussler's two following books, *Cyclops* and *Treasure*, both of which, like their predecessors, became best-sellers. In the former, the Cold War is in full swing as Pitt battles Communist forces anxious to get their hands on a missing ship, the *Cyclops*, and the statue it carries from the lost city of El Dorado.

Like his alter ego Dirk Pitt, Cussler—posing with one his seventy-five vintage autos—is a passionate classic automobile collector.

In the *New York Times Book Review,* Richard Nalley said that this "flat-out action book" provided the "expected pleasures" for fans of Cussler's other novels. Alan Ryan, writing in the *Washington Post Book World,* cited Cussler's "frenzied juggling act with plotlines" and concluded that "Dirk never disappoints."

In *Treasure,* Pitt is ostensibly probing for a Soviet submarine but stumbles upon a Greek sailing ship that contains the library and art collection of Alexandria. Peter L. Robertson in the Chicago *Tribune Books* applauded Cussler's "vibrant, rollicking narrative style that seldom shows signs of relenting." A reviewer in *Publishers Weekly* wondered if the author was "so intent on packing his tale with action that he forgot about credibility altogether," but Don G. Campbell, writing in the *Los Angeles Times Book Review,* found that "believability survives with fewer dents in its tough hide than you would suspect in this slam-bang rouser."

Dragon, which Cussler published in 1990, details a conspiracy designed to compel the West to accept Japanese world sovereignty. Pitt strives to keep himself alive—and the United States free—in a series of all-but-impossible adventures. Sybil Steinberg, writing in *Publishers Weekly,* described *Dragon* as a "page-turning romp that achieves a level of fast-paced action . . . that other practitioners of modern pulp fiction might well envy." In the *New York Times Book Review,* Newgate Callendar chided it for its "idiotic James Bond stuff and comic-book prose," but the book appeared on the best seller list the first week it was released.

Some of Cussler's novels seem like throwbacks to the thrillers of earlier decades. This is true of *Sahara,* which hinges on a deadly epidemic that sweeps through the Sahara Desert. Pitt's mission is to find its source below the surface of the Niger River. As a *Washington Post Book World* reviewer noted, "Delete the high-tech weaponry and the toxic waste that creates all the trouble and *Sahara* could as easily be written in the '30s as in the '90s." The reviewer concluded that "Dirk Pitt fans will find *Sahara* refreshing escapist entertainment." Steinberg remarked that Cussler "champions ecological issues with verve" and added that although "judicious cutting" might have helped the narrative, it was "great fun." In the *Chicago Tribune,* Richard Martins, noting Cussler's decision to include a stranded Civil War ironclad in the Sa-

hara desert, a deadly "red tide" that could engulf the Earth, and a daring rescue of a UN team stuck in a Malian mine, declared that "there's little more a writer could put into a sizzling yet thoughtful thriller."

In *Inca Gold,* Cussler sent Pitt on a rescue mission into a Cambrian Era sinkhole and well in the Andes, where his hero finds an ancient city full of stolen national treasures. Ultimately, everyone wants to get their hands on the booty, including the FBI, the U.S. Customs Service, an American family of smugglers, and an Indian tribe. Recounting the plot complications, *Chicago Tribune* reviewer David E. Jones lauded the author for avoiding depicting Pitt as a mere cartoon protagonist. Instead, Jones explained that Cussler shows Pitt to be a "caring, cared-about, flesh-and-blood human being . . . He makes mistakes and errors in judgment. It's just that he also thinks faster on his feet than most and has an uncanny ability to turn negative situations into positive ones." Less enchanted, Callendar, writing in the *New York Times Book Review,* noted the "germ of a plot" but took Cussler to task for "reviving the cliché and battering the reader with them." A critic in *Publishers Weekly* found the story "believable and gripping," adding that it was "pure escapist adventure, with a wry touch of humor . . . and the entertainment value meets the gold standard."

Shock Wave's plot returns to the threat of world destruction that loomed over *Sahara.* This time, people and animals succumb to fatal high-frequency sound waves on various ocean shores, victims of deadly diamond mining techniques of an Australian entrepreneur. In spite of reservations about Cussler's "not just wooden but petrified" prose, a *Publishers Weekly* reviewer declared that *Shock Wave* "should satisfy most action fans just fine."

His Aim: Satisfying Readers, Not Reviewers

Cussler remains unfazed by criticisms of his writing, telling Lambert that "there's no literary merit in my books." Early on, he worried about negative reviews and told his agent, Peter Lampack. The writer recalls that Lampack assured him, "Listen, when we start getting good literary reviews, we're in big trouble." Cussler aims to keep readers' attention with his story lines. As Cussler said in a *Contemporary Authors* interview, "Because I

If you enjoy the works of Clive Cussler, you might also want to check out the following books and films:

The James Bond novels of Ian Fleming, including *From Russia, With Love* (1957), *Goldfinger* (1959), and *The Man With the Golden Gun* (1965).
Ken Follett, *The Eye of the Needle*, 1979.
Robert Ludlum, *The Bourne Identity*, 1984.
Crimson Tide, Buena Vista, 1995.
The Hunt for Red October, Paramount, 1990.

was locked in for 18 years writing short, snappy ad copy, I could never sit down and write a Fitzgerald-Hemingway-Bellow-type Great American Novel. But it did prepare me to write easy, understandable prose, and also to look at writing and publishing from a marketing angle."

Cussler turns out a book about every two years. *Inca Gold*, for example, was written over a period of fourteen months, with about half the time given over to study. He works routinely from 9 A.M. to 6 P.M., seven days a week. The author admits that it's not the writing but the research that he enjoys most. As he told Jayroe, "Some days I write two pages, some days I write six. I'm not prolific at all. Hopefully, it adds up finally to a book, and I can type 'The End.' And then it's like being paroled from prison." His strategy is "the old cut-and-dried, time-tested what if?" as he told *Contemporary Authors*. He poses a series of questions to himself—for example, what if the United States and Canada became one country, as in *Night Probe?* Cussler usually has one main plot and juggles as many as four subplots. "The big trick," he said to *Contemporary Authors*, "is threading the needle at the end. I've been lucky in pulling this off."

When he's not writing, Cussler has funded and led more than thirty expeditions in search of lost ships and aircraft. With his NUMA scientists and engineers, he has discovered and surveyed some seventy historically significant shipwrecks all over the world. Among his findings are the Confederate submarine *Hunley*, the German submarine *U-20* which sank the *Lusitania*, the Confederate raider *Florida*, the Navy dirigible *Akron* which crashed at sea during a storm in 1933, and the troop transport *Leopoldville*, torpedoed on December 24, 1944,

off the coast of Cherbourg, France, killing over 800 American soldiers. All the recovered artifacts from the archeological sites are donated by NUMA to museums and universities. In 1996, Cussler and Craig Dirgo, another NUMA member, published *The Sea Hunters*, which details several of these operations.

Cussler has also amassed a huge collection of more than eighty classic and vintage cars. Among his trove are European classics, American town cars, and fifties convertibles, all lovingly restored by Cussler and his crew. Cussler courted his wife Barbara in a midnight-blue 1954 modified Jaguar XK120. Pitt's cars (part of the Cussler collection) are now featured on the back of his books in response to readers' requests.

Cussler takes pride in his readership, which is slightly more female than male. There's also a large following of younger people. As Cussler told *Contemporary Authors*, "I've a stack of letters that make me feel good from mothers who've always tried to get their kids to read. Finally the kids would try Dirk Pitt and get hooked on reading." He admitted to Lambert that "it's getting harder all the time to dream up this stuff. There's only so much in you." But he can't just stop. "Now the readers have gotten into Pitt. When you're hooked on a series, I suppose these people become like friends."

■ Works Cited

Callendar, Newgate, review of *Raise the Titanic!*, *New York Times Book Review*, December 19, 1976, p. 24.
Callendar, Newgate, review of *Dragon*, *New York Times Book Review*, June 17, 1990, p. 19.
Callendar, Newgate, review of *Inca Gold*, *New York Times Book Review*, May 22, 1994, p. 39.
Campbell, Don G., "Sexy, Slick, Searing and Shocking," *Los Angeles Times Book Review*, March 20, 1988, p. 12.
Cussler, Clive, interview with Connie Lauerman, *Chicago Tribune*, August 13, 1984.
Cussler, Clive, interview with Jean W. Ross, *Contemporary Authors, New Revision Series*, Volume 21, Gale, 1987, pp. 101-05.
Cussler, Clive, interview with Walt Jayroe, *Publishers Weekly*, July 11, 1994, pp. 58-59.
East, Andy, review of *Deep Six*, *Armchair Detective*, wnter, 1986, p. 79.

Hill, Douglas, review of *Deep Six, Globe and Mail* (Toronto), August 10, 1985.

Review of *Inca Gold, Publishers Weekly*, March 28, 1994, p. 80.

Jones, David E., "Clive Cussler Goes for the Gold," *Chicago Tribune*, May 22, 1994, p. 6.

Lambert, Pam, "Hard-Driving Clive," *People*, September 21, 1992, pp. 93-94.

Martins, Richard, "Desert Action a la Cussler, and What if the Nazis Had Won?," *Chicago Tribune*, June 21, 1992, p. 6.

Miller, Ronald C., review of *Inca Gold, Armchair Detective*, fall, 1994, p. 496.

Nalley, Richard, review of *Cyclops, New York Times Book Review*, February 16, 1986, p. 16.

North, John, review of *Night Probe, Quill and Quire*, September, 1981, p. 64.

Review of *Raise the Titanic!, Publishers Weekly*, August 23, 1976, p. 59.

Robertson, Peter L., "Back on the High Wire with Daring Dirk Pitt," *Tribune Books* (Chicago), March 20, 1988, p. 9.

Ryan, Alan, "Of Spies and Family Secrets," *Washington Post Book World*, March 2, 1986, p. 6.

Review of *Sahara, Washington Post Book World*, June 7, 1992, p. 8.

Review of *Shock Wave, Publishers Weekly*, December 18, 1995, p. 42.

Steinberg, Sybil, review of *Dragon, Publishers Weekly*, May 4, 1990, p. 51.

Steinberg, Sybil, review of *Sahara, Publishers Weekly*, April 13, 1992, p. 40.

Review of *Treasure, Publishers Weekly*, March 18, 1988, p. 71.

Wall, Chris, review of *Deep Six, Los Angeles Times Book Review*, August 5, 1984, p. 8.

■ For More Information See

BOOKS

Bestsellers 90, issue 4, Gale, 1991.

PERIODICALS

Armchair Detective, Winter, 1986, pp. 79, 108.

Booklist, November 15, 1978, p. 526; July 1, 1981, p. 1369; April 15, 1984, p. 1129; April 1, 1994, p. 1404.

Kirkus Reviews, July 1, 1975, p. 725; August 15, 1978, p. 889; July 1, 1981, p. 689; April 1, 1984, p. 310.

Inside Books, November, 1988, pp. 31-34.

Los Angeles Times Book Review, August 5, 1984, p. 8; March 20, 1988, p. 12.

New Yorker, June 27, 1994, p. 87.

New York Times Book Review, September 28, 1975, p. 37; December 16, 1976, p. 24; September 25, 1977, p. 49; May 29, 1988, p. 14; June 17, 1990, p. 19; May 22, 1994, p. 39.

Publishers Weekly, September 17, 1973, p. 59; July 14, 1975, p. 58; August 23, 1976, p. 59; August 28, 1978, p. 388; August 13, 1979, p. 64; April 13, 1984, p. 50; May 4, 1990, p. 51; June 7, 1993; March 28, 1994, p. 80; August 26, 1996, p. 87.

Tribune Books (Chicago), March 20, 1988, p. 9; May 22, 1994, p. 6.

West Coast Review of Books, January, 1979, p. 30; September, 1984, p. 46; June, 1988, p. 32; May, 1990, p. 30.

—Sketch by Megan Ratner

Ralph Ellison

■ Personal

Full name Ralph Waldo Ellison; born March 1, 1914, in Oklahoma City, OK; died of pancreatic cancer, April 16, 1994, in New York, NY; son of Lewis Alfred (a construction worker and tradesman) and Ida (maiden name, Millsap) Ellison; married Fanny McConnell, July, 1946. *Education:* Attended Tuskegee Institute, 1933-36. *Hobbies and other interests:* Jazz and classical music, photography, electronics, furniture-making, bird-watching, gardening.

■ Career

Writer, 1937-94; worked as a researcher and writer on Federal Writers' Project, New York City, 1938-42; edited *Negro Quarterly*, 1942; lecture tour in Germany, 1954; lecturer at Salzburg Seminar, Austria, fall, 1954; U.S. Information Agency, tour of Italian cities, 1956; Bard College, Annandale-on-Hudson, NY, instructor in Russian and American literature, 1958-61; New York University, New York City, Albert Schweitzer Professor in Humanities, 1970-79, professor emeritus, 1979-94. Alexander White Visiting Professor, University of Chicago,

1961; visiting professor of writing, Rutgers University, 1962-64; Gertrude Whittall Lecturer, Library of Congress, January, 1964; delivered Ewing Lectures at University of California, Los Angeles, April, 1964; visiting fellow in American studies, Yale University, 1966. Lecturer in American Negro culture, folklore, and creative writing at other colleges and universities in the United States, including Columbia University, Fisk University, Princeton University, Antioch University, and Bennington College. Member of Carnegie Commission on Educational Television, 1966-67; honorary consultant in American letters, Library of Congress, 1966-72; Trustee, Colonial Williamsburg Foundation, John F. Kennedy Center for the Performing Arts, 1967-77, Educational Broadcasting Corporation, 1968-69, New School for Social Research, 1969-83, Bennington College, 1970-75, and Museum of the City of New York, 1970-86; charter member of National Council of the Arts, 1965-67, and of National Advisory Council, Hampshire College. *Military service:* U.S. Merchant Marine, World War II. *Member:* PEN (vice-president, 1964), Authors Guild, Authors League of America, American Academy and Institute of Arts and Letters (vice-president, 1967), Institute of Jazz Studies (member of board of advisors), Century Association (resident member).

■ Awards, Honors

Rosenwald Grant, 1945; National Book Award and National Newspaper Publishers' Russwurm Award,

both 1953, both for *Invisible Man;* Certificate of Award, *Chicago Defender,* 1953; Rockefeller Foundation award, 1954; Prix de Rome fellowships, American Academy of Arts and Letters, 1955 and 1956; *Invisible Man* selected as the most distinguished postwar American novel and Ellison as the sixth most influential novelist by *New York Herald Tribune Book Week* poll of 200 authors, editors, and critics, 1965; recipient of award honoring well-known Oklahomans in the arts from governor of Oklahoma, 1966; Medal of Freedom, 1969; Chevalier de l'Ordre des Arts et Lettres (France), 1970; Ralph Ellison Public Library, Oklahoma City, named in his honor, 1975; National Medal of Arts, 1985, for *Invisible Man* and for his teaching at numerous universities. Honorary doctorates from Tuskegee Institute, 1963, Rutgers University, 1966, Grinnell College, 1967, University of Michigan, 1967, Williams College, 1970, Long Island University, 1971, Adelphi University, 1971, College of William and Mary, 1972, Harvard University, 1974, Wake Forest College, 1974, University of Maryland, 1974, Bard College, 1978, Wesleyan University, 1980, and Brown University, 1980.

■ **Writings**

NOVELS

Invisible Man, Random House, 1952.

Excerpts from novel-in-progress: "The Roof, the Steeple, and the People," published in *Quarterly Review of Literature,* 1960; "And Hickman Arrives," published in *Noble Savage,* March, 1960; "It Always Breaks Out," published in *Partisan Review,* Spring, 1963; "Juneteenth," published in *Quarterly Review of Literature 13,* 1965; "Night-Talk," published in *Quarterly Review of Literature 16,* 1969; "Song of Innocence," published in *Iowa Review,* Spring, 1970; "Cadillac Flambe," published in *American Review 16,* edited by Theodore Solotaroff, Bantam, 1973.

UNCOLLECTED SHORT STORIES

"Slick Gonna Learn," published in *Direction,* September, 1939.
"Afternoon." published in *American Writing,* James A. Decker, 1940.
"The Birthmark," published in *New Masses,* July 2, 1940.

"Mister Toussan," published in *New Masses,* November 4, 1941.
"That I Had Wings," published in *Common Ground,* summer, 1943.
"Flying Home," published in *Cross Section,* edited by Edwin Seaver, Fischer, 1944.
"In a Strange Country," published in *Tomorrow,* July, 1944.
"King of the Bingo Game," published in *Tomorrow,* November, 1944.
"Did You Ever Dream Lucky?," published in *New World Writing 5,* New American Library, 1954.
"A Coupla Scalped Indians," published in *New World Writing 9,* New American Library, 1956.
"Out of the Hospital and under the Bar," published in *Soon, One Morning: New Writings by American Negroes, 1940-62,* edited by Herbert Hill, Knopf, 1963.
"The Death of Clifton," published in *Brothers and Sisters,* edited by Arnold Adoff, Macmillan, 1970.
"Backwacking: A Plea to the Senator," published in *Massachusetts Review,* Autumn, 1977.

OTHER

(With Karl Shapiro) *The Writer's Experience,* Library of Congress, 1964.
Shadow and Act (essays), Random House, 1964.
(With Whitney M. Young and Herbert Gnas) *The City in Crisis,* Randolph Educational Fund, 1968.
Ralph Ellison: An Interview with the Author of Invisible Man (sound recording), Center for Cassette Studies, 1974.
(With William Styron and James Baldwin) *Is the Novel Dead?: Ellison, Styron and Baldwin on Contemporary Fiction* (sound recording), Center for Cassette Studies, 1974.
Going to the Territory (essays), Random House, 1986.
Collected Essays of Ralph Ellison, edited by John Callahan, foreword by Saul Bellow, Random House, 1995.
Flying Home and Other Stories, Random House, 1996.

Ellison's short stories have been anthologized in over 20 collections. Contributor to *Proceedings, American Academy of Arts and Letters and the National Institute of Arts and Letters,* 2nd series, 1965 and 1967. Also contributor of critical essays, articles and reviews to numerous journals and periodicals, including *American Scholar, New York Review of Books, New York Times Book Review, Reporter,*

Time, and *Washington Post Book World.* Contributing editor, *Noble Savage,* 1960, and member of editorial board of *American Scholar,* 1966-69. *Invisible Man* has been translated into 18 languages. Some of Ellison's papers are held in the archives of the Julius Rosenwald Fund, Fisk University, Nashville, Tennessee.

■ Sidelights

"I am an invisible man," announces the anonymous protagonist of Ralph Ellison's *Invisible Man.* "No, I am not a spook like those who haunted Edgar Allan Poe; nor am I one of your Hollywood-movie ectoplasms. I am a man of substance, of flesh and bone, fiber and liquids—and I might even be said to possess a mind. I am invisible, understand, simply because people refuse to see me." Among the best known opening lines in American fiction, these words might also serve as an epitaph to Ellison's later life. Essentially a one-book author, he spent the last half of his life at work on a second novel, part of which was destroyed in a fire in 1967. Up until almost the very day of his death on April 16, 1994, Ellison followed the same schedule, reported in an interview with David Remnick in the *New Yorker.* Rising early, he left his modest Harlem apartment to buy a paper on Broadway. Back at his apartment he went through the *Times* thoroughly, ate a breakfast of toast and coffee, and then turned the computer on in his study. "The hardest part of the morning is that first hour," Ellison told Remnick, "just getting the rhythm. So much depends on continuity." Like Hemingway, one of his literary heroes, Ellison went back several chapters at the outset of work to get the tone and feel of the prose, to make sure the days, months, and years of writing would segue together seamlessly. "But very often I'll start in the morning by looking back at the work from the day before and it ain't worth a damn." Blue cigar smoke gathered around his head on such days. On better days, his wife of almost forty years, Fanny, could hear him chuckling at some passage he was particularly pleased with.

But this daily labor was invisible to the reading public. By the time of his death in 1994, Ellison's great achievement with *Invisible Man* had been all but taken for granted as well. The very notion of the invisible black man—unseen by an indifferent white world—had been applied to a variety of ethnic and socio-economic groups. The term was

no longer the legacy solely of Ellison; it had become an Everyman concept. Even the firestorm of debate over the book—vilified by the Left for its portrayal of Marxists and by black nationalists for so-called Ivory Tower prose, and embraced by the literary establishment for experimentation and voice—had become distant thunder, while Ellison's prophecies in the book had all come to fruition in his lifetime.

But if the debates had calmed, Ellison had never lost the fire himself, and his one great achievement—beyond the lessons learned in the fiction—may well be the new voice that he gave to literature in general and African-American literature specifically. In a 1982 introduction to *Invisible Man* (the book has been continually in print since its publication in 1952), Ellison clearly announced his credo. There he answered the question "of why most protagonists of Afro-American fiction (not to mention the black characters in fiction by whites) were without intellectual depth. Too often they were figures caught up in the most intense forms of the human predicament but yet seldom able to articulate the issues which tortured them" But Ellison saw, indeed lived, a solution to this Catch-22: "By a trick of fate (and our racial problems notwithstanding), the human imagination is integrative—and the same is true of the centrifugal force that inspirits the democratic process."

Coming from the Territory

Ellison learned such optimism early on, from his parents who moved west from their native South Carolina to build a new life. The children of slaves, Ellison's parents knew firsthand the power of optimism, of hope and possibility. Lewis Ellison, his father, had travelled and fought in the Philippines, China, and Cuba before leaving the army. He and Ida Millsap married and settled in Chattanooga, Tennessee, where Ellison was partner in an ice-cream parlor and a restaurant, and where he subsequently became a construction foreman. It was this job that brought him to Oklahoma, still a territory at the time. Soon Ellison was in business for himself, selling ice and coal while his wife Ida, a political activist, canvassed black voters for the Socialist Party in Oklahoma City. Oklahoma was a frontier without the taint of a history of slavery that other nearby states such as Texas and Arkansas had. It was a place where African Americans could start a new life and

where they fought hard to keep any semblance of segregationist laws out of the constitution once the territory became a state. Ralph Waldo Ellison—named after Emerson in hopes the boy would become a poet—was thus born, on March 1, 1914, into a climate of relative personal racial equity. If there was a racist governor of the state, it did not prevent the young Ellison from having close white friends.

Lewis Ellison died in an accident when Ellison was three and his younger brother only four months old, forcing the boy's resourceful mother to work as a domestic in white homes and as an apartment house custodian. But it was not a deprived childhood, and Ellison grew up loving music and reading. Ellison and his buddies developed a legion of heroes: "Gamblers and scholars, jazz musicians and scientists," he chronicles in *Shadow and Act*. "Negro cowboys and soldiers from the Spanish-American and First World Wars, movie stars and stunt men, figures from the Italian Renaissance and literature." This last, especially stuck with the young Ellison, and he patterned himself on the all-round Renaissance spirit. It was an ideal that remained ingrained in him from Oklahoma City to his years of college in Alabama and on to New York when he finally determined to be a writer.

But growing up in Oklahoma City, the Renaissance ideal meant frequent trips to the all-black local library set up in a pool hall with the books scattered higgledy-piggledy. Freud could lie next to Conrad and a young reader could stumble onto serendipitous adventures. Ellison quietly worked his way through authors as different as James Fenimore Cooper, George Bernard Shaw, Guy de Maupassant, and Thomas Hardy, as well as writers of the Harlem Renaissance, introduced through the works of Langston Hughes. Ellison's Renaissance ideal also led him to take up the trumpet at an early age, joining the school band at age eight. Music indeed became his initial creative outlet, and he later took formal composition and private trumpet lessons. He set for himself the goal of composing a symphony by the time he was 26. Though he was not trained in it, jazz informed Ellison's musical world. Oklahoma City was well supplied with jazz musicians: Count Basie got his start with a local band, and the jazz musician Jimmy Rushing became and remained Ellison's close friend. In addition to books and music, Ellison also played high school football and

took an avid interest in electronics and radios—more of the Renaissance ideal at work.

Upon graduation from high school, Ellison won a scholarship from the state of Oklahoma. Such scholarships were a mixed blessing. They were intended for use outside of the state, thus keeping blacks out of the state colleges. Ellison opted for studying music at Tuskegee Institute in Alabama. He hitched a free ride on the railroad to

> *"I am an invisible man. No, I am not a spook like those who haunted Edgar Allan Poe; nor am I one of your Hollywood-movie ectoplasms. I am a man of substance, of flesh and bone, fiber and liquids—and I might even be said to possess a mind. I am invisible, understand, simply because people refuse to see me."*

get to his new school, having to run for his life at one point when he and other hoboes were caught by railroad detectives. Founded in 1881 by Booker T. Washington, Tuskegee Institute had a conservative tradition of accepting limitations on black upward mobility—it began as a trade school for blacks and retained something of this tradition even at the time of Ellison's arrival. It did, however, have an excellent music department headed by William L. Dawson. Ellison took classes in counterpoint, composition, conducting, harmony, and instrumentation, in addition to required courses in the humanities. He also continued his voracious reading at college, discovering T. S. Eliot's *The Waste Land* and being impressed with its jazz rhythms. It was this experience that first made Ellison see the possibilities of including the humor and energy of blacks in literature—something that up to that time had not been done. He also read the moderns of the time: Hemingway,

Stein, Ford Maddox Ford, Joyce, and Fitzgerald, as well as seminal thinkers such as Marx and Freud. He had a role in a school play as a sophomore and even took up sculpture and poetry writing. The Renaissance man was alive and well in Tuskegee.

By 1936, however, in his third year of college, Ellison began experiencing financial difficulties: a confusion over his scholarship left him without enough money to finish school. He went to New York in hopes of earning money to complete his senior year and to study sculpture with Augusta Savage, to whom his Tuskegee art instructor had given him a letter of introduction. It was not entirely a sad departure, for Ellison found the climate of Tuskegee and of the Deep South in general stifling, as much by the conservative know-your-place blacks themselves as by the whites. Once in New York City, there was no going back for Ellison. Arriving with $75 in his pocket, Ellison put up at the Harlem YMCA and the very next day after arriving he introduced himself to the author and cultural critic Alain Locke, whom Ellison had heard reading at Tuskegee. Locke in turn introduced Ellison to the poet Langston Hughes, and to the works of the French writer Andre Malraux, two connections that would eventually change the course of Ellison's life. Ellison initially took work as a waiter and counterman at the YMCA, but soon found other jobs: as a photographer and then file clerk for the psychiatrist Harry Stack Sullivan. Working for Sullivan, Ellison renewed his interest in Freud, reading his works again. Ellison also studied sculpture, but soon found that he was not cut out for that form of expression. His love of music continued, but he finally realized that writing was his real medium of expression. Langston Hughes introduced Ellison to Richard Wright, some of whose poems Ellison had read and admired. It was Wright, himself a struggling yet accomplished young writer at the time, who convinced Ellison to write.

That same year, 1937. Ellison's mother died in Dayton, Ohio, where she had resettled two years earlier. A doctor's negligence led to her untimely death from tuberculosis of the hip, and Ellison was never to forget the lesson that to be a professional, one must know one's craft well. Ellison went to Dayton for the funeral and stayed on for the next half year with his brother, sleeping in a car and staying alive by selling the quail they shot to General Motors executives. He also continued

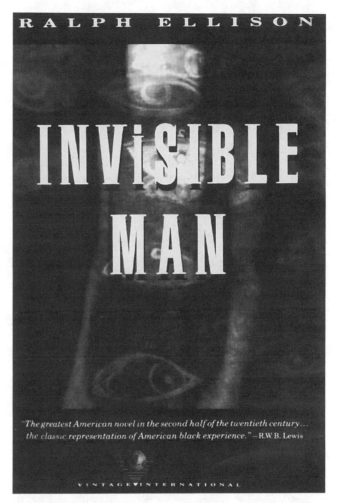

Ellison's classic 1952 novel, which gave a new voice to African American literature, won the National Book Award.

his studies of the great writers, focussing especially on Hemingway, who taught him not only sentence structure and organization, but how to lead a bird when wing-shooting—a matter of survival for Ellison at the time.

Writer Emergent

Back in New York, Ellison joined the Federal Writer's Project, earning $103.50 per month, and renewed his friendship with Wright, spending time with him at the office of the *Daily Worker* where Wright worked. Wright first persuaded Ellison to write for publication, assigning him to write the review of Edward Turpin's novel *These Low Grounds* for the autumn issue of *New Challenges*, a magazine Wright edited. Ellison began writing reviews for other magazines such as *New Masses,*

Direction, and *Negro Quarterly,* as well as continuing his research for the Federal Writer's Project, gathering Negro folklore, and children's rhymes, games, and songs for a book to be titled *Negroes in New York.* This research would prove invaluable in giving Ellison an ear for black idiom as well as providing a wealth of stories and images for his own work.

Ellison began a novel in 1939 which led to his first published short story, "Slick Gonna Learn." An apprentice piece, and one greatly influenced by the leftist political views of his immediate crowd, this story tells the tale of Slick, arrested for a fight which resulted from trying to win some money in a crap game to help his pregnant wife. A polemical tale, the story follows Slick's fortunes from trial to release to aborted beating by white police to being befriended by a white union organizer. "The Birthmark," his next published short story in *New Masses* in 1940, is, according to Joseph T. Skerrett, Jr., in *Studies in Short Fiction,* "like a Hemingway story . . . immediate and dramatic. The story of the lynching of a young black man named Willie, it has also been compared to Richard Wright's "Big Boy Leaves Home."

Both of these initial short stories are the work of a writer in training, though "The Birthmark" begins to showcase Ellison's later use of symbol and color imagery. More accomplished and closer to home are a trio of short stories built around the dialogues between two young boys, Buster and Riley: "Afternoon," "Mister Toussan," and "That I Had the Wings." Here Ellison begins to put the store of knowledge he had gained through his WPA researches to play: the use of strong black dialect as well as black folklore and rhyme is evident throughout. These stories are less political than his first two and closer to the experiences Ellison himself had lived. As a triptych, they all explore the theme of youth becoming aware of both freedom and restriction in their lives—the latter primarily the result of color and racial boundaries. "Afternoon" is a slice-of-life piece that follows the two boys through the course of one afternoon. "Mister Toussan," "a brilliant exercise in brevity," according to Skerrett, is a flight of fancy wherein the two boys recount and recreate the mythic adventures of Toussaint L'Ouverture who led the slave rebellion in Haiti at the time of Napoleon. "That I Had Wings" is Ellison's first use of blues music to develop a story. Not only is the story itself a blues tale, but it also contains

noticeable blues forms in improvised rhymes by young Riley. Skerrett noted that it was "a sensitive and dramatic perception of the emotions of childhood," and that it resembled "something from the hand of Mark Twain."

As accomplished as they were, these early stories were still apprentice pieces as Ellison struggled to learn his craft thoroughly. In 1943, after unsuccessfully trying to join the Navy during World War II, Ellison joined the Merchant Marine, serving as a cook until 1945. He found time aboard ship to continue his writing, working on a novel set in a prisoner of war camp and on various short stories. By 1944 he had hit his stride and produced another trio of stories that have been widely anthologized. The first of these, "In a Strange Country," is a tip of the hat to Hemingway's "In Another Country," in which a wounded American learns of life and the world by his experience in a foreign country. Ellison's tale takes place in Wales, where a black seaman is assaulted by his fellow sailors during a blackout, only to be rescued by a group of Welsh who take him to their private club and sing the American national anthem in his honor. The seaman, Parker, begins to search for his identity as a result—a theme to be replayed heavily in *Invisible Man.*

The second story of that year, "Flying Home" is, according to Mark Busby in his critical biography, *Ralph Ellison,* "perhaps Ellison's most successful short story." It brings together many of the themes, leit motifs, and techniques that would inform his later work: isolation, racial discord, search of identity, bird imagery, myth, folklore, and passages that employ surrealism as well as magical realism. The protagonist, Todd, a trainee pilot, finds his identity in his black roots when he hits a buzzard in flight training and breaks his ankle in the subsequent crash landing. An old sharecropper, Jefferson, tells him folktales involving birds and flight as help is being sought. The stories confront Todd, a northern black, with his southern origins and show him how his own arrogance has cut him off and isolated him from the world of his ancestors.

Ellison's last story of 1944, "King of the Bingo Game," in many ways is a direct predecessor of *Invisible Man.* In it, Ellison describes a nameless character much like the anonymous narrator of his later novel who moves from the rural South to the urban North and feels isolated and helpless

as he spends a night in a theater at bingo night. He is made desperate like the character in his first story, "Slick Gonna Learn," by the pregnancy of his wife and by being out of work. He hopes to win the $36.90 prize in the bingo game, but becomes exhilarated at the prospect of winning and is ultimately defeated by the pressure of the game. Here Ellison lets surrealism play as he would soon do in *Invisible Man*; creates lucky numbers soon to be echoed in his novel; and deals full square with the theme of identity and alienation, twin pillars of *Invisible Man*.

"I Am an Invisible Man"

Ellison would, in fact soon find himself engaged on that very novel. Ailing from a kidney infection brought on by contaminated water aboard ship, Ellison took a leave of absence in the clos-

ing months of the war. He and his soon-to-be-wife, Fanny McConnell, whom he had met in 1944 on leave, went to a friend's farm in Vermont where Ellison could recuperate. There he set up a typewriter on an old barn and tried to continue work on his prison camp novel. But soon other themes began playing in his head until one day he typed out the words "I am an invisible man." It was the beginning of a seven-year journey for Ellison. Only slowly did Ellison see who was initially speaking in this novel—indeed, the narrator maintained anonymity even after seven years of work, for he never has a name in the book. Back in New York, Ellison continued working on the book. He and Fanny married in 1946 and she took a job as an executive director of the American Medical Center for Burma, while Ellison won a Rosenwald grant, wrote reviews and articles, and built high-fidelity audio systems to finance the long process of writing his novel. As early as 1947

Ellison addressing a U.S. Senate subcommittee on the problems of urban America.

sections of it were published in England, and then in 1948 the same appeared in the United States. Finally, in 1952, the long-awaited book appeared.

An amalgam of episodic picaresque novel, realism and magical realism, *Invisible Man* tells the story of a nameless protagonist, often compared to Voltaire's Candide, who journeys from the South to the North, from naive ignorance to experience and knowledge, from a man defined by the white world to one who, at the end of the novel begins to have a sense of self-definition. This is an odyssey, an adventure, told through a series of bizarre and jarring events. Beginning with a prologue, which in fact comes chronologically at the end of the action, the reader is introduced to the Invisible Man who has holed up underground in a New York basement close to Harlem, syphoning off electricity from the ominous Monopolated Light & Power Company: to be exact, he illuminates his underground hole with 1,369 bulbs—the recurrence of lucky numbers that began in "King of the Bingo Game." In the prologue the reader gets the sense of a man on the run, hears the names of other characters soon to be met, experiences a surreal journey—aided by marijuana—through blues and into deeper layers of life symbolized by sermonizing, and learns of the protagonist's obsession and disgust with being invisible. Louis Armstrong's lyric, "What Did I Do to Be so Black and Blue," informs the narrator's life. In the ensuing pages he promises to tell the reader what he has done to be so blue. But this telling comes in two voices: that of the naive young boy experiencing events, and that of the satirical Invisible Man making asides from his illuminated hole.

The action begins some twenty years earlier, when the narrator recalls his upbringing in the South and his grandfather, the freed slave, who preached a doctrine of "yes-ing" the white man to death. Named valedictorian of his high school class, the narrator is invited to recite his speech for the prominent white citizens of his town, but in what has become known as Ellison's "Battle Royal" chapter, he is forced to fight blindfolded other black youths and then crawl over an electrified carpet for money before being allowed to give the speech. Here Ellison presents not only the sadism of race relations, but also an intraracial violence that affects the nation as a whole, as well as the introduction of the symbol of darkness and blind-

ness of unawakened youth. The protagonist is awarded a briefcase for his troubles—symbol of his initiation into the white middle class world. That night he dreams of his grandfather and of letters included in the briefcase—one which contains the message "To Whom It May Concern, Keep This Nigger-Boy Running."

The narrator, as Ellison himself had, wins a scholarship to a college reminiscent of Tuskegee Institute. There he becomes chauffeur to Mr. Norton, a white philanthropist, and much to the horror of the college president, the demonic Dr. Bledsoe, the narrator takes Norton to meet a disreputable sharecropper named Trueblood who is supposed to be a great storyteller. The story Trueblood presents, however, is one of incest that both unsettles and fascinates Norton, making him recall his own dubious feelings toward his dead daughter. Further misadventures with Norton at a saloon result in the narrator's expulsion from the college and its heavily white-washed buildings. On his own, the narrator now heads north to New York City and Harlem, bearing sealed letters of reference from Dr. Bledsoe, which, it turns out, are actually character defamations. He finally secures work, with Liberty Paints, which manufactures the white paint used on national monuments—a secret ingredient of which is the touch of black color that makes it whiter than white—symbol of the positive effects of the mixture of the races. But disaster awaits the narrator at every turn: held responsible for an accident, the protagonist is hospitalized and given lobotomy-like electroshock therapy. "A huge iridescent bubble seemed to enfold me," the narrator records in *Invisible Man*. "I was laved with warm liquids. . . . The sterile and weightless texture of a sheet enfolded me. I felt myself bounce, sail into the mist, striking a hidden wall beyond a pile of broken machinery and sailing back." After the treatment, the doctors detach the apparatus: "I felt a tug at my belly and looked down to see one of the physicians pull the cord which was attached to the stomach node, jerking me forward." This symbolic birth and cutting of the umbilical cord has the opposite effect of what the doctors desired. With mental overlays erased, the narrator is free for the first time to feel his Southern roots. In a sudden surge of black pride, he dumps a spittoon over the head of a man he mistakes for Dr. Bledsoe.

Befriended by a woman named Mary Rambo, the narrator begins to find an identity with his Afri-

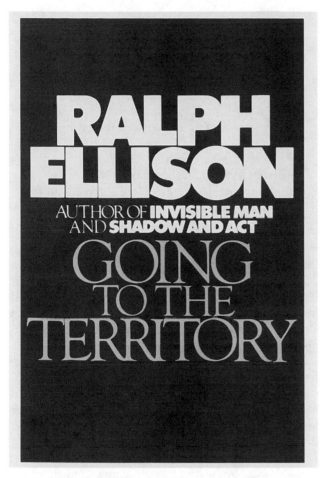

This 1986 collection of essays explores such diverse subjects as jazz great Duke Ellington and the role of the novel in American democracy.

can American roots. Seeing an old couple being evicted from their home, he delivers an off-the-cuff street corner speech which incites a riot and brings him to the attention of the Brotherhood, a stand in for the real-life Communist Party, who believe they can use his oratorical skills. He leaves Mary Rambo's to take up lodging in a Brotherhood apartment, but soon becomes disenchanted with their utopian ideals: They are not interested in civil rights, only in the millennium and all individual expression must be subverted to that end. This awakening on the part of the narrator is assisted by two further characters: Tod Clifton, who becomes a martyr to the cause, and Rinehart, whose chaotic, formless way of living suggests a way out of the Brotherhood's strictures. Ras the Destroyer, a haranguing black nationalist, meanwhile hounds the narrator as a traitor to the black people, eventually inciting a huge race riot—dealt with in surrealistic, hallucinatory images—that mirrors the actual Harlem race riots of the 1940s.

Taking refuge in his basement, the narrator now ponders, in the epilogue, the meaning of all these experiences. Having moved from purpose, to passion, he now reaches perception. The illumination cast by the 1,369 light bulbs helps this meditation: the narrator now sees the close connection between personal responsibility and self-identity. He begins to see that he must stop ranting and start engaging in society on a new footing. The power of imagination is transformational, he decides. The long journey from simplicity to acceptance of complexity, from isolation to inclusion is complete. And, in the end, though this is the story of one invisible black man, it is the story of us all.

A simple plot synopsis can hardly do justice to the thematic, symbolic, and stylistic complexities employed in *Invisible Man*. Like the best of literature, far more words have been written about the novel than are included between its covers. Ellison's themes and motifs include frontier myth, Christ-like awareness, search for identity, the struggle between African Americans and whites, the power of language and creation, and the acceptance of change. Symbols and imagery are found on every page—from sex to color to folklore. But perhaps it is Ellison's style, his use of language from blues to the dozens to straight realism and magical realism that sets the book apart, that gives it such a universal appeal.

Ellison also draws on a variety of literary traditions for his story: his predecessors include Frederick Douglass, Booker T. Washington, W. E. B. Du Bois, Marcus Garvey, Alain Locke, and Richard Wright. Indeed, there are even characters in the book reminiscent of each of these black ideologues and writers. The bombastic demagogic Garvey can be seen in Ras, as can Washington in the conservative faculty of Dr. Bledsoe's college. Yet it is perhaps Douglass's spirit that is most deterministic in the novel—his commitment to the Constitution and personal responsibility allied with a quiet self-esteem. It is the lesson of Ellison's grandfather and perhaps the one great lesson of the book. It was a lesson however, that met with varying degrees of acceptance.

Generally, reviews of *Invisible Man* by establishment white reviewers were favorable if not glowing. The writer Saul Bellow, in a *Commentary* review of *Invisible Man*, called it "a book of the very first order, a superb book . . . tragicomic, poetic, the tone of the very strongest sort of creative in-

telligence." Orville Prescott declared in the *New York Times* that the book "blazes with talent," while Wright Morris in the *New York Times Book Review* noted that it "is a resolutely honest, tormented, profoundly American book," and that it "belongs on the shelf with the classical efforts man has made to chart the river Lethe from its mouth to its source." Reviewers commented on Ellison's sense of the comic as well as his universality. Anthony West noted in the *New Yorker* that "few writers can have made a more commanding first appearance," and described the novel as "an exceptionally good book," while T. E. Cassidy labelled Ellison a "dynamic" writer in *Commonweal*. *New Republic* contributor George Mayberry, alluding to a turn of phrase by Graham Greene about how he was not a Catholic writer but a writer who happens to be Catholic, noted that "it can be said of Ralph Ellison that he is not a Negro writer, but a writer who happens to be Negro."

It was this last distinction that caused Ellison critical problems. Though his old friends Langston Hughes and Alain Locke praised the writing and the psychological depth displayed in the book, other African-American reviewers and reviewers on the Left decried it as propaganda and Uncle Tom-ism. Abner W. Berry, writing in *Daily Worker*, called the book "439 pages of contempt for humanity, written in an affected, pretentious and otherworldly style to suit the king-pins of world supremacy." John O. Killens, in *Freedom*, declared that "Negro people need Ralph Ellison's *Invisible Man* like we need a hole in the head or a stab in the back," and asserted that it was "a vicious distortion of Negro life." Despite such criticisms, Ellison and his *Invisible Man* received a plethora of awards, the Russwurm Award, the Certificate of Award from the *Chicago Defender*, and the National Book Award among them. The last award mentioned in particular how Ellison had managed to break away from the strictures of the tight, plot-driven novel format or most contemporary novels. Ellison had arrived.

Under Siege

Ellison's celebrated position brought him grants and teaching positions at colleges around the world. Because of his integrationist beliefs and eloquence, he also became a prominent speaker. His writing output was never staggering. In the

If you enjoy the works of Ralph Ellison, you may also want to check out the following books and films:

Ernest J. Gaines, *A Gathering of Old Men*, 1983.
The plays of August Wilson, including *Ma Rainey's Black Bottom*, 1985, and *The Piano Lesson*, 1990.
Richard Wright, *Native Son*, 1940.
The Autobiography of Miss Jane Pittman, 1974.

mid-1950s he wrote two further stories involving the character Mary Rambo from *Invisible Man:* "Did You Every Dream Lucky," and "Out of the Hospital and Under the Bar," originally intended for his novel. One of Ellison's best stories, "A Coupla Scalped Indians," appeared in 1956. Reminiscent of his earlier Buster and Riley tales, this is an initiation story—the scalping of the title refers to the circumcisions the two young protagonists have recently undergone. Ellison also began work on a second novel, a big sprawling book involving the theme of political assassination and the usual Ellisonian search for identity.

Increasingly, however, Ellison came under attack from younger black nationalists whose rallying cry became "black is beautiful." To this younger generation of militants, Ellison seemed like a sell-out to the white establishment: His integrationist beliefs were, to them, the worst example of Uncle Tom; his aesthetics and faith in the power of imagination denied the realities of poverty and oppression that his black brothers and sisters had to contend with daily. Ellison's support for the Vietnam War did nothing to ingratiate him with African-American leaders either, not in a time when leaders such as Martin Luther King, Jr., were coming out against it.

Ellison fought back with the only weapon he had at hand—words. His collection of essays published in 1964, *Shadow and Act*, devoted an entire chapter, "The World and the Jug," to refuting these critics. "The World and the Jug" argued for the interrelatedness of all types of experience and declaring that at least on the level of imagination, integration had been achieved in the United States. Ellison also includes carefully crafted essays on the blues and black folklore as well as on the nature of the novel. It was a tour de force that prompted

Stanley Edgar Hyman in *New Leader* to call Ellison "the profoundest social critic we have." Neither had the appeal of *Invisible Man* weakened with white readers: a 1965 *Book Week* poll of 200 predominantly white writers and editors selected *Invisible Man* as the most distinguished novel written in the last twenty years. At the same time, however, the novel was spurned by the new generation of black writers such as Imamu Amiri Baraka (LeRoi Jones). Young black militants identified with the character Ras the Destroyer (if anyone) in the book.

Ellison continued to work on his new book, but the political assassinations of the Kennedy brothers and Martin Luther King, Jr., in the 1960s made him think twice about the comic elements in his own novel which played with the theme of assassination. Also, in 1967, over 360 pages of manuscript were lost in a fire in his country house in Plainfield, Massachusetts. Seven portions of the novel in progress appeared in literary magazines throughout the 1960s and 1970s, but Ellison had a hard time picking up the strands of the novel after the 1967 fire. These excerpts give the broad outlines of the novel: set in the South in the years between the Jazz Age and the Civil Rights Movement, the book appears to be, somewhat like *Invisible Man*, a recreation of both American history and identity. The main characters include the Reverend Alonzo Zuber Hickman, a former jazz musician, and Bliss, his adopted son of very light skin who renounces his adopted father and his race and becomes Senator Sunraider, a militant white supremacist who is shot by a black assassin, Severen. Other characters include Cliofus, who is a friend of Severen and an aspiring writer, the white reporter McIntyre and Minifees, a black musician who burns his white Cadillac on Sunraider's lawn. Bliss, unlike the narrator of *Invisible Man*, refuses to accept his past and his roots, and becomes a traitor to his race, while Hickman, by celebrating his black heritage, finds value in his world. Like *Invisible Man*, the manuscript's tone is largely tragicomic, and once again Ellison stretches the bounds of novelistic storytelling. As he described the novel in *Shadow and Act*, the novel's form is "a realism extended beyond realism."

Final Chapter

But as the long years of writing dragged on, an irony worthy of the pages of his own fiction be-

set Ellison. Once the darling of white intellectuals, he was increasingly criticized as a one-book author by these same fans. The anathema of black nationalists and militants in the 1960s, by the late 1970s he was embraced by a new generation of African-American writers who saw in him a role model for self expression. As his stock rose and fell, he continued speaking and teaching, and awards came in from literary bodies as well as governments, including the National Medal of Arts and France's Chevalier de L'Ordre des Arts et Lettres presented by an early Ellison hero, the writer Malraux, then French minister of cultural affairs. In 1986 he published his third book, a collection of 16 essays entitled *Going to the Country*. Although they are not as thematic as the essays collected in *Shadow and Act*, these essays run the gamut from cultural themes to autobiography. There are pieces on the writer Erskine Caldwell as well as on Richard Wright, whom everybody including Ellison credits as being an formative influence on the Brotherhood sections of *Invisible Man*. There is even a tribute to Duke Ellington on his birthday and one essay examining the importance of the novel in American democracy. In fact, the panoply of Ellison themes—from jazz to a search for identity—are present in this collection which John Edgar Wideman praised in *New York Times Book Review*: "The reader is impressed and delighted by the integrity of Mr. Ellison's vision," Wideman wrote. "His voice is assured, calm, wise."

By the time *Going to the Country* was published, Ellison had become a respected man of letters. For the next eight years he continued his daily work on the novel in progress. He also delivered addresses and continued in his quiet and unassuming way to hold out hope for an interracial and truly integrated United States. His fiction had already influenced an entire generation of white American writers including Saul Bellow, Joseph Heller, Ken Kesey, Kurt Vonnegut, Jr., and John Irving. By the end of his career such influences were also evident in a new generation of African-American writers including Ishmael Reed, Ernest Gaines, Toni Morrison, and Alice Walker. At his death in 1994, he was still hard at work on the never-ending novel—edited posthumously for publication by his friend and literary executor John Callahan of Lewis and Clark College in Portland, Oregon. In the end, Ellison's was a writer's life and his search for identity, his frontier optimism, his belief in imagination are deeply ingrained in

the American experience. His message was universal; his themes transcend the African-American experience and illuminate all our lives. As his nameless protagonist declares at the close of *Invisible Man*: "Who knows but that, on the lower frequencies, I speak for you?"

■ Works Cited

Bellow, Saul, review of *Invisible Man*, *Commentary*, June, 1952.

Berry, Abner W., review of *Invisible Man*, *Daily Worker*, June 1, 1952.

Busby, Mark, *Ralph Ellison*, Twayne, 1991, p. 34.

Cassidy, T. E., "A Brotherhood Betrayed," *Commonweal*, May 2, 1952, pp. 99-100.

Ellison, Ralph, *Shadow and Act*, Random House, 1964.

Ellison, Ralph, *Invisible Man*, 50th anniversary edition, Random House, 1982.

Hyman, Stanley Edgar, review of *Shadow and Act*, *New Leader*, October 26, 1964.

Killens, John O., review of *Invisible Man*, *Freedom*, June, 1952.

Mayberry, George, "Underground Notes," *New Republic*, April 21, 1952, p. 19.

Morris, Wright, "The World Below," *New York Times Book Review*, April 13, 1952, p. 5.

Prescott, Orville, review of *Invisible Man*, *New York Times*, April 16, 1952.

Remnick, David, "Visible Man," *New Yorker*, March 14, 1994, pp. 34-38.

Skerrett, Joseph T., Jr., "Ralph Ellison and the Example of Richard Wright," *Studies in Short Fiction*, spring, 1978, pp. 145-53.

West, Anthony, "Black Man's Burden," *New Yorker*, May 31, 1952, pp. 93-96.

Wideman, John Edgar, review of *Going to the Territory*, *New York Times Book Review*, August 3, 1986, p. 15.

■ For More Information See

BOOKS

Concise Dictionary of American Literary Biography: The New Consciousness, 1941-1948, Gale, 1987, pp. 185-97.

Contemporary Authors New Revision Series, Volume 24, Gale, 1989, pp. 179-87.

Contemporary Literary Criticism, Gale, Volume 1, 1973, Volume 3, 1975, Volume 11, 1979, Volume 54, 1989.

Dictionary of Literary Biography, Gale, Volume 2: *American Novelists Since World War II*, 1978, pp. 136-41, Volume 76: *Afro-American Writers, 1940-1955*, Gale, 1988, pp. 37-56.

Dietze, Rudolf F., *Ralph Ellison: The Genesis of an Artist*, Verlag Hans Carl, 1982.

Gray, Valerie Bonita, *Invisible Man's Literary Heritage: "Benito Cereno" and "Moby Dick,"* Editions Rodopoi, 1978.

List, Robert N., *Dedalus in Harlem: The Joyce-Ellison Connection*, University Press of America, 1982.

McSweeney, Kerry, *"Invisible Man": A Student's Companion to the Novel*, Twayne, 1988.

Nadel, Alan, *Invisible Criticism: Ralph Ellison and the American Canon*, University of Iowa Press, 1988.

O'Meally, Robert G., *The Craft of Ralph Ellison*, Harvard University Press, 1980.

Reilly, John M., editor, *Twentieth-Century Interpretations of Invisible Man*, Prentice-Hall, 1970.

Schor, Edith, *Visible Ellison: A Study of Ralph Ellison's Fiction*, Greenwood Press, 1993.

Trimmer, Joseph A., editor, *A Casebook on Ralph Ellison's Invisible Man*, Crowell, 1972.

J. Madison Davis, "Ralph (Waldo) Ellison," *Twentieth-Century Young Adult Writers*, 1st edition, edited by Laura Standley Berger, St. James Press, 1994, pp. 200-2.

World Literature Criticism, Volume 2, Gale, 1992, pp. 1152-67.

PERIODICALS

Booklist, February 15, 1995, p. 1069.

Black World, December, 1970.

Chicago Tribune Book World, August 10, 1986.

English Journal, September, 1969; May, 1973; November, 1984.

New Criterion, September, 1983.

Publishers Weekly, February 20, 1995, p. 203.

Saturday Review, April 12, 1952; March 14, 1953; December 11, 1954; January 1, 1955; April 26, 1958; May 17, 1958; July 12, 1958; September 27, 1958; July 29, 1962; October 24, 1964.

Washington Post, August 19-21, 1973; April 21, 1982; February 9, 1983; March 30, 1983; July 23, 1986.

■ Obituaries

BOOKS

Contemporary Authors, Volume 145, Gale, 1995, pp. 129-30.

Contemporary Literary Criticism, Volume 86, Gale, 1995, pp. 317-29.

PERIODICALS

Los Angeles Times, April 17, 1994, p. A1.
New York Times, April 17, 1994, p. 38; May 27, 1994, p. B8.
Newsweek, May 2, 1994, p. 58.
Times (London), April 18, 1994, p. 17.*

—*Sketch by J. Sydney Jones*

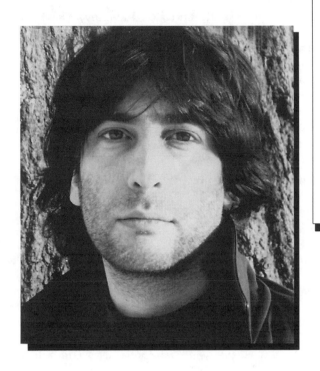

Neil Gaiman

■ Personal

Full name, Neil Richard Gaiman; born November 10, 1960, in Portchester, England; son of David (a company director) and Sheila (a pharmacist; maiden name, Goldman) Gaiman; married Mary McGrath, March 14, 1985; children: Michael, Holly, Madeleine. *Education:* Attended Ardingly College, 1970-74, and Whitgift School, 1974-77. *Politics:* "Woolly." *Religion:* Jewish. *Hobbies and other interests:* "Finding more bookshelf space."

■ Addresses

Home—England and the U.S. Midwest. *Agent*—Merrilee Heifetz, Writers House Inc., 21 West 26th St., New York, NY 10010.

■ Career

Freelance journalist, 1983-87; writer, 1987—. Member of advisory board, International Museum of Cartoon Art. *Member:* Society of Strip Illustrators (chair, 1988-90), Science Fiction Foundation (committee member), British Fantasy Society.

■ Awards, Honors

Mekon Award, Society of Strip Illustrators, and Eagle Award for best graphic novel, both 1988, both for *Violent Cases;* Eagle Award for best writer of U.S. comics, 1990; World Fantasy Award for best short story, 1991; eight Will Eisner awards, including award for best writer of the year, 1991, 1992, 1993, 1994; three Harvey awards, including best writer; recipient of international awards, including honors from Finland, Italy, Spain, Brazil, and Austria.

■ Writings

GRAPHIC NOVELS

(With Kim Newman) *Ghastly beyond Belief,* Arrow, 1985.
Violent Cases, illustrated by Dave McKean, Titan (London), 1987, Tundra (Northampton, MA), 1991.
Black Orchid (originally published in magazine form, 1989), illustrated by Dave McKean, lettered by Todd Klein, DC Comics, 1991.
The Sandman: A Doll's House, illustrated by Mike Dringenberg and Malcom Jones III, DC Comics (New York City), 1990.
The Sandman: Preludes and Nocturnes (previously

published in magazine form as *Sandman* volumes 1-8), DC Comics, 1991.

The Sandman: Dream Country (previously published in magazine form as *Sandman* volumes 17-20), illustrated by Kelley Jones and others, DC Comics, 1991.

The Sandman: Season of Mists (previously published in magazine form as *Sandman* volumes 21-28), DC Comics, 1992.

Signal to Noise, illustrated by Dave McKean, Dark Horse Comics, 1992.

Miracleman: The Golden Age, illustrated by Mark Buckingham, HarperCollins, 1993.

The Sandman: A Game of You (previously published in magazine form as *Sandman* volumes 32-37), illustrated by Shawn McManus, DC Comics, 1993.

The Books of Magic (previously published in magazine form, four volumes), illustrated by John Bolton and others, DC Comics, 1993.

The Sandman: Fables and Reflections (previously published in magazine form as *Sandman* volumes 29-31, 38-40, 50), illustrated by Bryan Talbot, DC Comics, 1994.

Death: The High Cost of Living (previously published in magazine form, three volumes), illustrated by Chris Bachalo, Mark Buckingham, and Dave McKean, DC Comics, 1994.

The Sandman: Brief Lives (previously published in magazine form as *Sandman* volumes 41-49), illustrated by Jill Thompson and Vince Locke, DC Comics, 1994.

Mr. Punch, illustrated by Dave McKean, DC Comics, 1994.

The Sandman: World's End (previously published in magazine form as *Sandman* volumes 51-56), illustrated by Dick Giordana, Vince Locke, and Dave McKean, DC Comics, 1995.

The Sandman: The Kindly Ones (previously published in magazine form as *Sandman* volumes 57-69), illustrated by Marc Hempel, D'Israeli, Richard Case, and others, DC Comics, 1996.

Author of additional "Sandman" magazines, including *The Tempest*, DC Comics, 1996; creator of characters for magazines, including *Lady Justice, Wheel of Worlds, Mr. Hero, the Newmatic Man,* and *Teknophage*, published by Tekno Comix (Boca Raton, FL), 1995.

FICTION

(With Terry Pratchett) *Good Omens: The Nice and Accurate Prophecies of Agnes Nutter, Witch* (novel), Workman (New York City), 1990.

(With Mary Gentle) *Villains!* (short stories), edited by Mary Gentle and Roz Kaveney, ROC (New York City), 1992.

(With Mary Gentle and Roz Kaveney) *The Weerde* (short stories), ROC, 1992.

Angels & Visitations: A Miscellany (short stories), illustrated by Steve Bissette, P. Craig Russell, and others, Dreamhaven Books & Art, 1993.

Neverwhere (based on Gaiman's BBC television series), [London], 1996.

The Day I Traded My Father for a Goldfish (juvenile), illustrated by Dave McKean, Whitewalls (Atlanta, GA), 1996.

Stardust (four volumes), illustrated by Charles Vess, DC Comics, forthcoming.

OTHER

Duran, Duran: The First Four Years of the Fab Five, Proteus (New York City), 1984.

Don't Panic: The Official Hitchhiker's Guide to the Galaxy Companion, Pocket Books (New York City), 1988, second edition, with material by David K. Dickson, published as *Don't Panic: Douglas Adams and The Hitchhiker's Guide to the Galaxy*, Titan, 1993.

Author of the television script for the series *Neverwhere*, BBC-TV, 1996.

■ Adaptations

The "Sandman" series has been optioned for film by Warner Bros.; *The Sandman: Book of Dreams* (DC Comics, 1996), contains short fiction based on Gaiman's characters by writers that include Stephen King, Clive Barker, and Tad Williams.

■ Work in Progress

A book of short fiction for Avon; a screenplay featuring the character "Death."

■ Sidelights

To describe British author Neil Gaiman as a "comic book writer" is to do scant justice to the author of what Frank McConnell calls in *Commonweal* "the best piece of fiction being done these days." As the author of the popular "The Sandman" illustrated prose epic, Gaiman has developed a

strong and devoted following in both his native Great Britain and the United States; his fantasy-based graphic novels, as well as his novels and shorter fiction, are eagerly sought out everywhere from bookstores to independent comic shops, many of which devote a small corner solely to his works. *Locus* writer Edward Bryant distills the reason for Gaiman's transcendent popularity: His work "can intrigue and satisfy dyed-in-the-wool prose chauvinists."

Indeed, the term "comic book" seems inadequate in describing the format in which Gaiman writes. The scripts he composes for his illustrated fantasies transcend the genre; many reviewers have compared them to the work of postmodernist writers like William Burroughs and Thomas Pynchon. Even when viewed within the limits of the graphic novel genre, Gaiman's haunting mythological fictions break molds, shatter assumptions, surprise, startle, and reflect upon their reader a totally new perspective. The central focus throughout each of his works is the relationship between people and story, especially the universal power of myth. "Anyone deploring the lack of innovation in speculative fiction today would be well-advised to seek out Gaiman's work," remarks Elizabeth Hand in the *Washington Post Book World*.

Finds a New Niche in Comic Books

A voracious reader of comics until the age of sixteen, Gaiman grew disillusioned with a genre he felt he had outgrown. The year was 1977, he recalled in an interview with Pamela Shelton for *Authors and Artists for Young Adults (AAYA)*, "and it was coincident . . . with the loss of the writers whose work I liked no longer working in comics. There weren't really many comics being written for people who'd outgrown superheroes and kid-sized supernatural fantasies, which of course is something that there is today. These days if you outgrow Spiderman, there's other stuff you can go on to, but there really wasn't back then." Although he continued to reread the work of Will Eisner, a comic writer/illustrator whose *Spirit* comics had been popular during the 1940s, it wasn't until 1983 that Gaiman discovered the works of an English writer named Alan Moore. "Moore's work convinced me that you really could do work in comics that had the same amount of intelligence, the same amount of passion, the same

amount of quality that you could put in any other medium."

In his first comic work, a forty-eight-page story called *Violent Cases*, Gaiman explores a young boy's imaginative recreation of the world of Depression-era gangster Al Capone. An adult narrator recounts his memories of the early 1960s; as a boy of four, his arm is accidentally fractured by his father. The boy finds himself in the office of an elderly osteopath who tells the impressionable child vivid stories of treating notorious gangland leader Al Capone. For the boy the 1960s and the Chicago of the 1920s begin to intermesh.

Violent Cases was followed by *Black Orchid*, the first of Gaiman's comics scripts to be released by DC Comics. "It was in a lot of ways less of a story and more of a reaction against stories," Gaiman explains of the three-part graphic novel. "I looked at all the things I didn't like in stories and didn't do them." Gaiman didn't care for the normal depiction of women in comics: in *Black Orchid* the heroine is a female character who is completely unique to comics: "vaguely feminist, ecological, essentially nonviolent. I liked the fact that at the end she doesn't get mad and start hitting people. There is an integrity to the story that I really am very proud of."

The Birth of Sandman, Lord of Dreams

In December 1988, almost a year after the release of *Black Orchid*, came "The Sandman." The epic series, which after eight years would ultimately number seventy-five issues and over a million words of script, details the cosmic duties of a family of seven immortals, anthropomorphic representations of the categories of human experience through which we attempt to harness the chaos in which we live: Dream, Desire, Despair, Destiny, Delirium (formerly Delight), Destruction, and Death. Among these "Endless" is the pivotal character, the Sandman, alias Dream, Morpheus, god of sleep, Master of Story. As each of the layered "Sandman" stories unfolds, Gaiman seduces his readers into entering a world of myth, magic, the unexpected, and the previously unexplored.

The Sandman: Preludes and Nocturnes introduces the reader to the ageless Sandman/Dream/Morpheus, who was imprisoned by a malignant English magician in the Arkham Asylum for the Criminally

AND THEN IT CRUMBLED IN HIS HAND.

IT WAS JUST DUST...

SAND,...

A GLITTERING, MULTICOLORED SAND THAT FELL AWAY INTO THE CHILLY WIND AT THE END OF THE WORLD.

A dreamworld turns to dust in Morpheus's hand in *The Sandman: A Game of You.*

Insane in 1916. Finally freeing himself seventy-two years later, Dream returns home to find his palace in ruins and his powers diminished. While on a quest to recover his three tools—a pouch of sand, a helm, and a ruby dreamstone—from mankind, Dream begins to realize that it is more than a lack of tools that has caused his new weakness. As McConnell explains, he "find[s] that he has become somehow tainted—spoiled—altered—by his captivity. Humanized in fact." It is through a character burdened with the knowledge of his own ultimate demise that we enter the world of "The Sandman."

In *The Sandman: A Doll's House*, Dream travels across America searching for the Arcana—stray dreams and nightmares of the twentieth century that have taken on human form. Child abusers and mass murderers people much of this story, and sister Death is never far away. *The Sandman: Dream Country* collects several shorter tales, and characters like Shakespeare and Calliope are featured alongside Morpheus and the other Endless. In *The Sandman: Season of Mists*, Lucifer, having decided to step down as the ruler of Hell, leaves the choice of a successor to Morpheus, who is also determined to rescue his lost love, Nada, from the land of the Dark where he previously condemned her.

In the fifth story, *The Sandman: A Game of You*, Gaiman puts a female in the role of protagonist, giving her the unlikely name of Barbie. Drawn back into the dream realm she ruled over as a child, she must now attempt to save it from the evil Cuckoo, who has assumed Barbie's childhood form and plans the realm's destruction. "*A Game of You* was, in many ways a kind of anti-story," Gaiman notes. "I wanted to look at what reader expectations are; why people go to fantasy, what kinds of fantasies people have." It is also a vehicle whereby he can examine the role that gender plays: "the difference between little-boy fantasies and little-girl fantasies." As in many of the "Sandman" stories, much of the action is violent, but a violence premeditated by an ancient justice. Writing about *A Game of You* in the *Village Voice Literary Supplement*, Erik Davis says, "Gaiman does not make this colorful story-book material 'mature' by clipping its wings with adult rationality or clever deconstructions. He just takes dream logic as far as it will go, right into darkness and blood."

The Sandman: Brief Lives finds Dream and Delirium on a quest to find Destruction, who exiled himself on Earth over three hundred years ago. They enlist the aid of the Greek mythological figure Orpheus, now a head without a body, in helping

them follow the path left in the wake of their brother. In *The Sandman: World's End* a group of travellers take shelter from a "reality storm"—a tempest of otherworldly proportions—in an inn where they share their mystical stories. And in *The Sandman: The Kindly Ones,* the series draws to its destined conclusion as Hippolyta Hall vows revenge against the Lord of Dreams for the disappearance of her son. Driven mad by loss and rage, she gains the help of beings known as the "Kindly Ones" to seek a redress that even Morpheus acknowledges is justified.

Throughout the series, the character of Morpheus remains enigmatic. "He's definitely not human," explains Gaiman. "I mean, he is the personification of dreams. He's the king of the dreaming place where you close your eyes each night and go. And whether he's [good or evil] depends an awful lot on where you're standing. From his own standards, he is always acting for the best, but his moral code and his point of view are not human. And I like that. You know, he's very stand-offish . . . he's a bit stuck-up."

Aiming at Younger Readers

"The Sandman" is written for a mature audience: as Gaiman maintains, "if you're too young for 'Sandman,' you will be bored silly by it. It's filled with long bits with people having conversations." More strongly focused towards a YA audience are *The Books of Magic* and *Death: The High Cost of Living. The Books of Magic* collected the four magazine issues that concern the initiation of a young boy with "powers" into the lore of real magic. It includes cameos by such figures as the Sandman and his sister, Death. "It's a fascinating look at magic, its benefits and burdens," notes *Locus* reviewer Carolyn Cushman, "all dramatically illustrated, and with a healthy helping of humor."

A spin-off of Gaiman's "Sandman" series, *Death: The High Cost of Living* features the Endless who, Gaiman notes, is "the friendliest, nicest, and easiest to get along with." Allowed to return to Earth only once each century—"better to comprehend what the lives she takes must feel like, to taste the bitter tang of mortality"—Death appears in the form of a sixteen-year-old girl who helps Sexton, a teenager contemplating suicide, to rediscover the many simple joys of living. "Gaiman brings a gritty urban contemporaneity to the fantasy genre," writes a *Publishers Weekly* reviewer. "The combination of wry mystic, immortal, and MTV slacker produces an engaging chemistry."

Even though these works are aimed at younger readers, they lack none of the sophistication that Gaiman brings to his other works. "Gene Wolfe, one of my favorite writers in the whole world, once defined good literature as 'that which can be read with pleasure by an educated reader and reread with increased pleasure.' And that's what I've always tried to do: create something that you can read with pleasure, that you can go back to and get more out of. It seems like part of a deal that there should be between a writer and a reader; that you want to give them more than they could get the first time."

In fact, younger readers are among Gaiman's most enthusiastic, and expressive, fans. "What I enjoy most is when people say to me, 'When I was sixteen I didn't know what I was going to do with my life and then I read "Sandman" and now I'm at University studying mythology,' or whatever. I think it's wonderful when you've opened a door to people and showed them things that they never would have been interested in, things that they would never've *known* they would have been interested in." Recognizing his responsibility to his audience, Gaiman considers it a "point of honor" that the history reflected in his fiction is "good history: that the mythology is good, accurate mythology."

Gaiman finds a specific value in introducing readers to mythology, not only the new mythology of Sandman but ancient human mythologies as well. "You gain a cultural underpinning to the last 2500 to 3000 years, which, if you lack it, there's an awful lot of stuff that you will simply never quite understand." As an example, Gaiman cites the seeming impenetrability of the Romantic Poets of the seventeenth and eighteenth centuries: "They assumed in their readers a level of classical education which nobody has anymore." Within "Sandman" even readers unfamiliar with the Norse god Loki or the three-headed spirit of Irish mythology "sort of half-know; there's a gentle and sort of delightful familiarity with these tales. It feels right. And I think that's probably the most important thing," he adds. "Giving people this stuff, pointing out that it can be interesting, but also pointing out what mythologies do know. And how they affect us."

Work in Traditional Prose Yields *Good Omens*

The inventiveness that critics see in Gaiman's graphic novels is also evident in his fantasy collaboration with former fellow journalist Terry Pratchett titled *Good Omens: The Nice and Accurate Prophecies of Agnes Nutter, Witch*. An avid fan of writer Douglas Adams, Gaiman had great fun outlining the origins, development, and phenomenal success of Adams's popular *The Hitchhiker's Guide to the Galaxy* in *Don't Panic: The Official Hitchhiker's Guide to the Galaxy Companion*. After the book was finished, he couldn't fight the temptation to mimic Adams's classic English humor style; he wrote the first 4,000 words of *Good Omens* in early 1988, sent it to a few friends—one being Pratchett—and then put it in a drawer. A year later Pratchett convinced Gaiman to collaborate on the novel. "I'd never written a novel at that point," Gaiman recalls, "so I thought I'd quite like the idea of doing it as an apprentice, with a master craftsmen." Most of the novel was written on the phone: "Terry and I would write our bits,

Morpheus is called to appear before Haroun Al Raschid in Issue #50 from 1993, *The Sandman: Ramadan*.

then we'd have long, long phonecalls during the course of which we'd read each other the bits we'd written and we'd just make each other laugh going over bits that were coming up. The fun was just getting the other one to the point of complete hysteria." Gaiman acknowledges that Pratchett authored sixty percent of *Good Omens*, "mainly because you couldn't stop him writing. It was a delight to write; it was really nine weeks of madness, that book."

In *Good Omens* Gaiman and Pratchett recount how, after six thousand years on earth, Hell decides it's time to send up the Antichrist and jump-start Armageddon—the end of humankind. The slightly tarnished but still angelic Aziraphale and the quasi-demonic Crowley, field agents for Heaven and Hell, respectively, are quite content with their long lives in the "Earthly Paradise" and would prefer not to return to the monotony of their former existences. While written in a slapstick style, full of wordplay, anti-heroic heroes, and a humor that sometimes borders on the sophomoric, *Good Omens* also tackles universal themes. Commending the novel, reviewer Howard Waldrup notes in the *Washington Post* that it "tackles things most science fiction and fantasy writers never think about, much less write."

In addition to *Good Omens*, Gaiman has written several other prose works, including the short story collection *Angels and Visitations*, which, along with 1994's *Mr. Punch* and the "Sandman" epic, he personally counts among his most accomplished works. Indeed, *Mr. Punch* stands out as one of his more concise creative efforts. Contained in a single volume, it follows in the tradition of Gaiman's first work, *Violent Cases*, as a narration by a man who recalls a haunting incident from his childhood and attempts to seek its meaning. "I was fascinated both by family secrets and the weirdness of families; what families are all about," explains Gaiman. "The Punch and Judy story—the incredible violence and the murders and the death in this little puppet

story designed to entertain children—became just a wonderful metaphor for just the relationship between kids and adults, the way that kids perceive the world versus the way that adults perceive the world." The most challenging thing about *Mr. Punch*, which falls into some as-yet-undefined category of literature between comic book and novella, was "trying to write it as if the narrator himself was starting to understand it for the first time while he was talking . . . that he'd known all this stuff but he'd never put it together." Gaiman's work raises introspective questions that the reader is left to ponder. Similarly, *Stardust*, a thought-provoking adult fairy story written by Gaiman and illustrated by Charles Vess, also attempts to bridge the gap between the graphic novel and novel formats. While *Mr. Punch*, with its haunting full-page montages by Dave McKean, *looks* like a comic, Gaiman describes the forthcoming *Stardust* as a "very extensively illustrated novella."

One of Those Kids Who Reads Everything

An intrigued reader of Gaiman's work might well ask, "Where does this all come from?" What kind of kid actually grows up to write fantasy comics? Gaiman's childhood may shed some light on such questions, then again, he is no ordinary scribbler of superhero exploits. Describing himself as "a completely omnivorous and cheerfully undiscerning reader," he admits to getting "very grumpy at school when they'd tell us that we couldn't read comics, because 'if you read comics you will not read OTHER THINGS.'" Gaiman, who had read the entire children's library over a period of about two or three years before starting on the adult library—"I don't think I ever got to 'Z' but I got up to about 'L'"—couldn't help but ask the logical question: "Why are comics going to stop me [from] reading?"

When he was fifteen Gaiman and his schoolmates took a battery of vocational tests, followed the next day by interviews with career advisors who "would look at our tests and say, 'Well, maybe you'd be interested in accountancy,' or whatever. When I went for my interview, the guy said 'What do you want to do?' and I said, 'Well, I'd really, really like to write American comics.' And it was obvious that this was the first time he'd ever heard that. He just sort of stared at me for a bit and then said, 'Well, how do you go about doing

that, then?' I said, 'I have no idea—you're the careers advisor. Advise.' And he looked like I'd slapped him on the face with a wet herring; he sort of stared at me and there was this pause and it went on for a while and then he said, 'Have you ever thought about accountancy?'" With that inspiring careers advice under his belt, Gaiman went on to become a journalist, which "was terrific in giving me an idea of how the world worked. I was the kind of journalist who would go out and do interviews with people and then write them up for magazines. I learned economy and I learned about dialogue."

Comic Books: From Concept to Book-Rack

After working in prose, television script, and comics formats, Gaiman has found comics to be the most challenging. "Frankly, all the three have in common is that they all use the alphabet," he notes. "With prose you're using words to reach into the back of somebody's head and build up pictures and images. It's as if you've put somebody in a dark room and you're talking to them. Its main strength is the fact that everybody is getting an individual experience. On the other hand, it has weaknesses. . . . You can loose immediacy in a book. Unlike a movie, you'll never be on the edge of your seat.

"With a T.V. script, you're writing something that is really a guide. You're giving the lines and you're saying what's happening, but there are hundreds of people involved in the process who will make other decisions about things, from lighting to where the camera is. Although you can suggest and although you can put everything you

If you enjoy the works of Neil Gaiman, you may also want to check out the following books and films:

Douglas Adams, *The Hitchhiker's Guide to the Galaxy Trilogy*, 1990-1992.
Esther Friesner, *Unicorn U*, 1992.
Peter Ustinov, *The Old and Man and Mr. Smith*, 1991.
A Midsummer Night's Dream, Warner Bros., 1935.
The Secret of Roan Inish, First Look Picture, 1994.

have in your head in the script, you know that a lot of it is going to be ignored.

"I think there are probably as many ways to write comics as there are comics writers and any way you do it is right. But the way that I do it is called 'full script.' You start with page one, panel one, and you describe everything in the panel. And you tell the artist what to draw. Then you go on to panel two. And you may well tell them what size the panels are, what kind of feeling you're after, etc." Scriptwriting is incredibly time-consuming: "When I started writing 'Sandman,' it took up two weeks of every month," Gaiman explains; "by the time I finished, it was taking up about six weeks of every month. It is two thousand pages long, which is quite large—four thousand pages of script, well over a million words." Some comics writers also do their own art, but they are in the minority. It takes a lot longer to both write and draw a story, notes Gaiman: "If you stop and think about it, it's kind of like saying that a playwright is somebody who should get up on stage and act everything out."

The Future of Comics

Although the new comics typically found on the racks of comic-book stores find a large audience, readership has begun to decline in recent years as both the biceps and quantity of interchangeable superheroes swell to the point of numbing the enthusiasm of even hard-core comic-book aficionados. What Gaiman would like to see is more comics for more people, for the medium of the illustrated graphic novel to "go legit" and become recognized as a work of serious fiction. "Many years ago, [science fiction writer] Theodore Sturgeon coined Sturgeon's law. And Sturgeon's law is that ninety percent of everything is crap. And its a good kind of touchstone. . . . The trouble is the ten percent. Ten percent of T.V. is good; ten percent of romance novels are probably wonderful . . . but it's the finding them." Gaiman believes that graphic novels are currently in a Golden Age, "And I just wish we could get [them] to the people who'd like them."

Meanwhile, Gaiman remains busy on several projects, including a novel based on his television series, *Neverwhere*, which began airing in Great Britain in the fall of 1996. While many fans have mourned the end of the "Sandman" saga, Gaiman notes that every story must have an ending. His fans can rest assured that any absence he takes from the world of comics will only be temporary. "Comics is my first love," Gaiman maintains, "and I think it's always something that I will go back to."

■ Works Cited

Bryant, Edward, review of *The Sandman: The Books of Magic, Locus,* January 1991, p. 21.

Cushman, Carolyn, review of *The Sandman: The Books of Magic, Locus,* April 1993, p. 29.

Davis, Erik, review of *The Sandman: A Game of You, Village Voice Literary Supplement,* July 8, 1993, p. 10.

Review of *Death: The High Cost of Living, Publishers Weekly,* February 21, 1994, p. 248.

Gaiman, Neil, interview with Pamela Shelton, July, 1996.

Hand, Elizabeth, review of *The Books of Magic, Washington Post Book World,* January 27, 1991, p. 8.

McConnell, Frank, "Epic Comics," *Commonweal,* October 20, 1995, pp. 21-23.

Waldrup, Howard, review of *Good Omens: The Nice and Accurate Prophecies of Agnes Nutter, Witch, Washington Post,* December 20, 1990.

■ For More Information See

BOOKS

Sanders, Joe, "Neil Gaiman," *St. James Guide to Science Fiction Writers,* St. James Press, 1995, pp. 350-52.

PERIODICALS

Analog: Science Fiction/Science Fact, February, 1991, p. 176.

Booklist, May 1, 1988, p. 1469; September 15, 1990, p. 140; March 15, 1992, p. 1364.

Detroit News, March 2, 1996, pp. C1, 4.

Kirkus Reviews, July 15, 1990, p. 950.

Library Journal, September 15, 1990, p. 104; July, 1993, p. 78; August, 1996, p. 120.

Locus, July, 1990, p. 29; November, 1990, p. 57; February, 1991, pp. 38, 39, 42; December, 1991, p. 52; April, 1992, p. 46; June, 1992, p. 15; December, 1993, p. 50.

New York Times Book Review, October 7, 1990, p. 27.

Publishers Weekly, April 1, 1988, p. 79; July 20, 1990, p. 50; February 10, 1992, p. 78; October 11, 1993, p. 54; October 24, 1994, pp. 57-58; March 6, 1995, p. 68; December 11, 1995, p. 15.

School Library Journal, February, 1991, p. 104.

Science Fiction Chronicle, October, 1985, p. 43; July, 1988, p. 42; February, 1991, p. 43; March, 1991, p. 30; November, 1992, p. 34.

Voice of Youth Advocates, August, 1992, p. 174; April, 1995, pp. 15-16.

Wilson Library Bulletin, December, 1990, p. 129.*

—Sketch by Pamela Shelton

Terry Gilliam

■ Personal

Full name, Terry Vance Gilliam; born November 22, 1940, in Minneapolis, MN; immigrated to England, 1967; son of James Hall (a carpenter) and Beatrice (Vance) Gilliam; married Margaret Weston (a makeup artist), 1974; children: Amy Rainbow, Holly du Bois, Harry Thunder. *Education:* Occidental College, B.A., 1962.

■ Addresses

Home—Highgate Village, England.

■ Career

Help! (satirical magazine), New York, NY, associate editor, 1962-64; freelance cartoonist, 1964-65; Carson Roberts Advertising Agency, Los Angeles, CA, copywriter and art director, 1966-67. Worked as freelance illustrator for periodicals, including Sunday edition of *London Times, Nova,* and *Queen,* and as artistic director of *Londoner Magazine,* 1967; worked as sketch writer and creator of animated films for television series *Do Not Adjust Your Set,* as resident cartoonist for television series *We Have*
Ways of Making You Laugh, and as animator for television series *Marty,* all 1968; member of Monty Python's Flying Circus comedy troupe, London, England, 1969, serving as animator, writer, director, producer, and set designer; appeared in *Monty Python's Flying Circus* television series, 1969-74, and in Monty Python theatrical films, 1971-83; co-directed *Monty Python and the Holy Grail,* 1975; made solo directorial debut with *Jabberwocky,* 1977.

■ Awards, Honors

British Academy of Film and Television Arts (BAFTA) Special Award for Graphics, 1969, and Silver Rose Award, Montreaux Television Festival, 1971, both for *Monty Python's Flying Circus;* Grand Prix Special du Jury award, Cannes Film Festival, 1983, for *Monty Python's The Meaning of Life;* Academy Award nomination, best screenplay (with Tom Stoppard), 1985, for *Brazil;* Michael Balcon Award for Outstanding British Contribution to Cinema (with Monty Python), BAFTA, 1987; honorary D.F.A., Occidental College, 1987; honorary D.F.A., Royal College of Art, 1989; Golden Globe Award nomination, best director, 1992, for *The Fisher King.*

■ Films

DIRECTOR

(With Terry Jones; and co-screenwriter and actor) *Monty Python and the Holy Grail,* 1975.
(And co-screenwriter, with Charles Alverson) *Jabberwocky,* Cinema 5, 1977.

(And producer; and co-screenwriter, with Michael Palin) *Time Bandits,* Avco-Embassy, 1981.

(Director of animation, co-screenwriter, and actor) *Monty Python's The Meaning of Life,* Universal, 1983.

(And co-screenwriter, with Tom Stoppard and Charles McKeown) *Brazil,* Universal, 1985.

(And co-screenwriter, with Charles McKeown) *Adventures of Baron Munchausen,* Columbia, 1989.

The Fisher King, Tri-Star, 1991.

12 Monkeys, Universal, 1995.

■ **Writings**

BOOKS

(Compiler, with Harvey Kurtzman) Charles Alverson, *Harvey Kurtzman's Fun and Games,* Fawcett, 1965.

(With Joel Siegel) *The Cocktail People,* Pisani Press, 1966.

(With Monty Python members Graham Chapman, John Cleese, Eric Idle, Terry Jones, and Michael Palin) *Monty Python's Big Red Book,* Methuen, 1972.

(Illustrator) Roger McGough, *Sporting Relations,* Methuen, 1974.

(Under pseudonym Jerry Gillian; with Chapman, Cleese, Idle, Jones, and Palin) *The Brand New Monty Python Bok,* illustrated by Gilliam and Peter Brookes, edited by Idle, Methuen, 1973, published as *The Brand New Monty Python Papperbok,* Methuen, 1974.

(With Chapman, Cleese, Idle, Jones, and Palin) *Monty Python and the Holy Grail (Book),* Methuen, 1977, published as *Monty Python's Second Film: A First Draft,* Methuen, 1977.

(With Lucinda Cowell) *Animations of Mortality,* Methuen, 1978.

(With Chapman, Cleese, Idle, Jones, and Palin) *Monty Python's Life of Brian,* Grosset, 1979.

The Complete Works of Shakespeare and Monty Python, Methuen, 1981.

(With Michael Palin) *Time Bandits,* Hutchinson, 1981, published as *Time Bandits: The Movie Script,* Doubleday, 1981.

(With Chapman, Cleese, Idle, Jones, and Palin) *Monty Python's The Meaning of Life,* Methuen, 1983.

(With Charles McKeown) *The Adventures of Baron Munchausen: The Novel,* Applause Book Publishers, 1989.

SCREENPLAYS; WITH CHAPMAN, CLEESE, IDLE, JONES, AND PALIN

Pythons in Deutschland (television movie), Bavaria Atelier, 1971.

And Now for Something Completely Different, Columbia Pictures, 1971.

Monty Python and the Holy Grail, Cinema 5, 1975.

Monty Python's Life of Brian, Warner Bros., 1979.

Monty Python Live at the Hollywood Bowl, Handmade Films/Columbia Pictures, 1982.

RECORDINGS; WITH MONTY PYTHON

Monty Python's Flying Circus, BBC Records, 1970.

Another Monty Python Record, Charisma, 1971.

Monty Python's Previous Record, Charisma, 1972.

Monty Python Matching Tie and Handkerchief, Charisma, 1973, Arista, 1974.

Monty Python Live at the Theatre Royal, Drury Lane, Charisma, 1974.

The Album of the Soundtrack of the Trailer of the Film of Monty Python and the Holy Grail, Arista, 1975.

Monty Python Live at City Center, Arista, 1976.

The Worst of Monty Python, Kama Sutra, 1976.

The Monty Python Instant Record Collection, Charisma, 1977.

Monty Python's Life of Brian (film soundtrack), Warner Bros., 1979.

Monty Python's Contractual Obligation Album, Arista, 1980.

Monty Python's The Meaning of Life (film soundtrack), CBS Records, 1983.

Monty Python's the Final Ripoff (compilation), Virgin Records, 1988.

■ **Sidelights**

Terry Gilliam has established himself as one of the movie world's most inventive and visionary filmmakers. A veteran of the famous British comedy troupe Monty Python, Gilliam is well known for his outrageous animation work for the group. His cartoons have often been cited as a sort of preview of his own unique filmmaking style. But his work as a director of visually stunning, thought-provoking films has long since eclipsed his output during the Monty Python days. As Michael Wilmington remarked in the *Chicago Tribune,* "Wild, lavish, bursting at the seams, set in outrageously cluttered worlds where past, present and future seem to crisscross delightfully, Gilliam's

films look like nobody else's." Indeed, Gilliam's cinematic efforts, which include *Jabberwocky, Time Bandits, Brazil, The Adventures of Baron Munchausen, The Fisher King,* and *12 Monkeys,* all bear the unmistakable stamp of a man fascinated by mythology, contemporary society, and spectacular—if often nightmarish—imagery.

Gilliam was born in Minneapolis, Minnesota, and raised in California's San Fernando Valley. He developed a love for drawing and movies at an early age and was particularly attracted to the more fanciful tales of adventure that he encountered in libraries and darkened movie theaters. "The movie that got me as a kid, gave me nightmares for years, was *The Thief of Bagdad,*" he said in an interview with Jack Mathews for *American Film.* "They were good nightmares, filled with

wondrous, inventive things. There's something about finding a bottle with a genie in it who can make anything happen."

After graduating from Occidental College in Los Angeles in 1962, Gilliam made his way to New York, where he landed an assistant editor position on a humor magazine called *Help!* The job proved to be an interesting one, he said in an interview with *Contemporary Authors (CA),* "because, at the time, it was the only outlet for a certain kind of young cartoonist. We were the first people to publish Robert Crumb and Gilbert Shelton and an awful lot of the people who subsequently went on to do all the underground comics." It was during his time at *Help!* that Gilliam first met John Cleese, who would later be a fellow member of Monty Python.

The Pythons appearing as favorite characters from the television series: John Cleese holding a dead parrot, Gilliam as the Nude Organist, Terry Jones as a Pepperpot, Graham Chapman as the Colonel, Michael Palin as a Gumby, and Eric Idle in Master of Ceremonies garb.

After three years in New York, Gilliam was weary of the city, so when the magazine stopped publication, the young cartoonist caught a plane for Europe. "I just fell in love with the place," he told *CA*. "It was wonderful." After hitchhiking around the continent for several months, he reluctantly returned to the United States, his savings gone. Following a brief stay in New York, Gilliam relocated to Los Angeles, where he worked in advertising for about a year. He disliked the advertising business, though, and when his English girlfriend expressed a desire to return to Europe, he gladly tagged along.

Having little luck finding a job after arriving in England in 1967, Gilliam called Cleese for help in securing employment. "I was really low—it seemed impossible to get anywhere with magazines, so I called John Cleese and asked him how I could get into television," he told George Perry in *Life of Python*. Cleese directed him to Humphrey Barclay, an executive with the British Broadcasting Corporation (BBC). Barclay was interested in the young artist's cartoon design experience, but it was not until Gilliam started working with Michael Palin, Terry Jones, and Eric Idle on a television show for children called *Do Not Adjust Your Set* that his career began to take off.

Before long the four of them, along with Graham Chapman and John Cleese, decided to create a new comedy show for television. Gilliam noted in *CA* that "John was the best known of everyone. He had a standing invitation from the BBC to do a show whenever he wanted to. He took the opportunity and said, 'There's five other people and myself who want to do a show. We don't know exactly what it's going to be, but it'll be funny.'"

Monty Python Days

Monty Python's Flying Circus was launched by the BBC in 1969, and it was an immediate hit in England. (It was similarly successful in the United States, where PBS began showing episodes in 1974.) Over the course of the next decade the Monty Python comedy troupe proved an incredibly prolific and daring gang, producing countless outrageous skits and a number of popular motion pictures, including *Monty Python and the Holy Grail* (1975), *Monty Python's Life of Brian* (1979), and *Monty Python's The Meaning of Life* (1983).

Monty Python humor was unlike anything that had been seen before on television. As Thomas Meehan observed in the *New York Times Magazine* in 1976, "unlike almost all other comedians these days, on TV or elsewhere, the Pythons are shamelessly willing to go in for absolute nonsense . . . to be not only utterly silly but often in outrageously bad taste. . . . Yet part of their infinite charm is that they're willing to try almost anything and to lampoon just about anyone."

The members of the group also cited their determination to please themselves as a big reason for their success. As Gilliam said in an interview with Tony DeSena in *Aquarian*, "We don't really care [what the fans want]. It sounds arrogant but it's also honest. We don't know or care about demographics. We write totally for ourselves, what *we* think is funny. We never take into consideration anyone else."

Gilliam—whom the other members of the troupe jokingly called their "token American"—made few on-screen appearances himself, content to let Cleese, Palin, and the other Pythons dominate the group's skits. Instead, Gilliam contributed bizarre, surrealistic cartoons that often served as bridges from one skit or movie segment to the next. "A lot of the cartoons I did for Python were very disturbing. There's a lot of anger, anarchy and nihilism along with the bright colors and silly pictures," he admitted to Leslie Bennetts of the *New York Times*. "You hope you can reach people on different levels. There's the odd dodo out there who just likes color and noise, and if people want to look at the surface, it's an entertaining surface, but if they want to look deeper there are other things going on." Other members of Monty Python recognized that a vibrant, wildly talented artist was lurking behind those alternately silly and sinister cartoons. As Palin once said, "It's the most wild and exciting part of Python, I think, the Gilliam edge. If Python was made up of six Gilliams, there would be this total explosion of creativity and bits of Pythons splattered all over the walls."

In 1977 Gilliam took his first step into the world of film direction with *Jabberwocky*, a medieval fantasy based on the Lewis Carroll poem of the same name. Most critics thought that the film did not measure up to Monty Python's more inspired work, but in 1981 Gilliam's second feature film, *Time Bandits*, received praise from both critics and

Gilliam's animation for the "Legendary Black Beast of Arrrghhh" from *Monty Python and the Holy Grail*.

moviegoers. A rollicking tale of a boy who is taken on a crazy, whirlwind tour through time by a small group of adventurous dwarves, *Time Bandits* is, as *Newsweek*'s David Ansen ventured, "a teeming and original stew that stirs in many genres and moods." A mixture of both light-hearted fantasy and dark surrealism, the film was a surprise box office hit. Some people worried that its content was too intense for youngsters, but the director dismissed such concerns. "Fairy tales used to frighten kids," he told *People* writer Jerene Jones. "They were wonderful to experience—and come out alive. I don't like *Sesame Street*—too bland and nice. We're correcting the balance a little."

Brazil Brings Controversy

In 1985 Gilliam completed work on *Brazil*, a black comedy set in a nightmarish near-future; the film follows a man's efforts to survive a dark world festooned in red tape, faceless administrative nonsense, awful pollution, and social isolation. *Brazil* is now regarded as a cult classic, but when the executives at Universal Pictures—the studio that had hired Gilliam to direct the picture—first saw the finished product, they were horrified. Universal refused to release the film unless Gilliam made some dramatic changes to it. Outraged, Gilliam refused, and the two sides became deadlocked. Gilliam finally arranged for his version of *Brazil* to be shown to the members of the Los Angeles Film Critics Association. The critics were so impressed by the film that they gave it their year-end awards for best picture, best director, and best screenplay. The accolades embarrassed Universal into releasing Gilliam's original version of the picture.

Critics around the country found *Brazil* to be a terrifically imaginative film. *New York Times* critic Janet Maslin called it "a jaunty, wittily observed vision of an extremely bleak future" and considered it "a superb example of the power of comedy to underscore serious ideas, even solemn ones." *Rolling Stone* critic Peter Travers agreed, citing it as "the most stinging comic indictment yet of the corporate mentality."

Heartened by *Brazil*'s critical reception and its respectable box office earnings, Gilliam tackled his next assignment with typical enthusiasm and energy. *The Adventures of Baron Munchausen* (1989) is an adventure fantasy set in the late eighteenth century, "a tall tale about a teller of tall tales," wrote the *Washington Post*'s Hal Hinson. As with his earlier efforts, many critics were bowled over by the sheer power of Gilliam's imagination. "*Baron Munchausen* is full of moments that dazzle, just for the fun of seeing the impossible come to life on the screen," wrote *New York Times* critic Vincent Canby. *Washington Post* contributor Desson Howe agreed, calling the movie a "brilliantly inventive epic of fantasy and satire."

Others, though, thought that *Baron Munchausen* was too chaotic and confusing for its own good. The mixed critical reception of the film, along with its disappointing ticket sales and higher-than-expected cost (budgeted for $23 million, it cost more than $40 million to make), made studio executives increasingly wary of the Monty Python alumnus. As long as his movies were profitable, the executives tried to accept Gilliam's uncompromising filmmaking vision. *Baron Munchausen*'s poor box office performance, however, made some observers wonder about Gilliam's filmmaking future.

For his part, Gilliam—who had always written the screenplays for his movies in the past—announced that he was "tired of defending his own ideas and was ready to direct someone else's work," wrote Elizabeth Drucker in *American Film*. A short time later, he read a screenplay by Richard LaGravenese that rekindled his excitement. "The moment I read [the screenplay], it was like, jeez, why didn't *I* write this?" he told Drucker. "The ideas, the characters—I understood everything."

Critical and Popular Acclaim

LaGravenese's screenplay became the basis for *The Fisher King*, a 1991 film starring Jeff Bridges and Robin Williams. Bridges plays a callous radio disc jockey whose on-air remarks trigger an explosion of violence, while Williams portrays a man victimized by that violence. The film, which also incorporates elements of myth and legend into the story of the relationship that develops between these two wounded characters, was one of the year's most popular movies with both audiences and reviewers. Travers observed that the film "betrays a drift toward the mainstream" for Gilliam, but noted that the director "is too mad-dog ballistic to make peace with convention for long. At its most outrageously entertaining, the film sweeps

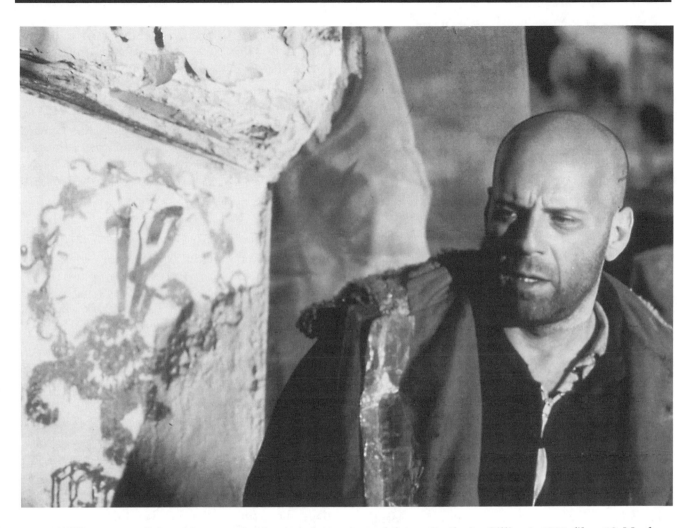

Bruce Willis stars as Cole, a time-traveler from a plague-ravaged future Earth, in Gilliam's 1995 film, 12 *Monkeys.*

you up on waves of humor, heartbreak and ravishing romance. It also bloodies itself in Gilliam's favorite battles: imagination versus logic, love versus hate, art versus commerce." *Newsweek*'s David Ansen praised the film as well, noting that while Gilliam's "dark, prankish satirical vision pervades this story, at the end of this sometimes harrowing tunnel is a glowing romantic light. . . . *The Fisher King* veers with great assurance from wild comedy to feverish fantasy, robust romanticism and tough realism—with only an occasional stumble." Some reviewers were more critical of the movie, but most concluded that its strengths outweighed its weaknesses. *Time*'s Richard Corliss, for instance, wrote that "some big emotional moments are bungled or botched. . . . At heart [it's] a buddy movie." Yet in the end Corliss said that the film contains "pleasures galore" and admitted, "A million reservations notwithstanding, I like *The Fisher King*." Travers also had a few quibbles

with the film, but he concluded: "So what if it's not perfect? It's magic."

The Fisher King, like all of Gilliam's previous works, boasted an easily recognizable appearance and tone that distinguishes his output from that of other directors. Ansen wrote in *Newsweek* that "you can watch only 10 minutes of *The Fisher King* and spot it as the work of Terry Gilliam: he leaves his eccentric stylistic footprints on every frame." Indeed, *The Fisher King* seemed to mark a certain turning point in people's perceptions of Gilliam. While cautioning that his films have not always matched his filmmaking ambition, many reviewers increasingly hailed his vision and his sense of daring.

People who have worked with Gilliam agree that he is an amazingly inventive and original director. Actor Bruce Willis marveled that "he has the

If you enjoy the works of Terry Gilliam, you may also want to check out the following books and films:

Allen Appel, *Till the End of Time*, 1990.
Madeline L'Engle, *A Wrinkle in Time*, 1962.
Robert Rice, *The Last Pendragon*, 1991.
T. H. White, *The Once and Future King*, 1958.
Blade Runner, Warner Bros., 1982.
1984, Atlantic Releasing, 1984.
Vertigo, Paramount, 1958.

entire film shot in his head when he gets to the set"; Mathews, writing in *American Film*, recalled that a producer once said: "To make the perfect Terry Gilliam film, you'd have to open the top of his head and pour the contents onto the screen."

For his part, Gilliam attributes his success to his determination and energy. "My greatest strength is my sheer stamina to get things made," he told Gene Siskel of the *Chicago Tribune*. "My great weakness is my ability to convince myself and everyone that I can do something, which sometimes I can't do. But even that fault helps get the films made. And that's all that matters to me." Indeed, Gilliam's devotion to his profession is even reflected in his home, a restored sixteenth-century mansion north of London that was once the home of English philosopher Sir Francis Bacon. Strange souvenirs or inspirational pieces from Gilliam's films can be found throughout the house, and even the ceiling of the master bedroom has been painted to match the beautiful sky that serves as a symbol for escape in his film *Brazil*. When asked by Siskel about his decision to live in England, Gilliam replied, "I choose to live in England because I'm tired of how simple-minded everything is becoming in American culture. For example, I don't like the way you give thumbs up and thumbs down to a movie. Films are more complex than that."

Another Fable of Apocalypse

In 1995, four years after the release of *The Fisher King*, Gilliam unveiled *12 Monkeys*, a dark tale about a convict named Cole (played by Bruce Willis) struggling for his life in the year 2035. Cole is sent back in time to the end of the twentieth century to try and find the source of a deadly virus that killed most of civilization and forced the survivors into an underground existence. Dismissed as insane by medical authorities, the convict meets two key people during his stay in a mental institution—a fellow patient (played by Brad Pitt) and a psychiatrist (Madeleine Stowe). As the story unfolds, the psychiatrist comes to believe Cole's claims that he comes from the future; meanwhile, Cole decides that he really is delusional.

A great success at the box office, the apocalyptic thriller further cemented Gilliam's reputation in the critical community. "The pleasure of *12 Monkeys* lies in the way Terry Gilliam plugs us so deeply into the moods that he creates that we find ourselves making the same hallucinatory leaps that Cole does," said *Entertainment Weekly* reviewer Owen Gleiberman. "Gilliam . . . turns a world falling apart into a funky, dizzying spectacle." *San Francisco Examiner* reviewer Barbara Shulgasser added that "Gilliam applies [a] fierce visual talent to a ripping story."

Gilliam was also credited with bringing out the best in his two lead actors, Willis and Pitt. "I liked the idea of altering the public's perception of both Bruce and Brad," he said in an online interview sponsored by Universal Pictures. "It was potentially dangerous and even disastrous if they had failed. But they didn't." Giving the principal role to Willis, an actor known primarily for parts in he-man action movies, was particularly risky, but Gilliam reflected, "I thought that if he could divest himself of his smart-ass tricks and clever attitudes he might be able to find the lonely lost but extremely dangerous style deep inside him that was James Cole."

With successes like *Brazil*, *The Fisher King*, and *12 Monkeys* under his belt, Gilliam is free to pursue just about any project he chooses. After *12 Monkeys* was released, he was asked by the *New York Times*'s Jill Gerston what his next film might be, but Gilliam was coy. "I'm very fearful of talking about several things I have floating around, because whenever I do, they don't happen. A couple of things are pretty heavy, and I was thinking maybe I should do something light. A comedy would be nice so I can be silly again and have fun."

In the past, Gilliam has also spoken of trying his hand at writing children's books. Such a possibil-

ity seems entirely in keeping with his persona. Gerston noted that a co-producer of *The Fisher King* once called Gilliam "the oldest living adolescent in the world," and Mathews wrote that "much about Gilliam is childlike: the wildly animated expressions that appear on a face which expands like Play-Doh; the explosive staccato laugh; and even his dress, a flaunting casualness punctuated with such things as electric orange Reeboks." But for the time being, the children's books will have to wait. "I never seem to find the time to sit down and concentrate on them," he told *CA.* "At the moment I like things that move and make noise, and that unfortunately keeps me involved with film. Perhaps when I'm old and too weak to do anything else I'll while away my autumn years churning out evil nonsense for kiddies. Either that or rewriting *War and Peace.*"

■ Works Cited

Ansen, David, "The Holy Grail in the Unholy City," *Newsweek,* September 23, 1991, p. 57.

Bennetts, Leslie, "How Terry Gilliam Found a Happy Ending for *Brazil,*" *New York Times,* January 19, 1986, Section 2, pp. 15-16.

Canby, Vincent, "How a Notorious Liar Might Have Lived," *New York Times,* March 10, 1989, p. C8.

Contemporary Authors, Volume 113, Gale, 1985.

Contemporary Authors New Revision Series, Volume 35, Gale, 1991.

Corliss, Richard, "Words of One Syllabus," *Time,* September 23, 1991, p. 68.

DeSena, Tony, "An Interview with Graham Chapman and Terry Gilliam," *Aquarian,* July 21-28, 1982, pp. 19, 28.

Drucker, Elizabeth, review of *The Fisher King, American Film,* September/October, 1991, pp. 50-51.

Gerston, Jill, "Terry Gilliam: Going Mainstream (Sort Of)," *New York Times,* December 24, 1995, pp. 9, 28.

Gleiberman, Owen, "Number of the Beasts," *Entertainment Weekly,* January 12, 1996.

Grossberger, Lewis, "Monty Python," *People,* August 2, 1982, pp. 46-48, 53-55.

Hinson, Hal, review of *The Adventures of Baron Munchausen, Washington Post,* December 7, 1989, p. E7.

Howe, Desson, "Red-Hot Baron," *Washington Post,* March 24, 1989.

Jones, Jerene, "The Only Yank in Monty Python Stares Down Critics as His *Time Bandits* Steals $24 Million," *People,* December 21, 1981, p. 50.

Maslin, Janet, "A Cynic's Quest for Forgiveness," *New York Times,* September 20, 1991, p. C10.

Mathews, Jack, "Earth to Gilliam," *American Film,* March, 1989, pp. 34-39, 56-58.

Meehan, Thomas, "And Now for Something Completely Different," *New York Times Magazine,* April 18, 1976, pp. 34-36.

Perry, George, *Life of Python,* Little, Brown, 1983.

Shulgasser, Barbara, "Grim, Gritty Story of Fatal Virus," *San Francisco Examiner,* January 5, 1996, p. C1.

Siskel, Gene, "Visual Overlord," *Chicago Tribune,* March 12, 1989, Section 13, pp. 8-9.

Travers, Peter, "That Old Black Magic," *Rolling Stone,* October 17, 1991.

Vincent, Mal, "Interview: Terry Gilliam on *12 Monkeys,*" *Virginian-Pilot,* 1995, article reprinted on Pilot Online, January 1, 1996.

Wilmington, Michael, "Worlds in Collision," *Chicago Tribune,* January 14, 1996, pp. 8-9.

Information was also used from Universal V/IP *12 Monkeys* online Web Chat interview, January 4, 1995.

■ For More Information See

BOOKS

Hewison, Robert, *Monty Python: The Case Against,* Methuen, 1981.

Johnson, Kim Howard, *The First 200 Years of Monty Python,* St. Martin's, 1989.

Mathews, Jack, *The Battle of Brazil,* Crown, 1987.

PERIODICALS

Chicago Sun-Times, January 5, 1996.

Entertainment Weekly, October 20, 1995, p. 36.

Gentlemen's Quarterly, March, 1989, p. 155.

New Republic, October 21, 1991, p. 27.

New York Times, November 6, 1981; November 13, 1981; May 21, 1982; June 25, 1982; January 9, 1983; March 31, 1983; June 24, 1983; December 18, 1985.

People, January 8, 1996; February 5, 1996, p. 128.

Premiere, May, 1991, pp. 86-92.

Time, January 8, 1996.*

—Sketch by Kevin Hillstrom

Ernest Hemingway

■ Personal

Born July 21, 1899, in Oak Park, Illinois; committed suicide, July 2, 1961, in Ketchum, Idaho; son of Clarence Edmonds (a physician) and Grace (a music teacher; maiden name, Hall) Hemingway; married Hadley Richardson, September 3, 1921 (divorced March 10, 1927); married Pauline Pfeiffer (a writer), May 10, 1927 (divorced November 4, 1940); married Martha Gellhorn (a writer), November 21, 1940 (divorced December 21, 1945); married Mary Welsh (a writer), March 14, 1946; children: (first marriage) John Hadley Nicanor; (second marriage) Patrick, Gregory. *Education:* Educated in Oak Park, Illinois.

■ Addresses

Ketchum, Idaho, and Finca Vigia, Cuba.

■ Career

Writer, 1917-61. *Kansas City Star,* Kansas City, MI, cub reporter, 1917-18; ambulance driver for Red Cross Ambulance Corps in Italy, 1918-19; Cooperative Commonwealth, Chicago, IL, writer, 1920-21; *Toronto Star,* Toronto, Ontario, Canada, covered Greco-Turkish War, 1920, European correspondent, 1921-24; covered Spanish Civil War for North American Newspaper Alliance, 1937-38; war correspondent in China, 1941; war correspondent in Europe, 1944-45.

■ Awards, Honors

Pulitzer Prize, 1953, for *The Old Man and the Sea;* Nobel Prize for Literature, 1954; Award of Merit from American Academy of Arts & Letters, 1954.

■ Writings

NOVELS

The Torrents of Spring: A Romantic Novel in Honor of the Passing of a Great Race (parody), Scribner, 1926, published with a new introduction by David Garnett, J. Cape, 1964, reprinted, Scribner, 1972.

The Sun Also Rises, Scribner, 1926, published with a new introduction by Henry Seidel Canby, Modern Library, 1930, reprinted, Scribner, 1969 (published in England as *Fiesta,* J. Cape, 1959).

A Farewell to Arms, Scribner, 1929, published with new introductions by Ford Madox Ford, Modern Library, 1932, Robert Penn Warren, Scribner, 1949, John C. Schweitzer, Scribner, 1967.

To Have and Have Not, Scribner, 1937, J. Cape, 1970.

For Whom the Bell Tolls, Scribner, 1940, published with a new introduction by Sinclair Lewis, Princeton University Press, 1942, reprinted, Scribner, 1960.

Across the River and Into the Trees, Scribner, 1950, reprinted, Penguin with J. Cape, 1966.

The Old Man and the Sea, Scribner 1952.

Islands in the Stream, Scribner, 1970.

The Garden of Eden, Scribner, 1986.

SHORT STORIES, EXCEPT AS INDICATED

Three Stories & Ten Poems, Contact (Paris), 1923.

In Our Time, Boni & Liveright, 1925, published with additional material and new introduction by Edmund Wilson, Scribner, 1930, reprinted, Bruccoli, 1977 (also see below).

Men Without Women, Scribner, 1927.

Winner Take Nothing, Scribner, 1933.

Fifth Column and the First Forty-nine Stories (stories and a play), Scribner, 1938, stories published separately as *First Forty-nine Stories,* J. Cape, 1962, play published separately as *The Fifth Column: A Play in Three Acts,* Scribner, 1940, J. Cape, 1968 (also see below).

The Short Stories of Ernest Hemingway, Scribner, 1938.

The Snows of Kilimanjaro and Other Stories, Scribner, 1961.

The Short Happy Life of Francis Macomber and Other Stories, Penguin, 1963.

Hemingway's African Stories: The Stories, Their Sources, Their Critics, compiled by John M. Howell, Scribner, 1969.

The Nick Adams Stories, preface by Philip Young, Scribner, 1972.

(Contributor) Peter Griffin, *Along With Youth* (biography that includes five previously unpublished short stories: "Crossroads," "The Mercenaries," "The Ash-Heel's Tendon," "The Current," and "Portrait of the Idealist in Love"), Oxford University Press, 1985.

The Complete Short Stories of Ernest Hemingway: The Finca Vigia Edition, Scribner, 1987.

OTHER

in our time (miniature sketches), Three Mountain Press (Paris), 1924 (also see above).

Today Is Friday (pamphlet), As Stable Publications (Englewood, NJ), 1926.

Death in the Afternoon (nonfiction), Scribner, 1932.

God Rest You Merry Gentlemen, House of Books, 1933.

Green Hills of Africa (nonfiction), Scribner, 1935, reprinted, Penguin with J. Cape, 1966.

The Spanish Earth (commentary and film narration), introduction by Jasper Wood, J. B. Savage (Cleveland, OH), 1938.

The Spanish War (monograph), Fact, 1938.

(Editor and author of introduction) *Men at War: The Best War Stories of All Time* (based on a plan by William Kozlenko), Crown, 1942.

Voyage to Victory, Crowell-Collier, 1944.

The Secret Agent's Badge of Courage, Belmont Books, 1954.

Two Christmas Tales, Hart Press, 1959.

A Moveable Feast (reminiscences), Scribner, 1964.

Collected Poems, Haskell, 1970.

The Collected Poems of Ernest Hemingway, Gordon Press, 1972.

Ernest Hemingway: Eighty-Eight Poems, Harcourt, 1979.

Ernest Hemingway, Selected Letters, 1917-1961, Scribner, 1981.

Complete Poems, edited by Nicholas Gerogiannis, University of Nebraska Press, 1983.

Hemingway on Writing, Scribner, 1984.

The Dangerous Summer (nonfiction), introduction by James A. Michener, Scribner, 1985.

Conversations With Ernest Hemingway, University Press of Mississippi, 1986.

OMNIBUS VOLUMES

The Portable Hemingway (contains *The Sun Also Rises, A Farewell to Arms, To Have and Have Not, For Whom the Bell Tolls,* and short stories), edited by Malcolm Cowley, Viking, 1944.

The Essential Hemingway (contains one novel, novel extracts, and twenty-three short stories), J. Cape, 1947, reprinted, 1964.

The Hemingway Reader, edited with foreword by Charles Poore, Scribner, 1953.

Three Novels: The Sun Also Rises, A Farewell to Arms, and The Old Man and the Sea, each with separate introductions by Malcolm Cowley, Robert Penn Warren, and Carlos Baker, respectively, Scribner, 1962.

The Wild Years (collection of journalism), edited by Gene Z. Hanrahan, Dell, 1962.

By-line, Ernest Hemingway: Selected Articles and Dispatches of Four Decades, edited by William White, Scribner, 1967.

Fifth Column and Four Stories of the Spanish Civil War, Scribner, 1969 (also see above).

Ernest Hemingway, Cub Reporter: Kansas City Star Stories, edited by Matthew J. Bruccoli, University of Pittsburgh Press, 1970.

Ernest Hemingway's Apprenticeship: Oak Park, 1916-1917, edited by Bruccoli, Bruccoli Clark NCR Micro-card Editions, 1971.

The Enduring Hemingway: An Anthology of a Lifetime in Literature, edited by Charles Scribner, Jr., Scribner, 1974.

Dateline—Toronto: Hemingway's Complete Toronto Star Dispatches, edited by White, Scribner, 1985.

Hemingway at Oak Park High: The High School Writings of Ernest Hemingway, 1916-1917, Alpine Guild, 1993.

■ Adaptations

Several of Hemingway's works have been adapted for motion pictures, including *A Farewell to Arms*, Paramount, 1932, Twentieth-Century Fox, 1957; *For Whom the Bell Tolls*, Paramount, 1943; *To Have and Have Not*, Warner, 1945, as *The Breaking Point*, Warner, 1950, as *The Gun Runners*, United Artists, 1958; *The Killers*, Universal-International, 1946, 1964, and as *A Man Alone*, Republic, 1955; *The Macomber Affair*, United Artists, 1947; *The Snows of Kilimanjaro*, Twentieth-Century Fox, 1952; *The Sun Also Rises*, Twentieth-Century Fox, 1957; and *The Old Man and the Sea*, Warner Bros., 1958.

■ Sidelights

Few writers have made their mark on American letters and American culture like Ernest Hemingway. Bursting on the American literary scene in 1925 with the publication of the short story collection *In Our Time*, Hemingway announced himself as a major literary presence and the progenitor of a new prose style. Within a few years the publication of more short stories and a stunning first novel, *The Sun Also Rises*, had secured his reputation as a writer. Hemingway's best writing came out of the 1920s, but his near-mythic public persona—part big-game hunter, part Hollywood hobnobber, part war correspondent, and all-around tough guy—developed in the 1930s and 1940s, when he was a darling of the magazines and an international traveler. Though the quality of his writing deteriorated with the passing years, he won the Nobel Prize in 1954 before ending his own life in 1961. Even after his death, however, Hemingway continued to influence the direction of American writing, for he had established a style so easily recognizable yet so difficult to copy that every short story writer since has had to grapple with his ghost. His work has influenced the style of writers as different as Norman Mailer, Thomas Pynchon, and Raymond Carver.

Hemingway's achievements were great—nearly alone, he established a new standard for precision and clarity in the short story—but they were made all the greater by the fact that Hemingway seemed to catch the very spirit of his age. Born just before the turn of the century, Hemingway identified himself with a new "modern" generation, one that had lost touch with the values of a declining Victorian culture and would struggle to articulate values of its own. Hemingway traveled to Paris, France, where he became part of a group of famous writers and artists that included Gertrude Stein, James Joyce, Ezra Pound, and F. Scott Fitzgerald. These writers helped define Modernist literature and epitomized the rejection of the past. For his part, Hemingway wrote of individuals dislocated and disoriented by a social system that no longer made sense; he depicted characters, usually men, who turned in upon themselves to develop the skills to survive in the modern world, thus reinventing American individualism for a new age; and he did it all in a style so compact and exacting that it became a challenge he threw in the face of every other living writer. In the end the challenge of his philosophy and his style proved too great for even him to endure, and when he finally recognized that he could no longer write well, he placed a shotgun to his head and fired.

"Broad Lawns and Narrow Minds"

Ernest Miller Hemingway was born on July 21, 1899, the son of Dr. Clarence Hemingway, a general practitioner, and Grace Hall Hemingway, a trained opera singer and strong-willed feminist whose income from teaching singing was larger than her husband's. The family lived in a large house in the prosperous Chicago suburb of Oak Park, a neighborhood made famous by the architecture of native son Frank Lloyd Wright. For many years, Hemingway was the lone boy in a family of girls; his companions until he was fifteen were his four sisters. Most of Hemingway's biographers depict his childhood as idyllic, at least on the surface. Hemingway attended good schools

and spent many summers at the family's cabin on Walloon Lake in Michigan. He graduated from Oak Park High School in 1917 with a strong academic background and a busy extracurricular record, having played cello in the orchestra, been a member of the football and swimming teams, and written for the school's newspaper and literary magazine.

Hemingway's own accounts of his childhood, usually filtered through his fictional stories of a boy summering in Michigan, depict a struggle with parents who had very strong yet very different personalities. Grace Hemingway dominated her family, dictating the flow of family life and insisting that her children be educated in dance and the arts. She was by all accounts a dramatic woman, eager to draw attention to herself and less inclined to give attention to her children. Yet she never gave Ernest the unqualified love that he

seems to have wanted. When Ernest sent her a copy of the first book he published, she returned him a newspaper notice of an exhibition of her paintings; when *The Sun Also Rises* met with critical acclaim, Grace labeled it "one of the filthiest books of the year."

Clarence Edward Hemingway, known to friends as Ed, was a dedicated doctor and an equally dedicated Christian. Susan F. Beegel, writing in the *Dictionary of Literary Biography*, described him as "a pillar of the local Congregational church," adding that "he had a piety that was sometimes indistinguishable from intolerance, and his opposition to smoking, drinking, dancing, and cardplaying left his children socially isolated." A strict and demanding parent, Dr. Hemingway once forced young Ernest to cook and eat a porcupine he had killed in order to teach his son a lesson about killing harmless animals. Yet Ernest held a great

Once the home of Hemingway in Key West, Florida, this two-story Spanish colonial was turned into a museum-shrine in 1965.

love for his father, who also taught him to love the outdoors and to develop the observant habits of the naturalist. Dr. Hemingway loved to hunt and fish, and was happiest in the Michigan woods.

As Hemingway grew older his love for and identification with his father could only have troubled him, for the elder Hemingway also bequeathed to his son a history of mental illness. As he aged, Dr. Hemingway was increasingly subject to depression, anxiety, and even paranoia; his fits of rage and his delusions took their toll on members of his family, who never knew what to expect from him. In 1928, the fifty-seven-year-old Dr. Hemingway shot himself in the head with a pistol, setting an example that three of his six children, including Ernest, would eventually follow.

Hemingway fictionalized the twisted relationships between him and his parents in several short stories; though Hemingway insisted to his death that his stories were not strictly autobiographical, the correlations between fiction and life are so close that critics and biographers have used these stories as insights into the psyche of the author. In "The Doctor and the Doctor's Wife," a story from *In Our Time,* for example, the doctor's wife is depicted as a pious nag, eager to control her husband and her son, while the doctor appears disciplined and willing to help his son elude the snares of his wife. Seen from the viewpoint of the son, Nick, the father provides an example of courage and an escape from a corrupting mother. Yet Hemingway never painted his father as a saint; in another story from *In Our Time* titled "Indian Camp," in which Nick's father helps an Indian woman deliver a baby while her husband slits his throat in the bunk above her, the father maintains an icy calm that borders on racist disregard. The father, it seems, is quite capable of having no feeling at all for other human beings. Other such stories, including "Fathers and Sons," "Now I Lay Me," and "Soldier's Home," have also provided fodder for analysts trying to understand Hemingway's feelings about his parents.

Glory Bound

When the United States entered World War I on April 4, 1917, Hemingway felt that pull of potential heroism that drew so many young American men. Not yet graduated from high school, he longed to join the army, but poor eyesight, his father's refusal to give his permission, and his parents' desire that he attend college all kept him home. Hemingway had no interest in college, however, and that fall he took a job with the *Kansas City Star,* covering the police and hospital beat. It was good training for a youth who had begun to aspire to be a writer: the paper's style sheet demanded precision and brevity, and its editors knocked their young reporter's prose into shape. After six months at the *Star,* Hemingway found another way to get close to the glory of war when he volunteered for duty as an ambulance driver for the Red Cross in Europe. What he was about to experience would forever shape him.

Arriving in a Paris decimated by German bombing, Hemingway was soon sent to the Italian front. In Milan he pulled body fragments from the devastation of a munitions factory; near Monte Pasubio he piloted an aging Fiat ambulance on steep mountain roads. Near midnight on July 8, 1918, as Hemingway delivered supplies to Italian soldiers near Fossalta di Piave, an Austrian shell exploded nearby, spraying fragments of blistering metal across his legs. Despite his injuries, Hemingway tried to drag an Italian soldier to safety, only to be hit by machine gun fire in his leg and foot. Badly wounded, he was carried to a ruined stable to await evacuation, then transported to a hospital in Milan. According to Peter Hays, writing in *Ernest Hemingway,* "He was the first American to be wounded in Italy and survive, and American newspapers made a hero of him."

Hemingway returned again and again to his war experiences and especially to his wounding, both in short stories and in the novel *A Farewell to Arms,* written in 1929. In the latter, Hemingway replays the scene of his wound, recreating it as the signal event in the life of the novel's hero, Frederic Henry:

Then there was a flash, as when a blast-furnace door is swung open, and a roar that started white and went red and on and on in a rushing wind. I tried to breathe but my breath would not come and I felt myself rush bodily out of myself and out and out and out and all the time bodily in the wind. I went out swiftly, all of myself, and I knew I was dead and that it had all been a mistake to think you just died.

Hemingway had the good luck to recuperate in a new American Red Cross hospital converted from

an Italian villa. There the patients were tended by attentive nurses and brought back to health with a steady diet of cocktails and soft music. In the three months he was there, Hemingway fell in love with and pursued a nurse named Agnes von Kurowsky. Though Kurowsky enjoyed the attention, she found Hemingway too serious, too ardent, and, after agreeing to travel to the United States to marry him, she sent him a letter ending their relationship. Their romance, if not its conclusion, is also fictionalized in the love story between Henry and Catherine Barkley in *A Farewell to Arms*.

Hemingway returned to Oak Park a war hero, decorated with Italian medals and full of stories of battle and romance. Moreover, during his time in the hospital he had decided that he would be a writer, and he began to write and submit stories to magazines like the *Saturday Evening Post*, the most popular magazine of the day. While he enjoyed the brief adulation of family and peers, his parents soon made it clear that they didn't want to support him while he wrote. When Hemingway spent the summer of 1920 at the cabin on Walloon Lake hunting, fishing, swimming, and writing, his parents accused him of being a "sponger" and his mother wrote a letter asking him to leave home. Hemingway never forgave her.

One of Hemingway's most powerful and disturbing stories, "Soldier's Home," relates the story of Harold Krebs, who has returned from war to his family home only to find that no one recognizes the trauma he has been through. Hemingway expertly evokes the tension between mother and son through compressed dialogue and carefully selected visual detail:

"Have you decided what you are going to do yet, Harold?" his mother said, taking off her glasses.
"No," said Krebs.
"Don't you think it's about time?" His mother did not say this in a mean way. She seemed worried.
"I hadn't thought about it," Krebs said.

The exchange continues, reaching its emotional peak with this exchange:

"I've worried about you so much, Harold," his mother went on. "I know the temptations you must have been exposed to. I know how weak men are. I know what your own dear grandfather, my own father, told us

about the Civil War and I have prayed for you. I pray for you all day long, Harold."

Krebs looked at the bacon fat hardening on his plate.

With this exchange echoing in his head, Krebs decides to move away. This scene is vintage Hemingway, a story that many critics point to when trying to explain what Hemingway achieved in creating a new style of writing. Shearing his prose of every excess word, especially of adverbs and adjectives, Hemingway presents clear and concrete images that manage to reverberate with the force of all that is left out.

Upon his banishment from his home, Hemingway moved to Chicago, where his neighbor was the esteemed writer Sherwood Anderson, author of *Winesburg, Ohio* (1919), a collection of stories to which Hemingway's *In Our Time* is sometimes compared. It was Anderson who provided Hemingway and his new bride, Hadley Richardson, letters of introduction to a circle of writers and artists living in Paris. Arriving in January of 1922, the Hemingways rented a small fourth-floor apartment and Ernest began to dedicate himself to writing.

An Expatriate in Paris

Paris proved the ideal place for Hemingway. Surrounded by an intelligent and fun-loving circle of people, he was able to engage his love of socializing and, with what became his characteristic bluster, to dominate every situation he entered. Hemingway studied at the side of Gertrude Stein, a student of the philosopher William James who was herself trying to reinvent American prose styles. Stein's famous advice to Hemingway was to "Begin over again and concentrate"; he took it to heart. Stein was a brilliant teacher and talker, and she introduced Hemingway to the painting of a new school of artists led by Henri Cezanne and the cubists, including Pablo Picasso. Anderson also provided Hemingway with a letter to the poet Ezra Pound, the founder of the imagist movement in poetry. Under Pound's influence, Hemingway learned to use economy of language and concentration of a single image to produce an emotional reaction in the reader.

In Paris, under the tutelage of some of the greatest minds of the twentieth century, Hemingway began to perfect his craft. Writing all morning,

standing in his apartment, carefully sharpening the point of his pencil so as to make it last, he strived to write the clearest, truest sentences he could imagine. "I always worked until I had something done and I always stopped when I knew what was going to happen next," he remembered in *A Moveable Feast*, a collection of memoirs of life in Paris published just after his death in 1961. The Hemingway's were always short on money, and Hemingway later contended that hunger was good discipline, for it sharpened the colors in his favorite paintings. When he worried that he could write no more he told himself, "You have always written before and you will write now. All you have to do is write one true sentence." "Up in that room," he wrote, "I decided that I would write one story about each thing that I knew about. I was trying to do this all the time I was writing, and it was good and severe discipline."

Hemingway drove himself hard, setting standards for himself that were impossibly high. In Paris he developed what has come to be known as his "iceberg theory," which holds that only five percent of what is known should actually be told, for the real weight of the story looms in that which is submerged beneath the surface. He described his approach in *A Moveable Feast*: "It was a very short story called 'Out of Season' and I had omitted the real end of it which was that the old man hanged himself. This was omitted on my new theory that you could omit anything if you knew that you omitted and the omitted part would strengthen the story and make people feel something more than they understood." Such discipline and focus led to the publication of *Three Stories and Ten Poems* in 1923, eighteen short imagistic vignettes called *in our time* in 1924, and in 1925, the American publication of *In Our Time*, a collection of fifteen stories that included "Big Two-Hearted River," now considered one of his best.

A Lost Generation

The year 1925 was a high point for American letters; in that year, F. Scott Fitzgerald published *The Great Gatsby*, Willa Cather published *The Professor's House*, William Carlos Williams published *In the American Grain*, and Theodore Dreiser published *An American Tragedy*. With the exception of *Gatsby*, no book made a bigger splash than *In Our Time*, which perceptive reviewers saw as announcing the

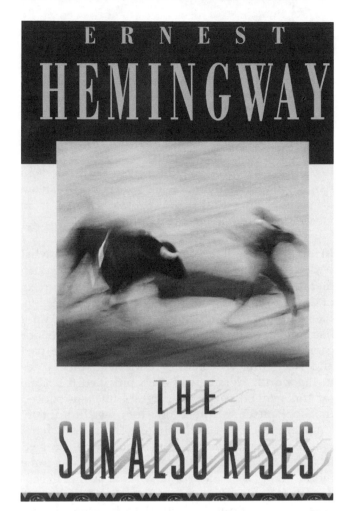

This novel about the Lost Generation of post-World War I, featuring American and English expatriates in Paris, established Hemingway as one of the greatest writers of his day.

emergence of a major new literary talent. In *In Our Time*, wrote Walter Allen, "Hemingway is the dramatist of the extreme situation. His overriding theme is honour, personal honour: by what shall a man live, by what shall a man die, in a world the essential condition of whose being is violence?" Irving Howe found that the stories evoked a new kind of hero, one who can "salvage from the collapse of social life a version of stoicism that can make suffering bearable." The reception of this collection encouraged Hemingway's already vast ambition, and he knew that if he could publish a novel that was as good he would attain the prominence he desired.

While his reputation grew, his marriage soured. Since he had come to Paris, Hemingway had been devouring experiences, bouncing across Europe to

fish, ski, and watch bullfights. But he had also had a son, and the demands of child-rearing made Hadley a less adventurous companion than she had once been. Even worse, Hadley had made the terrible mistake of losing a briefcase that contained all of the manuscripts that Hemingway had been working on through 1921 and 1922, manuscripts that were never recovered. Hemingway could not forgive his wife, and his roving interest soon fastened on an attractive and wealthy American named Pauline Pfeiffer, with whom he began an affair that eventually led to his divorce from Hadley and remarriage to Pauline in 1927.

In the summer of 1926 Hemingway finished what was to be one of the great novels in American literature, *The Sun Also Rises*. The story of a group of Americans living in Paris and playing in Spain, the novel tapped into the sense that World War I had given birth to a new generation of Americans who were freed from the mores of the past and struggling to come to terms with their place in the world. Hemingway even provided the name for this generation in the epigraph that introduced the book, itself a quotation from Gertrude Stein: "You are all a lost generation." The novel's hero, Jake Barnes, recovering from wounds he received in a war he did not believe in, seeks to find some moral compass in a world without a moral center. What peace Barnes is able to find is intensely personal, an individual effort to be true to himself.

Critic Alfred Kazin, writing in *An American Procession*, described the effect Hemingway achieved in this way: "[Hemingway's] greatest gift, the foundation of all his marvelous pictorial effects, was his sense of some enduring injustice, of some fundamental wrongness at the heart of things, to which an American can still rise, and which he will endure (and describe) as a hero." Edmund Wilson, one of Hemingway's most perceptive readers, claimed in *The Wound and the Bow: Seven Studies in Literature,* that "Hemingway has expressed with genius the terrors of the modern man at the danger of losing control of his world, and he has also, within his scope, provided his own kind of antidote." That antidote was what critics have since come to know as "the code," a way for individuals to hold onto their honor and individuality in a world that is intensely hostile to the individual. Many critics have since claimed that the "code hero" is the essential character in most of Hemingway's fiction.

The circumstances under which *The Sun Also Rises* was published tell much about Hemingway's ruthlessness and his ambition, his own code. The publisher of *In Our Time*, Boni & Liveright, held contractual rights to Hemingway's next book, but Hemingway wanted to place his novel with a more prestigious firm. So Hemingway quickly wrote a vicious parody of Sherwood Anderson's writing called *The Torrents of Spring* and offered it to the publisher, whose longstanding relationship with Anderson forced them to decline it. Thus, Hemingway killed two birds with one stone: he found himself a prominent publisher, Scribner, who published both *Torrents* and *The Sun Also Rises*, and he "bested" a literary rival to whom he had been compared. Hemingway's need to belittle his literary peers would become a recurrent theme in his life, as he later attacked every other living writer of any stature.

Success followed success for Hemingway; the 1920s truly were his decade. A second volume of short stories, titled *Men Without Women*, was published by Scribner in 1927, followed in 1929 by a second novel, *A Farewell to Arms*. Like *In Our Time*, the stories in *Men Without Women* were bound together through a loose thematic correspondence, one Hemingway described cryptically as the lack of a "softening feminine influence, through training, death, or other causes." The stories told of a bullfighter who fights to his own death ("The Undefeated"), of soldiers dealing with wounds ("In Another Country"), and of two boxers trying to double cross each other ("Fifty Grand"). Two of the stories—"The Killers" and "Hills Like White Elephants"—are now considered classics. In the former, a young boy watches as two hired killers try to find an aging boxer the boy has befriended, and realizes that the fighter will do nothing to escape a fate he has decided is inescapable. In the latter, a young couple waiting for a train discuss an unnamed decision that they must make. Nothing happens in the story, and yet the tension that Hemingway creates as each person jockeys for position is as great as in any thriller. This much-anthologized story is often used to show just how much a writer can communicate through dialogue. On the strength of these two collections of stories, Hemingway is now considered one of the greatest short story writers ever.

With *A Farewell to Arms*, Hemingway was able to bring together a love story, a war story, and a

story of the alienation of his generation in a story that pleased critics and sold 28,000 copies in one month in the fall of 1929. The story's hero, Frederic Henry, is wounded fighting in a war he doesn't care about, and while recuperating in the hospital falls in love with a nurse, Catherine Barkley. Sent back to battle, Henry soon deserts the army and flees across the Italian border with the now-pregnant Barkley. The story concludes with her death in childbirth, and Henry's realization that for all that he has endured he has nothing.

Critics lauded the book for its fine descriptions, its attention to detail, and for its exposition of the absurdity of war. But it was not only war that Hemingway found tragic, but life itself, for which war was a metaphor, a highly dramatized enactment. In describing Henry's reaction to the war around him, Hemingway gave the clearest description yet of the death of Victorian values in the Modern age:

I was always embarrassed by the words sacred, glorious, and sacrifice and the expression in vain. We had heard them, sometimes standing in the rain almost out of earshot, so that only the shouted words came through, and had read them, on proclamations that were slapped up by billposters over other proclamations, now for a long time, and I had seen nothing sacred, and the things that were glorious had no glory and the sacrifices were like the stockyards at Chicago if nothing was done with the meat except to bury it.

Having fled the war, Henry hopes to find more meaning in the love he has for Catherine Barkley, but even that is taken from him and he is left with nothing, not even the hope of a "separate peace" that animated Jake Barnes in *The Sun Also Rises*. Hemingway wrote:

If people bring so much courage to this world, the world has to kill them to break them, so of course it kills them. The world breaks every one and afterward many are strong at the broken places. But those that will not break it kills.

Hemingway's was a bleak and existential view of the world, one that saw man absolutely alone and without solace in a world that could easily crush him. It was a quintessentially modern attitude.

The late 1920s continued to be tumultuous years for Hemingway, who seemed to seek out brutal

If you have enjoyed the works of Ernest Hemingway, you may also want to check out the following books and films:

Sherwood Anderson, *Winesburg, Ohio*, 1919.
Raymond Carver, *What We Talk about When We Talk about Love*, 1981.
F. Scott Fitzgerald, *Tender Is the Night: A Romance*, 1934.
Gertrude Stein, *Three Lives*, 1909.
The Deer Hunter, Warner Brothers, 1978.

contact with life. "Confronting danger everywhere," wrote Kazin, "he made himself one with his time by running full tilt into everything that would bring a fresh emergency into his life." Some of the danger he brought on himself, as when he pulled a skylight down upon his head and received such a bad concussion that he could not complete a long story he had been writing, or when he flipped his car in Wyoming in 1930 and broke his arm so badly that bone stuck out through the muscle. And some of the danger came to him unbidden, though perhaps not unexpectedly. In 1928, Hemingway's father put a Smith and Wesson revolver behind his ear and shot himself to death, thus ending his most recent battle with depression and paranoia. Identifying with his father as he did, Hemingway must have been deeply disturbed by his father's death, though he dealt with it by throwing himself ever harder at his work.

Good Times, Sloppy Writing

By 1930 Hemingway was no longer a young writer striving to prove himself to the world. Though he was barely in his thirties, he had arrived and he basked in the pleasures that success and a ready supply of money could provide during a decade when most Americans had to make do with less. The $80,000 he was paid for movie rights to *A Farewell to Arms* along with help from Pauline's rich uncle helped fund the purchase of a luxurious winter home in Key West, a thirty-eight-foot boat he named *Pilar*, and adventures throughout the world. Soon, however, Hemingway began to drink more heavily and to work less. His short stories were readily accepted by the leading magazines; in fact, the newly-founded *Esquire* magazine gave Hemingway first billing

whenever he wished to write for them. Newspapers and magazines published photos of the author beside his latest conquest, be it a fish or a lion. After spending a summer in Spain immersing himself in the world of bullfighting, Hemingway penned *Death in the Afternoon,* a scholarly introduction to the sport that also contained Hemingway's most self-assured comments about his own approach to writing. The volume has often been consulted by those scholars eager to gain insight into Hemingway's aesthetic, for it contains such open expressions of Hemingway's moral stance as this statement: "What is moral is what you feel good after and what is immoral is what you feel bad after." Such comments shed light on the kind of heroism Hemingway took pains to portray in his

fiction. *Death in the Afternoon* was, however, neither a critical nor popular success.

The fiction that Hemingway published in the 1930s has never been thought to be as good as that written earlier. His short story collection *Winner Take Nothing* (1933) collected stories written in the previous five years, only one of which, "A Clean, Well-Lighted Place," stands alongside the best of his earlier work. In this story an old Spanish waiter utters what Beegel called "perhaps the best-known statement of existential dread in American literature": *"Our nada who art in nada, nada be thy name they kingdom nada they will be nada in nada as it is in nada. Give us this nada our daily nada and nada us our nada as we nada our nada and nada us not into nada but deliver us from nada; pues nada. Hail nothing full of nothing, nothing is with thee."*

Two other good stories emerged from Hemingway's experiences in the 1930s, both taken from his adventures hunting in Africa, experiences he also covered in the nonfiction work *Green Hills of Africa.* "The Short Happy Life of Francis Macomber" tells the chilling tale of a man and his wife on safari in Africa. The tensions in their relationship, exacerbated by the wife's flirtation with the big game hunter, set the stage for a final scene in which the wife, ostensibly aiming for a lion, shoots her husband through the back of the skull just moments after he had finally shown the resolve he had earlier lacked. The ambiguity of the story troubles readers to this day—Was the murder intentional? Had Macomber transcended his wife's betrayal in the moments before his death?—and added fuel to feminist attacks on Hemingway on the grounds that he glorifies violence and hates women.

"The Snows of Kilimanjaro," first published in *Esquire* magazine and later collected in *The Fifth Column and the First Forty-Nine Stories* (1938), has also given readers much to think about. In this story a writer named Harry contracts gangrene while on safari near Mt. Kilimanjaro. The hastening decay of his flesh is compared to the decay of his talent, which he had squandered on chasing women, drinking, and adventuring. As death approaches, Harry dreams that he is lifted to a higher, cleaner place by the plane come to rescue him—but it is only a vision. Stylistically the story was a departure for Hemingway, incorporating flashbacks and stream-of-consciousness visions. Hemingway's use of the mountain and of a pre-

Containing ten of his best short fictional works, this collection showcases the unique prose style of Hemingway, who won the Nobel Prize for Literature.

served leopard left many readers pondering the significance of these symbols. Moreover, the story prompted many to wonder whether Hemingway wasn't musing upon his own lost talent; that in so doing he produced one of his best stories indicated that he was not yet finished as a writer.

Hemingway's lone attempt at a novel in the 1930s was a miserable failure. Rushed to print to assuage his and other's concerns that he hadn't published a novel in nearly a decade, *To Have and to Have Not* was about the adventures of an ex-policeman named Harry Morgan who charters a fishing boat between Key West and Cuba. "There is little within it worth quoting," noted Hays, "except to contrast unfavorably with his writing at its best." The sentences were baggy and long, the images indistinct, the point unclear. Kazin, who understood Hemingway as few critics have, argued that Hemingway's best writing came out of his personal experience with danger, something that had been lacking in the easy days of paid-for adventure. "One of the recurrent themes in his work is the rallying from discomfort to comfort, from danger to safety, from death to life, from ordeal to escape." But Hemingway had become used to comfort and safety; his "influence began to influence *him* too much. The famous brushwork became bloated and sometimes suggested the relaxed intention that all good American writers seek *after* writing." Hemingway seemed to need some new danger, some new upset, to set him right.

A Welcome War

The events of the late 1930s seemed to set Hemingway back on track. Again bored with a wife who now had children, and perhaps feeling trapped by her wealth (he had referred to the wife in "The Snows of Kilimanjaro" as "this rich bitch, this kindly caretaker and destroyer of his talent"), Hemingway began to consort with a younger journalist named Martha Gellhorn, who he would marry in 1940. More importantly, Hemingway dedicated himself to the cause of Republican, or Loyalist, Spain as it fought against the Fascist forces of General Francisco Franco in the Spanish Civil War. Traveling to Spain in 1937 as a foreign correspondent for the North American Newspaper Alliance, Hemingway reported on the war from a bullet-riddled hotel in Madrid. These experiences revived Hemingway's fighting spirit and he set out to write his most ambitious novel.

For Whom the Bell Tolls, published in 1940, quickly halted rumors that Hemingway's talent had declined and sold nearly 200,000 copies in the first three months of publication. Stuart Sanderson, author of *Hemingway*, called it "a great novel, humane, vivid, intensely memorable." Like *A Farewell to Arms*, this novel combined war and romance, yet it did so in service of a larger idea: the protection of a democratic country against the forces of Fascism. Robert Jordan, an American sympathetic to the Loyalist cause, joins a band of guerrillas to secretly blow up a bridge held by Fascist forces. Jordan falls in love with a guerilla named Maria, and he is assisted by the female leader of the guerillas, Pilar, one of Hemingway's strongest female characters. Jordan and the guerillas succeed at blowing the bridge, but Jordan is too badly wounded to escape. The novel ends with Jordan bravely ready to meet his death. Hemingway, who in earlier works had denied the validity of any abstract cause, in this novel brilliantly portrayed a cause that was worth fighting for. Though the hero dies and life is still harsh and sometimes tragic, in this novel the words "courage" and "valor" have meaning. The novel is given credit for stirring Americans in the battle against Fascism that would soon dominate the world.

Hemingway's happiness with Gellhorn did not last as long as with his previous wives, for she refused to subordinate her career to his own, insisting on continuing to travel and write when he wanted her attention on him. Hemingway stayed alone at his new home in Cuba during the early part of World War II. By all accounts Hemingway was not well in these years, and he struggled to control his alcoholism and the more frequent bouts of depression that began to haunt him. But by 1944 Hemingway had returned to his old form, helped along by his adventures as a war correspondent and by his new romance with another lady journalist, Mary Walsh. Hemingway joined American forces at the liberation of Paris from German control in 1944, and returned to many of his old haunts; later he was awarding a Bronze Star for his conduct. By war's end he had secured a divorce from Martha and had made plans to marry Mary, his fourth and final wife.

"The Endless Turmoil in the Human Heart"

Hemingway published little in the late 1940s, though he worked on a long and convoluted story

of a writer named David Bourne and his bisexual wife Catherine, a story that was published twenty-five years after his death as *The Garden of Eden* (1986). On a hunting trip to Italy in 1948 Hemingway's flirtation with a youthful countess named Adriana Ivancich provided the spark to write a short novel, *Across the River and Into the Trees* (1950), which was widely panned by critics. Some critics found the work so bad that they were ready to revise the former estimates of Hemingway's talent. With bad reviews ringing in his years, and ongoing problems with drink and depression, Hemingway somehow managed to produce another great work, publishing *The Old Man and the Sea* in 1952.

If *The Sun Also Rises* is a novel of youth, and *For Whom the Bell Tolls* a novel of middle age, then *The Old Man and the Sea* is a novel of experience gained over the years. The story of an elderly Cuban fisherman whose prize catch is taken by sharks, it pays homage to patience and endurance, to wisdom gained painstakingly over time. "*The Old Man and the Sea*," writes Herbie Butterfield in *American Fiction: New Readings*, "is a story of skill, of all kinds of courage, of defeat in the flesh, of victory in the spirit, of pride humbled and self-respect earned, of suffering, and of final great peace of mind." Again quashing talk that Hemingway was finished as a writer, *The Old Man and the Sea* won the Pulitzer Prize for Literature for 1952, a prize that had been denied the more-impressive *For Whom the Bell Tolls* because of the earlier novel's left-leaning politics and sexual bluntness. With *Old Man*, Hemingway had written a novel that displayed his skills as a writer and yet was acceptable for "impressionable" readers; though it was not his best work, it was probably the one most taught in American high schools. It was also Hemingway's last novel.

Ever hungry for new experiences, Hemingway continued to throw himself into exciting and dangerous situations. Only now, in his fifties, his body refused to recuperate as readily. On safari in Africa in 1953, the Hemingways' plane hit a telegraph wire and crashed to the ground, causing only minor injuries. When a plane came to rescue them it too crashed, this time giving Hemingway ruptured internal organs, crushed vertebra, and another severe concussion. Though Hemingway laughed at his obituaries in the newspapers, the injuries took their toll, as he suffered from complications from the damage to his kidney and liver

for the rest of his life. Poor health kept him inactive, and inactivity made him depressed; the depression worsened, just as it had with his father before him.

Hemingway continued to write in the late 1950s, but the work he produced was of uneven quality. Signed to write a bullfighting article for *Life* magazine, Hemingway suffered from confusion and his writing got away from him as the manuscript ballooned in length. The results of this work were eventually published as *The Dangerous Summer* in 1985. But in 1959 Hemingway submitted the manuscript of *A Moveable Feast* to Scribner. This collection of sketches and remembrances from his years in Paris was both moving and troubling. It provided a glimpse into the early years of America's most prominent writer, but it also revealed the meaner side of his personality, for Hemingway seemed to delight in demeaning those he knew. Kazin called the book "wicked in its attempt to destroy Stein, Ford, and Fitzgerald."

By 1960 Hemingway's depression had worsened, and he was wracked by suspicions, later confirmed, that the FBI was following him. Gaining and losing weight, gaining and losing touch with reality, Hemingway was admitted to the Mayo Clinic, where he was diagnosed with a variety of ailments and given electroshock therapy to treat his depression. Returning to his home in Ketchum, Idaho, early in 1961, Hemingway found himself unable to write. Twice he tried to kill himself, once with a gun, once by walking into the propeller of a running airplane, but Mary intervened. More electroshock therapy destroyed his short-term memory. On July 2, 1961, Hemingway followed his father in seeking a way out of the bewildering mental disease he had inherited: he woke early, loaded his shotgun, placed the barrel to his forehead, and fired. Hemingway's many biographers have found his death oddly suitable to his life. Hemingway always held himself to the highest standards; he was not happy unless he was stronger than the next man, a better writer than the next hack, a better lover than the younger men. In the end he could not bear to live a life in which he could not triumph.

As a young writer in Paris, Hemingway had compared his talent to that of the best writers of all time and constantly pushed himself to be better. Decades after his death his place in literary history seems secure, despite attempts by his critics

to label him as merely a short-story writer, merely a chronicler of violence, merely a writer for men. One could be merely a short-story writer before Hemingway, but Hemingway elevated the short-story to an art form by compressing such detail and such emotion into so little space. It is this compressed emotion for which readers return to Hemingway. "He was by turns so proud yet so often stricken a human creature that the reader again and again surrenders to him," wrote Kazin. "For Hemingway makes you feel in painfully distinct human detail how much the world merely echoes the endless turmoil in the human heart."

■ Works Cited

Allen, Walter, *The Modern Novel*, Dutton, 1964.

Beegel, Susan F., "Ernest Hemingway," *Dictionary of Literary Biography*, Volume 102: *American Short Story Writers, 1910-1945*, Gale, 1991.

Butterfield, Herbie, "Ernest Hemingway" in *American Fiction: New Readings*, edited by Richard Gray, Barnes & Noble, 1983, pp. 184-199.

Hays, Peter, *Ernest Hemingway*, Continuum, 1990.

Hemingway, Ernest, *The Sun Also Rises*, Scribner, 1926.

Hemingway, *A Farewell to Arms*, Scribner, 1929.

Hemingway, *Death in the Afternoon*, Scribner, 1932.

Hemingway, *Winner Take Nothing*, 1933.

Hemingway, *A Moveable Feast*, Scribner, 1964.

Hemingway, *The Complete Short Stories of Ernest Hemingway: The Finca Vigia Edition*, Scribner, 1987.

Howe, Irving, *A World More Attractive: A View of Modern Literature and Politics*, Horizon Press, 1963.

Kazin, Alfred, "Hemingway the Painter" in *An American Procession: The Major American Writers from 1830 to 1930—The Crucial Century*, New York, Knopf, 1984.

Sanderson, Stewart, *Hemingway*, Oliver and Boyd (Edinburgh, Scotland), 1961.

Wilson, Edmund, "Hemingway: Gauge of Morale" in *The Wound and the Bow: Seven Studies in Literature*, Farrar, Straus, 1941, 1981.

■ For More Information See

BOOKS

Aldridge, John W., *Time to Murder and Create: The Contemporary Novel in Crisis*, McKay, 1966.

Alexander, Karl, *Papa and Fidel*, T. Doherty Associates, 1989.

Baker, Carlos, *Hemingway: The Writer as Artist*, Princeton University Press, 1956.

Baker, editor, *Ernest Hemingway: Critiques of Four Major Novels*, Scribner, 1962.

Baker, *Ernest Hemingway: A Life Story*, Scribner, 1969.

Barrett, William, *Time of Need: Forms of Imagination in the Twentieth Century*, Harper, 1972.

Beegel, Susan F., *Hemingway's Craft of Omission: Four Manuscript Examples*, UMI Research Press, 1988.

Benson, Jackson, *Hemingway: The Writer's Art of Self-Defense*, University of Minnesota Press, 1969.

Benson, editor, *The Short Stories of Ernest Hemingway: Critical Essays*, Duke University Press, 1975.

Benson, editor, *New Critical Approaches to the Short Stories of Ernest Hemingway*, Duke University Press, 1990.

The Best of Bad Hemingway: Choice Entries from the Harry's Bar & American Grill Imitation Hemingway Competition, Harcourt, 1989.

Bloom, Harold, editor, *Brett Ashley*, Chelsea House, 1991.

Brenner, Gerry, *The Old Man and the Sea: Story of a Common Man*, Twayne, 1991.

Brian, Denis, *The True Gen: An Intimate Portrait of Ernest Hemingway by Those Who Knew Him*, Grove Press, 1988.

Bruccoli, Matthew J., *Fitzgerald and Hemingway: A Dangerous Friendship*, Carrol & Graf, 1994.

Bruccoli, Matthew J. and C. E. Frazer Clark, Jr., editors, *Fitzgerald-Hemingway Annual*, Bruccoli Clark Books, 1969-76, Gale, 1977.

Burgess, Anthony, *The Novel Now: A Guide to Contemporary Fiction*, Norton, 1967.

Burgess, *Urgent Copy: Literary Studies*, Norton, 1968.

Burgess, *Ernest Hemingway and His World*, Scribner, 1978.

Callaghan, Morley, *That Summer in Paris: Memories of Tangled Friendships with Hemingway, Fitzgerald, and Some Others*, Coward-McCann, 1963.

Castillo-Puche, Jose L., *Hemingway in Spain*, Doubleday, 1974.

Concise Dictionary of American Literary Biography: The Twenties, 1917-1929, Gale, 1989.

Civello, Paul, *American Literary Naturalism and Its Twentieth-Century Transformations: Frank Norris, Ernest Hemingway, Don DeLillo*, University of Georgia Press, 1994.

Comley, Nancy R., *Hemingway's Gender: Rereading the Hemingway Text*, Yale University Press, 1994.

Conrad, Barnaby, *Hemingway's Spain*, Chronicle Books, 1989.

Contemporary Literary Criticism, Gale, Volume 1, 1973, Volume 3, 1975, Volume 6, 1976, Volume 8, 1978, Volume 13, 1980, Volume 19, 1981, Volume 30, 1984, Volume 34, 1985, Volume 39, 1986, Volume 41, 1987, Volume 44, 1987, Volume 50, 1988, Volume 61, 1990, Volume 80, 1994.

Cowley, Malcolm, *A Second Flowering: Works and Days of the Lost Generation*, Viking, 1973.

Dictionary of Literary Biography, Gale, Volume 4: *American Writers in Paris, 1920-1939*, 1978, Volume 9: *American Novelists, 1910-1945*, 1981, Volume 102: *American Short-Story Writers, 1910-1945, Second Series*, 1991.

Diliberto, Gioia, *Hadley*, Ticknor & Fields, 1992.

Donaldson, Scott, *By Force of Will: The Life in Art and Art in the Life of Ernest Hemingway*, Viking, 1977.

Donnell, David, *Hemingway in Toronto: A Post-Modern Tribute*, Black Moss Press, 1982.

The Faces of Hemingway: Intimate Portraits of Ernest Hemingway by Those Who Knew Him, Grafton Books, 1988.

Fiedler, Leslie A., *Love and Death in the American Novel*, Criterion, 1960.

Fiedler, *Waiting for the End*, Stein & Day, 1964.

Frohock, W. M., *The Novel of Violence in America*, South-ern Methodist University Press, 1957.

Geismar, Maxwell, *American Moderns: From Rebellion to Conformity*, Hill & Wang, 1958.

Grebstein, Sheldon N., *Hemingway's Craft*, Southern Illinois University Press, 1973.

Griffin, Peter, *Along With Youth: Hemingway, the Early Years*, Oxford University Press, 1985.

Gurko, Leo, *Ernest Hemingway and the Pursuit of Heroism*, Crowell, 1968.

Hardy, Richard E. and John G. Cull, *Hemingway: A Psychological Portrait*, Banner Books, 1977.

Hassan, Ihab, *The Dismemberment of Orpheus: Toward a Postmodern Literature*, Oxford University Press, 1971.

Hemingway, Gregory H., *Papa: A Personal Memoir*, Houghton, 1976.

Hemingway, Jack, *Misadventures of a Fly Fisherman: My Life With and Without Papa*, Taylor, 1986.

Hemingway, Leicester, *My Brother, Ernest Hemingway*, Fawcett, 1972.

Hemingway, Mary Welsh, *How It Was*, Knopf, 1976.

Hoffman, Frederick J., *The Modern Novel in America*, Regnery, revised edition, 1963.

Hotchner, A. E., *Papa Hemingway: A Personal Memoir*, Bantam, 1966.

Hotchner, *Papa Hemingway: The Ecstasy and Sorrow*, Quill, 1983.

Kazin, Alfred, *Bright Book of Life: American Novelists and Storytellers from Hemingway to Mailer*, Little, Brown, 1973.

Kert, Bernice, *The Hemingway Women*, Norton, 1983.

Laurence, Frank M., *Hemingway and the Movies*, University Press Of Mississippi, 1981.

Lynn, Kenneth, *Hemingway*, Macmillan, 1987.

Madden, David, editor, *Tough Guy Writers of the Thirties*, Southern Illinois University Press, 1968.

Mellow, James R., *Hemingway: A Life Without Consequences*, Houghton Mifflin, 1992.

Meyers, Jeffrey, *Hemingway: A Biography*, Harper & Row, 1985.

Monteiro, George, editor, *Critical Essays on Ernest Hemingway's "A Farewell to Arms,"* G. K. Hall, 1994.

Morris, Wright, *The Territory Ahead: Critical Interpretations in American Literature*, Harcourt, 1958.

Nagel, James, editor, *Critical Essays on Ernest Hemingway's "The Sun Also Rises,"* G. K. Hall, 1995.

Nahal, Chaman, *The Narrative Pattern in Ernest Hemingway's Fiction*, Fairleigh Dickinson, 1971.

Nelson, Raymond S., *Ernest Hemingway: Life, Work and Criticism*, York Press, 1984.

Phillips, Gene D., *Hemingway and Film*, Ungar, 1980.

Priestley, J. B., *Literature and Western Man*, Harper, 1960.

Rahv, Philip, *The Myth and the Powerhouse*, Farrar, Straus, 1965.

Reynolds, Michael S., *Hemingway's First War: The Making of "A Farewell to Arms,"* Princeton University Press, 1976.

Reynolds, *The Young Hemingway*, Basil Blackwell, 1986.

Reynolds, *Hemingway, The Paris Years*, Basil Blackwell, 1989.

Rollyson, Carl E., *Nothing Ever Happens to the Brave: The Story of Martha Gellhorn*, New York, St. Martins, 1990.

Rovit, Earl R., *Ernest Hemingway*, Twayne, 1963.

Sanderson, Rena, editor, *Blowing the Bridge: Essays on Hemingway and "For Whom the Bell Tolls,"* Greenwood Press, 1992.

Seward, William, *My Friend Ernest Hemingway*, A. S. Barnes, 1969.

Spilka, Mark, *Hemingway's Quarrel with Androgyny*, University of Nebraska Press, 1990.

Stephens, Robert O., *Hemingway's Nonfiction: The Public Voice*, University of North Carolina Press, 1968.

Unfried, Sarah P., *Man's Place in the Natural Order: A Study of Ernest Hemingway's Major Works,* Gordon Press, 1976.

Updike, John, *Picked-Up Pieces,* Knopf, 1975.

Wagner, Linda W., editor, *Ernest Hemingway: Five Decades of Criticism,* Michigan State University Press, 1974.

Wagner, editor, *Ernest Hemingway: Six Decades of Criticism,* Michigan State University Press, 1987.

Waldhom, Arthur, *Ernest Hemingway,* McGraw, 1973.

Westbrook, Max, editor, *The Modern American Novel: Essays in Criticism,* Random House, 1966.

Wylder, Delbert E., *Hemingway's Heroes,* University of New Mexico Press, 1969.

Young, Philip, *Ernest Hemingway,* University of Minnesota Press, revised edition, 1965.

Young, *Ernest Hemingway: A Reconsideration,* Pennsylvania State University Press, revised edition, 1966.

PERIODICALS

American Scholar, summer, 1974.
Arizona Quarterly, spring, 1973.
Chicago Tribune, July 17, 1986; December 27, 1987.
Chicago Tribune Book World, October 13, 1985; May 4, 1986; August 24, 1986.
Detroit News, June 9, 1985.
Georgia Review, summer, 1977.
Globe and Mail (Toronto), November 30, 1985; May 31, 1986.

Kenyon Review, winter, 1941.
Los Angeles Times, May 22, 1986; January 25, 1987.
Los Angeles Times Book Review, June 23, 1985; November 29, 1987.
Mediterranean Review, spring, 1971.
Midwest Quarterly, spring, 1976.
Modern Fiction Studies, summer, 1975.
New Masses, November 5, 1940.
Newsweek, May 19, 1986.
New Yorker, May 13, 1950.
New York Review of Books, December 30, 1971; April 16, 1981.
New York Times, June 1, 1985; May 21, 1986; July 24, 1989; August 17, 1989.
New York Times Book Review, May 28, 1967; June 9, 1985; May 18, 1986.
New York Times Magazine, August 18, 1985.
Observer, February 8, 1987.
Publishers Weekly, January 11, 1985.
Southwest Review, winter, 1976.
Time, May 26, 1986.
Times (London), July 18, 1985; August 1, 1986; February 12, 1989.
Times Literary Supplement (London), October 16, 1970; May 22, 1981; February 6, 1987.
Washington Post, July 29, 1987.
Washington Post Book World, June 30, 1985; November 3, 1985; June 1, 1986.
Yale Review, spring, 1969.*

—Sketch by Tom Pendergast

Monica Hughes

1984-85. *Military service:* Women's Royal Naval Service, 1943-46. *Member:* International PEN, Writers Union of Canada, Canadian Society of Children's Authors, Illustrators, and Performers, SF Canada, Writers Guild of Alberta.

■ Personal

Born November 3, 1925, in Liverpool, England; naturalized Canadian citizen, 1957; daughter of Edward Lindsay (a mathematician) and Phyllis (Fry) Ince; married Glen Hughes (in city government), April 22, 1957; children: Elizabeth, Adrienne, Russell, Thomas. *Education:* Convent of the Holy Child Jesus, Harrogate, Yorkshire, graduated 1942; attended Edinburgh University, 1942-43. *Hobbies and other interests:* Swimming, walking, beachcombing ("very difficult on the prairies"), gardening.

■ Addresses

Home—13816 110A Ave., Edmonton, Alberta, Canada T5M 2M9.

■ Career

Dress designer in London, England, 1948-49, and Bulawayo, Rhodesia (now Zimbabwe), 1950; bank clerk in Umtali, Rhodesia, 1951; National Research Council, Ottawa, Ontario, laboratory technician, 1952-57; writer, 1975—. Writer-in-residence at several universities, including University of Alberta,

■ Awards, Honors

Vicky Metcalf Award, Canadian Authors Association, 1981, for body of work, and 1983, for short story; Alberta Culture Juvenile Novel Award and Bay's Beaver Award, both 1981, Canada Council prize for children's literature, 1982, American Library Association (ALA) Best Book for Young Adults citation, and Young Adult Canadian Book Award, both 1983, all for *Hunter in the Dark;* Canada Council prize for children's literature, 1981, for *The Guardian of Isis;* ALA Best Book for Young Adults citation, 1981, and International Board on Books for Young People's honor list citation, 1982, both for *The Keeper of the Isis Light;* Guardian Award runner-up, 1983, for *Ring-Rise, Ring-Set;* Alberta R. Ross Annett Award, Writers Guild of Alberta, 1983, 1984, 1986; Hans Christian Anderson Award nomination, 1984.

■ Writings

NOVELS

Gold-Fever Trail: A Klondike Adventure, illustrated by Patricia Peacock, LeBel (Edmonton, Alberta), 1974.
The Ghost Dance Caper, Hamish Hamilton, 1978.

Hunter in the Dark, Atheneum, 1982.

The Treasure of the Long Sault, illustrated by Richard Conroy, LeBel, 1982.

My Name Is Paula Popowich!, illustrated by Leoung O'Young, Lorimer (Toronto), 1983.

Blaine's Way, Irwin (Toronto), 1986, Severn House (London), 1988.

Log Jam, Irwin, 1987, published as *Spirit River*, Methuen (London), 1988.

Little Fingerling: A Japanese Folk Tale, illustrated by Brenda Clark, Kids Can Press (Toronto), 1989.

The Refuge, Doubleday (Toronto), 1989.

A Handful of Seeds, illustrated by Luis Garay, Lester (Toronto), 1993.

Castle Tourmandyne, HarperCollins, 1995.

SCIENCE-FICTION NOVELS

Crisis on Conshelf Ten, Copp (Toronto), 1975, Atheneum (New York City), 1977.

Earthdark, Hamish Hamilton (London), 1977.

The Tomorrow City, Hamish Hamilton, 1978.

Beyond the Dark River, Hamish Hamilton, 1979, Atheneum, 1981.

Ring-Rise, Ring-Set, F. Watts (New York City), 1982.

Space Trap, MacRae (London), 1983, F. Watts, 1984.

Devil on My Back, MacRae, 1984, Atheneum, 1985.

Sandwriter, MacRae, 1984, Holt (New York City), 1988.

The Dream Catcher, MacRae, 1986, Atheneum, 1987.

The Promise, Methuen, 1989, Simon & Schuster (New York City), 1992.

Invitation to the Game, HarperCollins (Toronto), 1990, Simon & Schuster, 1991.

The Crystal Drop, Methuen, 1992, Simon & Schuster, 1993.

The Golden Aquarians, Simon & Schuster, 1995.

"ISIS" TRILOGY

The Keeper of the Isis Light, Hamish Hamilton, 1980, Atheneum, 1981.

The Guardian of Isis, Hamish Hamilton, 1981, Atheneum, 1982.

The Isis Pedlar, Hamish Hamilton, 1982, Atheneum, 1983.

OTHER

Contributor to numerous anthologies, including *Magook*, McClelland & Stewart (Toronto), 1977; *Dragons and Dreams*, Harper (New York City), 1985; and *Mother's Day*, Methuen, 1992. Hughes's manuscripts are collected at the University of Calgary, Alberta.

■ Sidelights

Monica Hughes is considered by many to be one of Canada's finest writers for children and young adults. Opening the door into other worlds through her many popular works of science fiction, Hughes has also received critical praise and recognition for novels whose plots are grounded here on earth, using both historical and contemporary themes as her subjects. Claiming her as "Canada's finest writer of science fiction for children," critic Sarah Ellis wrote of Hughes in *Horn Book:* "There is a gentleness to her books that is rare in science fiction. The hairsbreadth escapes, the exotic flora and fauna, the humanoids, the vast intergalactic reaches, the villains and the heroes—all are enclosed in one overriding concern, subtle but ever-present: the value of kindness."

Hughes was born in Liverpool, England, on November 3, 1925, but moved with her family to Egypt shortly after her birth. Her father, a professor of mathematics, had accepted a position at the newly established University of Cairo; Monica and her family—she gained a baby sister in 1927—would live in this exotic African city, in view of the pyramids, until 1931, when her parents decided it was time to return to London so that their daughters could attend English schools.

"I soon learned the rules and enjoyed myself," Hughes recalled of her introduction to British schools and culture in an autobiographical essay for *Something about the Author Autobiography Series* (*SAAS*). As her teachers exposed her to an ever changing supply of British literature, she grew more fascinated with language and story: "We were read aloud to every day, not from the kind of storybooks that we could read for ourselves, but from more difficult material: the myths and beliefs of Early Man, for instance, and the Norse Sagas," continued Hughes in *SAAS*. "I still remember the day when the teacher read to us the story of the death of Balder the Beautiful through the cunning of the treacherous Loki, and how we sat at our desks with the tears streaming down our faces. This is when I discovered the idea of Hero, a concept that has been very important in my writing life."

Family and Fine Arts Influences

Always a good, if overly impressionable, student, Hughes was intrigued by museums, libraries, and art galleries; her constant visits to these places increased both her interest and understanding of history and culture that would one day find a voice in her writing. As Hughes would one day comment in *Twentieth-Century Science-Fiction Writers*, "I grew up fascinated by the story of humankind, the way in which we acquired language, told stories, developed tribal customs, and at last discovered our world and learned how to dominate it. The interconnectedness of it all."

Hughes's parents were equally influential in determining their daughter's eventual choice of her life's work. Her father, a noted mathematician, was an amateur astronomer and shared his love of the stars with his daughter, while her mother, a biologist, supplemented her husband's technical talk with wonderful stories of Halley's comet. And Hughes began to read the works of writers like Jules Verne, long considered to be the father of science fiction, whose works she devoured. "I discovered science fiction in the works of Jules Verne," Hughes recalled in her *SAAS* essay. "A world not only of might-have-been, but of might-be-in-the-future. *Twenty Thousand Leagues under the Sea. A Journey to the Moon* and *Around the Moon.* I read these speculative adventures in huge nineteenth-century volumes with etched illustrations, and, when I had finished all the library had, I discovered more in the original French and struggled through them. The science fiction bug had bitten me."

This 1982 multi–award–winning realistic novel about a young cancer victim on a secret deer–hunting trip to prove himself has been considered Hughes's masterpiece.

Exploring a World at Peace

In 1939 World War II broke out in Europe. With her country in constant threat of German invasion, Hughes enlisted in the Women's Royal Naval Service three years later, when she turned eighteen. While she had joined the Naval Service hoping to see some of the world after the war, Hughes found herself working as a meteorologist, first in Scotland, and then in Belfast during her four years in the service. After her discharge in 1946, her wanderlust still not satisfied, Hughes decided to visit Southern Rhodesia on the advice of a friend. She lived there for two years, supporting herself, first as a dress designer and then as a bank clerk in Umtali. News that her sister

was ill prompted a return to London; in 1952, after her sister's health had returned to normal, Hughes booked passage on a boat bound for Montreal. A move to Ottawa, Ontario, found her working as a laboratory technician for Canada's National Research Council, where her aptitude for science was sparked once more. "We tested airplanes, new materials, all sorts of interesting things," she recalled in *SAAS*. "The other members of the staff were friendly and interesting too, and we spent many coffee breaks and lunches arguing over the possibility of life on Mars and the significance of flying saucers."

In 1957 Hughes married fellow sci-fi buff Glen Hughes, a civil servant employed at the giant Seaway Hydroelectric Power Project located at the

mouth of Ontario's St. Lawrence Seaway. Her marriage cemented her relationship with her new country; Hughes obtained Canadian citizenship and dedicated the next few years to raising the couple's four children. While snatching time in the late evenings to write and explore her other hobbies, it wasn't until 1971, after her youngest son had started school full-time, that Hughes made a

> *". . . one should write as truthfully as possible, even if it isn't easy or painless. One faces oneself in the darkest inside places of one's memory and one's sorrow. But always . . . always there must come hope."*
> *—Monica Hughes*

decision: "That I would spend a year attempting to write professionally—as opposed to playing at writing, which I had done all my life," she explained in *SAAS*. "I promised myself that I would write uninterruptedly for four hours every weekday for a year and see what came of it, and that I would do this first thing in the morning while my energy level was high and before the outside world could begin taking tiny bites of time from me until there was nothing left of my days."

Embarks on Career as Sci Fi Writer

It wasn't until she took a commission to write a historical novel for grade-school children that Hughes thought about writing for anyone but adult readers. But the success of *Gold-Fever Trail: A Klondike Adventure* changed all that. The story of two children and their search for their father during the years of Canada's Gold Rush, 1974's *Gold-Fever Trail*—which was adopted as a supplement to many Alberta, Canada, history-class textbooks—changed the course of Hughes's writing career at its very inception. And just a year later she had a science fiction novel to her credit: *Cri-*

sis on Conshelf Ten would become the first of Hughes's many popular books of futuristic fiction for younger readers. *Crisis on Conshelf Ten* takes place on earth, but a different earth than her readers had ever imagined. In the near future, people have colonized portions of land under Earth's seas; not average humanoids, but surgically created "mer-men" who can more easily adapt to the underwater environment. A popular novel, its success encouraged the beginning author to write others in the genre.

Hughes's most noted works of young adult science fiction are the books in her "Isis" trilogy: *The Keeper of the Isis Light*, *The Guardian of Isis*, and *The Isis Pedlar*, all published between 1980 and 1982. Taking place on a remote planet, Hughes's Isis novels depict the growth of a colonial planetary outpost over many years. Readers first meet protagonist Olwen Pendennis in *The Keeper of the Isis Light* and follow her as she overcomes a series of adventures that test both her physical and moral strength. Olwen is born on Isis shortly after her Earth-born parents, both scientists, are sent to the planet to serve as researchers. Together with a remarkably intelligent robot, the four make up the planet's sole inhabitants—until her parents die when Olwen is only five years old. Fortunately, the robot is able to care for the young girl, even altering her body so that she can survive the planet's atmosphere. Years pass in quick succession, until another ship is sent from Earth, this time carrying a group of colonists. While the long-isolated Olwen wants to be accepted by these new arrivals, the physical changes that have been made to her over the years set her apart, and she chooses to remain in insolation, accepting herself for what she has become.

The "Isis" trilogy continues with *The Guardian of Isis*, the story of the descendants of that first colony from Earth. Out of contact with their own planet, the group rapidly becomes more primitive in their ways, adopting a host of superstitions that threaten to disrupt their small society. When a young boy named Jody N'Kumo seeks the help of the mysterious Olwen and her robot guardian, the two original inhabitants of the planet help restore order to the struggling colony. Praised by reviewers, *The Guardian of Isis* prompted *Junior Bookshelf* reviewer Marcus Crouch to note, "Monica Hughes tells a grand story; she is also a serious anthropologist and philosopher and she knows how the human mind works." She "brings before

us the strange world of Isis in all its beauty," Crouch added, "and integrates setting and action and character in exemplary fashion. Her book is an excellent 'read,' a tract on society and a relevant commentary on the history of our own times."

With *The Isis Pedlar*, Hughes's multi-generational trilogy comes to a close as a romance between N'Kumo's nephew and the daughter of a roguish peddlar results in an effort by the peddlar himself to exploit the colonists. Taken as a whole, the three "Isis" novels encapsulate the major themes of their creator: personal growth, survival, and cultural development. The series was particularly appreciated by critics and readers in her native Canada, and Hughes earned the Canada Council prize for children's literature for her work. Kit Pearson, writing in *Christian Science Monitor*, pointed out that the "Isis" trilogy, "although set in the future, is truly Canadian in its theme—immigrants to a new land dealing with the accompanying pressures of prejudice and culture clash."

Other popular works in the science fiction genre include 1982's *Ring-Rise, Ring-Set*, an exploration of the conflict between a technologically advanced civilization and the Ekoes, a nature-based Inuit tribe that ultimately becomes jeopardized when technological developments threaten to destroy them. Similar in design, *Beyond the Dark River* introduces fifteen-year-old Benjamin to a young Cree Indian woman as both search the wreckage of a post-apocalyptic Canadian city in hope of saving their two cultures from the same fate. In *The Crystal Drop*, published in 1992, Hughes paints "a well-written picture of what could happen in the near future if we don't pay more attention to conserving our resources," according to Andrea Davidson in *Voice of Youth Advocates*. Taking place in the year 2011, the ozone layer protecting the Earth has disappeared and Canada has become an arid wasteland; the lack of water transforms those not killed by the harsh conditions caused by the ensuing greenhouse effect into survivalists. It is within this future world that two abandoned children must travel across the Alberta desert to Gaia, a commune organized by their Uncle Greg prior to the onset of global warming, amid the increasing realization that all life on their planet is facing destruction.

While calling herself "primarily a science fiction writer," Hughes is quick to add that she avoids

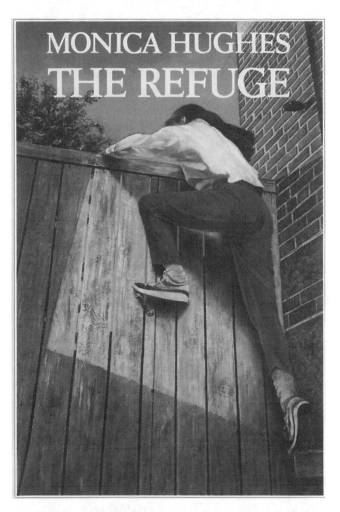

Although twelve-year-old Barb's father has abandoned his wife and child, Barb copes with the new poverty and loneliness by fleeing to a secret beautiful garden.

straying into the world of the fantastic. As she told interviewer Raymond E. Jones of *Canadian Children's Literature: A Journal of Criticism and Review*, "I do not write fantasy. I haven't attempted to write it. All my worlds are logically based upon the universe that we know and the normal Newton's laws and laws of thermodynamics. That is science fiction. Fantasy is if you design your own universe and it may have different laws. I've never gone that way."

Back from the Future

Although never going the way of fantasy, Hughes has taken a lead from her first novel, *Gold-Fever Trail*, and written several well-received books of realistic and historical fiction. The themes of isolation and the personal search for identity that

characterize her science-fiction novels are also present in such books as 1982's *Hunter in the Dark,* a poignant story of a young man's attempt to deal with cancer. Lacking a ritual through which he can ascend to manhood before his life ends, the novel's protagonist goes on a dangerous hunting expedition, where his maturity is tested in unexpected ways. Winner of several awards, the novel was praised by Gerald J. Rubio in *Twentieth-Century Children's Writers* for its portrayal of both death and a young man's coming of age. Claiming it as Hughes's "masterpiece," Rubio noted of *Hunter in the Dark,* "Adults will find themselves as impressed and moved by this work as younger readers are."

If you enjoy the works of Monica Hughes, you may also want to check out the following books and films:

Tanith Lee, *The Black Unicorn,* 1991.
Meredith Ann Pierce, *A Gathering of Gargoyles,* 1984.
Pamela Sargent, *Earthseed,* 1983.
Brian's Song, Columbia Tristar, 1971.
Silent Running, MCA/Universal, 1971.

1983's *My Name Is Paula Popowich!* tells of another young person's search, this time for a sense of ethnic identity. Growing up in a predominately Germanic town in Canada, twelve-year-old Paula Herman doesn't fit in with her blonde-haired, blue-eyed neighbors. Even bleaching her hair blonde doesn't help; and Paula's mother, who is trying to raise her daughter without the help of Paula's long-departed father, is too stressed out to recognize and deal with the budding teenager's feelings of inadequacy. It is only after the dark-eyed Paula learns of her Ukrainian ancestry from her newly discovered grandmother on her father's side of the family that she gains a positive sense of her individuality and of her place within her community.

Other novels written in the realistic vein include *The Ghost Dance Caper,* in which a boy of mixed-race heritage deals with the conflicts of combining rural and urban cultures; *Log Jam,* which recounts Lenora's emotional turmoil in coming to terms with her parent's divorce and the adventures she shares with an Indian named Isaac

Manyfeathers as she adjusts to her new family situation; and *Blaine's Way,* a historical novel about a young man growing up in rural Ontario during the Depression years.

Realizes Obligations to Audience

In her years as a published writer, Hughes has traveled many miles, through both time and space, to create her fictional worlds, and recognizes that she has come a long way since she first began writing stories as a hobby. "I think my life story helps to prove that writing is not a miraculous activity," she was quick to note in her essay for *SAAS.* "It depends a great deal on persistent hard work, and on understanding how one's mind works—how to balance the necessary imaginative right brain and the equally necessary logical left brain which must turn the ideas into written words and sentences and paragraphs. It depends on rewriting, and writing again, on accepting the advice of a trusted editor and yet not deviating from one's clear idea of what is supposed to come out of each book."

In an essay for *Canadian Children's Literature: A Journal of Criticism and Review,* Hughes shared her overall philosophy on writing for children: "I think one of the functions of being a good writer for children (besides, obviously, being entertaining) is to help them explore the world and the future. And to find acceptable answers to the Big Questions: 'What's life about?' 'What is it to be human?'. . . These are the questions that demand truthful answers, not part ones. So I think my chief criterion for a story for children—it should be for all fiction in fact, of course, but very especially that written for the young—is that one should write as truthfully as possible, even if it isn't easy or painless. One faces oneself in the darkest inside places of one's memory and one's sorrow. But always . . . always there must come hope."

The aspect of hope—for individuals as well as cultures—is addressed throughout Hughes's work; but in realistically anticipating the future of planet Earth and its inhabitants, she has developed some concerns. "It is only a step around a dark corner from the past into the future," she explained in *Twentieth-Century Science-Fiction Writers:* "given what happened then, what might happen when . . . ? I am particularly concerned with the

fragility of our environment and with the loss of the 'bloom on the grape' of life as our technological society progresses like a juggernaut, threatening rain forests, oceans, indigenous native cultures."

■ Works Cited

Crouch, Marcus, review of *The Guardian of Isis, Junior Bookshelf*, October, 1981, p. 212.

Davidson, Andrea, review of *The Crystal Drop, Voice of Youth Advocates*, December, 1992, p. 310.

Ellis, Sarah, "News from the North," *Horn Book*, September/October, 1984, pp. 661-64.

Hughes, Monica, "The Writer's Quest," *Canadian Children's Literature: A Journal of Criticism and Review*, number 26, 1982, pp. 6-27.

Hughes, Monica, autobiographical essay in *Something about the Author Autobiography Series*, Volume 11, Gale, 1991.

Hughes, Monica, comments in *Twentieth-Century Science-Fiction Writers*, 3rd edition, edited by Noelle Watson and Paul E. Schellinger, St. James Press, 1991, p. 397.

Jones, Raymond E., "The Technological Pastoralist: A Conversation with Monica Hughes," *Canadian Children's Literature: A Journal of Criticism and Review*, number 44, 1986, p. 618.

Pearson, Kit, "A Harvest of Children's Books from Canada," *Christian Science Monitor*, October 5, 1984, pp. B8-B9.

Rubio, Gerald J., "Monica Hughes," *Twentieth-Century Children's Writers*, 3rd edition, edited by Tracy Chevalier, St. James Press, 1989, pp. 473-74.

■ For More Information See

BOOKS

Children's Literature Review, Volume 9, Gale, 1985, pp. 61-79.

Twentieth-Century Young Adult Writers, St. James Press, 1994, pp. 307-08.

PERIODICALS

Booklist, April 15, 1977; June 1, 1985.

Bulletin of the Center for Children's Books, June, 1996, p. 339.

Canadian Children's Literature: A Journal of Criticism and Review, number 13, 1979, pp. 20-26; number 17, 1980; number 33, 1984, pp. 40-45; number 37, 1985, pp. 18-28; number 48, 1987, pp. 15-28.

Globe & Mail (Toronto), May 2, 1987.

Horn Book, June, 1982, pp. 298-99; May/June, 1985; January/June, 1992, p. 275.

Magpies, May, 1996, pp. 22-24.

School Library Journal, June, 1993, p. 106.

Science Fiction and Fantasy Book Review, March, 1982, p. 21; July/August, 1982.

Times Literary Supplement, March 28, 1980; September 18, 1981; July 23, 1982.*

—Sketch by Pamela L. Shelton

Welwyn Wilton Katz

London. *Member:* Writers' Union of Canada, Canadian Society of Children's Authors, Illustrators and Performers.

■ Personal

Born June 7, 1948, in London, Ontario, Canada; daughter of Robert and Anne (Taylor) Wilton; married Albert N. Katz, 1973 (separated 1989); children: Meredith Allison. *Education:* University of Western Ontario, B.S., 1970. *Hobbies and other interests:* Playing the flute, reading myths and legends, finding recipes that incorporate the herbs she grows, knitting.

■ Addresses

Home and Office—549 Ridout St., N., Unit 502, London, Ontario, Canada, N6A 5N5.

■ Career

Writer; South Secondary School, London, Ontario, Canada, teacher, assistant head of mathematics, 1970-77. Past refugee coordinator, Amnesty International; treasurer and member of the steering committee, London Children's Literature Round Table; former researcher, Girls' Group Home of

■ Awards, Honors

Book of the Year Runner-up, Canadian Library Association, 1985, for *Witchery Hill*, 1987, for *Sun God, Moon Witch*, 1988, for *False Face*, and 1989, for *The Third Magic*; Ruth Schwartz Award Finalist, 1987, for *False Face*, and 1988, for *The Third Magic*; International Children's Fiction Prize, Governor-General's Award Finalist, Max and Greta Ebel Award, and Trillium Award Finalist, all 1987, and selected one of *School Library Journal*'s Best Books and a Pick of the List, *American Bookseller*, both 1988, all for *False Face*; Governor-General's Award, 1988, for *The Third Magic*; Young Adult Honour Book Award, Canadian Library Association, 1996, for *Out of the Dark*.

■ Writings

The Prophecy of Tau Ridoo, illustrated by Michelle Desbarats, Tree Frog Press, 1982.
Witchery Hill, Atheneum, 1984.
Sun God, Moon Witch, Douglas & McIntyre, 1986.
False Face, Douglas & McIntyre, 1987, Macmillan, 1988.
The Third Magic, Douglas & McIntyre, 1988, Macmillan, 1989.

Whalesinger, Douglas & McIntyre, 1990, Macmillan, 1991.
Come Like Shadows, Viking, 1993.
Time Ghost, Simon & Schuster/Margaret K. McElderry, 1995.
Out of the Dark, Groundwood, 1996.

■ Sidelights

For Welwyn Wilton Katz, it was the books of J. R. R. Tolkien that changed everything. As she once stated in *Something About the Author (SATA)*, "I found that it was possible, using words alone, to create a whole world, a marvellously complex and unreal world that other people could believe in." Katz has used her interest in myths, legends, and the supernatural to weave stories that incorporate both current problems most teenagers face—insecurity and parental divorce to name just two—and timeless mythological themes that play out the conflict between good and evil. Whether on their home turf or transported to another time or planet, her characters deal with evil outside themselves or within, when the protagonist becomes the unwitting prey of evil powers.

Katz, a fifth-generation Canadian, was born June 7, 1948, in London, Ontario, Canada. She credits her Scottish and Cornish ancestors with her abiding interest in Celtic myths. Unlike many writers, Katz does not recall writing very much when she was young. One exception was a high school final exam in which she was asked to write for three hours on one of five topics. "I spent two hours trying to decide which of those awful topics I would choose," she told *SATA*, "and the remaining hour `taking dictation' from some inspired part of my brain, the words simply flowing out of me. . . . It was one of the most exciting experiences I've ever had." But even with the excellent grade she earned and the thrill of this feeling, it took a long time for Katz to try her hand at writing again.

An honors student in mathematics, Katz became a high school teacher, a position she held until she was twenty-eight. She found it difficult to adjust to being in the classroom, though she liked her students and made a good salary. She tried several makeovers—pierced ears, contact lenses, new clothes—but still felt awkward in her chosen profession. Uninspired, Katz worried that her whole life would continue on this steady, dull course and, as she told *SATA*, "it gave me the creeps."

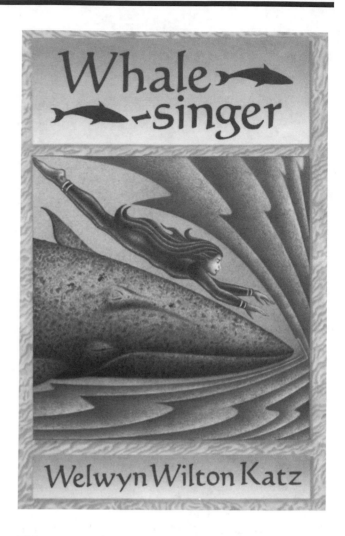

This 1990 work touches upon the environment, history, and personal problems in the life of two young conservationists.

Getting Hooked on Writing

It was at this point that she read Tolkien; the immediate effect was that Katz decided to write an adult fantasy novel. Initially, she devoted evenings and summers to her writing, but found that part-time writing didn't suit her. A year's leave of absence was followed by another, and by then she had finished her first draft, a hefty 750 pages. The ambitious story took place in a different world and had a huge cast of characters, whose complex setting demanded long, detailed exposition. By 1979, she had resigned as a teacher and used another year to rewrite the manuscript.

Katz sent it out to several publishers but none expressed interest. "When there was no one left

to send it to, I cried a little—okay, a lot!—and then put the book on my top shelf. There it sits to this day," she wrote in *SATA*. But Katz made a very important discovery: she wanted to write. Furthermore, she learned about writing itself from doing the work, honing her technique and style. Among her characters were several children, and Katz thought she might try a children's book next.

Her breakthrough came in 1982, when her first novel *The Prophecy of Tau Ridoo* appeared. In it, the five Aubrey siblings find themselves in the strange and threatening world of Tau Ridoo, controlled by the terrifying Red General. He sends his deputies after the children, who become separated from each other. Cooky, a sorceress, comes to their aid and together they manage to defeat the evil General and to be reunited.

Witchery Hill's protagonist is Mike, whose parents have recently divorced. Along with his journalist father, Mike travels to Guernsey (one of the English Channel Islands) for a summer visit with the St. Georges, family friends. Mike's friendship with the eldest daughter, Lisa, reveals surprising turmoil beneath the apparently calm surface of her family life. Diabetic and fiercely attached to her father, Lisa suspects her stepmother is not only a witch, but trying to gain control of the local coven. Vanquishing the evil powers set loose on the island and destroying the coven fall to Mike, who must also reconcile himself to a less-than-perfect relationship with his father. A contributor in *Publishers Weekly* lauded Katz for holding the reader in "thrall," concluding that *Witchery Hill* "is a knockout, with each character deftly delineated and a socko finish." John Lord, writing in *Voice of Youth Advocates*, echoed this view, praising Katz's use of the setting, with its Stonehenge-like standing stones and its invitation to adventure in a world of facts interwoven with fantasy. "For the reader who needs action and intrigue," Lord stated, "this book is definitely `IT.'"

Witchery Hill sprang out of a series of coincidences connected to Katz's chance visit to Guernsey, whose ferry docked in the small town where she dropped off a rental car. A randomly chosen hotel happened to be staffed by a woman with an interest in the island's folklore. Katz found references to witchcraft on the island as late as 1967 and came upon a manual of witchcraft in a bookstore. She decided to set her story on the island

and to use a very powerful book of sorcery as the source of the witches' strife.

Historical facts were the inspiration for *Sun God, Moon Witch* as well. Katz read widely on dowsers (also known as water-witchers), who often reported strong electrical shocks when they came into contact with standing stones like those in the stone circles in England. Katz also recalled a family story about a dowser who had discovered a spring on their farm, and she knitted the two together. In *Sun God, Moon Witch*, Thorny McCabe is underwhelmed by the idea of summering with her cousin Patrick in an English village. But she soon discovers that the village is engaged in a controversy over the ancient stone circle of Awen-Ur. Like *Witchery Hill*, *Sun God, Moon Witch* re-

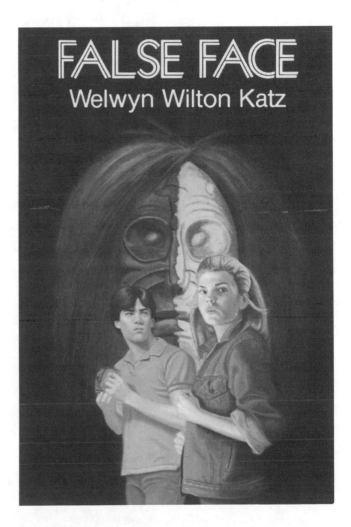

Two teenagers, struggling with family problems, discover Iroquois masks that put them in touch with the supernatural and their deepest selves.

volves around the protagonist's struggle to keep evil from taking over the world.

False Face tackles a different kind of ethical dilemma—the appropriate handling of cultural artifacts—as played out against a difficult family drama. Protagonist Laney McIntyre finds an Indian mask in a bog near her London, Ontario, home. The tensions in her house following her parents' recent divorce are symbolized by their

If you enjoy the works of Welwyn Wilton Katz, you may also want to check out the following books and films:

Lloyd Alexander's "Prydain" series, including *The High King,* Holt, 1968.

Nancy Bond's *A String in the Harp,* Atheneum, 1976, or her *Country of Broken Stone,* Atheneum, 1980.

Susan Cooper's "The Dark Is Rising" series, including *The Grey King,* Atheneum, 1975.

Ursula K. Le Guin's "Earthsea" books, including *A Wizard of Earthsea,* Parnassus, 1968.

J. R. R. Tolkien, *The Hobbit,* Houghton, 1938, adapted by Rankin-Bass as a made-for-television animated movie, 1977.

different reactions to Laney's find: as a successful antiques dealer, her mother encourages her to profit by it, but her father, a professor, encourages her to donate it to a museum. Meanwhile, the mask itself appears to be emitting corrupting powers that only she and her Indian friend Tom seem able to stop. *Voice of Youth Advocates*'s Rosemary Moran pointed out that the novel is "steeped in Canadian lore" and that the characters embodied the difficulties of dealing with different cultures "with enough suspense to keep the reader involved until the climax." A *Publishers Weekly* reviewer found that Katz "welds the supernatural element onto the family's conflicts with grace and competence."

Environmental Concerns

Katz describes *The Third Magic* as a kind of predecessor to the King Arthur legend. The novel

took her about three years to complete, much of it spent constructing Nwm, an imaginary world, in as much detail as possible. Morgan LeFevre, a fifteen-year-old, has accompanied her father to Tintagel to assist with a TV documentary on the King Arthur legend. Centuries before, Morrigan, a sister in the matriarchal society of Nwm, had been sent to Tintagel, fated to become Morgan Le Fay. Because of her resemblance to Morrigan, Morgan is transported to Nwm, confronted by two warring forces of magic. To Margaret Miles of *Voice of Youth Advocates,* Katz tried hard but failed to find a new twist to the Arthurian and Celtic-based fantasies and wrote that Arthurian fans "may be interested in some aspects . . . but are likely to find it rather less magical than the classics of the genre." Although Robert Strang, in reviewing the book for *Bulletin of the Center for Children's Books,* complained of a plot "convoluted even by genre standards," he found it to be a "unique recasting of a legend."

Katz changed direction a bit with *Whalesinger,* which looks at the relationships between humans, animals, and nature. Set in spectacular Point Reyes National Seashore in northern California, *Whalesinger* features two teenagers with problems, both of whom are involved in a summer marine conservation program. Nick is an angry young man eager to blame the team leader for Nick's older brother's death in a shipboard explosion, and Marty is a learning-disabled, lonely girl who has an empathic bond with a gray whale and her calf. Katz uses the coastline as emblematic of nature's power—the action climaxes in an earthquake—and history—there are references to an accident that occurred centuries before when Sir Francis Drake visited the area. A critic in *Publishers Weekly* chided Katz for a "veritable bouillabaisse of fishy plot developments," finally determining that she "has gone overboard." *School Library Journal*'s Patricia Manning applauded Katz for her "complex pattern of science, personalities, a lost treasure, and a whale mother with an ailing baby" and pronounced the book "intriguing."

Now, for Some Classic Witches

With her interest in the supernatural, it's no surprise that Katz would find herself drawn to *Macbeth*—and making full use of the play's reputation among theater people for being cursed. Teenaged Kinny O'Neill, the protagonist of *Come*

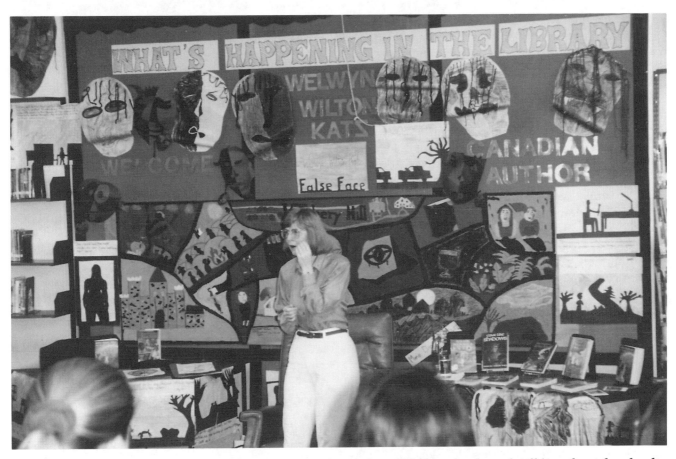

Katz, a high school math teacher before coming a writer, enjoys visiting schools and talking about her books.

Like Shadows, has a summer job with the director of the Stratford, Canada, Shakespeare festival. When she finds the perfect mirror prop, Kinny has no idea that it contains the spirit of the eleventh-century witches that destroyed the real Macbeth. The company travels to perform in Scotland, the witches by now in modern dress and using the apparently helpless Kinny to further their plot to renew their coven. Barbara L. Michasiw wrote of the book in *Quill and Quire* that *"Come Like Shadows* is difficult to reconcile with reality. . . . This is a challenging story that will probably not be comfortably accessible" to all readers. Lucinda Snyder Whitehurst of the *School Library Journal* also found the alternating points of view, from Kinny to Macbeth, a little difficult to follow, but felt that it would be "appreciated by drama and Shakespeare enthusiasts." Reviewing the book for *Voice of Youth Advocates*, Mary Jane Santos declared it "an intriguing mystery-fantasy with well developed characters and realistic dialogue."

Again and again, reviewers point to Katz's ability to use landscape and location to great advan-

tage in her work. She proved herself especially adept in her 1995 novel, *Time Ghost*, which is set in the polluted world fifty years hence. Along with their friends—brother and sister Josh and Dani—Sara and her brother Karl accompany their grandmother to the North Pole. An argument between Sara and her grandmother catapults Sara and Dani back in time, to the late twentieth century before nature was irrevocably ruined. In *Booklist*, Carolyn Phelan predicted that readers would be drawn to the "flow of action and emotion, the deft descriptions of the natural world, and the sympathetic characters." Susan L. Rogers of *School Library Journal* was impressed with Katz's "absorbing story" that delivers "a serious ecological message," sentiments echoed by a *Publishers Weekly* critic, who also noted the ecological message and found it "stifles neither characters nor the plot."

After a break from myths, Katz returned to the ancient Norse tales for *Out of the Dark*, which *Children's Reader* reviewer Janet Wynne-Edwards termed "satisfying." Thirteen-year-old Ben, his

younger brother Keith and their father move from Ottawa to start a new life in Newfoundland, in the town of Ship Cove, where his father grew up. Before her death, Ben's mother told him many of the Viking stories, and in her honor he begins to carve a knarr (a Viking ship), the myths and historical details helping him to deal with his own problems. As Wynne-Edwards wrote, "The young reader is not subjected to an anthropological checklist of artifacts and so may well retain this history."

Despite plots that sometimes strike reviewers as too complex, Katz consistently provides her readers with strong writing, compelling characters, and believable dialogue. She manages to work in her environmental concerns and her own fascination with ancient tales without overloading the story, earning her many awards and an enthusiastic, loyal following.

■ Works Cited

Review of *False Face, Publishers Weekly,* July 29, 1988, p. 234.

Katz, Welwyn Wilton, comments in *Something About the Author,* Volume 62, Gale, 1990.

Lord, John, review of *Witchery Hill, Voice of Youth Advocates,* April, 1985, p. 48.

Manning, Patricia, review of *Whalesinger, School Library Journal,* May, 1991, p. 111.

Michasiw, Barbara L., review of *Come Like Shadows, Quill and Quire,* February, 1993, p. 36.

Miles, Margaret, review of *The Third Magic, Voice of Youth Advocates,* June, 1989, p. 116.

Moran, Rosemary, review of *False Face, Voice of Youth Advocates,* February, 1989, p. 286.

Phelan, Carolyn, review of *Time Ghost, Booklist,* May 1, 1995, p. 1573.

Rogers, Susan L., review of *Time Ghost, School Library Journal,* May, 1995, p. 108.

Santos, Mary Jane, review of *Come Like Shadows, Voice of Youth Advocates,* October, 1993, p. 228.

Strang, Robert, review of *The Third Magic, Bulletin of the Center for Children's Books,* February, 1989, p. 150.

Review of *Whalesinger, Publishers Weekly,* December 21, 1990, p. 57.

Whitehurst, Lucinda Snyder, review of *Come Like Shadows, School Library Journal,* December, 1993, p. 134.

Review of *Witchery Hill, Publishers Weekly,* November 2, 1984, p. 77.

Wynne-Edwards, Janet, "The Mythical Presence of Here: Recent Canadian Children's Fiction" in *The Children's Reader,* Winter, 1995-96.

■ For More Information See

BOOKS

Twentieth-Century Children's Writers, edited by Laura Standley Berger, St. James, 1995, pp. 503-04.

PERIODICALS

Canadian Children's Literature, Number 47, 1987.
Kirkus Reviews, August 1, 1988, p. 1151.
Publishers Weekly, July 15, 1996, pp. 74-75.

—Sketch by Megan Ratner

Kathryn Lasky

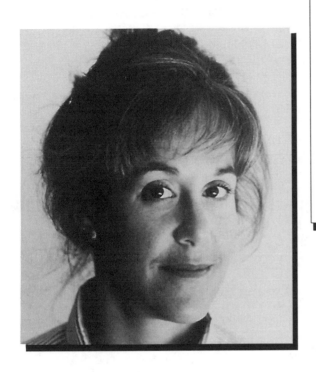

■ Personal

Also writes under name Kathryn Lasky Knight; born June 24, 1944, in Indianapolis, IN; daughter of Marven (a wine bottler) and Hortense (a social worker); married Christopher Knight (a photographer and filmmaker), May 30, 1971; children: Maxwell, Meribah. *Education:* University of Michigan, B.A., 1966; Wheelock College, M.A., 1977. *Hobbies and other interests:* Sailing, skiing, hiking, reading.

■ Addresses

Home—7 Scott St., Cambridge, MA, 02138. *Agent*—Jed Mattes, 175 West 73rd St., New York, NY.

■ Career

Writer and educator.

■ Awards, Honors

Boston Globe-Horn Book Award, 1981, for *The Weaver's Gift;* American Library Association (ALA) notable book citations, 1981, for *The Night Journey*

and *The Weaver's Gift,* 1984, for *Sugaring Time,* 1985, for *Puppeteer,* 1990, for *Dinosaur Dig,* and 1993, for *Surtsey: The Newest Place on Earth;* National Jewish Book Award, Jewish Welfare Board Book Council, and Sydney Taylor Book Award, Association of Jewish Libraries, both 1982, both for *The Night Journey;* ALA best books for young adults citations, 1983, for *Beyond the Divide,* 1984, for *Prank,* 1987, for *Pageant,* and 1994, for *Beyond the Burning Time; New York Times* notable book citation, 1983, for *Beyond the Divide;* Newbery Honor Book, ALA, 1984, for *Sugaring Time; Washington Post*/Children's Book Guild Nonfiction Award, 1986, for body of work; "Youth-to-Youth Books: A List for Imagination and Survival" citation, Pratt Young Adult Advisory Board, 1988, for *The Bone Wars;* Paleontological Society Golden Trilobite Award, 1990, for *Traces of Life: The Origins of Humankind;* Parenting Reading Magic Award, 1990, for *Dinosaur Dig;* Edgar Award nominee for Best Juvenile Mystery, 1992, for *Double Trouble Squared;* Sequoyah Young Adult Book Award, 1994, for *Beyond the Burning Time;* CBC-IRA Children's Choice selection, for *She's Wearing a Dead Bird on Her Head.*

■ Writings

JUVENILE BOOKS

Agatha's Alphabet, Rand McNally, 1975.
I Have Four Names for My Grandfather, illustrated with photographs by husband, Christopher Knight, Little, Brown, 1976.

Tugboats Never Sleep, illustrated with photographs by Knight, Little, Brown, 1977.

Tall Ships, illustrated with photographs by Knight, Scribner, 1978.

My Island Grandma, Warne, 1979, Morrow, 1993.

The Weaver's Gift, illustrated with photographs by Knight, Warne, 1981.

The Night Journey, illustrated by Trina Schart Hyman, Warne, 1981.

Dollmaker: The Eyelight and the Shadow, illustrated with photographs by Knight, Scribner, 1981.

Jem's Island, Scribner, 1982.

Sugaring Time, illustrated with photographs by Knight, Macmillan, 1983.

Beyond the Divide, Macmillan, 1983.

A Baby for Max (in the words of son, Maxwell B. Knight), illustrated with photographs by Knight, Scribner, 1984.

Prank, Macmillan, 1984.

Home Free, Macmillan, 1985.

Puppeteer, illustrated with photographs by Knight, Macmillan, 1985.

Pageant, Four Winds Press, 1986.

Sea Swan, illustrated by Catherine Stock, Macmillan, 1988.

The Bone Wars, Morrow, 1988.

Traces of Life: The Origins of Humankind, illustrated by Whitney Powell, Morrow, 1989.

Dinosaur Dig, illustrated with photographs by Knight, Morrow, 1990.

Fourth of July Bear, illustrated by Helen Cogancherry, Morrow, 1991.

Double Trouble Squared, Harcourt, 1991.

Surtsey: The Newest Place on Earth, illustrated with photographs by Knight, Hyperion, 1992.

I Have an Aunt on Marlborough Street, illustrations by Susan Guevara, Macmillan, 1992.

Shadows in the Water, Harcourt, 1992.

Think Like an Eagle: At Work with a Wildlife Photographer, illustrated with photographs by Knight and Jack Swedberg, Little, Brown, 1992.

The Solo, illustrations by Bobette McCarthy, Macmillan, 1993.

The Tantrum, illustrations by McCarthy, Macmillan, 1993.

Monarchs, illustrated with photographs by Knight, Harcourt, 1993.

Searching for Laura Ingalls: A Reader's Journey, with daughter Meribah Knight, illustrated with photographs by Knight, Macmillan, 1993.

Lunch Bunnies, illustrated by Marilyn Hafner, Little, Brown, 1993.

A Voice in the Wind, Harcourt, 1993.

Memoirs of a Bookbat, Harcourt, 1994.

Beyond the Burning Time, Scholastic, 1994.

Cloud Eyes, illustrations by Barry Moser, Harcourt, 1994.

The Librarian Who Measured the Earth, illustrated with photographs by Kevin Hawkes, Little, Brown, 1994.

Days of the Dead, illustrated with photographs by Knight, Hyperion, 1994.

Pond Year, illustrations by Mike Bostok, Candlewick, 1995.

She's Wearing a Dead Bird of Her Head, illustrations by David Catrow, Hyperion, 1995.

The Gates of the Wind, illustrations by Janet Stevens, Harcourt, 1995.

A Journey to the New World: The Diary of Remember Patience Whipple, Mayflower, 1620, Scholastic, 1996.

True North: A Novel of the Underground Railway, Scholastic, 1996.

A Life Between Two Comets: The Story of Mark Twain, illustrated by Barry Moser, Harcourt, 1996.

ADULT BOOKS; UNDER NAME KATHRYN LASKY KNIGHT

Atlantic Circle, illustrated with photographs by Knight, Norton, 1985.

Trace Elements, Norton, 1986.

The Widow of Oz, Norton, 1989.

Mortal Words, Simon & Schuster, 1990.

Mumbo Jumbo, Simon & Schuster, 1991.

Dark Swan, St. Martin's Press, 1994.

OTHER

Contributor to various periodicals, including *Sail*, *Horn Book*, and *New York Times Book Review*.

■ **Adaptations**

Sugaring Time was adapted as a filmstrip by Random House, 1986, for audio cassette, 1986, and for videocassette, 1988.

■ **Work in Progress**

The Most Beautiful Roof, Harcourt, expected 1997; *Grace O'Malley*, Hyperion, expected 1997; *Marren of the Great North*, Harcourt, expected 1997.

■ Sidelights

"It is easy to get seduced into a kind of formulaic creativity," author Kathryn Lasky said in a 1991 article in *Horn Book*. "If a book works once, it might work twice, and then thrice, and then forty times. . . . I can't stand doing the same thing twice. I don't want to change just for the sake of change. But the whole point of being an artist is to be able to get up every morning and reinvent the world." That is just what Lasky has done in more than fifty books, most of which were written for young people. In the process, Lasky has won a wide readership and earned a reputation as a prolific and versatile author. While some reviewers have chided her for her "wordiness," most have praised her vivid imagery, readable style, and ability to deal with difficult topics in words that young readers can understand and enjoy.

Lasky's nonfiction books, many of which have been illustrated with photographs by her husband Christopher Knight, are among her most popular. In some, Lasky focuses on traditional arts and crafts such as dollmaking, weaving, puppet making, and gathering maple sugar. In others, she looks at various topics in science or natural history such as monarch butterflies, paleontology, volcanic islands, tall ships, the history of the Audubon Society, and even the birth of her daughter Meribah. "In my own experience in writing [nonfiction] I have always tried hard to listen, smell, and touch the place that I write about—especially if I am lucky enough to be there," Lasky explained in a 1985 article in *Horn Book*.

Lasky also writes fiction, both for children and adults; she has done more than a dozen novels for young people and five adult novels under her married name Kathryn Lasky Knight. Whatever audience she is writing for, her fiction shows the same meticulous attention to detail as her nonfiction. A contributor in *Children's Literature Review* once pointed out that "Lasky's novels . . . feature strong-willed protagonists and generally contain ethnic, historical, or religious elements which inspire or challenge the characters."

Kathryn Lasky was born and raised in Indianapolis, Indiana, where she was educated at "a very old fashioned all-girls school," as she wrote in the *Sixth Book of Junior Authors and Illustrators*. As a youngster she was a "reluctant reader" since most of the books she encountered in school were boring. "But I loved the [ones] my mom was reading to me—books like *Peter Pan* and the *Wonderful Wizard of Oz*," Lasky wrote in a press release for Blue Sky Press. Such tales fired the imagination of a girl who was a self-described "compulsive story-maker." One of her earliest literary efforts was a seventh-grade science report about the Pleistocene Age. "My route of research went something like this: First I went to the dictionary and looked up a definition," she explained in her 1985 *Horn Book* article. "Then I would proceed to the *World Book Encyclopedia*. If I was feeling very scholarly, I would persevere and take on the Mount Everest of research—*Encyclopedia Britannica*. . . . I would tremble at the thought of those

In this 1981 tale, Rachel learns how her grandmother escaped from old Russia when she was a child.

thousands of tissue-thin pages and masses of fine print under my arm. I would silently curse the idiot who had set his mind to collecting all this information in the first place. But more often than not, I would skip the *Britannica* and go on to my final step in the research process: Bursting into my sister's room, I would fling myself on her bed and in anguish cry, 'Quick, I need a first sentence about the Pleistocene Age!' Sometimes I would get one from her, and sometimes she'd tell me to get out."

Apart from her school essays, Lasky did not show anyone what she wrote. "I always wanted to be a writer, but on the other hand it seemed to lack a certain legitimacy as a profession," she once told *Contemporary Authors.* As a result, while Lasky continued inventing stories, she felt doing so was just a hobby. It was only after she graduated from the University of Michigan in 1966 with a B.A. degree in English and began working as a teacher that Lasky started showing her stories to her parents and to her husband Christopher Knight, who encouraged her to do more. She continued to write in her spare time, while teaching and studying at Wheelock College, where she earned an M.A. degree in 1977. Lasky's first book was *Agatha's Alphabet* (1975), a colorful alphabet book for children aged four to eight. Her second book was published the next year; *I Have Four Names For My Grandfather* (1976) was the first of her books to be illustrated by her husband's photographs.

Though aimed at young readers, *I Have Four Names For My Grandfather* in some ways established what was to come from the pen of Kathryn Lasky. That book—like so many others she has written—was notable for its strong characters and themes, and for its powerful sense of time and place. The book's timing, the year after her first, also proved to be a sign of Lasky's amazing literary productivity. In the two decades since she has never been without a book project in the works and has added at least one new title to her bibliography almost every year. From the beginning, Lasky's forte has been her nonfiction books, which are instructional and filled with a wealth of information and detail; her writing is an extension of her work as a teacher. Lasky's books have been characterized by the depth of her research, careful attention to the storyline, and the kind of vivid writing that brings characters, places, and scenes to life for young readers. Ironically,

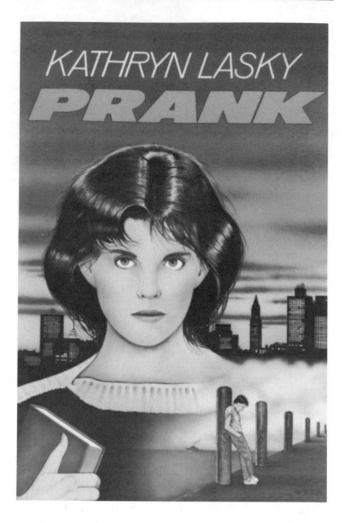

Sixteen-year-old Birdie Flynn begins to study the Holocaust after her brother is arrested for vandalizing a synagogue in this 1984 novel.

Lasky says she never read nonfiction books when she was a girl. "[They] were really dry back then," she stated in the press release from Blue Sky Press. "But then I realized that you can make the characters in nonfiction as fascinating as those in fiction."

Tugboats Never Sleep (1977) was her first nonfiction book, and it set the pattern for her writing of subsequent books: Lasky immerses herself in the details of her subject and then tries to convey as much information as she can in simple, straightforward language. Her aim is to satisfy a reader's curiosity. "I write directly from my own experiences," she once explained in *Something About the Author.* "The tugs of the tugboat book chug about right outside the window of our house which overlooks Boston harbor."

Nonfiction Draws Praise

Continuing with nautical themes, Lasky looked at America's sailing heritage. *Tall Ships* (1978) was partly history, partly a celebration of the graceful sailing vessels which took part in the 1976 United States bicentennial festivities. The enthusiasm Lasky and her husband felt for this subject was reflected in the amount of effort that went into the research, writing, and photography in the book. It was a labor of love, for both of them are avid sailors, and the work earned favorable reviews. "[It] is a short book, but this history of the 19th-century American sailing trade is surprisingly solid and consistently entertaining," wrote Peter Freedberger of the *New York Times Book Review*. "Like the sailing trade it describes, [it] is a lively, instructive and satisfying work." A writer for *Kirkus Reviews* echoed those comments, describing *Tall Ships* as "an interesting, instructive, exceptionally well-integrated book." Some reviewers criticized aspects of the book, like Barbara C. Campbell in *School Library Journal*, who expressed disappointment that Lasky had not fully explored her subject. Campbell acknowledged that the author covered items from shipbuilding to trade but noted, "all are topics worthy of fuller development."

Lasky has written more than a dozen other nonfiction books. Notable among them have been her works about natural history and scientific topics. In *Traces of Life: The Origins of Humankind* (1989), she describes the work of paleontologists, those scientists who seek to uncover evidence of humanity's evolutionary predecessors by looking for fossils and old bones. Ellen Mandel, writing in *Booklist*, deemed the work "authoritative yet highly readable," and *Bulletin of the Center for Children's Books* contributor Betsy Hearne stated that "the information is up to date and fairminded in presenting controversial theories." Reviewer Jon R. Luoma of the *New York Times Book Review* praised the *Traces of Life* as "a shining example of what science books for young readers can be," and he observed that Lasky's writing "positively brims over with [a] sense of wonder and mystery and discovery."

These same qualities are evident in many of Lasky's subsequent nonfiction books. *Dinosaur Dig* (1990) tells what happened when Lasky and her family went on a fossil dig. "Lasky's writing literally covers new ground on the dinosaur fron-

tier as she takes readers along through the hot Montana sun to share the excitement of uncovering bones that have lain unseen for millions of years," said Cathryn A. Camper in *School Library Journal*. "This book leaves one covered with sand, with dirt under his nails, bugs in his face and dryness in his mouth, but reawakens a powerful, currently underrated awe for nature and our earth's history," wrote Barbara Bottner of the *Los Angeles Times Book Review*. In *Think Like an Eagle: At Work with a Wildlife Photographer* (1992), Lasky looked at the work and dedication it takes to be a nature photographer; in *Surtsey: the Newest Place on Earth* (1992), she chronicled the creation of a volcanic island in the North Atlantic; and in *Monarchs* (1994), she explained the miraculous process by which tiny eggs develop into beautiful orange-and-black adult butterflies.

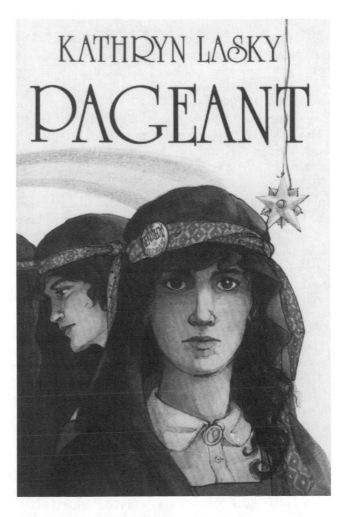

In this 1986 work, a Jewish teenager survives the trials and tribulations of life in a stuffy private school during the early 1960s.

In addition to her nonfiction books, Kathryn Lasky has also written more than twenty stories for young readers. Some are based on real-life-events and discuss topical historical, ethnic, or moral issues. *Home Free* (1985) deals with ecology, death, and autism; *The Solo* (1994) with self-reliance and friendship; *True North: A Novel of the Underground Railway* (1995) with slavery; and *A Journey to the New World: The Diary of Remember Patience Whipple, Mayflower, 1620,* (1996) with the early Pilgrim experience in America.

Exploring Her Jewish Heritage

History and Lasky's own Jewish heritage are the themes of several of her novels. *The Night Journey* (1981) tells what happens when thirteen-year-old Rachel begins keeping her great-grandmother Nana Sashie company. During these afternoon visits, Nana tells Rachel the story of how she and her family fled persecution in Czarist Russia. "The structure of the narrative underlines [a] sense of continuity and the book is full of images which echo across time and back into Jewish history," said Peter Kennerley of *School Librarian*. Marilyn Kaye in *School Library Journal* similarly remarked, "The portrayal of warm, supportive families in both stories becomes a link between past and present."

In *Prank* (1984), Lasky relates how Birdie Flynn, an Irish Catholic teenager from a troubled blue collar family living in East Boston, struggles to cope with the consequences after her brother helps vandalize a synagogue. When Birdie researches the Nazi treatment of Jews during World War II, she begins to understand the dangers of anti-Semitism and in the process gains insights into the nature of her own family's problems. Prank received decidedly mixed reviews, as Linda Garrett, writing in *Twentieth-Century Young Adult Writers*, noted: "Though criticized for a weak plot, this book was distinguished for vital characterization and development of as topic not often addressed in young adult literature." Michele Carlo, reviewing the work in *Best Sellers*, praised the subtlety of Lasky's message, stating that the author "lays a careful path to compare the observers of the death camps" to those people who witness crimes and yet remain silent. However, Zena Sutherland in the *Bulletin of the Center for Children's Books* commented that through "overwriting," Lasky had in some ways "defeated her apparent purpose, to show how deeply the Holocaust can still affect young people. . . ." And *Interracial Books for Children Bulletin* contributor Albert V. Schwartz, while declaring that "Lasky's characters are vital, her scenes dynamic," added that Lasky ignores the work's important themes by "suggesting that anti-Semitism is due to troubled individuals rather than societal factors."

Lasky drew on her own experiences and concerns again in the novel *Pageant* (1986). Set in Indianapolis in the period from 1960 to 1963, this book tells of the adventures of Sarah Benjamin, a strong-willed Jewish teenager who attends a conservative Christian private high school. *Pageant* is a thoughtful coming-of-age book that chronicles Sarah's loss of idealism and innocence. Desperate to escape the bigotry and intolerance of her hometown, Sarah runs away to New York. While on the road driving east that she learns that her hero, President John F. Kennedy, has been assassinated. "For anyone who lived through the Kennedy years, the dreams and glory of that time are tough to communicate, especially to younger people. Kathryn Lasky . . . has finally done it," remarked reviewer Cynthia Samuels in the *New York Times Book Review*. Wrote Christine Behrmann in *School Library Journal*, "The structure and writing of the book is smooth to the point of slickness, and, although the story is autobiographical, events seem to be stage-managed to coincide with national attitudes."

In *Memoirs of a Bookbat* (1994) Lasky proved she is not shy about tackling potentially difficult contemporary themes. The book's heroine is a fourteen-year-old girl named Harper Jessup, who loves reading. However, trouble arises when ideas in some of her books bring her into conflict with the views of her fundamentalist Christian parents. In telling this story, Lasky deals with such issues as book banning, censorship, and the right of parents to direct their children's lives. *Booklist* reviewer Hazel Rochman felt *Memoirs* was less a novel than "an essay about the danger of the religious Right," adding "[Lasky] makes an excellent case, but it remains a sermon, not a story about people." Alice Casey Smith in *School Library Journal* expressed similar concerns, describing *Memoirs of a Bookbat* as "a problematic story with a cast of disappointing, one-dimensional characters and a plot that misses the mark." Other critics offered more positive assessments. Cathi Dunn MacRae, reviewing the work in *Wilson Library*

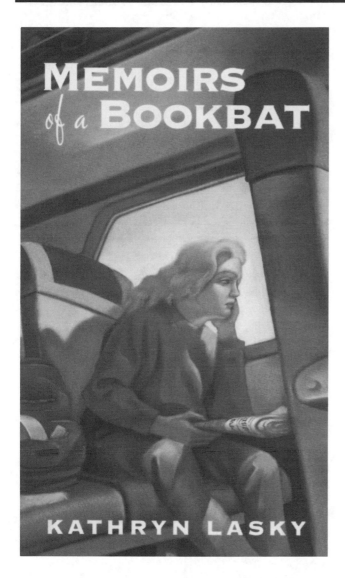

MEMOIRS
of a BOOKBAT

KATHRYN LASKY

Harper Jessup must confront her parents' fundamentalist Christian beliefs in this 1994 tale.

Bulletin, remarked that "Lasky demonstrates the enormous power of books as vital to survival, ultimately giving Harper courage to break away, to lives with the grandmother she has been forbidden to see ever since she told folktales to Harper."

Looking at America's Past

American history provided Lasky with the backdrop for several other novels, including *Beyond the Divide* (1983), *The Bone Wars* (1988), and *Beyond the Burning Time* (1994). *Beyond the Divide* tells the story of a young Amish girl named Maribah Simon, who gets separated from her family in the

Sierra wilderness in 1849. She survives with the help of Indians, who teach her to be strong and resourceful. "The novel is so realistic it would be easy to believe that *Beyond the Divide* is directly from the diary of a young girl going West," stated Garrett in *Twentieth-Century Young Adult Writers*. "[This book] is engrossing, a strong presentation of what life must surely have been like for those amazing souls who crossed this vast country in its unsettled state so short a time ago," stated Natalie Babbitt in the *New York Times Book Review*.

The Bone Wars is set in the badlands of Montana in the late nineteenth century. The action centers around the competition for dinosaur bones among researchers from Harvard, Yale, and Cambridge universities. The book's hero is Thad Longsworth, an orphan who is hired as a scout by the Harvard team. When Thad and the son of a British paleontologist become friends, they decide to stage their own dig and donate any fossils they find to a museum where everyone can see them. "The details Lasky uses to describe both the monotony and the thrill of excavation work are excellent, the historical background rich, the sense of adventure keen and the characterizations intriguing, but perhaps not so developed as they might be," stated Kem Knapp Sawyer in the *Washington Post Book World*. Yvonne A. Frey in *School Library Journal* commented, "This is poetically written historical fiction that will give young adult readers a real sense of a complex period of our history."

In contrast to *The Bone Wars*, which deals with the pursuit of scientific knowledge, *Beyond The Burning Time* deals with the terrifying and tragic effects of ignorance and superstition. It is a story about twelve-year-old Mary Chase, who lives in Salem, Massachusetts, in 1692, a time when women are accused of being witches and are put to death. When Mary's own mother is accused, tried, and sentenced to hang, Mary and her brother decide to take action. Reviewer Carolyn Noah in *School Library Journal* praised *Beyond the Burning Time* as "a readable, engrossing, and sometimes exciting tale of an important era in American history." *Bulletin of the Center for Children's Books* contributor Roger Sutton praised the depth of Lasky's research, observing that she "explore[s] the economic rivalries that may have caused the attention-begging hysterics" of a group of girls that eventually led to the Salem witchcraft trials.

Mystery Titles Add Variety

In contrast to most of Lasky's fiction for young people is a series of adventure-mystery books she has written about the Starbuck family. The Starbucks have two sets of twins—one of twelve-year-olds and the other younger—who can read each other's minds and communicate telepathically. While Lasky still uses her storytelling to inform and challenge her readers (one of her characters is Zanny the Nanny, who does double duty as the girls' teacher), the Starbuck books are meant as light, fun reading. Lasky introduced the Starbucks in *Double Trouble Squared* (1992), which takes place in London, England. The sisters get involved in a series of strange events that echo details from cases solved by Sir Arthur Conan Doyle's fictional detective Sherlock Holmes. Critics were generally not enthused about *Double Trouble Squared*; the consensus of opinion was this first book in the projected series took too long to get moving. "The narrative has an improvisational aimlessness to it that occasionally tips into total confusion," said Roger Sutton of the *Bulletin of the Center for Children's Books* "There are simply too many characters, both human and . . . otherwise," argued Michael Cart in *School Library Journal*.

Nonetheless, the Starbuck twins returned in *Shadows in the Water* (1992) and *A Voice in the Wind* (1993). *Shadows in the Water* is set in the Florida Keys and involves the twins in capturing a gang of villains who are engage in illegal dumping of toxic waste. "The culminating adventure and capture of the villains is exciting, but the story as a whole lacks focus," wrote Ruth S. Vose in *School Library Journal*. In her descriptions of the Florida Keys, "Lasky is affectionate and winning; but a consistent style and a truly persuasive narrative are sacrificed in the process," declared a contributor in *Kirkus Reviews*. Janice Del Negro, however, stated in *Booklist* that *Shadows in the Water* is "solid, involving light fiction with a lot of appeal."

A Voice in the Wind, the third book in the Starbuck series, finds the twins in the American southwest solving a 600-year-old murder mystery, catching grave robbers, and helping their father deal with a river diversion project. A *Kirkus Reviews* contributor expressed disappointment in the work, citing "scattershot points of view; mixed tenses; choppy Native American dialogue; threads of plotting that go nowhere." Julie Halverstadt in *School Library Journal* was more appreciative. Although

If you enjoy the works of Kathryn Lasky, you may want to check out the following books and films:

Pam Conrad, *My Daniel*, 1989.
Sook Nyul Choi, *Year of Impossible Goodbyes*, 1991.
Norma Howe, *God, the Universe and Hot Fudge Sundaes*, 1984.
Madeleine L'Engle, *Many Waters*, 1986.
Richard Peck, *Voices after Midnight*, 1989.
Schindler's List, MCA/Universal, 1993.

the plot was "far-fetched," she believed "young readers will soon be drawn into the mystery and the well-researched history of the area."

In addition to her books for young people, Kathryn Lasky has written four novels and a work of nonfiction for adults under her married name—Katherine Lasky Knight. The latter, a nonfiction book entitled *Atlantic Circle* (1985), is an account of what happened when the author and her husband sailed across the Atlantic and then cruised around Europe in a thirty-foot ketch they received as a wedding gift. Susan Ebershoff-Coles in *Library Journal* wrote that *Atlantic Circle* was "one of the most readable books on sailing yet written." Christopher Buckley of the *New York Times Book Review* agreed. "[This is a] thoroughly engaging, funny, and beautifully written book," he stated.

The reaction to Lasky's four books of adult fiction has been lukewarm, and none of the books has been as widely reviewed as her writings for young people. A reviewer for *Publisher's Weekly* described *Trace Elements* (1986), her first adult novel, as "an uneven debut in crime fiction for adults." The story centers on a character named Calista Jacobs, a world famous children's book illustrator. Calista, with help from her young son, unravels the snake-bite murder of her husband Tom, a Harvard physicist, and of a German friend. "A curious lack of feeling dilutes the menace here," observed the *Publisher's Weekly* reviewer, who added that the Calista character was not easy to like or identify with.

The Widow of Oz (1989) was Lasky's second murder mystery. As in *Trace Elements*, the heroine is a woman who sets out to solve the murder of

her husband. Like Calista, Dorothy soon rediscovers romance, and life becomes a series of adventures. "Widowhood is treated as a plot gimmick," wrote Bethami Probst of the *New York Times Book Review,* mentioning that Dorothy's good fortune, including a marriage proposal and success in the stock market, come too easily to seem realistic. "In real life and better novels, widows suffer guilt, loneliness and inescapable anguish," Probst observed.

Despite the criticism, Lasky continues to write adult fiction. She brought Calista Jacobs back for an encore in a novel entitled *Mortal Words* (1990). In the work, a religious fanatic disrupts a panel discussion at a convention of children's book authors. One of the authors is later found murdered, and when Calista, who has been attending the conference, starts to investigate, she discovers a fundamentalist extremist plot to undermine research in genetics and fossils, and to promote biblical creationism. Crime mystery columnist Marilyn Stasio of the *New York Times Book Review* felt the novel's many storylines were confusing, noting that "Any one of the multifarious schemes described here in daunting scientific detail might have served for the plot."

Regardless of the reaction to Lasky's adult novels, she enjoys a reputation as an important writer who, as Garrett in *Twentieth-Century Young Adult Writers* notes, "has made and continues to make an impact on young adult literature." Lasky herself seems less concerned with reviews than with achieving her ultimate goals: stimulating her young readers in new and exciting ways. She has argued against what she says is a tendency in the publishing industry towards "packaging" books—paying big money to celebrity authors (many of which are ghost-written by somebody else) and then selling concepts rather than strong characters in multi-million dollar promotions and advertising campaigns. "I believe in the notion that the human mind is not packageable, that our young people want something more," she argued in her 1991 article in *Horn Book.* Lasky refuses to go along with the trend; she continues to write books that are filled with information and inspiration. As she related in her 1985 *Horn Book* article, "I really do not care if readers remember a single fact. What I do hope is that they come away with a sense of joy—indeed celebration—about something they have sensed in a world in which they live."

■ Works Cited

Babbitt, Natalie, review of *Beyond the Divide, New York Times Book Review,* August 21, 1983, p. 26.

Behrmann, Christine, review of *Pageant, School Library Journal,* December, 1986, p. 119.

Bottner, Barbara, review of *Dinosaur Dig, Los Angeles Times Book Review,* March 25, 1990, p. 8.

Buckley, Christopher, review of *Atlantic Circle, New York Times Book Review,* February 10, 1985, p. 15.

Campbell, Barbara C., review of *Tall Ships, School Library Journal,* March, 1979, p. 141.

Camper, Cathryn A., review of *Dinosaur Dig, School Library Journal,* May, 1990, p. 98.

Carlo, Michele, review of *Prank, Best Sellers,* September, 1984, pp. 234-35.

Cart, Michael, review of *Double Trouble Squared, School Library Journal,* February, 1992, p. 87.

Casey Smith, Alice, review of *Memoirs of a Bookbat, School Library Journal,* July, 1994, p. 119.

Children's Literature Review, Volume 11, Gale, 1986.

Del Negro, Janice, review of *Shadows in the Water, Booklist,* January 15, 1993, p. 908.

Ebershoff-Coles, review of *Atlantic Circle, Library Journal,* December, 1984, p. 2278.

Freedberger, Peter, review of *Tall Ships, New York Times Book Review,* March 18, 1979, p. 26.

Frey, Yvonne, review of *The Bone Wars, School Library Journal,* November, 1988, p. 126.

Garrett, Linda, "Kathryn Lasky," *Twentieth-Century Young Adult Authors,* edited by Laura Standley Berger, St. James Press, 1994, pp. 371-73.

Halverstadt, Julie, review of *A Voice in the Wind, School Library Journal,* December, 1993, p. 114.

Hearne, Betsy, review of *Traces of Life: The Origins of Humankind, Bulletin of the Center for Children's Books,* June, 1990.

Kaye, Marilyn, review of *The Night Journey, School Library Journal,* January, 1982, p. 79.

Kennerley, Peter, review of *The Night Journey, School Librarian,* June, 1983, p. 144.

Lasky, Kathryn, comments in *Something about the Author,* Volume 13, Gale, 1978.

Lasky, Kathryn, comments in *Contemporary Authors, New Revision Series,* Volume 11, Gale, 1984, p. 320.

Lasky, Kathryn, "Reflections on Nonfiction," *Horn Book,* September-October, 1985, pp. 527-32.

Lasky, Kathryn, comments in *Sixth Book of Junior Authors and Illustrators,* H. W. Wilson, 1989, pp. 160-61.

Lasky, Kathryn, "Creativity in a Boom Industry," *Horn Book,* November/December, 1991, pp. 705-11.

Lasky, Kathryn, comments in press release from Blue Sky Press, c. 1996.

Luoma, Jon R., review of *Traces of Life: The Origins of Humankind, New York Times Book Review,* June 24, 1990, p. 29.

MacRae, Cathi Dunn, review of *Memoirs of a Bookbat, Wilson Library Bulletin,* December, 1994, pp. 102-3.

Mandel, Ellen, review of *Traces of Life: The Origins of Humankind, Booklist,* May 1, 1990.

Noah, Carolyn, review of *Beyond the Burning Time, School Library Journal,* November, 1995, p. 108.

Probst, Bethami, review of *The Widow of Oz, New York Times Book Review,* November 19, 1898, p. 21.

Rochman, Hazel, review of *Memoirs of a Bookbat, Booklist,* April 15, 1994, p. 1526.

Samuels, Cynthia, review of *Pageant, New York Times Book Review,* November 9, 1986, p. 45.

Sawyer, Kem Knapp, review of *The Bone Wars, Washington Post Book World,* December 25, 1988, p. 13.

Schwartz, Albert V., review of *Prank, Interracial Books for Children Bulletin,* Volume 16, number 1, pp. 7-8.

Review of *Shadows in the Water, Kirkus Reviews,* September 15, 1992, p. 1190.

Stasio, Marilyn, review of *Mortal Words, New York Times Book Review,* August 8, 1990, p. 21.

Sutherland, Zena, review of *Prank, Bulletin of the Center for Children's Books,* May, 1984, p. 168.

Sutton, Roger, review of *Double Trouble Squared, Bulletin of the Center for Children's Books,* February, 1992, p. 160.

Sutton, Roger, review of *Beyond the Burning Time, Bulletin of the Center for Children's Books,* December, 1994, pp. 134-35.

Review of *Tall Ships, Kirkus Reviews,* February 1, 1979, p. 130.

Review of *Traces Elements, Publishers Weekly,* April 18, 1986, p. 51.

Review of *A Voice in the Wind, Kirkus Reviews,* December 15, 1993, p. 1592.

Vose, Ruth S., review of *Shadows in the Water, School Library Journal,* January, 1993, p. 101.

■ For More Information See

PERIODICALS

Booklist, November 15, 1981, pp. 439-40; July, 1983, p. 1402; May 1, 1984, p. 1250; January 15, 1986, pp. 758-59; June 1-15, 1993, p. 805; November 15, 1993, p. 618; October 15, 1994, p. 421.

Bulletin of the Center for Children's Books, May, 1979, p. 157; June, 1983, p. 192; February, 1986, p. 112; November, 1988; February, 1992, p. 160; March, 1992; February, 1993, p. 181; November, 1993, p. 88; April, 1994, p. 264; October, 1994, p. 54.

Children's Book Review Service, June, 1984, p. 117.

Children's Literature Association Quarterly, spring, 1992, pp. 5-8.

English Journal, January, 1984, pp. 87-89.

Horn Book, March/April, 1996, p. 189.

Kirkus Reviews, November 1, 1985, p. 1198.

Kliatt, July, 1996, p. 13.

Language Arts, January, 1984, pp. 70-71.

New York Times Book Review, December 18, 1988, p. 30; June 24, 1990, p. 28; October 23, 1994, p. 30.

Publishers Weekly, January 10, 1986, p. 84; November 2, 1992, p. 72; July 15, 1996, p. 75; August 5, 1996, pp. 441-42.

School Library Journal, March, 1986; February, 1993, p. 100; September, 1993, p. 244; October, 1994, p. 135; August, 1996, p. 144.

Scientific American, December, 1993, p. 133; December, 1994, p. 118.

Times Educational Supplement, November 19, 1982, p. 36.

Voice of Youth Advocates, October, 1983; February, 1985, p. 328; February, 1989, pp. 286-87; June, 1990, pp. 126-27; April, 1994, pp. 27-28; June, 1994, p. 86; December, 1994, p. 276.*

—Sketch by Ken Cuthbertson

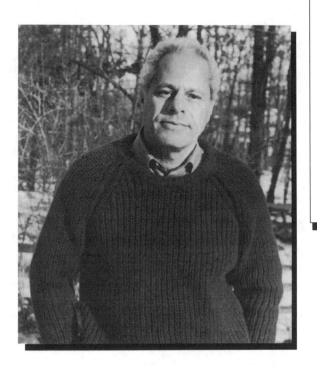

Myron Levoy

of Congress Children's Books of 1977 citation, *Boston Globe/Horn Book* honor book citation and Jane Addams Honor Book Award, both 1978, National Book Award nomination, 1980, Silver Pencil Award (Netherlands) and Austrian State Prize for Children's Literature, both 1981, German State Prize for Children's Literature, 1982, Buxtehude Bulle Award (Germany), 1982, American Library Association (ALA) Booklist citation, 1984, *New York Times* Parents Guide to the Best Books for Children, 1988, ALA Best of the Best for Children citation, and Young Adult Library Services Association Best of the Best List citation, 1994, all for *Alan and Naomi*; Best Book for Young Adults citation, American Library Association, and Books for the Teen Age citation, New York Public Library, both 1981, both for *A Shadow Like a Leopard*; Books for the Teen Age citation, New York Public Library, 1985, for *Three Friends*; ALA Best Book for Young Adults citation, and International Reading Association Young Adult Choice citation, both 1986, both for *Pictures of Adam*; Books for the Teen Age citation, New York Public Library, 1993, for *Kelly 'n' Me*.

■ Personal

Born in New York, NY; married; wife's name, Beatrice (a junior high school teacher); children: Deborah, David. *Education:* Purdue University, M.A. *Hobbies and other interests:* Swimming, tennis, hiking, cross-country skiing.

■ Addresses

Agent—c/o Writers House Inc., 21 West 26th St., New York, NY 10010.

■ Career

Writer. Previously worked as a chemical engineer.

■ Awards, Honors

Library of Congress Children's Books of 1972 citation, *Book World* honor book citation, 1972, and Children's Book Showcase citation, 1973, all for *The Witch of Fourth Street and Other Stories*; Library

■ Writings

YOUNG ADULT NOVELS

Alan and Naomi, Harper, 1977.
A Shadow Like a Leopard, Harper, 1981.
Three Friends, Harper, 1984.

Pictures of Adam, Harper, 1986.
Kelly 'n' Me, HarperCollins, 1992.

CHILDREN'S FICTION

The Witch of Fourth Street and Other Stories, illustrated by Gabriel Lisowski, Harper, 1972.
Penny Tunes and Princesses, illustrated by Ezra Jack Keats, Harper, 1972.
The Hanukkah of Great-Uncle Otto, Jewish Publication Society, 1984.
The Magic Hat of Mortimer Wintergreen, Harper, 1988.

PLAYS

The Penthouse Perspective, produced in Northport, NY, 1967.
Eli and Emily, produced in New York City, 1969.
The Sun Is a Red Dwarf (one-act), produced Off-Off Broadway at New York Theatre Ensemble, 1969.
Sweet Tom (two-act), produced Off-Off Broadway at the Playbox, 1969.
Footsteps, (produced in New York City, 1970), Breakthrough, 1971.
Smudge, produced in New York City, 1971.

OTHER

A Necktie in Greenwich Village (novel), Vanguard, 1968.

Contributor of short stories and poems to periodicals, including *Antioch Review*, *Massachusetts Review*, and *New York Quarterly*. Stories from *The Witch of Fourth Street* have appeared in elementary school reading texts.

■ Adaptations

A theatrical film, *Alan and Naomi*, based on Levoy's novel of the same title, was released in the United States early in 1992. The title story from *The Witch of Fourth Street* was featured in the PBS television series *Read It*.

■ Sidelights

Myron Levoy's works range from the realism of the young adult novel *Alan and Naomi* to the surrealistic stories *Penny Tunes and Princesses* and *The Witch of Fourth Street and Other Stories*. All of them, however, share a common theme. In each instance, the story's protagonists have a choice to make—whether to recognize their individuality or to submerge it. "In my work for children and adults," Levoy declares in *Contemporary Authors*, "my continuing concern has been for the 'outsider,' the loner." In each of his works, Levoy's protagonists "must come to terms with and face their own uniqueness," the writer continues in *Contemporary Authors*. "Their stories are open-ended; there are no pat solutions, but rather, growth and discovery, with more struggles ahead to be met, one hopes, with greater strength and insight."

"I was born and grew up in New York City," Levoy remembers in his autobiographical essay published in *Speaking for Ourselves: Autobiographical Sketches by Notable Authors of Books for Young Adults*. "Times were hard and toys were few, but I remember from a very early age constant trips to the library with my mother and brother, and the smell and feel of books." He even tried his hand at writing. His first story, he explains in *Speaking for Ourselves*, was completed at age eight. In high school he began writing poetry and served as editor of the school newspaper's poetry column. In college, however, Levoy's interests led him into chemical engineering. He received bachelors and masters of science degrees from the City College of New York and Purdue University, and he had a successful career as a chemical engineer.

Levoy continued to write even during his engineering days, publishing poetry and short stories in the *Massachusetts Review*, the *Antioch Review*, and in the *New York Quarterly*. In 1967, his first play, *The Penthouse Perspective*, was produced in Newport, New York. The following year Levoy published his first novel, *A Necktie in Greenwich Village*, a story about college students during the revolutionary "youth decade" of the 1960s. It tells about Brian Benson, a senior at Princeton University (a prim Ivy League school) and the choices facing him as he nears graduation. He has to choose between careers (working for his father or finding his own path), between issues (joining a civil rights demonstration or following his animal instincts), and between girlfriends (fussy Carol or hip but good-hearted Vera). "All are good for a couple of therapeutic belly laughs," states Martin Levin in the *New York Times Book Review*. The reviewer concludes, "Levoy has a nice offhand way with college humor."

A Timeless Neighborhood in New York City

Levoy turned to children's literature when his own children, David and Debbie, were growing up. His first story was written for them as a Hanukkah present. Levoy submitted it to the publishers Harper & Row, but an editor sent it back with the suggestion that he either expand the story into a novel or add more stories to make a collection. The seven interconnected stories that resulted from this became his first book for children, *The Witch of Fourth Street and Other Stories*. All of the stories—plus an additional one, *Penny Tunes and Princesses*, published separately as a picture book with illustrations by Ezra Jack Keats—tell about the trials and joys of living in the mixed ethnic neighborhoods of New York City. The protagonist of *Penny Tunes and Princesses* is Janos Ady, a Hungarian violinist. He sells his violin to pay his pas-

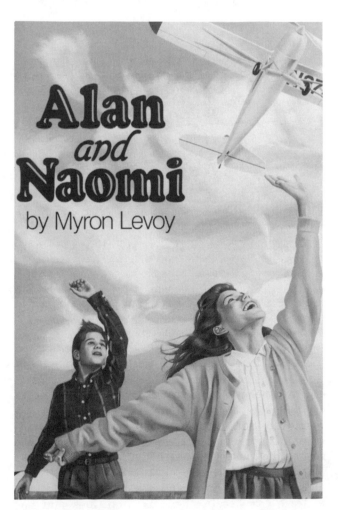

In this novel, which is set in 1944, New Yorker Alan Silverman befriends a French Jewish girl who bears scars from the Holocaust.

sage to the New World and has to earn a living as a sandwich man, walking up and down streets wearing signs on his front and back advertising hats and fortune-tellers. After three years as a walking advertisement, Janos manages to buy a new violin, but he discovers that he has lost his skill in the interim. However, there is a bright spot: "he was getting more pennies more quickly for bad music in New York than for superb music in Budapest," Levoy explains in the book. Eventually, Janos regains his skill, marries a gypsy fortune-teller, and plays for the customers in her tea-room. Michael J, Bandler, writing in the *Washington Post Book World*, calls *Penny Tunes and Princesses* "a rich, engaging story . . . written with warmth and compassion—and a dash of humor."

Most of the major characters of *The Witch of Fourth Street and Other Stories* are also immigrants or second-generation Americans. Cathy Dunn (Irish), Vincent DeMarco (Italian), Andreas Kastanakis (Greek), Noreen Callahan (Irish), Mr. Keplik (Lithuanian), Aaron Kandal (Jewish), and Samuel Moscowitz (Russian) all feature in stories centered around their Lower East Side neighborhood. Cathy Dunn allows her fears of the title character to overcome her good sense and make her sick in "The Witch of Fourth Street." Vincent DeMarco learns that even his father has needs in "Vincent-the-Good and the Electric Train." Mr. Keplik, the retired watchmaker, enlists the help of the local children to slow the elevated trains that shake his apartment so that he can finish his *magnum opus*— a match stick model of the Brooklyn Bridge—in "Keplik, the Match Man." Finally, toymaker Samuel Moscowitz recaptures his Russian Jewish childhood for a few brief hours in "The Hanukkah Santa Claus." "Myron Levoy does not compromise with truth," declares *Book World* contributor Natalie Babbit: "there is pain . . . and frustration—and in the final story, death. What makes this such a good book is the author's compassion, imagination, and humor; his clear eye for detail and craftsman's sense of what language means and can be made to do. It is a first book for children by a first-rate writer."

Confronting the Holocaust

Levoy takes an equally uncompromising look at pain and frustration in his young adult novel *Alan and Naomi*, which concerns anti-Semitism and the legacy of World War II. The story is set in New

York City in 1944. Naomi Kirshenbaum, a French Jewish girl of twelve, has been rescued from the Holocaust. Four years previously she saw her father, a member of the French Resistance, beaten to death by the Gestapo, and the experience has left her emotionally damaged. She now lives in the same building with Alan Silverman's family, who have hopes that Alan can bring her out of her mental nightmare. For his part, Alan—a year older than Naomi—would rather not be bothered. Alan prefers playing stickball with his friend Shaun Kelly, and he fears that paying attention to Naomi will make Shaun think he's a sissy. Alan is up-front about his lack of enthusiasm, but he does make an effort to befriend the French girl. "Alan uses his Charlie McCarthy dummy to establish communications with Naomi, for at first she will only talk through her doll Yvette," writes a reviewer for *Growing Point*, "but at last she does relax and enjoy some of the simple pleasures proper to her age." However, all of Alan's efforts are undone when a local bully makes some anti-Semitic remarks and Alan gets into a fist-fight with him. "Naomi, a witness, relives her earlier trauma, withdraws again, and is institutionalized—sending Alan into a pained outburst which closes the book," explains a *Kirkus Reviews* contributor. "No happily ever after here."

Alan and Naomi appeared on many recommended reading lists and was nominated for the 1980 National Book Award. Critics were very vocal in their praise for the book. Brigette Weeks of the *Washington Post Book World* admired *Alan and Naomi*'s gutsy approach to Naomi's personal tragedy, declaring that "the story is inspiring without a trace of sentimentalism—mainly due to Alan's failings and his awareness of them." Paul Heins praised the story in *Horn Book* not only for its depiction of the way the Holocaust impacted an American Jewish family, but also for the way that it "presents the crisis in terms of the understanding and the emotions of a sensitive, well-intentioned schoolboy." Julia B. Fuerst, writing in the *School Library Journal*, called it "one of the more honest approaches to the repercussions of W. W. II." *New York Times Book Review* contributor Milton Meltzer said much the same thing in his assessment of the novel: "This is a fine example of honest, compassionate writing about personal responsibility."

Personal responsibility also appears in *A Shadow Like a Leopard*. It tells the story of Ramon Santiago,

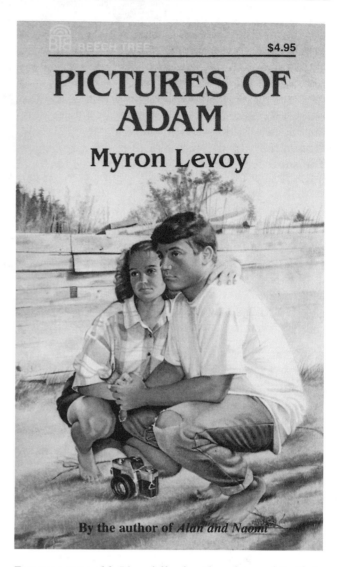

Fourteen-year-old Lisa falls for the class oddball in this 1986 work.

a fourteen-year-old New York City kid who mixes his street smarts with poetry. Ramon's mother is confined to a mental hospital, while his father is serving time in Attica State Prison. In order to prove his machismo to his father Ramon joins a street gang. In the process of mugging the elderly wheelchair-bound artist Arnold Glasser, however, Ramon has to confront questions about what sort of person he wants to become. "Not only does Glasser not have the money the gang assumed he had," writes William G. McBride in *Voice of Youth Advocates*, "but he is not in the least afraid." The old man and the young man begin to learn from each other. "By pure luck and native wit," declares Ann A. Flowers in *Horn Book*, "Ramon managed to get Glasser's paintings exhibited in a prestigious gallery, and in an emo-

tional confrontation with the old man, he traded his knife for Glasser's promise of a renewed attempt to face the world." Still, the book offers no easy answers for Ramon, and in the end he reemphasizes his individuality. "This is no fairy tale; Ramon does not live happily ever after," *Interracial Books for Children* contributor Sonia Nieto states. "But in the last scene, he resolves to determine his own future."

Like a Flower in the Pavement

All three of the major characters of *Three Friends* are outsiders. Fourteen-year-old Joshua Freeman is tall, lanky, and—he believes—unattractive to girls. His great passions are for chess (he is ranked sixth in the United States) and psychology. His interests bring him into contact with Karen, a developing feminist and activist, and Lori, a troubled artist. Karen and Joshua begin dating; Lori, feeling left out and, states Audrey B. Eaglen in *School Library Journal*, "half in love with both of them," tries to commit suicide. Joshua uses his interest in psychology to help Lori "admit her jealousy and her injured pride that her two dear friends ever want to do things without her," explains a reviewer for the *Bulletin of the Center for Children's Books*. Again, there are no easy answers. The relationship between the three continues to be complex and challenging.

Two of Levoy's most recent books look at the relationship between teenagers and their parents. *Pictures of Adam* features budding teenaged photojournalist Lisa Daniels and her new classmate Adam. Lisa first becomes interested in Adam as a photographic subject. As time passes, she gains interest in the boy himself. Although she is put off by Adam's story that he is in fact an extraterrestrial, Lisa comes to understand that this is Adam's way of dealing with his departed, alcoholic, and abusive father. She also has to come to terms with her mother's disapproval of her friendship with Adam. "Lisa finally forces Adam to admit the truth," says a reviewer for the *Bulletin of the Center for Children's Books*. The critic concludes that "Lisa's voice is convincing in this percipient and touching story." *Kelly 'n' Me* also looks at the problem of absent, alcoholic, and neglectful parents. Anthony Milano is, at age fifteen, a successful New York City street musician. While performing in Central Park he meets Kelly, another performer who is avoiding her rich but indiffer-

If you enjoy the works of Myron Levoy, you might want to check out the following books and films:

Mary Anderson, *The Unsinkable Molly Malone*, 1991.
Patricia MacLachlan, *Journey*, 1991.
Margaret Mahy, *Memory*, 1988.
This Boy's Life, Warner Bros., 1993.

ent parents. "As their romance builds," states Mary L. Adams in *Voice of Youth Advocates*, "each must confront their parents' love and the strings attached to it."

In his autobiographical essay published in *Speaking for Ourselves*, Levoy compares the choices his loner, outsider characters must make to his first story, written at age eight. The story was about a flower, he explains, that grew in a crack in the pavement in the middle of the street, constantly in danger of being crushed. Like the flower, Levoy's characters are placed in difficult environments. They have the potential for great beauty, also like the flower. Unlike the plant, however, the human characters have the capability and the responsibility to change their circumstances by making choices about their lives. "Their choices are painful, tentative, and, in some instances, courageous," Levoy states in *Speaking for Ourselves*. "They must grow . . . alone, unique, and not be crushed. And so the theme recurs, like an arc, from the eight-year-old to me, here, now."

■ Works Cited

Adams, Mary L., review of *Kelly 'n' Me*, *Voice of Youth Advocates*, April, 1993.
Review of *Alan and Naomi*, *Growing Point*, September, 1979, pp. 3566-69.
Review of *Alan and Naomi*, *Kirkus Reviews*, October 15, 1977, pp. 1103-4.
Babbit, Natalie, review of *The Witch of Fourth Street and Other Stories*, *Book World*, May 7, 1972.
Bandler, Michael J., "Harlequins, Dinosaurs, Ducks in the Bathtub," *Washington Post Book World*, July 8, 1973, p. 13.
Eaglen, Audrey B., review of *Three Friends*, *School Library Journal*, April, 1984, p. 125.
Flowers, Ann A., review of *A Shadow Like a Leopard*, *Horn Book*, June, 1981, pp. 310-11.

Fuerst, Julia, review of *Alan and Naomi, School Library Journal,* November, 1977, p. 59.

Heins, Paul, review of *Alan and Naomi, Horn Book,* December, 1977, pp. 664-65.

Levin, Martin, "Reader's Report," *New York Times Book Review,* April 14, 1968, p. 31.

Levoy, Myron, *Penny Tunes and Princesses,* illustrated by Ezra Jack Keats, Harper, 1972.

Levoy, Myron, "Myron Levoy," *Speaking for Ourselves: Autobiographical Sketches by Notable Authors of Books for Young Adults,* compiled and edited by Donald R. Gallo, National Council of Teachers of English, 1990, pp. 120-21.

Levoy, Myron, comments in *Contemporary Authors, New Revision Series,* Volume 40, Gale, 1993, pp. 261-62.

McBride, William G., review of *A Shadow Like a Leopard, Voice of Youth Advocates,* June, 1981, p. 30.

Meltzer, Milton, "Victims and Survivors," *New York Times Book Review,* November 13, 1977, p. 39.

Nieto, Sonia, review of *A Shadow Like a Leopard, Interracial Books for Children,* Volume 13, numbers 2 & 3, pp. 34-35.

Review of *Pictures of Adam, Bulletin of the Center for Children's Books,* April, 1986, pp. 151-52.

Review of *Three Friends, Bulletin of the Center for Children's Books,* May, 1984, pp. 168-69.

Weeks, Brigette, review of *Alan and Naomi, Washington Post Book World,* February 12, 1978, p. 4G.

■ **For More Information See**

BOOKS

Donelson, Kenneth L., and Alleen Pace Nilsen, *Literature for Today's Young Adults,* 2nd edition, Scott, Foresman, 1985.

Lipson, Eden Ross, *The New York Times Parent's Guide to the Best Books for Children,* Times Books, 1988.

Trelease, Jim, *The Read-Aloud Handbook,* Penguin Books, 1985.

PERIODICALS

Booklist, July, 1986, p. 1614; January 1, 1993, p. 801.

Horn Book, August, 1984, pp. 476-77; July/August, 1986; September/October, 1988; January, 1993, p. 151.

Interracial Books for Children, Volume 12, numbers 4 & 5, pp. 21-22; Volume 14, numbers 1 & 2, p. 15.

Kirkus Reviews, November 1, 1972, p. 1234.

New York Times Book Review, June 18, 1972, p. 8.

School Library Journal, March, 1981, p. 158; May, 1986, p. 106; October, 1992, p. 144.

Times Literary Supplement, April 3, 1987, p. 358.

Voice of Youth Advocates, June, 1984, p. 96.*

—*Sketch by Kenneth R. Shepherd*

Chris Lynch

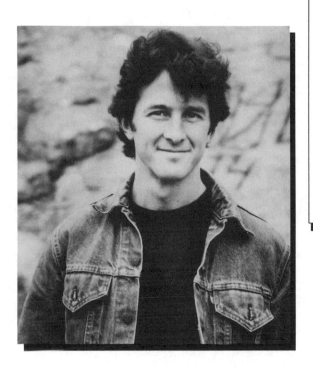

1994. *Member:* Authors Guild, Author's League of America.

■ Personal

Born July 2, 1962, in Boston, MA; son of Edward (a bus driver) and Dorothy (a receptionist; maiden name, O'Brien) Lynch; married Tina Coviello (a technical support manager), August 5, 1989; children: Sophia, Walker. *Education:* Suffolk University, B.A. in journalism, 1983; Emerson University, M.A. in professional writing and publishing, 1991. *Politics:* "Decidedly no affiliation." *Religion:* "Decidedly no affiliation." *Hobbies and other interests:* Running.

■ Addresses

Agent—Fran Lebowitz, Writers House, 21 West 26th St., New York, NY 10010.

■ Career

Writer. Teacher of writing at Emerson University, 1995, and Vermont College, 1997—. Proofreader of financial reports, 1985-89. Conducted a writing workshop at the Boston Public Library, summer,

■ Awards, Honors

American Library Association (ALA) Best Books for Young Adults and Quick Picks for Reluctant Young Adult Readers citations, 1993, for *Shadow Boxer,* 1994, for *Iceman* and *Gypsy Davey,* and 1996, for *Slot Machine;* Best Books of the Year list, *School Library Journal,* 1993, for *Shadow Boxer;* Blue Ribbon Award, *Bulletin of the Center for Children's Books,* 1994, for *Iceman* and *Gypsy Davey;* Editors' Choice award, *Booklist,* 1994, for *Gypsy Davey;* finalist, Dorothy Canfield Fisher Award and Book of the Year award from *Hungry Mind Review,* for *Slot Machine.*

■ Writings

Shadow Boxer, HarperCollins, 1993.
Iceman, HarperCollins, 1994.
Gypsy Davey, HarperCollins, 1994.
Slot Machine, HarperCollins, 1995.
Political Timber, HarperCollins, 1996.

"BLUE-EYED SON" SERIES

Mick, HarperCollins, 1996.
Blood Relations, HarperCollins, 1996.
Dog Eat Dog, HarperCollins, 1996.

"HE-MAN WOMAN-HATERS CLUB" SERIES; FOR YOUNG READERS

Johnny Chest Hair, HarperCollins, 1997.
Babes in the Woods, HarperCollins, 1997.

Also a contributor of a short story, "The Hobbyist," to *Ultimate Sports,* edited by Donald Gallo, Delacorte, 1995, and another short story to *Night Terrors,* edited by Lois Duncan, Simon & Schuster, 1996. Contributor of stories and articles to periodicals, including *Signal, School Library Journal,* and *Boston Magazine.*

Lynch's books have also been published in Ireland and have been translated into Taiwanese and Italian.

■ Work in Progress

Three other titles in the "He-Man Woman-Haters Club" series for HarperCollins.

■ Sidelights

Chris Lynch writes tough and edgy streetwise fiction. Episodic and fast-paced, his stories and novels question the male stereotypes of macho identity and inarticulate violence. His youthful characters are often athletes, or wanna-be athletes, or kids who have been churned up and spit out by the system. Outsiders, Lynch's protagonists desperately want to just be themselves. "You were not born into physical greatness and all the love and worship and happiness that are guaranteed with it," the narrator muses in the short story "The Hobbyist." "But fortunately you were born American. So you can buy into it."

Using irony and a searing honesty that cuts through adolescent facades, Lynch lays out a deck of impressionistic cards of what it means to be young and urban and male in America in the 1990s, warts and all. "I was speaking at a school for disturbed kids," Lynch told *Authors and Artists for Young Adults (AAYA)* in an interview, "and this one kid came up and said to me that everybody I write about is weird. And I thought, 'Yes. I've done my job.' Because beneath it all, we're all weird. And it's okay. It's okay to be who you are. You don't have to be what others say you should be. It's my job as a novelist to celebrate the oddities, or at least make them less stigmatized."

In his ten novels for young adults and young readers, Lynch has used sports such as boxing and hockey as metaphors for male rites of passage, has portrayed lonely outsiders and troubled families struggling to make it, and has dealt with racism and exploitation. Violence plays a part in these books, "the hovering menace that is urban life," as Lynch described it in *AAYA,* but his violence is never gratuitous. Lynch is part of a new generation of YA writers who are not afraid to tackle formerly taboo subjects, who are reaching out to adolescent readers with topics relevant to them and written in an idiom they understand. In a *Horn Book* review of several hard-hitting young adult novels including Lynch's *Iceman,* Patty Campbell noted that "in the hands of skillful writers, material that could be repellent is transcended to make a larger statement about coming of age. . . . Perhaps we can hope that it is a mark of the growing maturity of the genre . . . that serious YA novels, like adult novels, are coming to be judged on the basis of the quality of the whole work."

If Lynch can speak so directly to young readers, it is because he has been there. "Growing up I listened way too much to the rules as they were handed down," he recalled for *AAYA.* Though his youth was a much more stable one than those of many of his fictional characters, he was no stranger to the urban melange that is the backdrop for most of his work. Fifth of seven children, he grew up in the Jamaica Plains district of Boston, one that was once an Irish stronghold, but which had become largely Hispanic by the time of Lynch's youth. His father died when Lynch was five, and the family was then brought up by a single mother. "She did a good job of covering it up, but things were pretty lean back then," Lynch told *AAYA.* "We were definitely a free cheese family, though I never felt deprived as a kid." A somewhat reclusive child, Lynch attended Catholic schools through primary and secondary levels. "I wasn't what you'd call bookish," Lynch told *AAYA,* "though I do have a very clear memory of sparking to the Dr. Seuss book club. It made a difference that I got my own book in the mail. It wasn't so much the book itself, but the fact that it was mine. . . . In the fourth or fifth grade I was eating up military history books, then some sports bios, but not fiction. Not yet."

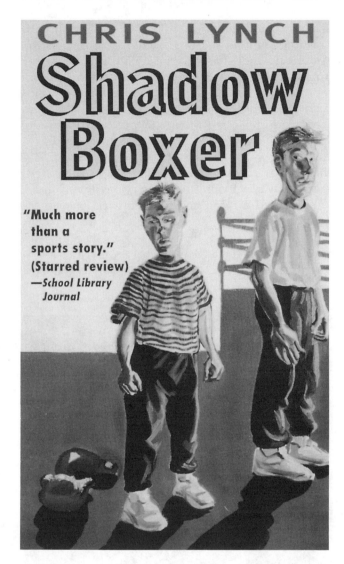

CHRIS LYNCH

Shadow Boxer

"Much more than a sports story." (Starred review)
—*School Library Journal*

George tries to prevent his younger brother Monty from entering the brutal world of boxing in this 1993 work.

His grammar school experience was what he calls "nurturing," but high school was a different matter for Lynch. "I hated high school—every minute. It was rigid, kind of a factory. An all-boys' football factory. Nothing like the arts was encouraged in any way." Though Lynch had participated in street hockey, football, and baseball as a younger kid, by high school he had stopped playing. "When it was fun I played," Lynch recalled. But the football-factory ethic ruined it for him, a sentiment echoed by protagonists in many of his novels. "I'm not against all athletics," Lynch said in his interview. "Sports has a tremendous potential for channeling energy. But instead it mostly encourages the macho ethos and schools let athletes run wild. This carries through life, and re-

sults in Mike Tysons. People who were never told what they could not do."

High school was discouraging enough for Lynch that he dropped out in his junior year and entered Boston University where he studied political science. "And then I thought, 'Oh no, I'm going to get stuck with this thing that is only a beard.'" A news-writing course at Boston University provided a stimulus for change, for discovering what he really wanted to be doing. "I transferred to Suffolk where I took more writing classes, finally majoring in journalism. But I was still hiding from myself. At Suffolk I took a novel writing class which helped lead me closer to what I was really going for all the time. But I just wouldn't allow it. Wouldn't let myself say that I wanted to be an artist."

The Literary Life

After graduation, Lynch spent about six years trying to let himself admit that simple fact. He took jobs as a house painter, a driver of a moving van, and for several years proofread financial reports. "That kind of work can really give a person a shove," Lynch told *AAYA*. "I figured there had to be something more out there. I had enough optimism to think there was something for me to learn." In 1989 Lynch enrolled in a master's program at Boston's Emerson University in professional writing and publishing. "So I was still hiding, you know, having to think of myself as an editor or publisher. Not a creative writer. All this reflects my feeling that you've got to put up first; you've got to earn titles. I actually only told my mother what I was doing *after* I published my first book."

At Emerson Lynch found a new direction. Taking a children's writing class from Jack Gantos, he began what became his first published novel, *Shadow Boxer*, as a class assignment. "We were supposed to write five pages on a childhood incident," Lynch told *AAYA*. "I had a vague idea of writing about some things my brother and I had done in our youth, but as soon as I sat down with it, I was off to the races. The stuff just poured out. Before this all my adult fiction had been too stylized, what everybody else was doing. What I thought was expected of me. I had no emotional investment in my own work, and that makes all the difference. With this assignment,

the very first words actually made it into the actual published book. I was fortunate to discover early on in my career that one bit of writing magic—matching yourself and your material."

This early assignment grew until Lynch had written about sixty percent of his novel in class. If he had stutter-stepped about getting into writing, there was no hesitation once he'd begun. With the help of Gantos, he first tried to place his manuscript with various editors, then found an agent who quickly found a willing publisher. By 1992, he was on his way, *Shadow Boxer* being readied for publication. According to Lynch, the book is about twenty percent autobiographical, a story of two brothers learning to deal with life after the death of their father, a journeyman boxer. Fourteen-year-old George is left as the man of the house after his father dies from all the years of battering he has taken in the ring. George's mother is bitter, hating the sport which cost her husband his life, but George's younger brother, Monty, wants to follow in his father's footsteps. He begins to train at the local gym with his uncle, and George sets about to discourage him from this path, exacerbating their sibling rivalry. Told in brief, episodic vignettes with urban slang, the novel reaches its climax when Monty is shown a video of one of the brutal beatings his father took in the ring. In the end, Monty is finally convinced, and George gets the final lines: "We left the gloves there on the ground, where they could rot in the coming rain."

Reviewing *Shadowboxer* in *Horn Book*, Peter D. Sieruta was particularly struck with the cast of characters Lynch captures "with unflinching honesty" in the working-class Boston neighborhood where George and Monty live. While Sieruta found that, for him, the episodic style weakened the plot, he noted that individual chapters "read like polished short stories and are stunning in their impact." Gary Young in *Booklist* commented that "this is a guy's book. It is also a tidy study of sibling rivalry." Other reviewers also noted how the novel transcended the usual sports story tag. Tom S. Hurlburt, writing in *School Library Journal*, pointed to the passages describing the problems of a single-parent family in an urban setting and concluded that "Lynch has written a gritty, streetwise novel that is much more than a sports story. . . ." And John R. Lord also commented upon Lynch's episodic style in *Voice of Youth Advocates*, calling the book "a series of character

sketches," and noting that it could serve well with "reading for the at-risk students." Named to the American Library Association's Best Book for Young Adults and Recommended Book for Reluctant Readers lists, *Shadow Boxer* also found a place with its intended audience: young male readers who were not often drawn to books.

Regarding his episodic style, Lynch told *AAYA* that it was a "critical leap" for him to start writing that way. "I don't see transitions in my life," Lynch noted. "I can see moments. So it was incredibly liberating for me to realize that I don't have to write 'and then . . . and then' in my books any more than I have that in my life. Reading [Sherwood Anderson's] *Winesburg Ohio* and

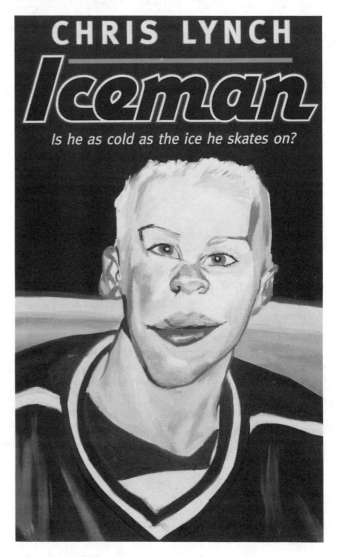

A young hockey player is deemed too violent for his own good in this 1994 novel.

[Joan] Didion's *Play It As It Lays* made me understand how scenes assemble and at the end you don't miss the transitions. You still get the sense of the whole without 'and then.' I guess I write a little less episodically now than when I first started, but I don't see myself ever *not* writing in that general way." Lynch's short, snappy paragraphs also result in books that seem to grow organically. "I don't really plot my books. I write characters; that's where it all starts. If you have real people, stuff is going to happen to them. I don't feel like I've got to maneuver them; they have their own DNA and act within a range that is themselves. If I start heavily plotting, then the writing is just like filling in the numbers. It's lifeless." More than one critic has also noted that such writing—brief, hard-hitting vignettes that reveal character—makes it easier for reluctant readers to get into the material.

Hard-hitting Images

While *Shadow Boxer* was being prepared for publication, Lynch was already hard at work on his second novel, *Iceman*, the story of a troubled youth for whom violence on the ice is his only release. "For me, *Iceman* is the book that is closest to being autobiographical in the whole inability to express yourself. Where does that go, the frustration. It's got to go someplace. Writing it, I tapped into something very adolescent American male where anger is cool and you've got to suck it up. Acting out the whole male role thing." Lynch's protagonist is fourteen-year-old Eric, a great hockey player with a reputation as a fine shooter and a strong defensive player with a penchant for hitting. Known as the "Iceman" for his antics on the ice, Eric actually seems to enjoy hurting people. His only friends are his older brother Duane, whose act of trading his skates for a guitar impresses Eric, and the local embalmer, McLaughlin, who equally impresses Eric with his devotion to his work.

Lynch divides the novel into three sections, echoing the periods of a hockey game, and the novel follows Eric's conflict-laden life to a certain epiphany. The source of his rage comes from his own dysfunctional family—his mother, a former nun, who continually spouts from the Bible, and a father who only comes alive when Eric is doing damage on the ice. Slamming out his frustrations on the hockey rink, he is soon shunned by

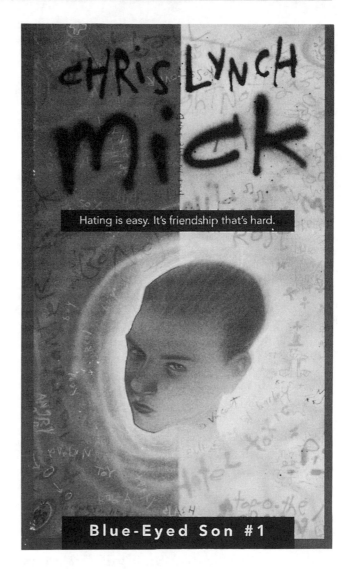

This 1996 novel, the first in Lynch's "Blue-Eyed Son" trilogy, follows a Boston teenager whose neighborhood—and life—are rapidly changing.

even his own teammates. McLaughlin at first gives him some comfort in his world of death, and Eric for a time thinks he might want to go into mortuary science until he comes upon the embalmer entwined with one of the female corpses. This startling scene helps Eric to face some of his own worst demons and begin to control his anger, to stop working out his father's vicarious rage—to in fact, join the living. Randy Brough, writing in *Voice of Youth Advocates*, noted that he found "this novel of disaffected adolescence to be as satisfying as a hard, clean hip check," and Jack Forman in *School Library Journal*, while commenting that the book would appeal to hockey enthusiasts, also pointed out that "this novel is clearly about much

more and is no advertisement for the sport." Forman concluded that *Iceman* "will leave readers smiling and feeling good." Stephanie Zvirin summed up the effect of the novel in *Booklist:* "This totally unpredictable novel . . . is an unsettling, complicated portrayal of growing up in a dysfunctional family. . . . A thought-provoking book guaranteed to compel and touch a teenage audience."

"I don't have any answers," Lynch told *AAYA*, commenting on messages inherent in his books. "I just want to let you go on to a new set of questions. The world should be a little broader when you're done reading. There should be more options, not necessarily more choices. I don't go in much for ah-ha's in my work. When I do readings in schools and someone says 'That's me, that kid is me,' I am happy. I'd rather hit *my* group hard than cast wider nets. . . . One of the great things we can do as novelists is to take a good close-up view of characters. To get beneath the surface. With my third book, I was trying to show the confusion of life, the cyclical nature of it rather than a linear portrayal. The victim is perpetrator is victim. To show that even crappy people have their sides to them. To depict hope in the midst of it all."

That third book was *Gypsy Davey*, the story of a brain-damaged youth and his family who doesn't care, and of the tenement neighborhood surrounding the boy—cheap bars and drug dealers. Out of this bleak atmosphere, Lynch weaves a tale of hope, of young Davey who tries body and soul to break the cycle of parental neglect initiated by his parents and seemingly perpetuated by his older sister, Jo. Another dysfunctional family forms the centerpiece of this novel, and it is Davey's attempts to bring love to Jo's son, his nephew, that is one of the few bright spots. Jo and her child ultimately drive off with a stranger—a new lover? a social worker?—and Davey tells himself, in stream-of-consciousness exposition—that the kid will be okay, that there is hope. "I'm gonna have my own find somebody who's gonna love me and we're gonna have some babies and I'm gonna love 'em to pieces like nobody ever loved babies before." W. Keith McCoy, writing in *Voice of Youth Advocates*, noted that in spite of the dreary atmosphere of the novel, "Lynch provokes empathy for this family and its situation, and perhaps that is the only positive outcome in the book." Also focusing on the bleakness of the theme, especially

as perceived by adults, Elizabeth Bush in *Bulletin of the Center for Children's Books* concluded that "young adults will appreciate its honesty and fast pace. . . . Lynch . . . paints characters who . . . ring true every time."

"For me the ending worked out with hope," Lynch said in his interview. "Davey remains intact in his purity. Things have happened to him, but there's still a charming sweetness. Something's out there that he's going to love and he's going to find it. . . . I plan to get back to Davey sometime."

Creating a "Body of Work"

Lynch's fourth book was something of a departure: On the surface it is a boys-at-summer-camp comedy about an overweight youth who resists attempts at turning him into a jock. Thirteen-year-old Elvin Bishop is attending a Christian Brothers summer camp with a heavy emphasis on sports as preparation for high school—the coaches literally "slot" young athletes for upcoming sports. Friends with Mike, who seems to fit in anywhere, and Frank, who sells his soul to fit in, Elvin steers a middle course and finally finds a niche for himself with the help of an arts instructor, finally lets himself be himself, finally sees that it's okay to be a non-athlete. But before this happens, he suffers from all forms of physical torture in football, baseball, and wrestling. According to Stephanie Zvirin, writing in a *Booklist, Slot Machine* is a "funny, poignant coming-of-age story." While noting Lynch's ability to write broad, physical comedy as well as dark humor, Zvirin concluded that "this wry, thoughtful book speaks with wisdom and heart to the victim and outsider in us all." Maeve Visser Knoth in *Horn Book* also noted the use of humor and sarcasm in this "biting, sometimes hilarious novel," as well as the serious purpose in back of it all: "Lynch writes a damning commentary on the costs of conformity and the power gained by standing up for oneself."

"I experienced something similar to this in my freshman year," Lynch recalled for *AAYA*. "Except that my camp was only overnight, not three weeks. What makes this book funny is Elvin's filtering of events. The dark underbelly is still there, but delivered through somebody the reader feels better about. He's making jokes about what's happening to him, but the events of the book are as

If you enjoy the works of Chris Lynch, you may also want to check out the following books and films:

Michael Cadnum, *Calling Home,* Viking, 1991.
Robert Cormier, *The Chocolate War,* Pantheon, 1974.
David Klass, *The Danger Zone,* Scholastic, 1996.
Erika Tamar, *Fair Game,* Harcourt, 1993.
Youngblood, MGM/UA, 1986.

grim as in some of my other books. . . . Elvin's voice more closely represents the way I talk than the other narrators. . . . I'm going to do more with Elvin as a narrator."

With his "Blue-Eyed Son" trilogy, Lynch returned to the grittier mean streets of Boston to explore latent and sometimes very overt racism. "Boston is the inspiration for this one," Lynch said. "It's the city that never changes. There was this whole flap about gays not being allowed in a St. Patrick's Day parade, then they were allowed, then they weren't. I kept looking at that situation, but not using it, that situation that says we're integrated, but actually it's a separate reality. The myth of diversity while there are white streets, black streets, Spanish streets. We have reversed the clock on civil rights, but it hasn't just happened. It's been happening all along. I wanted to look at racism in a microcosm. . . . I wanted to put the spotlight on us. This is what we look like. Do we know we look like this? Do we even recognize what we do as racism?"

Lynch's microcosm involves fifteen-year-old Mick, who sees his once predominately Irish neighborhood changing into a racially-mixed one as blacks, Latinos and Asians move in. Mick unwittingly becomes a neighborhood hero when he throws an egg at a Cambodian woman during a St. Patrick's Day Parade. Though Mick hates that his friends and older brother Terry have planned to disrupt the parade by harassing gay and Cambodian marchers, he is forced into throwing the egg, an action caught on television. A hero in the local bar, he becomes an outcast at school. Only Toy, a mysterious sort of character, remains his friend, and soon Mick begins to break off ties with his close-knit Irish family and neighborhood and

hangs out with Latinos instead. His drunken, oafish older brother has Mick beaten for such treachery, ending the first book of the trilogy, *Mick.* The story is carried forward in *Blood Relations* where Mick struggles to find himself, forming a brief liaison with beautiful Evelyn, and finally ending up in the bed of Toy's mother. The series is concluded with *Dog Eat Dog* in which the brothers face off for a final showdown and Mick's friend Toy comes out of the closet. "With realistic street language and an in-your-face writing style. . . . Lynch immerses readers in Mick's world," Kelly Diller noted in *School Library Journal.* According to Diller, Lynch has created a "noble anti-hero." Reviewing *Blood Relations* in *School Library Journal,* Kellie Flynn commented that "this story moves quickly, Mick's seriocomic edginess is endearing, and the racism theme is compelling." However, Flynn also noted that the series concept made the ending of the novel something of a let-down, a point Elizabeth Bush returned to in a *Bulletin of the Center for Children's Books* review of the three books: "When the finish finally arrives, the unrelenting brutalities of the earlier volumes will leave the audience virtually unshockable."

While Lynch's inspiration for his books usually comes from his own life or from life around him in Boston, *Political Timber* was inspired by newspaper accounts of a teenager who ran for mayor of his small town. "I saw the kid's picture in the paper," Lynch told *AAYA,* "and he was a goof. It was all a lark for him. I loved that spirit and I went with it." What resulted is a novel about a high school senior, Gordon Foley, who runs for mayor at the insistence of his grandfather who is an old machine politician serving time for fraud. While young Gordon thinks it's all great fun, his grandfather is actually using him as his proxy. Less bleak than much of his fiction, *Political Timber* is also unique in that it is specifically written for high teens, "a woefully under-served constituency," according to Lynch. "I wanted to portray an eighteen-year-old, someone who is on the cusp between the adult and kid world."

"I see my books increasingly as a body of work," Lynch concluded in his interview. "They deal with the whole idea of identity and individuality. . . . My job is to make noise and be relevant and catch momentarily the attention of what seems to be a neglected reading group. We need to attract teenagers to the concept and let them know it is here. They've been driven away by the idea that [young

adult literature] is baby food. I want to attract them again, and then deliver them to the next level of writing."

■ Works Cited

Brough, Randy, review of *Iceman, Voice of Youth Advocates,* April, 1994, p. 28.

Bush, Elizabeth, review of *Gypsy Davey, Bulletin of the Center for Children's Books,* November, 1994, p. 93.

Bush, Elizabeth, review of *Mick, Blood Relations,* and *Dog Eat Dog, Bulletin of the Center for Children's Books,* April, 1996, p. 270.

Campbell, Patty, "The Sand in the Oyster," *Horn Book,* May/June, 1994, pp. 358-62.

Diller, Kelly, review of *Mick, School Library Journal,* March, 1996, pp. 220-1.

Flynn, Kellie, review of *Blood Relations, School Library Journal,* March, 1996, p. 221.

Forman, Jack, review of *Iceman, School Library Journal,* March, 1994, p. 239.

Hurlburt, Tom S., review of *Shadow Boxer, School Library Journal,* September, 1993, p. 252.

Knoth, Maeve Visser, review of *Slot Machine, Horn Book,* November/December, 1995, pp. 746-7.

Lord, John R., review of *Shadow Boxer, Voice of Youth Advocates,* December, 1993, p. 295.

Lynch, Chris, *Shadow Boxer,* HarperCollins, 1993.

Lynch, Chris, *Gypsy Davey,* HarperCollins, 1994.

Lynch, Chris, "The Hobbyist," *Ultimate Sports,* edited by Donald Gallo, Delacorte, 1995.

Lynch, Chris, interview with J. Sydney Jones for *Authors and Artists for Young Adults,* conducted June 13, 1996.

McCoy, W. Keith, review of *Gypsy Davey, Voice of Youth Advocates,* December, 1994, p. 277.

Sieruta, Peter D., review of *Shadow Boxer, Horn Book,* November/December, 1995, pp. 745-6.

Young, Gary, review of *Shadow Boxer, Booklist,* December 15, 1993, p. 747.

Zvirin, Stephanie, review of *Iceman, Booklist,* February 1, 1994, p. 1001.

Zvirin, Stephanie, review of *Slot Machine, Booklist,* September 1, 1995, p. 74.

■ For More Information See

PERIODICALS

Booklist, March 15, 1994, p. 1358; October 1, 1994, p. 318; January 15, 1995, p. 860; November 15, 1995, p. 547.

Bulletin of the Center for Children's Books, October, 1995, p. 61.

English Journal, November, 1994, p. 101; November, 1995, p. 96.

Horn Book, September/October, 1996, pp. 602-3.

Kirkus Reviews, November 15, 1993, p. 1464; February 1, 1994, p. 146; October 1, 1995, p. 1433.

Publishers Weekly, August 23, 1993, p. 73; September 12, 1994, p. 127; March 11, 1996, p. 66.

School Library Journal, April, 1993, p. 150; December, 1993, p. 26; October, 1995, p. 156.

Voice of Youth Advocates, August, 1996, pp. 157-58.

Wilson Library Bulletin, September, 1994, p. 127.*

—Sketch by J. Sydney Jones

Kit Pearson

■ Personal

Born April 30, 1947, in Edmonton, Alberta, Canada; daughter of Hugh and Kay (Hastie) Pearson. *Education:* University of Alberta, B.A., 1969; University of British Columbia, M.L.S., 1976; Simmons College, Center for the Study of Children's Literature, M.A., 1982.

■ Addresses

Home—3888 West 15th Ave., Vancouver, British Columbia V6R 2Z9, Canada. *Agent*—Lee Davis Creal, c/o Lucinda Vardey Agency, 297 Seaton St., Toronto, Ontario M5A 2T6, Canada.

■ Career

Has worked as a children's librarian in Ontario, Canada, and as a reviewer and teacher of juvenile literature and writing for children.

■ Awards, Honors

Book of the Year for Children Award, Canadian Library Association (CLA), 1988, for *A Handful of Time;* Mr. Christie's Book Award, 1989, Book of the Year for Children Award, CLA, 1990, Geoffrey Bilson Award for historical fiction for young people, 1990, and Governor General's Award shortlist citation, all for *The Sky Is Falling;* Geoffrey Bilson Award, 1994, and a National IODE Violet Downey Award, for *The Lights Go On;* Governor General's Award shortlist citation, for *Looking at the Moon.*

■ Writings

JUVENILE FICTION

The Daring Game, Viking Kestrel, 1986.
A Handful of Time, Viking Kestrel, 1987.
The Sky Is Falling (first book in a trilogy), Viking Kestrel, 1989.
Looking at the Moon (second book in a trilogy), Viking, 1991.
The Lights Go On Again (third book in a trilogy), Viking, 1994.

OTHER

(Reteller) *The Singing Basket,* illustrated by Ann Blades, Firefly Books, 1991.

■ Work in Progress

A ghost story.

■ **Sidelights**

"I like to think that I'm on the kids' side in my fiction," Canadian author Kit Pearson said in her essay in the *Seventh Book of Junior Authors and Illustrators*; "perhaps that's because I have such strong memories of being nine to twelve years old." Having won numerous honors for her fiction, Pearson is well-known for her stories that usually feature pre-teen girls as protagonists. But although these characters face problems that Pearson's audience can easily relate to, "to call them 'problem novels' would misrepresent them," according to Gwyneth Evans in her *Twentieth-Century Young Adult Writers* article: "the difficulties and dilemmas the girls encounter are treated as part of the fabric of life, and the world of each novel is larger than the immediate concerns of its protagonists."

> *"I like to think that I'm on the kids' side in my fiction."*
> *—Kit Pearson*

Pearson's family moved back and forth between Edmonton and Vancouver while she was a child. Born in Edmonton, she lived in Vancouver from the age of nine to thirteen, whereupon her family returned to Edmonton only to send her back to Vancouver to the Crofton House boarding school. This experience may be one reason why one of the themes in the author's stories concerns "children being uprooted," as she wrote in the *Seventh Book of Junior Authors and Illustrators*. Other topics in her work include "children feeling separate from adults, and children identifying with Canadian landscapes and with books."

Books have always been an important part of Pearson's life, and she often has her characters reading stories she enjoyed when she was their ages. When she was a child she read fiction voraciously and was greatly influenced by the work of another Canadian author, L. M. Montgomery, especially the novel *Emily of New Moon*. It was this love of literature that led Pearson to get a degree in library science, teach literature to children, and eventually become an author herself, though she didn't begin to write seriously until

she was in her mid-thirties. A busy career served as a handy excuse to procrastinate her writing, until she decided to get serious and studied children's literature at Simmons College. Encouraged and inspired by the courses she took there, she resolved to begin her novel in earnest.

Personal Experience Reflected in Books

Pearson's first novel, *The Daring Game*, has its roots in her own personal experiences at boarding school. She chose the subject of girls sent away by their parents to school because she was fascinated by their sense of isolation and how young people tend to form their own little societies that are virtually independent of adult control. The novel is an episodic portrayal of the daily lives of boarding school students, showing both the good and bad aspects of such an experience. The main character is Eliza, a somewhat shy eleven-year-old girl. Eliza, who does not want to grow up, has similar emotions to the ones the author had at that age. "Eliza is exactly the way I was," Pearson told Dave Jenkinson in an *Emergency Librarian* interview. "In fact, three friends and I made a pact when we were 12 that we would not grow up, and we really thought that we didn't have to." The author later added, "What Eliza doesn't want to do, and I don't blame her, is all the *artificial* stuff about growing up— being a 'feminine' teenager, being an object."

But, like everyone, Eliza does have to learn about becoming more mature. She gains some insights through her relationship with an older girl named Madeleine, but her first real taste of what adulthood means comes as a result of her friendship to the "problem" student, Helen. Helen has become rebellious as a result of her unhappy life at home. "The Daring Game," which Helen proposes, involves seeing just how far they can go in breaking the rules of the school. Eventually—inevitably— this leads to trouble, and Eliza is forced into an ethical dilemma of choosing between friendship and obeying the rules. Pearson adds interest to her story by having Eliza lie for Helen, rather than taking the more expected, virtuous, and preachy route.

It is this ethical quandary that makes *The Daring Game* unique among the subgenre of boarding school stories. Critics, however, have noted that the novel still fits into this traditionally British

category of children's books that sets a group of boys or girls against the authority of the principal, dean, or headmistress in a series of adventures. "Pearson's challenge," remarked *Canadian Children's Literature* contributor Lorraine M. York, ". . . [is] to create a Canadian version of this well-known subgenre." JoAnna Burns Patton pointed out in *CM: Canadian Materials for Schools and Libraries* that Pearson achieves this by giving the story more emotional depth. The reader gets "a look at the loneliness of girls away from home for the first time . . . and the closeness that being in a similar situation can create." "The relationships among the school girls in *The Daring Game*," Evans asserted, "are created with a remarkably observant and unsentimental eye and ear."

After completing *The Daring Game*, Pearson began another book about "two kids who were trying to conceal the fact that their uncle had quit law school," as she explained it to Jenkinson. But the story wasn't going anywhere, and Pearson found the research she had to do about law school to be boring. Still, she plodded on, fearful that if she didn't get through her second manuscript it would prove she was only a one-book author. Eventually, though, she had to admit to herself that the story just wasn't worth the effort, and she abandoned it for a new one that became the award-winning *A Handful of Time*.

Time Travel Book Wins Honors

A Handful of Time, like her first book, has roots in Pearson's past. The setting is a lake in Alberta that was once the site of her family's summer cottage. Some of the incidents she recreates in the story, such as a scene in which the kids have a water bomb fight, are also based on her childhood. Parallels between fiction and the author's life end there, however, for the story's premise of time travel leaves reality behind. *A Handful of Time* is about a twelve-year-old girl named Patricia, who, like Eliza, is rather shy. Her parents are divorcing, and she is sent away to spend time with relatives for the summer. While there, Patricia finds an old watch that has stopped working. Incredibly, when she winds it up the watch transports her back thirty-five years to the time when it originally stopped working.

Once in the past, Patricia discovers she is invisible to those around her, including her mother,

If you enjoy the works of Kit Pearson, you may want to check out the following books and films:

Maeve Binchey, *Light a Penny Candle*, 1989.
Margaret Buffie, *The Haunting of Frances Rain*, 1989.
Michael Cadnum, *Breaking the Fall*, 1992.
Michelle Magorian, *Good Night, Mr. Tom*, 1982.
Hope and Glory, Columbia, 1987.

Ruth, whose troubled early life she is now able to observe firsthand. In the present time, Patricia is unable to relate to her mother, who is a glamorous television news personality and who maintains a cold, self-assured facade in front of everyone, including her family. Once in the past, however, Patricia sees a twelve-year-old girl who is nagged incessantly by her mother—Patricia's grandmother—to fit into the mold of a proper young lady. Her trips to the past help Patricia become more sympathetic to her mother, and the two are, by the end of the book, able to reconcile their differences somewhat. However, as Mary Ainslie Smith observed in *Books in Canada*, "the reader is left with the uneasy feeling that the problems of this family are so deep that they will have no easy solutions."

A Handful of Time, which some critics felt was influenced by Philippa Pearce's *Tom's Midnight Garden*, a fact acknowledged by Pearson in the book's epigraph, was highly praised by reviewers and won the 1988 Book of the Year for Children Award from the Canadian Library Association. Critics noted that the book's quality was significantly improved over the author's first work. *A Handful of Time* is "a much more complex and self-aware piece of writing," according to York in *Canadian Children's Literature*. York especially praised Pearson's avoidance of offering quick and easy solutions to her protagonist's dilemma (a trap that many young adult "problem novels" fall into) with her parents' divorce and her relationships with her parents, grandmother, and cousins at the summer cabin. However, York disliked the fact that Patricia has ambitions of becoming a woman much like the model her mother rebelled against. Other critics, however, noted the strength of Pearson's portrayal of family relationships. "What Pearson manages very well is the tension between

family members," wrote *Bulletin of the Center for Children's Books* contributor Roger Sutton, for example.

Pearson also noted differences between her first and second novels. "*The Daring Game* I still think doesn't have enough plot . . .," she told Jenkinson. "[If] I wrote it again, I would make it a lot tighter. *Handful of Time* had plenty of plot—too much plot—and the trouble was the characters." In particular, Pearson's editor thought Patricia's grandmother was "too nasty," a trait Smith noticed when she called the grandmother "the unpleasant link between the two times."

Pearson's World War II Trilogy

With her trilogy of books set during the time of World War II, *The Sky Is Falling, Looking at the Moon,* and *The Lights Go On Again,* Pearson no longer included elements of her own life in her books. However, the theme of the problems of a child's separation from her parents is still central to these books. The trilogy was originally inspired by storyteller Alice Kane, who Pearson remembers talking about telling such stories as "Alenoushka and Her Brother" to evacuee children in Canada (Norah also hears this folktale in the plot of *The Sky Is Falling*). *The Sky Is Falling* was also inspired by Arthur Ransome's characters Bridget and Titty, who Pearson imagined in a situation of being evacuated from England during the war. Eventually, however, Pearson's book evolved in a different direction as she became more interested in simply telling a tale about English children having to come to Canada to avoid the shelling from Hitler's Germany.

The Sky Is Falling begins in 1940 in England. Ten-year-old Norah and her five-year-old brother, Gavin, are sent to Toronto to live with a rich widow, Mrs. Florence Ogilvie. Neither Norah nor Gavin are very happy, but Norah seems to be having a worse time of it when Mrs. Ogilvie gives more attention to the younger Gavin. Norah becomes withdrawn and misbehaves, causing tensions between her and Mrs. Ogilvie to rise. Upset and homesick, she decides to run away, taking Gavin with her because her father has charged her with his care. Norah comes to realize, however, that running from her problems is no answer. She returns, and she and Mrs. Ogilvie begin to reach an understanding in which Norah can

begin to cope with her new life. "Pearson's novel is a compelling, sensitive study of children traumatized by separation," said Denise Wilms in *Booklist.* And *School Library Journal* contributor Louise L. Sherman similarly called it "Superior and compelling historical fiction for middle graders."

The story of Norah and Gavin is picked up three years after the first book with *Looking at the Moon.* Norah, now settled in and more comfortable with her Canadian family (she and Gavin now call Mrs. Ogilvie "Aunt Florence"), has other problems to deal with, including her first menstrual cycle and her growing romantic feelings for her nineteen-year-old adopted cousin, Andrew. Andrew is old enough to enlist in the army, and his family is pressuring him against his will to join. Andrew abhors the idea of killing another person, and he brings a message of pacifism to the tale. However, as Zena Sutherland remarked in her *Bulletin of the Center for Children's Books* review, "As she does with other facets of the story, Pearson keeps the concept of pacifism in perspective." Although a few critics complained that the number of characters and their relationships to one another might be confusing to some readers—"it will take a patient reader to sort out the people," Lucinda Snyder Whitehurst wrote in *School Library Journal.* Pearson's grasp of period details and her description of adolescent growing pains have drawn praise. Noting that Norah is a more sympathetic character in this second book of the trilogy, *Quill & Quire* reviewer Jane Cobb said, "Her story is told with humour and realism, and with the dignity that sensitive young girls like Norah enjoy in a coming-of-age novel." "In Norah," asserted Lisa Prolman in *Voice of Youth Advocates,* "Pearson wonderfully captures the essence of adolescence, a time when everything is right and wrong concurrently."

With *The Lights Go On Again* Pearson focuses for the first time on a male protagonist—Gavin. The war is over and it is time for Gavin, now ten, and Norah, fifteen, to think about returning to England. Gavin, however, is reluctant. His memories of his former home have faded, and he is quite satisfied to remain in Canada with wealthy Aunt Florence. When news comes to the children that their parents have been killed during a shelling, it appears that Gavin may get his wish, and Aunt Florence considers adopting him. But then his grandfather arrives with the intention of taking Norah and him back home to England. The

grandfather's presence reawakens old memories of the past, and Gavin not only develops an affection for him but also begins to realize that he has been spoiled at his Canadian home and that his true place is back in England. *Horn Book* contributor Hanna B. Zeiger called this story "a touching account of a young boy's search for a piece of his lost childhood." "Although girls may be disappointed by Norah's more shadowy presence in this sequel," wrote Mary Beaty in *Quill & Quire*, "Gavin's realistic predicament brings the series to a sensitive and fulfilling conclusion."

With her trilogy now behind her, Pearson has already written a wide variety of books: a boarding school book, a time-travel tale, and a historical trilogy. Her next project is a ghost story. Despite being very different genres, however, all these stories share themes concerning the separation of young people from their parents, and the author offers no simple answers to the challenges they must confront and conquer. Pearson tries to keep a sympathetic ear turned toward her young audience when she writes. As she states in the *Seventh Book of Junior Authors and Illustrators*, she believes that, while times have changed for children since she was young, "I don't think their inner lives have."

■ Works Cited

Beaty, Mary, review of *The Lights Go On Again*, *Quill & Quire*, September, 1993, p. 68.

Cobb, Jane, review of *Looking at the Moon*, *Quill & Quire*, November, 1991, p. 24.

Evans, Gwyneth, "Kit Pearson," *Twentieth-Century Young Adult Writers*, 1st edition, St. James, 1994.

Jenkinson, Dave, "Kit Pearson: Boarding Schools, Beaches and Bombs," *Emergency Librarian*, September-October, 1989, pp. 65-69.

Patton, JoAnna Burns, review of *The Daring Game*, *CM: Canadian Materials for Schools and Libraries*, July, 1986, p. 167.

Pearson, Kit, comments in *Seventh Book of Junior Authors and Illustrators*, H. W. Wilson, 1996.

Prolman, Lisa, review of *Looking at the Moon*, *Voice of Youth Advocates*, October, 1992, p. 228.

Sherman, Louise L., review of *The Sky Is Falling*, *School Library Journal*, June, 1990, p. 125.

Smith, Mary Ainslie, "Living in the Past," *Books in Canada*, June-July, 1987, pp. 35-37.

Sutherland, Zena, review of *Looking at the Moon*, *Bulletin of the Center for Children's Books*, June, 1992, p. 273.

Sutton, Roger, review of *A Handful of Time*, *Bulletin of the Center for Children's Books*, May, 1988, p. 186.

Whitehurst, Lucinda Snyder, review of *Looking at the Moon*, *School Library Journal*, August, 1992, p. 156.

Wilms, Denise, review of *The Sky Is Falling*, *Booklist*, May 15, 1990, p. 1805.

York, Lorraine M., review of *The Daring Game*, *Canadian Children's Literature*, Number 46, 1987, pp. 79-81.

York, Lorraine M., "A Journey to Confidence," *Canadian Children's Literature*, Number 49, 1988, pp. 53-55.

Zeiger, Hanna B., review of *The Lights Go On Again*, *Horn Book*, September/October, 1994, pp. 590-91.

■ For More Information See

PERIODICALS

Books for Young People, April, 1987, p. 10.

Bulletin of the Center for Children's Books, January, 1987, p. 95; June, 1994, p. 331.

Horn Book, September/October, 1990, p. 603.

Quill & Quire, November, 1989, p. 14.

School Library Journal, May, 1988, p. 100; July, 1994, pp. 103-104.*

—Sketch by Janet L. Hile

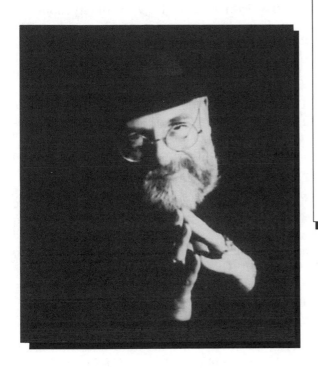

Terry Pratchett

■ Awards, Honors

British Science Fiction Awards, 1989, for "Discworld" series, and 1990, for *Good Omens: The Nice and Accurate Predictions of Agnes Nutter, Witch;* Writers' Guild of Great Britain Best Children's Book Award, 1993, for *Johnny and the Dead;* British Book Award, 1993, for Fantasy and SF Author of the Year.

■ Personal

Full name Terence David John Pratchett; born April 28, 1948, in Forty Green (now Beaconsfield), Buckinghamshire, England; son of David (an engineer) and Eileen (a secretary; maiden name, Kearns); married, wife's name, Lyn; children: Rhianna. *Education:* Attended Wycombe Technical High School. *Politics:* None. *Religion:* None. *Avocational interests:* Growing carnivorous plants.

■ Addresses

Home—Somerset, England. *Agent*—Colin Smythe Ltd., P.O. Box 6, Gerrards Cross, Buckinghamshire SL9 8XA, England.

■ Career

Journalist in Buckinghamshire, Bristol and Bath, England, 1965-80; Western Region Central Electricity Generating Board, England, press officer, 1978-87; freelance writer, 1987—. Co-host of wildlife documentary on the Borneo orangutans.

■ Writings

"DISCWORLD" FANTASY SERIES

The Colour of Magic, Colin Smythe (Gerrards Cross, Buckinghamshire), 1983, Signet, 1983.
The Light Fantastic, Colin Smythe, 1986, Signet, 1986.
Equal Rites, Gollancz, 1987, Roc, 1987.
Mort, Gollancz, 1987, Signet, 1987.
Sourcery, Gollancz, 1988, Signet, 1989.
Wyrd Sisters, Gollancz, 1988, Roc, 1990.
Pyramids, Gollancz, 1989, Roc, 1989.
Guards! Guards!, Gollancz, 1989, Roc, 1991.
Eric, Gollancz/Corgi, 1990, Roc, 1995.
Moving Pictures, Gollancz, 1990, Roc, 1992.
Reaper Man, Gollancz, 1991, Roc, 1992.
Witches Abroad, Gollancz, 1991, Roc, 1993.
Small Gods, Gollancz, 1992, HarperCollins, 1994.
Lords and Ladies, Gollancz, 1992, HarperCollins, 1995.
Men at Arms, Gollancz, 1993, HarperCollins, 1996.
Soul Music, Gollancz, 1994, HarperCollins, 1995.

Interesting Times, Gollancz, 1994.
Maskerade, Gollancz, 1995.
Feet of Clay, HarperCollins, 1996.
Hog Father, Gollancz, 1996.

"THE BROMELIAD" SERIES

Truckers, Doubleday, 1989, Delacorte, 1990.
Diggers, Doubleday, 1990, Delacorte, 1991.
Wings, Doubleday, 1990, Delacorte, 1991.

"JOHNNY" SERIES

Only You Can Save Mankind, Doubleday, 1992.
Johnny and the Dead, Doubleday, 1993.
Johnny and the Bomb, Transworld, 1996.

OTHER

The Carpet People, illustrated by the author, Colin
 Smythe, 1971, revised edition, Doubleday, 1992.
The Dark Side of the Sun, St. Martin's, 1976.
Strata, St. Martin's, 1981.
(With Grey Joliffe) *The Unadulterated Cat*, Gollancz,
 1989.
(With Neil Gaiman) *Good Omens: The Nice and
 Accurate Predictions of Agnes Nutter, Witch*,
 Gollancz, 1990, Workman, 1991.
(With Stephen Briggs) *The Streets of Ankh Morpork*
 (map), Corgi, 1993.
Mort: A Discworld Big Comic (graphic novel), il-
 lustrated by Graham Higgins, Gollancz, 1994.
(With Briggs) *The Discworld Companion*, Gollancz,
 1994.
(With Briggs) *The Discworld Mapp*, Corgi, 1995.

Contributor to periodicals, including *Science Fan-
tasy, Bookcase, GM, New Worlds*, and *Time Out*.
Contributor to anthologies, including *The Drabble
Project*, edited by Rob Meads and David B. Wake,
1988; *Hidden Turnings*, edited by Diana Wynne
Jones, Methuen Children's Books, 1989; *Digital
Dreams*, edited by David V. Barrett; *Now We Are
Sick*, edited by Neil Gaiman and Stephen Jones;
After the King, and *Forbidden Planet SF Anthology 2*.

■ **Adaptations**

Two computer games based on the Discworld se-
ries have been produced: *The Colour of Magic*
(computer game), Delta 4, and *Terry Pratchett's
Discworld* (computer game), Sony/Psygnosis, 1994.
The Colour of Magic was adapted as a four-part
work by Scott Rockwell with illustrations by
Steven Ross, Innovation Corporation, 1991, and
published as a graphic novel, Corgi, 1992; *The
Light Fantastic* was adapted as a four-part work
by Rockwell with illustrations by Ross, Innovation
Corporation, 1992, and published as a graphic
novel, Corgi, 1993. *Truckers*, the first volume of the
"Bromeliad" was released on video by Thames
Television International, and *Johnny and the Dead*
was adapted for film and is also available on
video. The "Bromeliad" series, *Only You Can Save
Mankind, Johnny and the Dead*, and most of the
"Discworld" series have been recorded and are
available on audio cassette from Corgi. Stephen
Briggs has adapted *Wyrd Sisters, Mort* and *Guards!
Guards!* for the stage; they were staged by Studio
Theatre Club, Oxford. *Music from the Discworld*, a
CD of music by composer Dave Greenslade, was
released by Virgin Records, 1994. David Langford
compiled *Terry Pratchett's Discworld Quizbook: The
Unseen University Challenge*, which was published
by Vista in 1996. Fans of Terry Pratchett meet
regularly on the Internet in a UseGroup known
as alt.fan.pratchett.

■ **Sidelights**

*In a distant and second-hand set of dimensions, in an
astral plane that was never meant to fly, the curling
star-mists waver and part . . .*

See . . .

*Great A'Tuin the turtle comes, swimming through the
interstellar gulf, hydrogen frost on his ponderous limbs,
his huge and ancient shell pocked with meteor craters.*

These words first appeared in 1983 with the pub-
lication of *The Colour of Magic*, a fantasy novel by
a press officer for a series of nuclear power sta-
tions. Since that time, Terry Pratchett's uniquely
humorous brand of fiction has made him one of
the most popular of modern writers. "His books
parody many aspects of our own lives and his-
tory," *West Australian* contributor Todd Owen ex-
plains, "covering topics from religion to gender
equality, death folklore, rock and roll, death and
Shakespeare (which has plenty of death)." Critics
compare Pratchett's work to that of J. R. R.
Tolkien, P. G. Wodehouse, Douglas Adams, Charles

Dickens, and Jonathan Swift. "Pratchett is Gilbert and Sullivan to the Wagner of Tolkien's *Ring;* both the acceptable, popular face of the genre, and *fun,*" David V. Barrett writes in *New Statesman & Society.* "But like G & S, Pratchett's work is much more than simply a parody. . . . The Discworld novels, to continue the metaphor, are works of marvellous composition and rattling good stories. You would whistle them in the street if you could."

"By disregarding the conventions of novel-writing whenever it suits him," declares a writer for *Bookcase* magazine, "Terry Pratchett has developed his own distinctive form of humor and gained a dedicated following." Overseas Pratchett's sales rival those of Stephen King in the United States. "He doesn't look like someone who's written around 20 best-selling books over the last 15 years and is universally regarded as the funniest, most inventive fantasy writer in the world today," Gary Whitta asserts in *PC Gamer* magazine. "Nor does he look like one of Britain's 500 wealthiest individuals." "His . . . books about the Discworld sold eight million copies and established him as one of the most popular authors in Western countries around the world," writes Owen, "apart from America."

Pratchett's works are all celebrated for their expert use of comedy in literature—a type of comedy that differs from the traditional literary comedy as well as from more recent film and television comedy. The author uses a variety of techniques to both entertain and enlighten the reader. One of these is what the *Bookcase* interviewer calls "his wildly surreal footnotes," which Pratchett uses to refine his comic timing. "A stand-up comedian has a whole armory of techniques he can use," Pratchett tells *Bookcase.* "The author has fewer. So I use the footnote as a delayed drop. The reader has to take his eye off the page, then move it down. That's timing."

Terry Pratchett is reticent about his own life. He has revealed, however, that he grew up in Buckinghamshire, England, and was strongly influenced by his independent reading of science fiction and fantasy writers. "He quotes *Wind in the Willows,* history (because it was the same as fantasy) and violence (received from teachers) as the influences in creating the wacky story writing style," Owen explains. "When I was a kid," the author tells *Midweek* radio interviewer Christine

Hardimant, "fantasy and science fiction got me reading, because they blew my socks off and made my brain fizz . . . and the books that I was being given to read at school didn't have the same effect. And when the fantasy ran out . . . I started reading mythology, because that was pretty much the same sort of thing, and I started reading ancient history because *that* was pretty much the same thing. We're still talking guys in helmets bashing one another with swords. So I kind of got an education via fantasy and science fiction." According to an interview published in *The Discworld Companion,* he credits his parents for "pointing me in the right direction and just letting me get on with it. They took the view that if I was reading, that was all right."

Pratchett began writing his own stories while still in school. One of his earliest stories, entitled "The Hades Business," was originally written as an assignment and was published in the school magazine. Then the headmaster of the school denounced what he called the "moral tone" of the story in front of a school assembly. The issue of the magazine containing "The Hades Business" promptly sold out. The budding author then had the story typed by a close relative and sold it to the magazine *Science Fantasy,* where it appeared in 1963. Pratchett used the proceeds from the sale to invest in a typewriter, took typing lessons, and after graduation found a job in journalism. "He started work as a journalist one day in 1965," explains the "About the Author" blurb in the American edition of *Small Gods,* "and saw his first corpse three hours later, work experience *meaning* something in those days." The author considers his journalism experience as very important to his career as a writer. "I don't believe in writers' block," Pratchett explains in a CompuServe forum. "I was a journalist for too long. You *have* to write on newspapers. Otherwise you don't get paid and people shout at you." "It's a job," he concludes, "but it's the best you can have."

Snibril, Glurk, Tregon Marus, Woodwall, and Damion Oddfoot

Pratchett's first novel, the fantasy *The Carpet People,* was completed when he was just over seventeen and published in England in 1971. It tells about a whole civilization of tiny people known as Munrungs who live within a carpet. "Their capital city is the size of a full stop," explains

Pratchett's "Discworld," as envisioned by artist Stephen Player.

School Library contributor Jessica Yates. Five major characters gather together after an attack by the monster Fray destroys their village. They include the village's chief, his intelligent younger brother, a freelance warrior, a deposed king, and the shaman of the tribe. "They discover a plan by the 'mouls,' misshapen creatures rather like goblins, to conquer the empire of the carpet people," Yates states, "and they gather allies on their journey to devise a strategy for defeating the mouls."

In 1978, Pratchett added a new job to his list of credits. "I had a job as a Press Officer for what was then the Central Electricity Generating Board," Pratchett tells an interviewer for *PC Zone* magazine. "There were four nuclear power stations on my patch (and lots of other sorts, but they seldom made the news). And in my spare time I wrote." In 1976, he had published *The Dark Side of the Sun*, a parody of some of the conventions of "space-opera" science fiction, and he followed this in 1981 with *Strata*, marking the first appearance of the Discworld—although probably not the same Discworld as appears in his later series. "Within a couple of years of *The Colour of Magic* coming out," the author continues in the *PC Zone* interview, "it was obvious to me that I was losing money by going to work every day, and I quit."

The publication of *The Colour of Magic* in 1983 marked the first appearance of the Discworld proper in Pratchett's fiction. It was published by a small press, Colin Smythe Ltd., and sold amazingly well—so well, in fact, that the American publisher St. Martin's Press picked up the book for an American hardcover edition the same year. By 1985, the book had sold so well that the rights to two paperback editions—Corgi Press in England, Signet in America—were sold. "In the first year," Roger Peyton of Andromeda Books, a British bookstore specializing in science fiction and fantasy, states in *The Discworld Companion*, "it was our number 2 best seller of the year, and Terry stayed in our top four for the next two years. He only started to move out of that position when his books became so widely available that fans no longer needed to come to specialist shops to get them."

Pratchett got the idea of a discworld—a flat, circular world carried on the back of a gigantic turtle—from his childhood science reading. "When I was a kid," the author reminisces in an interview with Frank Delany broadcast on the *Sky News Bookshow*, "I wanted to be an astronomer, and I bought lots of books on astronomy. Those were the days when the white heat of technology was just taking over, and they always had a chapter on 'Let's Have a Good Laugh About Stupid People in History and How They Thought the World Worked.'" Although the author has made the discworld concept popular, the idea has deep roots buried in many different human cultures. "There were always pictures of the discworld, because it figures in the mythology of mankind," the author continues in the *Sky News Bookshow* interview. "The idea that the world was flat and went through space on the back of a giant turtle was found in Africa. It was found in North America. It was found in Australia. It was found everywhere in Asia, and when I needed a funny background for some novels, it was just there waiting for me."

Another element in the evolution of the Discworld came from the role-playing game *Dungeons and Dragons*. "Around 1970-71," Pratchett tells Whitta, "the kid who lived next door came round with his parents on Boxing Day and showed me this Dungeons & Dragons game. . . . And I thought, hey, if I'd been 13 when this came out, I'd have been lost." "I did some game scenarios for him," the author continues, "and some of those things actually got incorporated into *The Colour of Magic*. One or two others even turned up later in the series. I quite enjoyed it. I was a pretty good Dungeon Master—providing people worked out what the plot was."

Since that time, Pratchett's popularity has exploded. "People started reading [the books] in a big way in 1985," Pratchett tells an interviewer for Radio Derby, "so teenagers then have got kids now. They're all growing up and new ones are coming along." Although most interviewers believe that his books attract a certain type of reader—the standard is apparently a fourteen-year-old boy named Kevin who is fond of computer games and wears an anorak—at least fifty percent of his readership is female and adult. "I seem to have quite a large readership among, to use that nice old-fashioned term, 'women of a certain age,'" Pratchett tells the Radio Derby interviewer. Partly, he explains, this was because "a couple of the books were serialized on BBC Women's Hour, God bless them," but also because mothers began reading their children's books. They have helped make

the Discworld books one of the most popular fantasy series ever published in England.

The Turtle Moves!

The Discworld is a large, flat plate-like planet that rests on the backs of four huge elephants—Berilia, Tubul, Great T'Phon and Jerakeen—which in turn stand on the shell of the enormous star-turtle Great A'Tuin. "A tiny sun and moon spin around them, on a complicated orbit to induce seasons," Pratchett explains in *Wyrd Sisters*, "so probably nowhere else in the multiverse is it necessary for an elephant to cock a leg to allow the sun to go past." Since such a thing is impossible according to the physics we know, the author explains, the Discworld can only exist because Reality is very weak in its vicinity. "Influences leak across from other more prosaic worlds," Pratchett writes in his introduction to *Terry Pratchett's Discworld Challenge: The Unseen University Challenge*. "A city Watchman in a breastplate and helmet and tight corner finds himself speaking in the tones of Harry Callaghan. A young Druid pioneering a new type of popular music might have, for perfectly logical and defensible reasons, a name which translates as 'Bud of the Holly.'" An institution of higher learning might even employ an orangutan with a vocabulary that consists of the word "Oook" as its librarian.

The planet's strong magical field may also be a product of this fringe existence. The faculty at the wizard's school, known as Unseen University and located in the Discworld's oldest and largest city, Ankh-Morpork, figure in most of the Discworld novels, providing the author with a chance to poke fun at some of the absurdities of the educational system and offer an explanation of how the Discworld works. The faculty tends to be more interested in collegiate infighting, maintaining its status, and eating big dinners than in teaching or performing magic. Nonetheless, some of the Discworld wizards have broken down the study of magic and reality in a way reminiscent of modern post-Einsteinian physics—breaking down the magical particle, the *thaum*, and the reality particle, the *reson*, into their constituent elements.

The Colour of Magic introduces Rincewind, an inept wizard who has flunked out of Unseen University. He meets Twoflower, a traveler from the Agatean Empire, who is the Discworld equivalent

Three witches must recover a baby that they gave away in this 1988 Discworld novel.

of the tourist: interested in everything, and holding an unsettling belief that nothing can harm him because he is "not involved" in local problems. Twoflower is followed by his Luggage, a box that follows its owner on hundreds of tiny legs and has the attitude of a mass murderer on very bad drugs. Pratchett has explained that the Luggage was based on a personal observation. "Many years ago," he states in his dedication to *Sourcery*, "I saw, in Bath, a very large American lady towing a *huge* tartan suitcase very fast on little rattly wheels which caught in the pavement cracks and generally gave it a life of its own. At that moment the Luggage was born." The Luggage has since become one of Pratchett's most popular characters.

Rincewind and Twoflower tour the Discworld, meeting the Discworld equivalents of Robert E.

Howard's Conan the Barbarian (Hrun), Fritz Leiber's Fafhrd and the Gray Mouser (Bravd the Hublander and the Weasel), Anne McCaffrey's Dragonriders (the denizens of the Wyrmberg), and many others. Most of their adventures place Rincewind in extremely precarious positions, from which he barely escapes with his life—perhaps only because he is of value to a certain supernatural being known as The Lady. "Heroic barbarians, chthonic monsters, beautiful princesses and fiery dragons: they're all here, but none of them is doing business as usual," declares a *Publishers Weekly* reviewer.

The two travelers continue their adventures in *The Light Fantastic*, which introduces managers seduced by the powers of the chthonic Dungeon Dimensions, Druidic computer salesmen, and the most famous barbarian adventurer in the world, Cohen the Barbarian—now, in his 87th year, old and toothless. Eventually Rincewind and Twoflower manage to save the Discworld from its own citizens (who believe that the end of the world is approaching). Twoflower returns home after giving Rincewind the Luggage; Rincewind reenters Unseen University in the hopes of learning something about magic. "You won't stop grinning except to chuckle or sometimes roar with laughter," asserts a *Kirkus Reviews* critic. "The most hilarious fantasy since—come to think of it, since Pratchett's previous outing."

Rincewind and the Luggage are also featured in *Sourcery, Eric,* and *Interesting Times*. In each case Rincewind is forced into a heroic role by circumstances beyond his control. In *Sourcery*, he has to face the most powerful natural wizard the world has ever seen. When the wizards begin turning on one another in an effort to gain supreme power, it is up to Rincewind to face the Sourcerer and to defeat the horrible creatures of the Dungeon Dimensions—armed only with a homemade blackjack. In *Eric* he becomes responsible for a would-be Faust, a pimply fourteen-year-old boy who wants power, women, and everlasting life. Eric gets them, thanks to Rincewind and the intervention of some demons, but they prove to be quite different from what he expected. Twoflower and Genghiz Cohen reappear in *Interesting Times*, a satire of the Communist societies of eastern Asia. The book, states Boyd Tonkin in *New Statesman & Society*, "works as a kind of Popperian fable, which aims to prove the superiority of an open society of plain-speaking traders and fighters

against a rigid hierarchy whose servile peasantry suffer 'whips in the soul.'"

The Maiden, the Mother, and the Crone

Equal Rites, the third volume in the Discworld series, tells what happens when sex roles are challenged. A little girl named Esk is the eighth child of an eighth son—destined to be a powerful wizard. She "sets off with the magic staff left to her by a dead magician to go to the Unseen University," explains Paul Tomlinson in *Starlog*, "and to become the first female wizard despite the prejudices of all the sorcerers she encounters." Eventually Esk becomes involved so deeply in the affairs of Unseen University that the faculty is forced to award her the coveted pointy hat. *Equal Rites* differed from both *The Colour of Magic* and *The Light Fantastic* in theme and in structure, and it established a pattern that has persisted throughout the Discworld series. The first two novels of the series, Pratchett tells Tomlinson, "were gag books. *Equal Rites* is where I found out that you can only go so far by running from gag situation to gag situation."

Equal Rites also introduces one of the author's favorite characters: the witch Esmeralda, or "Granny," Weatherwax. Granny Weatherwax is "the character [Pratchett] most strongly identifies with," according to *Weekend Independent* contributor Lisa Southgate. She is "a witch who mistrusts magic, doesn't hold with candles or dancing in the forest and dresses in serviceable black, bolstered with hundreds of petticoats." Strong-minded and quite straitlaced, Granny prefers her own system of "headology" (like practical psychology) over traditional magic. "I want to make it quite clear," Pratchett tells Southgate, "she's a bad witch who happens to be on the right side. She would be much better as a bad witch. But she's got too much pride to be bad."

Granny returns in *Wyrd Sisters*, a Shakespearean spoof that mocks the conventions of the live theater. The same book introduces the other members of Granny's tiny coven: Gytha "Nanny" Ogg, the much-married matriarch (and witch) of a large brood of (now adult) children, and Magrat, a young "New Age" witch, who believes in herbal cures and finding herself. "The interplay between the witches is a continuous delight," writes *Locus* contributor Faren Miller, ". . . and the result is a

wise nonsense which should set Shakespeare to chuckling in his grave." The three reappear in *Witches Abroad*, which examines the power of archetypes within fairy tales and introduces the concept of what the author calls "narrative causality." "What if the fairy godmother wants to *control* the lives of her charges in an unremittingly *good* world?" explains Barrett. *Lords and Ladies*, the third of the witches' books, looks at the dark side of elves—their cruelty and thievery instead of their Tolkienian beauty and grace. In *Maskerade*, Granny Weatherwax and Nanny Ogg investigate the power of stories again in the depths of Ankh-Morpork's opera house—which is haunted by a mask-wearing ghost.

Death: An Anthropomorphic Personification of Entropy

Although Death is the only character to appear in all the Discworld novels, he first becomes a featured player in the fourth volume of the series, *Mort*. He has also become, with Rincewind and Granny Weatherwax, one of Pratchett's most popular characters. "I can trace the origins of my own version of Death to images which helped me put my thoughts in order," Pratchett tells Tomlinson. "One of them was the 'Prophet's Song' by Queen. . . . The other one was the Blue Oyster Cult album *Don't Fear the Reaper*, which has a pretty good Death, on a horse, on its front." "He's really the generic medieval personification, right out of *The Seventh Seal*, but with a few modifications," Pratchett states in *The Discworld Companion*. "I think people like him because he's got this pathetic lack of any sense of humor and is powerful and innocent and vulnerable all at the same time."

Each of Pratchett's Death novels explores questions about life, especially how it is lived and how it ends. *Mort* tells how Death looks for an apprentice and discovers one (appropriately named Mort) that he takes home and trains in the business. After some training Death goes off on a vacation to learn about life, leaving Mort and Death's adopted daughter Ysabel to take care of business. Mort tries to run the business according to his conscience rather than his instructions, and as a result Death has to make a dramatic return. In *Reaper Man*, Death is suddenly confronted with his own mortality. He is relieved of duty for being too sympathetic towards people and has to deal

with becoming a human being, albeit a very thin one. Meanwhile the rest of the world has to cope with extra life forces: people, animals and plants are not dying because there is no Death.

"Soul Music," declares *SFX* contributor David Langford, "continues the 'Death saga' from *Mort* and *Reaper Man*, with skeletal Death again going off duty and worrying about the Meaning Of It All." In part, it is the story of Susan, Mort and Ysabel's daughter, and what happens to her after they die in a sudden carriage crash. In part it is also about a young musician and what happens to *him* when he begins to popularize a new type of music known as Music With Rocks In. "The book's about Discworld rock 'n' roll and what rock 'n' roll really is," Pratchett explains to Whitta.

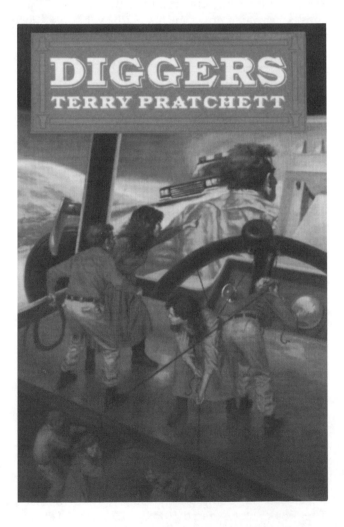

The four-inch-tall nomes fear that their home in an abandoned quarry may be exposed in this 1989 work, the second in Pratchett's "Bormeliad" trilogy.

Soul Music confronts the question of immortality when the spirit of Music With Rocks In offers the bard Imp y Celyn (translated: Bud of the Holly) the chance to live forever in memory in exchange for dying young in reality. Once again Death returns to his duty in time to avert a catastrophe.

Fabricati diem, punc

The latest of Pratchett's recurring characters to be introduced are the members of the Ankh-Morpork Night Watch, including Captain Vimes, Sergeant Colon, Corporal Nobbs, and Constable Carrot. In *Guards! Guards!* Carrot (an adopted dwarf who stands over six feet tall) comes to Ankh-Morpork and enlists in the Night Watch in the hopes that the job will make a man of him. The other members of the watch—written off by society as a bunch of drunks and losers—gradually regain some of their self-esteem from Carrot's enthusiasm and pull themselves together in time to fight off an invading dragon. "I just wanted to distill all the police procedural films we've ever seen, generally with Clint Eastwood in," Pratchett explains to *Loose Ends* radio interviewer Robert Elms. "I wanted to get all those into a fantasy situation so maybe then people could look at the cliches for the first time and see what they really were."

Carrot & Company reappear in *Men at Arms*, which is both a fantasy novel and a mystery novel. In Ankh-Morpork, the criminals are unionized and therefore responsible for the level of crime in the city. When unauthorized bodies with large messy holes in them begin to appear in the river, the Night Watch begins to investigate. Who killed the harmless clown Beano? What caused the explosion at the Assassin's Guild? What is the mysterious "Gonne" that was apparently taken? The Watch's expanded squad—now including a werewolf, a troll and a dwarf—works to solve the mystery before Ankh-Morpork's ethnic population riots. A *Publishers Weekly* reviewer claims that "there are a few more gargoyles and exploding dragons than Sam Spade ever had to deal with," but adds, "Pratchett skewers the hard-boiled detective novel as effectively as he's satired fantasy fiction."

Three of Pratchett's Discworld novels feature characters or situations that either do not appear or appear only rarely elsewhere in the series. *Pyramids, Moving Pictures* and *Small Gods* look in dif-

When a witch becomes a fairy godmother, the Discworld may find itself doomed to "happy endings."

TERRY PRATCHETT

A Novel of Discworld

WITCHES ABROAD

A Fantasy Novel

ROC ★ 451-LE5225 ★ (CANADA $5.99) ★ U.S. $4.99

The three witches travel to Genua to prevent a fairy godmother from giving Discworld a "happy ending" in this 1993 work.

ferent ways at questions of divinity, immortality and reality and the differences between them. *Moving Pictures* is a spoof of Hollywood (Holy Wood, in Discworld terms) that "relentlessly shows the squalor and emptiness inside the glamour, the dreadful living power that Holy Wood exerts over everyone caught up in it," explains Barrett. It also explains how the magic of Holy Wood really operates, and examines the—sometimes catastrophic—consequences of using magic irresponsibly.

Pyramids and *Small Gods* both examine religion and the abuse of it in organized structures. *Pyramids* is set in the Discworld equivalent of Ancient Egypt, in the kingdom of Djelibeybi. Like Ancient Egypt, the denizens of Djelibeybi have a count-

If you enjoy the works of Terry Pratchett, you may want to check out the following books and films:

Douglas Adams, *The Hitchhiker's Guide to the Galaxy*, 1979.
Kenneth Grahame, *The Wind in the Willows*, 1940.
Jonathan Swift, *Gulliver's Travels*, 1726.
J. R. R. Tolkien's *The Hobbit; or, There and Back Again*, 1937, and *The Lord of the Rings* trilogy, 1954-55.
Labyrinth, TriStar, 1986.
Willow, MGM/UA, 1988.

less number of gods, all of which are worshiped with their own rituals. *Small Gods* is the story of the monotheistic theocracy of Omnia, dedicated to the idea that the world is round and does not travel through space on the back of a turtle. When the foreign philosopher Didactylos suggests that the Discworld is in fact flat and *does* travel on an astrochelonian, the church sends its officers out to "correct" both his "errors of faith" and those of his country.

The antagonists in both stories are played by high-ranking members of the established religion: the chief priest Dios in *Pyramids* and the Exquisitor Vorbis in *Small Gods*. The protagonists are played by genuine believers who later come to question the assumptions of their organizations: Teppic, the king trained as an assassin in *Pyramids*, and Brutha, an aspiring monk in the Omnian religion. Pratchett concludes that when belief becomes dogmatic and intolerant, faith suffers and dies. "I was watching the news one day," he states in *The Discworld Companion*, "and some alleged holy man in Iran or Iraq or somewhere was pictured standing in front of a fountain flowing with fake blood and telling people how truly holy it was to die for God. And I thought: no, even I can see through that one." The books both conclude with the defeat of the dogmatists and the establishment of tolerance in Djelibeybi and Omnia.

Angels and Others

Pratchett again considers a question of religion in collaboration with Neil Gaiman in *Good Omens: The Nice and Accurate Prophecies of Agnes Nutter,*

Witch. The work is about the end of the world—the Apocalypse—as predicted in the Book of Revelations. However, there is a complication: the Antichrist has been misplaced at birth. Instead of the complicated education based on power planned for him, the Antichrist (named Adam) is raised in the small English village of Lower Tadfield by a normal couple and grows up with normal childhood friends. The local Heavenly and Diabolic agents on the scene, Aziraphale and Crowley, respectively, are old and comfortable antagonists who have more in common with each other than they do with their respective bosses. "It's up to Adam in the neatly tied end," states a *Publishers Weekly* reviewer, "as humanity prevails over the Divine Plan and earthly bungling."

Good Omens marked a departure from Pratchett's Discworld, one that the author welcomed. "I'm very pleased with it," he tells Tomlinson, "because the spin-off from it will be very good for my other writing in that I've had to explore different types of ideas, and I've demonstrated that I can write outside of Discworld." He continued this process with two sets of books for young adults, the "Nomes" series and the "Johnny" books. The Nomes of *Diggers, Truckers,* and *Wings* are tiny, four-inch-high people, who have lived on this world so long that they have forgotten how they got here. Masklin, leader of a small tribe of wandering nomes, comes across a whole civilization of nomes living in a department store. The store nomes have built a civilization in the store and a whole religion around Arnold Bros. (Est. 1905), which they envision as a godlike figure that watches over them. Thanks to the Thing, a tiny black box that speaks, Masklin and his friends Angalo, Grimma, Dorcas, and Abbot Gurner, learn of the impending destruction of the store and help the Nomes flee by hijacking a truck. "The final 'chase' scene is hysterical," declares *Voice of Youth Advocates* contributor Patrick Jones, "as the nomes work together . . . to drive the big truck to a new world."

At the beginning of *Diggers*, Masklin, Angalo and Gurner leave the nomes' new home on a flight to Cape Canaveral, Florida, hoping to find a way to return to the ship that originally brought the nomes to earth centuries ago. The leadership of Grimma and Dorcas is challenged by the religious fanatic Nisodemus. Eventually Grimma and Dorcas manage to overcome the harmful effects of Nisodemus's zeal and bring the nomes together

to fight off humans threatening their new home. *Wings* tells of Masklin, Angalo and Gurner's trip to Florida and how they try to find the lost nome spacecraft. "If it sounds like Swift," Jones declares, "it is supposed to because the nomes read *Gulliver's Travels* and are fascinated by humans' perceptions of nomes." Pratchett "tells the story almost entirely from the nomish viewpoint," explains Katherine L. Kan in *Voice of Youth Advocates*, "which allows the reader to look at our present world from a different perspective." "Here is a real effort of creativity," states a *Junior Bookshelf* contributor, "and a criticism of society no less forceful for being clothed in the garb of comedy."

Pratchett again explores our own world in a series of young adult novels, beginning with *Only You Can Save Mankind*, and continuing with *Johnny and the Dead* and *Johnny and the Bomb*. Johnny Maxwell is a loner, more interested in computers and computer games than in socializing with most of the people he knows. In *Only You Can Save Mankind*, set during the Gulf War, however, his computer games take a sudden unexpected turn: the aliens he is fighting surrender. Now Johnny is in the position of rescuing the alien fleet and sending it home again—which, in a game designed to destroy the aliens, is not easy. "That is not all by a long inter-galactic mile," declares a *Junior Bookshelf* reviewer. "Most teenagers should thoroughly enjoy the teasing competence of Mr. Pratchett's high-tech conundrums, by turns comical, whimsical and downright terrifying." *Johnny and the Dead* puts Johnny and his friends in conflict with a development site sold to a big company by the local city government. "Terry Pratchett's philosophy is based on a humorous view of life and humanity," another reviewer states in *Junior Bookshelf*, "and the fact that most of the characters in *Johnny and the Dead* are indeed dead does not mean that they are the less funny. The comedy and the philosophy are inseparable."

Pratchett himself has no doubts about the value of humor, fantasy, and philosophy—in moderation, at least. "Fantasy is like alcohol," the author explains in "Turtles All the Way," his introduction to *The Discworld Companion*, "too much is bad for you, a little bit makes the world a better place. Like an exercise bicycle it takes you nowhere, but it just might tone up the muscles that will. Daydreaming got us where we are today; early on in our evolution we learned to let our minds wan-

der so well that they started coming back with souvenirs." "Civilization turns us a little bit mad all the time," he tells an interviewer for the television program *The Little Picture Show*. "We have to cope with it, and it seems to me that the really sane people are the ones who find a way to let the madness leak out."

■ Works Cited

"A Brief History of Discworld," *The Discworld Companion*, compiled by Terry Pratchett and Stephen Briggs, Gollancz, 1994, pp. 265-76.

Barrett, David V., "Serious Fun," *New Statesman & Society*, January 3, 1992, p. 33.

Review of *The Colour of Magic*, *Publishers Weekly*, August 26, 1983, p. 373.

Delaney, Frank, interview with Terry Pratchett, *Sky News Bookshow*, c. 1993.

Elms, Robert, interview with Terry Pratchett, *Loose Ends*, BBC Radio 4, November 27, 1993.

Review of *Good Omens*, *Publishers Weekly*, July 20, 1990, p. 50.

"The Grin Reaper," *Bookcase*, May/June, 1994.

Hardimant, Christina, interview with Terry Pratchett, *Midweek*, BBC Radio 4, April 26, 1995.

Review of *Johnny and the Dead*, *Junior Bookshelf*, August, 1993, p. 157.

Jones, Patrick, review of *Diggers* and *Truckers*, *Voice of Youth Advocates*, February, 1991, p. 366.

Kan, Katherine L., review of *Wings*, *Voice of Youth Advocates*, October, 1991, p. 248.

Langford, David, review of *Soul Music*, *SFX*, number 1, c. 1994.

Review of *The Light Fantastic*, *Kirkus Reviews*, May 1, 1987, p. 679.

Review of *Men at Arms*, *Publishers Weekly*, January 29, 1996, p. 96.

Miller, Faren, review of *Wyrd Sisters*, *Locus*, January, 1989, p. 17.

Review of *Only You Can Save Mankind*, *Junior Bookshelf*, February, 1993, pp. 33-34.

Owen, Todd, "Wizard of Words Sets a New War for Rincewind," *West Australian*, February 4, 1995.

Pratchett, Terry, *The Colour of Magic*, Signet, 1983.

Pratchett, Terry, *Sourcery*, Signet, 1989.

Pratchett, Terry, *Wyrd Sisters*, Roc, 1990.

Pratchett, Terry, conference on CompuServe Science Fiction/Fantasy Forum, August 11, 1991.

Pratchett, Terry, interview on Radio Derby, c. 1992.

Pratchett, Terry, "Turtles All the Way," *The Discworld Companion*, compiled by Terry Pratchett and Stephen Briggs, Gollancz, 1994, pp. 7-9.

Pratchett, Terry, *Small Gods*, HarperCollins, 1994.

Pratchett, Terry, interview on *The Little Picture Show*, January, 1995.

Pratchett, Terry, interview in *PC Zone*, January, 1995.

Pratchett, Terry, introduction to *Terry Pratchett's Discworld Quizbook: The Unseen University Challenge*, Vista, 1996, pp. 5-7.

Southgate, Lisa, "A Glimpse Inside the Fantasy Toolbox," *Weekend Independent Arts & Entertainment Guide*, July 8, 1994.

"Terry Pratchett: The Definitive Interview," *The Discworld Companion*, compiled by Terry Pratchett and Stephen Briggs, Gollancz, 1994, pp. 277-88.

Tomlinson, Paul, "Gag Writer," *Starlog*, August, 1990, pp. 33-36, 63.

Tonkin, Boyd, "Pratchett's Orient Excess," *New Statesman & Society*, November 25, 1994, p. 48.

Whitta, Gary, "Terry Pratchett—Going by the Book," *PC Gamer*, December, 1993.

Review of *Wings*, *Junior Bookshelf*, December, 1990, p. 300.

Yates, Jessica, review of *The Carpet People*, *School Library*, November, 1992, p. 159.

■ For More Information See

BOOKS

Twentieth-Century Science Fiction Writers, St. James, 1991.

PERIODICALS

Best Sellers, November, 1976, pp. 249-50.

Booklist, June 1, 1991, p. 1861.

Fantasy Review, November, 1986, pp. 31-32.

Horn Book, March/April, 1990, p. 202; May/June, 1991, p. 332.

Junior Bookshelf, February, 1990, p. 52; October, 1992, p. 210; June, 1996, p. 124.

Locus, October, 1991, pp. 15, 17; June, 1992, p. 18; September, 1992, p. 66; February, 1993, p. 58.

New Statesman, August 29, 1986, p. 26; January 29, 1988, p. 30.

New York Times Book Review, October 7, 1990, p. 27.

Publishers Weekly, February 24, 1989, p. 226; September 30, 1996, p. 65.

School Library Journal, September, 1991, pp. 258-59.

Science Fiction and Fantasy Review, April, 1982, p. 20; March, 1984, p. 35.

Spectator, August 22, 1992, p. 23.

Times (London), February 12, 1987; August 9, 1990; November 21, 1991, p. 16.

Times Literary Supplement, April 28, 1972, p. 475.

Voice of Youth Advocates, February, 1991, p. 366; August, 1992, p. 174.

Washington Post, December 20, 1990.

Washington Post Book World, February 11, 1990, p. 6; March 27, 1994, p. 11.*

—Sketch by Kenneth R. Shepherd

Faith Ringgold

■ Personal

Born October 8, 1930, in New York, NY; daughter of Andrew Louis Jones, Sr., and Willi (a clothing designer; maiden name, Posey) Jones; married Robert Earl Wallace (a jazz pianist), November 1, 1950 (divorced, 1956); married Burdette Ringgold (a General Motors employee; retired), May 19, 1962; children: (first marriage) Barbara, Michele. *Education*: City College of the City University of New York, B.S., 1955, M.A., 1959.

■ Addresses

Home—La Jolla CA, and New York, NY. *Agent*— (literary) Marie Brown Associates, Room 902, 625 Broadway, New York, NY 10012.

■ Career

Painter, mixed media sculptor, performance artist, and writer. Professor of art, University of California, San Diego, 1984—. Art teacher in public schools, New York City, 1955-73. In 1960s, after

trip to Europe, completed first political paintings and held first one-person show. In 1972, began making paintings framed in cloth (called tankas), soft sculptures, costumes, and masks, later using these media in masked performances of the early and mid-1970s. In 1980, produced first painted quilt and in 1983 created first story quilt. Performances include appearances at various colleges, universities, and museums, including Purdue University, 1977, University of Massachusetts, 1980, Rutgers University, 1981, Occidental College, 1984, Long Island University, 1986, Baltimore Museum of Art, 1988, De Pauw University, 1989, and Washington and Lee University, 1991. Visiting lecturer and artist at art centers, universities, and museums, including Mills College, 1987, Museum of Modern Art, 1988, University of West Florida, 1989, San Diego Museum, 1990, Museum of African American Art, 1991, and Atlantic Center for the Arts, 1992. Ringgold was also featured in "Faith Ringgold: The Last Story Quilt," a video by Linda Freeman that won the 1992 Cine Gold Eagle Award.

■ Exhibitions

Artwork has been nationally exhibited in many museums and numerous galleries as well as in Europe, Asia, South America, and Africa. Artwork has been featured in many one-person shows, including shows at the Spectrum Gallery, New York

City, 1967, 1970, and the Bernice Steinbaum Gallery, 1987, 1989, 1992. Artwork is in many public and private collections, including Boston Museum of Fine Art, Chase Manhattan Bank Collection, Clark Museum, Guggenheim Museum, High Museum, Metropolitan Museum of Art, Museum of Modern Art, Newark Museum, Philip Morris Collection, and Studio Museum in Harlem. Her work was also featured in "Faith Ringgold: A 25 Year Survey," a nationally touring retrospective exhibition, curated by the Fine Arts Museum of Long Island, 1990-93.

■ Awards, Honors

Coretta Scott King Illustrator Award and Caldecott Honor Book Award, both 1992, both for *Tar Beach;* Jane Addams Children's Book Award, 1993, for *Aunt Harriet's Underground Railroad in the Sky.* Artwork has received numerous awards, including Creative Artists Public Service Award, 1971; American Association of University Women Award for travel to Africa, 1976; National Endowment for the Arts Awards, 1978, for sculpture, 1989, for painting; John Simon Guggenheim Memorial Foundation fellowship, 1987, for painting; New York Foundation for the Arts Award, 1988, for painting; and Henry Clews Foundation Award, 1990, for painting in the south of France. Honorary Doctor of Fine Arts degrees from Moore College of Art, 1986, College of Wooster, 1987, Massachusetts College of Art, 1991, City College of the City University of New York, 1991, and Brockport State University, 1992.

■ Writings

(Contributor) Amiri Baraka and Amina Baraka, editors, *Confirmation: An Anthology of African American Women,* Morrow, 1983.

Faith Ringgold: A 25 Year Survey (exhibition catalog), Fine Arts Museum of Long Island, 1990.

Tar Beach, Crown, 1991.

Aunt Harriet's Underground Railroad in the Sky, Crown, 1993.

Dinner at Aunt Connie's House, Hyperion, 1993.

My Dream of Martin Luther King, Crown, 1995.

(With Linda Freeman and Nancy Roucher) *Talking to Faith Ringgold,* Crown, 1995.

We Flew Over the Bridge: The Memoirs of Faith Ringgold, Little, Brown, 1995.

Bonjour, Lonnie, Hyperion, 1996.

Also contributor of articles, essays, and short stories to periodicals, including *Artpaper, Heresies: A Feminist Publication on Art and Politics, Women's Art Journal, Women's Artists News, Feminist Art Journal, Arts Magazine,* and *Art Gallery Guide.*

■ Work in Progress

A quilt depicting the history of Crown Heights, a racially troubled section of Brooklyn, New York, that she plans to turn into a children's book.

■ Sidelights

"I am a woman of color," says Faith Ringgold, *"making a serious statement about my life and work."* This quote, from an interview with Virginia Butterfield published in *San Diego Magazine Online,* epitomizes the major theme of Faith Ringgold's life. In whatever medium she works—painting, mixed media sculpture, history quilts and tankas, performance art, politics, teaching or literature—she maintains a high standard of professionalism. She is considered by many critics to be the leading black female artist working in America today. "Her compelling art," writes interviewer Eleanor Flomenhaft in *Faith Ringgold: A 25 Year Survey,* "encapsulates the yearnings and goals of black American women in terms capable of transcending racial barriers and penetrating the hardest of hearts."

Faith Ringgold grew up in New York's Harlem during the Great Depression. She was the youngest child of Andrew Louis Jones Sr., who drove trucks for the city's sanitation department, and Willi Posey Jones, who became a dressmaker and fashion designer in the 1940s. "Life for me was quite wonderful!" Ringgold tells Margaret Mazurkiewicz in an interview for *Something about the Author.* "While I had asthma and was home sick a lot, I got a chance to do a lot of things with my mother. When I was recuperating my mother would take me to see live performances of people like Duke Ellington and Jimmy Lunceford and Count Basie. Actually those people were my first stars—my first artists. Part of my being with my mother a lot was that I was the youngest in the family. So when the other kids were in school she would take me to the museums. Also because I would be home with asthma, she would teach me and give me crayons and paper so I could draw. My mother would also give me pieces of

fabric since she was a dressmaker. Later on, my mother became a fashion designer but at the time she was just making clothes for my family. She learned the skill from her mother and her mother learned from her mother and so on, and I learned from my mother. . . . My childhood was the best aside from the fact that I was sick."

"I had a wonderful childhood," Ringgold explains to Flomenhaft. The fact that her father had a job at a time when so many people were out of work gave the family a treasured measure of stability. "The stock market crash of 1929, which devastated the rich and sent them flying off their roofs, had just the opposite effect on poor black people," Ringgold states in *We Flew Over the Bridge: The Memoirs of Faith Ringgold.* "It drew us closer together, and most people were very serious about their jobs."

Leisure time was important as well. "On hot summer evenings," explains Butterfield, "the family would go up to the tar-covered roof of the apartment building; they called it Tar Beach. This escape from the heat of the city became the setting for Ringgold's famous *Tar Beach* children's book, which gave her a foothold in the publishing world." "It's not an autobiography," Ringgold tells Flomenhaft, "but we often went up on the roof at nights when it was hot. My father would come home from work and take the mattress up for us and my mother would fix our bed; and all of us kids would get a chance to sleep together on the one mattress; and we were supposed to be real quiet; and we could eat all night." "Raising children in the thirties was far simpler than it is today," Ringgold reminisces in *We Flew Over the Bridge.* "Everybody agreed that parents were in charge of their own children and were account-

"The Flag Is Bleeding," Ringgold's 1967 oil painting, symbolizes a nation scarred by conflict.

able for their actions. As a result, being a child came with a certain security, but not too much freedom. It was understood that parents knew best. You didn't really have to listen to your peers, because it was your parents you were trying to please, not them."

War Brings Independence

Ringgold's parents did not have an idyllic marriage. In 1942, Willi Jones divorced her husband and, Ringgold continues in her interview with Flomenhaft, "got her first job making Eisenhower jackets for the army; and then she decided that if only she could use the power machine, she could make clothes, because she was always making our clothes. She wanted to become a fashion designer and she did." Her financial independence enabled her to relocate her children to the more affluent area of New York City known as Sugar Hill—the area where Duke Ellington, Willie Mays, Marian Anderson, Jimmy Lunceford, Sarah Vaughn, Dinah Washington, and Harry Belafonte lived or kept residences. "My mother was a woman who knew how to take care of everything; her house; the kids; and she also had the time to develop her own skills. She was fabulous," Ringgold concludes. "In some ways I try to be something like her."

After graduating from high school in 1948, Ringgold enrolled at the City College, a branch of the City University of New York, where she declared a major in art. "When I went on to City College, they taught art in a traditional way," she tells Flomenhaft. "We copied Greek busts; we copied Cezanne and Degas; we copied the European masters. It was generally thought that we weren't experienced enough to be original; and if we were original we were sometimes up for ridicule." Ringgold began to turn away from the Eurocentric art taught by her instructors in search for a type of art that reflected her own origins and ethnicity. "I had no idea what it was to be an artist," she reveals to Mazurkiewicz. "I had no idea of the difficulties involved for an African American woman in the field of visual art."

The artist's difficulties were compounded by her marriage to jazz pianist Robert Earl Wallace, a neighbor she had known from childhood. Ringgold eloped with him in 1950. She gave birth to their two daughters, Barbara and Michele, in the first year of the marriage. Soon, however, his addic-

tion to drugs put a great strain on the relationship. Ringgold tells Teresa Annas of the Norfolk *Virginian-Pilot* that "thinking of the lack of control [he] had over his life" helped persuade her to leave Wallace. She was granted a divorce in 1956. Despite the unhappiness of the relationship, the artist later told Annas that the experience "positively affected the entire rest of my life."

Another positive experience came from her job as an art teacher in the New York public schools. Ringgold reveals to Mazurkiewicz that she learned at least as much from her students as she had from her own teachers in college. "They paint so beautifully and have this wonderful facility with form and space and color that is art," she states. "So I would paint with them and notice that my paintings were not as free and wonderful as their paintings were." "I had to go through this massive relearning process to go from Picasso and all the great artists I had to copy in college," she continues. "I had to go from them to me via African art. I wanted to find a way of creating American art out of my experiences as an African-American. So the children really helped me to do that—they showed me what it is to be free, to be able to express yourself directly."

Struggles of a Professional Artist

Despite these good things happening in her life, Ringgold faced enormous obstacles in her effort to become a professional female African American artist. She wanted to make a statement about the relationship between blacks and whites in America in the same way that James Baldwin had done in his book *The Fire Next Time*—but, she states in *We Flew Over the Bridge*, "I had something to add—the visual depiction of the way we are and look. I wanted my painting to express this moment I knew was history. I wanted to give my woman's point of view to this period." "Being unknown and a newcomer," she continues, ". . . I was concerned with making truthful statements in my art and having it seen." "Ringgold was the originator of the first black demonstration against a major museum in New York City, the Whitney Museum of American Art," states Butterfield, "which she accused of snubbing black artists. She then turned her ire on the Museum of Modern Art. From 1968 to 1970, she says, she was caught up in a steady stream of activities protesting MOMA's exclusion of black artists."

In 1970, Ringgold took up another challenge: the problem of the status of women in American society. "In this year," she states in *We Flew Over the Bridge*, "I became a feminist because I wanted to help my daughters, other women, and myself aspire to something more than a place behind a good man." "In the 1970s," Ringgold continues, "being black and a feminist was equivalent to being a traitor to the cause of black people. 'You seek to divide us,' I was told. 'Women's Lib is for white women. The black woman is too strong now—she's already liberated.'" Feminist themes began to appear in her work. In 1972, during a trip to Europe, Ringgold discovered another fac-

Part of Ringgold's "Bitter Nest Series," this 1988 work titled "The Letter" depicts a young man confronting the woman who raised him after he discovers a haunting letter from his biological mother.

tor that would have a great influence on her work—Tibetan and Nepalese paintings on silk framed in cloth, called tankas. "In the fall of 1972," she relates, "I painted my first cloth-framed paintings. . . . I named them The Feminist Series." These tankas formed the basis for the artwork that would inspire *Tar Beach.*

Ringgold's mother Willi also had a strong influence on the design of Ringgold's fabric paintings. "What was so wonderful about collaborating with her was her ingenious solutions to design problems. For example, I was not sure how the tankas should look for the Slave Rape Series"—paintings with a feminist as well as a black message. "The Tibetan tankas I had shown Mother were cut out of a single piece of cloth and were not patched." Willi took an original approach to the problem and came up with a new form of tanka that combined African American and Tibetan elements. "When she was a little girl growing up in Florida," Ringgold continues, "Mother had learned quilt-making in the free-hand piecing technique her grandmother, Betsy Bingham, had taught her." The two began to collaborate on story quilts in 1980 and they completed one, called "Echoes of Harlem," before Willi's death in the fall of 1981.

The story quilt mixes text, painting, and fabric arts to make its point. "The central part of the quilt," Dina Stein states in *Alumnus City College*, "is done on canvas while the borders are done in the traditional pieced fabric method. The story text is frequently written directly on the quilt." "For the most part," Stein continues, "these quilts address political and social issues. For example, *Flag Story Quilt* is about a disabled Vietnam vet; *Slave Rape Story* is about a young slave girl on a South Carolina plantation; and *Street Story Quilt* is a pictorial narrative of urban American life." Ringgold's major innovation was her use of pictures and text to communicate her themes. "I really felt that writing was very important," Ringgold tells Mazurkiewicz in her *SATA* interview. "It helped to develop the work in the minds of other people in a way that just a picture could not, that the words could go places that pictures could not go. . . . I had very specific things I wanted to say and I wanted to get those things published and I couldn't count on getting a publisher to do it for me. So I would write the words on the quilts and as the quilts were published, the words would be too."

A Change of Media

"Since 1987," Ringgold continues in *We Flew Over the Bridge,* "I had tried to get my story quilts published but was constantly told, 'Oh, but they are art books and there is no market for them.'" This attitude changed when Andrea Cascardi, an editor for Crown Publishers, recognized that the story quilt "Tar Beach" from Ringgold's "A Woman on a Bridge" series of quilts, would make a good children's book. "I must say I had not realized that I could write children's stories; rather, I was simply trying to recall my childhood experience of going up to "Tar Beach" and writing in a child's voice," the author states in *We Flew Over the Bridge.* "*Tar Beach* launched my new career as a published writer and illustrator of children's books."

Tar Beach is the story of eight-year-old Cassie Louise Lightfoot. She finds freedom in her dreams from the poverty and oppression that dog her father and mother. "Being on the roof with the stars all around her and the beautiful George Washington Bridge in the distance," Ringgold explains in her memoir, "makes Cassie fantasize that she can fly over buildings and claim them as her own." Cassie's flight, the postscript to *Tar Beach* declares, "echo[es] an important motif in African-American folk-tale literature, in which slaves told of 'flying' to freedom as wish fulfillment or as a metaphor for escaping from slavery." Cassie also dreams of having the power to break the "grandfather clause" of the construction labor union that controls her father's job. The "grandfather clause" excluded some minorities, such as African Americans and Native Americans, on the basis that their grandfathers had not been union members. "Ringgold created entirely new paintings for the book, using acrylic on canvas paper, similar to the canvas fabric she used in the original quilt painting," the *Tar Beach* postscript states.

Tar Beach won much praise from critics for its distinctive, imaginative portrayal of childhood dreams. "It's hard to imagine a child who wouldn't willingly imagine something—a place, a tough spot, a hard life or a high ambition—worth flying out of or into," declares Rosellen Brown in the *New York Times Book Review.* "There's an air of triumph, not the downfall or Icarus but perhaps the swooping power of the eagle or the phoenix, only domesticated in perfect detail, in Ms. Ringgold's vision." "Children will recognize

"Dancing on the George Washington Bridge," a 1988 quilt, presents fifteen African American women in a powerful, jubilant fantasy.

and delight in the universal dream of mastering one's world by flying over it," *Horn Book* reviewer Nancy Vasilakis states; "their curiosity will be aroused by the book's quaint and provocative images. A practical and stunningly beautiful book."

Cassie and her little brother Be Be also appear in *Aunt Harriet's Underground Railroad in the Sky,* Ringgold's second children's book. In this fantasy, Be Be boards nineteenth-century abolitionist Harriet Tubman's freedom train to escape from slavery. Cassie gets left behind. Guided by Tubman's wisdom, however, she makes her way

from slavery in Maryland to freedom in Canada along the underground railroad. "Cassie sleeps by day and by night follows the North Star, stopping at farmhouses, funeral parlors, and graveyards and traveling in hearses and concealed compartments," Ringgold explains in her memoirs. Finally she reaches freedom and Be Be and makes him promise never to desert her again. "Be Be responds lovingly," Ringgold confides, "but tells Cassie that 'being free is more important than just being together.'" "With gripping immediacy," states *School Library Journal* reviewer Kate McClelland, "Ringgold puts readers in the story on the side of the victims, insuring, through powerful words

If you enjoy the works of Faith Ringgold, you may want to check out the following:

The writings of Harlem Renaissance authors W. E. B. DuBois, Countee Cullen, and Zora Neale Hurston.

The paintings of the famous European masters, including works by Henri Matisse and Vincent Van Gogh.

The artworks of African American artists from the civil rights era, including works by collagist Romare Bearden and painter Jacob Lawrence.

and images, 'that we will never forget the cost of freedom.'" *New York Times Book Review* contributor Enola G. Aird declares, "I look forward to Cassie's next trip."

Dinner at Aunt Connie's House and *Bonjour, Lonnie* are related in much the same way that *Tar Beach* and *Aunt Harriet's Underground Railroad in the Sky* are. *Dinner at Aunt Connie's House* is based on a story quilt called "The Dinner Quilt," and it introduces Melody and her adopted cousin Lonnie. "While playing," records Carol Jones Collins in *School Library Journal*, "the youngsters discover 12 paintings in the attic, each of which depicts a famous African-American woman." The portraits tell their stories to the children, inspiring them to dream their own dreams. "Lonnie is inspired to be an opera singer like Marian Anderson," Ringgold explains in *We Flew Over the Bridge*, "and Melody thinks she'd like to be president of the United States." "The heart of the book—the pages in which the women tell their stories—is at once a magical and a ringing affirmation of their achievements," declares a *Publishers Weekly* reviewer. "But the surrounding pages are less impressive." *Bonjour, Lonnie* tells of Lonnie's trip from the orphanage where he lived before his adoption to find his roots. He discovers that his grandfather "went to France in 1917 as one of the famed Harlem Hell fighters and married a French woman," Ringgold states. "The story ends at Aunt Connie's house (where the dinner quilt begins), with Lonnie finding a home."

My Dream of Martin Luther King, like *Tar Beach*, emphasizes the power of dreams. The dreaming narrator sees King experiencing the pain and joys of his childhood, then sees him stating his own dream in Washington. She then sees his death—but she also has a vision of people exchanging their prejudices and racism in exchange for King's dream. "As she awakens," writes a *Publishers Weekly* reviewer, "we share with her a powerful message: EVERY GOOD THING STARTS WITH A DREAM." "My books," Ringgold asserts in *We Flew Over the Bridge*, "are even more about children having dreams, and instilling in them a belief that they can change things. When Cassie believes she can fly, it is not because she wants to go to Florida to see her grandma, but rather because she envisions a better life for her family. Already at eight years old she wisely recognized that all good things start with a dream." It is the same message that Cassie told her brother Be Be in *Tar Beach*:

Anyone can fly.

All you need is somewhere to go that you can't get to any other way.

The next thing you know, you're flying among the stars.

■ Works Cited

Aird, Enola G., review of *Aunt Harriet's Underground Railroad in the Sky*, *New York Times Book Review*, February 21, 1993, p. 22.

Annas, Teresa, "The Fabric of Freedom," *Virginian-Pilot* (Norfolk), July 19, 1991, pp. B1, B4.

Brown, Rosellen, "Children's Books," *New York Times Book Review*, February 24, 1991, p. 30.

Butterfield, Virginia, "Faith, Hope and Anger," *San Diego Magazine Online*, November, 1995.

Collins, Carol Jones, review of *Dinner at Aunt Connie's House*, *School Library Journal*, October, 1993, p. 110.

Review of *Dinner at Aunt Connie's House*, *Publishers Weekly*, August 16, 1993, p. 104.

Flomenhaft, Eleanor, "Interviewing Faith Ringgold/ A Contemporary Heroine," *Faith Ringgold: A 25 Year Survey*, Fine Arts Museum of Long Island, 1990, pp. 7-15; amended by Faith Ringgold.

McClelland, Kate, review of *Aunt Harriet's Underground Railroad in the Sky*, *School Library Journal*, December, 1992, pp. 88, 90.

Review of *My Dream of Martin Luther King*, *Publishers Weekly*, January 1, 1996, p. 70.

Ringgold, Faith, *Tar Beach*, Crown, 1991.

Ringgold, Faith, interview with Margaret Mazurkiewicz, *Something about the Author,* Volume 71, Gale, 1993, pp. 159-64.

Ringgold, Faith, *We Flew Over the Bridge: The Memoirs of Faith Ringgold,* Little, Brown, 1995.

Stein, Dina, "Faith Ringgold and the Story Quilt," *Alumnus City College,* winter, 1990, pp. 8-9.

Vasilakis, Nancy, review of *Tar Beach, Horn Book,* May-June, 1991, p. 322.

■ For More Information See

BOOKS

Chadwick, Whitney, *Women, Art, and Society,* Thames & Hudson, 1990.

Children's Literature Review, Volume 30, Gale, 1993.

Contemporary American Women Artists, Cedco Publishing, 1991.

Davis, Marianna W., *Contributions of Black Women to America: The Arts,* Kenday, 1982.

Gouma-Peterson, Thalia, *Faith Ringgold Change: Painted Story Quilts,* Bernice Steinbaum Gallery, 1989; amended by Faith Ringgold.

Holze, Sally Holmes, *Seventh Book of Junior Authors and Illustrators,* H. W. Wilson, 1996.

Miller, Lynn, and Sally S. Swenson, *Lives and Works: Talks with Women Artists,* Simon & Schuster, 1981.

Munro, Eleanor, *Originals: American Women Artists,* Simon & Schuster, 1979, pp. 409-16.

Sills, Leslie, *Inspirations: Stories of Women Artists for Children,* A. Whitman, 1988, pp. 40-51.

Slatkin, Wendy, *Women Artists in History: From Antiquity to the Twentieth Century,* 2nd edition, Prentice-Hall, 1990, pp. 190-92.

Turner, Robyn Montana, *Faith Ringgold,* Little, Brown, 1993.

Twentieth-Century Children's Writers, 4th edition, St. James Press, 1995.

Witzling, Mara R., editor, *Writing in Voicing Our Visions: Writings by Women Artists,* Universe, 1991.

PERIODICALS

ARTS, April, 1992, p. 88.

Artweek, February 13, 1992, pp. 10-11.

Atlanta Constitution, July 30, 1990, pp. E1-E5.

Black American Literary Forum, spring, 1985, pp. 12-13.

Bulletin of the Center for Children's Books, December, 1992, p. 121.

Detroit Free Press, February 1, 1996, pp. 1C-2C.

Entertainment Weekly, February 8, 1991, pp. 68-69.

Essence, May, 1990, p. 78.

Gallerie Women's Art, Volume 6, 1989, pp. 40-43.

Horn Book, May/June, 1996, p. 351.

Journal and Guide, June 12-18, 1991, p. 3.

Los Angeles Times Book Review, February 24, 1991, p. 8.

Newsweek, September 9, 1991, pp. 64-65.

New York, February 18, 1991, p. 56.

New York Times, July 29, 1984, pp. 24-25; February 14, 1992.

Publishers Weekly, February 15, 1991, pp. 61-62; October 16, 1995, p. 51.

Quilt World, February/March, 1991, pp. 22-24.

San Diego Union, February 16, 1991, pp. C1, C3.

School Arts, May, 1989, pp. 23-26.

Village Voice Literary Supplement, April 1, 1991, p. 25.*

—Sketch by Kenneth R. Shepherd

Arnold Schwarzenegger

■ Personal

Full name Arnold Alois Schwarzenegger; born July 30, 1947, in Graz, Austria; immigrated to the United States, 1968, naturalized U.S. citizen, 1983; son of Gustav (a police chief) and Aurelia (Jedrny) Schwarzenegger; married Maria Owings Shriver (a broadcast journalist), April 6, 1986; children: Katherine Eunice, Christina Aurelia. *Education:* University of Wisconsin—Superior, B.A. (business and international economics), 1980. *Hobbies and other interests:* Horseback riding, reading, travel, classical music, art, motorcycles.

■ Addresses

Home—Santa Monica, CA. *Office*—321 Hampton Dr., Suite 203, Venice, CA 90291.

■ Career

Actor, fitness expert, entrepreneur, and real estate investor. Body builder, 1962-76; former health club manager and instructor, Munich, Germany. Pro-

ducer of Mr. Olympia/Mr. International competition, 1975-81; national weight training coach, Special Olympics, 1977; chair, President's Council on Physical Fitness and Sports, beginning 1990; lecturer on fitness and bodybuilding. Occasional television commentator for bodybuilding events, "Wide World of Sports," ABC-TV; founder, Oak Productions, Inc.; director for television, including episode of *Tales from the Crypt*, HBO, 1990, and movie *Christmas in Connecticut*, TNT, 1992. Planet Hollywood (restaurant), New York City, co-owner, 1991—. *Military Service:* Austrian Army, 1965.

■ Awards, Honors

Thirteen world champion bodybuilding titles, 1965-80, including "Mr. Universe," "Mr. World," and "Mr. Olympia"; Golden Globe Award for best newcomer in films, Hollywood Foreign Press Association, 1976, for *Stay Hungry*; named International Star of the Year, National Association of Theatre Owners, 1984; National Leadership Award, Simon Wiesenthal Center, 1991, for support of Holocaust studies; named International Star of the Decade, National Association of Theatre Owners, 1993.

■ Writings

(With Douglas Kent Hall) *Arnold: The Education of a Bodybuilder*, Simon & Schuster, 1977.

(With Hall) *Arnold's Bodyshaping for Women,* Simon & Schuster, 1979.

(With Bill Dobbins) *Arnold's Bodybuilding for Men,* Simon & Schuster, 1981.

(With Dobbins and Bruce Algra) *Arnold's Encyclopedia of Modern Bodybuilding,* Simon & Schuster, 1985.

(With Charles Gaines) *Arnold's Fitness for Kids Ages Birth to Five: A Guide to Health, Exercise, & Nutrition,* Doubleday, 1993.

(With Gaines) *Arnold's Fitness for Kids Ages Six to Ten: A Guide to Health, Exercise, & Nutrition,* Doubleday, 1993.

(With Gaines) *Arnold's Fitness for Kids Ages Eleven to Fourteen: A Guide to Health, Exercise, & Nutrition,* Doubleday, 1993.

Author of a magazine bodybuilding column, "Ask Arnold." Contributor to periodicals, including *Muscles and Fitness.*

■ Films

ACTOR

(As Arnold Strong) *The Long Goodbye,* United Artists (UA), 1973.
Stay Hungry, UA, 1976.
Pumping Iron (documentary), Cinema Five, 1977.
The Villain, Columbia, 1979.
The Jayne Mansfield Story (television), CBS-TV, 1980.
Conan the Barbarian, Universal, 1982.
Conan the Destroyer, Universal, 1983.
The Terminator, Orion, 1984.
Commando, Twentieth Century-Fox, 1985.
Red Sonja, Metro-Goldwyn-Mayer/UA, 1985.
Raw Deal, DeLaurentiis Entertainment Group, 1986.
Predator, Twentieth Century-Fox, 1987.
The Running Man, TriStar, 1987.
Red Heat, TriStar, 1988.
Twins, Universal, 1988.
Kindergarten Cop, Universal, 1990.
Total Recall, TriStar, 1990.
Terminator 2: Judgement Day, TriStar, 1991.
Feed (documentary), Original Cinema, 1992.
(And executive producer) *Last Action Hero,* Columbia, 1993.
Beretta's Island, Phoenix Group, 1994.
True Lies, Twentieth Century-Fox, 1994.
Junior, Universal, 1994.
Eraser, Warner Bros., 1996.
Jingle All the Way, 20th Century Fox, 1996.

Batman and Robin, Warner Bros., 1997.

Also appeared in *Terminator 2: 3-D* (also known as *T2 3-D: Battle across Time*), 1996.

■ Sidelights

Arnold Schwarzenegger—bodybuilder, real estate investor, former chairman of the President's Council on Physical Fitness, and action-film superstar—was the first civilian to own a military transport vehicle in the United States. Bill Zehme of *Rolling Stone* described this "massive war wagon," known as a humvee, as "a tank with wheels." Every morning Schwarzenegger drives from his house in Santa Monica to the World Gym in Venice, California. At the gym where he made himself into Mr. Olympia and Mr. Universe, Arnold's reserved parking space is paved with marble. In a weight room full of oversized physiques, Arnold's presence is still colossal; in a country where everything from buildings to cars to restaurant portions is disproportionately large, Schwarzenegger is truly larger-than-life. "Arnold is the embodiment of the Superior Man," film director John Milius explained to Zehme. "Arnold is the Nietzschean man. There's something wonderfully primeval about him, harking back to the real basic foundational stuff: steel and strength and will. And that's what Arnold is about."

Arnold Alois Schwarzenegger was born shortly after the close of the Second World War, on July 30, 1947, in Graz, Austria. He was raised in the village of Thal, near Graz, where his father was the local police chief. Throughout the years of Schwarzenegger's childhood, Austria struggled to recover from the effects of war. The Schwarzenegger family didn't have indoor plumbing, a telephone, or refrigerator until Arnold was a teenager. In this environment of scarcity, Schwarzenegger's father was a strict disciplinarian. Arnold and his older brother, Meinhard, were awakened shortly after sunrise to begin their morning chores. After their chores, the brothers had to complete an exercise routine before breakfast. At meal time there was a strict emphasis on eating properly.

Athletics were also important in the Schwarzenegger household. Schwarzenegger's father was a champion curler, and his brother (who died in an automobile accident at the age of twenty-three) was a champion boxer. Arnold began playing soccer

as a child, and at the age of twelve was playing wing for a senior level team, the Graz Athletic Club. Even at this early age Schwarzenegger was determined to excel and dedicated himself to his sport. However, when he began lifting weights to strengthen his legs for soccer, Schwarzenegger discovered the sport he would eventually dominate and represent to the world: bodybuilding.

Begins Career in Bodybuilding

By the age of fifteen, Schwarzenegger was serious about transforming his body through weightlifting. He conceived of himself as a sculptor whose material was the human body, and he studied anatomy and developed training routines in order to maximize the results of his hard work. His parents, somewhat disturbed by this newfound obsession, forbade Schwarzenegger from going to the gym more than three times a week. Unwilling to compromise, Schwarzenegger set up a gym at home in an unheated room, where he continued to work out every day, even as temperatures dropped well below freezing.

After graduating from high school in 1965, Schwarzenegger enlisted in the Austrian army. Following his disciplined upbringing, the regimentation of army life appealed to him. Despite his responsibilities as a soldier, which included driving a tank, Schwarzenegger continued his strenuous training regimen. Unlike the Schwarzenegger home, where meat was served once a week, the army diet was rich in protein, and Schwarzenegger's physique grew by leaps and bounds. After just one month of military service Schwarzenegger won his first bodybuilding title, Mr. Junior Europe, in Stuttgart, Germany. Schwarzenegger left his base without permission, however, to compete in Stuttgart. Upon his return he was sentenced to a year in the brig.

When Schwarzenegger resumed training he concentrated on powerlifting. After winning the Austrian Junior Olympic Powerlifting championship, Schwarzenegger concluded that the human body was not designed to sustain the stress of Olympic-style powerlifting. He returned to bodybuilding, enduring daily sessions that routinely lasted five hours. Schwarzenegger refused to allow the pain and fatigue that resulted from these intense workouts to become an obstacle to his growth. In fact, he considered exhaustion at the conclusion of each weight-lifting session an indication of progress, and firmly believed that each hour spent in the gym brought him closer to his goals.

In 1967 Schwarzenegger claimed the bodybuilding title of Mr. Universe. At twenty years of age, he was the youngest champion in the history of the event. The following year, Schwarzenegger made his first visit to the United States to defend his crown at the Mr. Universe competition in Miami, Florida. Schwarzenegger was upset by veteran bodybuilder Frank Zane and finished a surprising second. Despite this setback, fitness pioneer Joe Wieder was impressed by Schwarzenegger's early success and invited Arnold to live and train under his patronage. Schwarzenegger moved to Los Angeles, where Weider provided him with an apartment, a car, and a weekly salary. In exchange, Schwarzenegger contributed articles on his innovative training methods to Weider's bodybuilding magazines, including *Muscle and Fitness*. Weider's backing allowed Schwarzenegger to devote himself almost exclusively to training, and he focused his energies on recapturing the Mr. Universe crown.

Schwarzenegger prepared at Gold's Gym in Venice, California, where several other elite bodybuilders also trained. In 1969 Schwarzenegger recaptured the Mr. Universe title in New York City, and in the ensuing year he accomplished the unrivaled feat of winning all three major bodybuilding competitions. Schwarzenegger was Mr. Universe, Mr. World, and Mr. Olympia, and he reigned over the sport in unprecedented fashion. When he retired from bodybuilding in 1975, Schwarzenegger had six consecutive victories in Mr. Olympia contests and had five Mr. Universe titles to his credit. Schwarzenegger came out of retirement briefly in 1980 to take his seventh and final Mr. Olympia title. Still relatively young at thirty-three, Schwarzenegger closed the book on his remarkable bodybuilding career.

Arnold capitalized on his bodybuilding accomplishments by founding a series of small businesses. He began investing in real estate as well, a decision which proved increasingly profitable with time. Schwarzenegger, however, was not satisfied to dwell out of the limelight for long, and he began to pursue an acting career in earnest. His professed admiration for the overscaled, theatrical aspects of American society stimulated him

to attempt a career in acting well before his retirement from bodybuilding. His early roles were less than notable. In 1970, Schwarzenegger's heroic physique made him ideal for the title role in the low-budget Italian television production, *Hercules Goes to New York*.

"Arnold is the Nietzschean man. There's something wonderfully primeval about him, harking back to the real basic foundational stuff: steel and strength and will. And that's what Arnold is about."

—*John Milius*

In 1973 Schwarzenegger briefly appeared in the Robert Altman film *The Long Goodbye*, and in 1975 landed the breakthrough role of bodybuilder Joe Santos in Bob Rafelson's *Stay Hungry*. The film pits Santos against a group of land-hungry developers in Birmingham, Alabama, who want to demolish the gym where Santos and his comrades train. While the movie received little attention from critics, Schwarzenegger's performance was praised. Reviewers were impressed by his confidence and unaffected manner, and, in 1976, awarded him the Golden Globe for best new actor.

In 1977 Schwarzenegger appeared in the critically acclaimed documentary *Pumping Iron*, directed by George Butler and Robert Fiore. The film observes several world-class bodybuilders as they prepare for competition. The directors present bodybuilding as an artistic endeavor, and bring audiences into the gym where "sculpting" takes place. Culminating in a bodybuilding contest, the film reveals the depths of rivalry and tension that develop between contestants in such close quarters. In this setting, Schwarzenegger plays on his opponents' anxieties as easily as he moves heavy weights, and shows the full range of attributes that made him a champion. Although he was not acting in a role, critics were again stirred by Schwarzenegger's presence on screen, and the film brought him to the attention of a wider public.

Stars in First Feature Film

In 1982 Schwarzenegger appeared in his first feature role in John Milius's *Conan the Barbarian*. Based on the adventures of a comic-book character created by Robert E. Howard, *Conan* matched a sword-wielding Schwarzenegger against an evil sorcerer and his minions. The film and Schwarzenegger's performance were almost universally panned by critics, who found Schwarzenegger's German accent difficult to overcome, delivery of dialogue awkward, and onscreen movement unconvincing. Audiences, apparently, thought otherwise. *Conan the Barbarian* and Richard Fleischer's sequel *Conan the Destroyer*, were box office hits, earning $100 million and $80 million respectively.

In 1984 Schwarzenegger made the film that catapulted him to the top of the action-film industry, James Cameron's *The Terminator*. The film opens in the year 2029, and the world as we know it has been destroyed in a nuclear war initiated by a supercomputer entrusted with the defense of the United States. The computer has since spawned an army of machines whose purpose is to exterminate the human race. Schwarzenegger assumed the role of one of these murderous cyborgs (a robotic skeleton and digital brain encased in human flesh) known as a Terminator. Schwarzenegger's Terminator is shipped back through time to 1984, with the mission of assassinating the mother of the yet-to-be-born leader of the survivors of the impending holocaust. Knowing only that the mother's name is Sarah Connor, the Terminator begins systematically killing women with that name. The Sarah Connor in question, however, manages to elude the Terminator, and is joined by Kyle Reese, a human soldier who has traveled backward in time to protect her from the Terminator. The remainder of the picture is a tense, extended chase sequence, during which Reese and Connor must constantly outmaneuver the relentless and virtually indestructible Terminator.

Filmed on a moderate budget, *The Terminator* was another box-office success for Schwarzenegger, earning $100 million. *The Terminator* is a "smart, unpretentious, thoroughly enjoyable thriller—an ideal B movie," declared *New Yorker* reviewer Terrence Rafferty. The role of the Terminator required only convincing physical acting and the monotone delivery of appropriately timed one-liners, thereby making assets of Schwarzenegger's acting liabilities, Rafferty concluded. This pattern

Schwarzenegger starred with Danny DeVito and Emma Thompson in the 1994 film *Junior*, in which he portrays a geneticist who tries a fertility drug on himself with amusing results.

of violence interspersed with comic relief established the formula for Schwarzenegger's next few films. *The Terminator* also gave Schwarzenegger his trademark line: "I'll be back."

Commando (1985) and *Raw Deal* (1986) both featured Schwarzenegger in high-action, predictably violent roles. While reviewers found neither film notable, both grossed the enormous sums that were becoming routine for Schwarzenegger features. Although reviews of his performances were generally not positive, critics recognized improvement in Schwarzenegger's acting, and acknowledged he had acquired fluency of movement and poise as a physical actor.

As with other challenges he had mastered, Schwarzenegger gained proficiency as an actor through dedication and hard work. Early in his

career Schwarzenegger took acting lessons. As his career gained momentum, however, he concluded that the Hollywood soundstage was the best learning atmosphere for him. "I think the best practice you can get—the thing that makes you feel most comfortable and grow as an actor—is to work with different directors and different talented actors. It's on-the-job training," Schwarzenegger explained to Pat H. Broeske in *Interview*. "The things that I have always worked on are the accent and the movement," Arnold added. "Not that I want to get rid of the accent completely, because it has become a trademark, a signature."

Schwarzenegger returned to the genre of science fiction with the role of Major Alan "Dutch" Schaefer in John McTiernan's 1987 film, *Predator*. Dutch is summoned at the film's outset by the American military to lead a hostage-rescue mis-

sion in a Central American jungle. After discovering that the hostages have been murdered, members of the rescue squad begin to die similarly grisly deaths at the hands of some unseen creature. Before long, Dutch is the sole survivor of the rescue mission, and must elude, or destroy, the Predator. During the course of several encounters between Dutch and the Predator, it becomes apparent that the Predator is actually an extraterrestrial, seemingly on earth for a recreational hunting expedition. Eventually, the tenacious Dutch overcomes the Predator, turning hunter into hunted. *Predator* gave audiences striking visual effects, especially in the presentation of the alien, and was nominated for an Academy Award for Best Visual Effects.

In 1988 Schwarzenegger co-starred with comic actor Jim Belushi in *Red Heat*, the first American motion picture to include scenes filmed in the Soviet Union. Schwarzenegger played the role of Ivan Danko, a Soviet detective from Moscow who has come to the United States in pursuit of a Russian drug-czar. Upon arriving in Chicago, Danko is teamed with the cynical Art Ridzik (Belushi). The film alternates action scenes, including a car chase involving city buses, with the comic relief that develops between the antic Ridzik and the stoic Danko. *Newsweek* reviewer David Ansen found Schwarzenegger and Belushi's relationship unconvincing and declared that director Walter Hill failed to "work up the faintest bit of conviviality between his two stars." Peter Travers expressed a different opinion in his *People* review, asserting that "Schwarzenegger and Belushi prove they can crack heads and jokes with the best of them."

Schwarzenegger's acting career reached another turning point with the production of Ivan Reitman's *Twins*. Forsaking his usual action-hero role, Schwarzenegger teamed with diminutive veteran actor Danny DeVito in this comedy about fraternal twins separated at birth. The brothers are the result of a genetic experiment in which Schwarzenegger's Julius inherits their parents' positive genetic traits, while DeVito's Vincent receives the leftovers. Once they are born, the brothers are spirited away from their mother; Vincent is then abandoned in an orphanage, while Julius is raised and educated in luxurious seclusion on a tropical island. The brothers are reunited in adulthood—Vincent now an unsuccessful petty criminal in Los Angeles—and join in searching for

their mother. As they journey, each gains from the other the attributes and experiences he has been lacking. *Time* reviewer Richard Schickel pointed out that the costars do a remarkable job of "playing dumb" throughout the film—as when Julius learns to drink beer, or Vincent is utterly baffled by his brother's honesty. Schickel also considered the movie touching. "The whole movie has a warmth about it that never slops over into sentiment: there is much more here than tall-guy, short-guy jokes." *Maclean's* reviewer Brian D. Johnson similarly noted: "The muscle-bound Schwarzenegger demonstrates a remarkably delicate comedic touch. Suddenly the brute from *The Terminator* and *Red Heat* does not seem to have a vengeful bone in his body."

Chairs President's Council on Physical Fitness

In 1990 Schwarzenegger's life expanded in yet another remarkable direction: President George Bush named Schwarzenegger chairman of the President's Council on Physical Fitness and Sports. Armed with his reputation as a fitness expert and the slogan "Fitness for the 90's," Schwarzenegger campaigned the fifty states to change American attitudes about fitness. In an essay published in *Newsweek*, Schwarzenegger called lack of physical fitness among children "America's secret tragedy." He advocated greater involvement on the part of schools and parents in getting children to exercise regularly. Adults and senior citizens, too, need to make a commitment to regular activity to remain vigorous and productive, Schwarzenegger reminded. "In the last 10 years, the only gain in fitness in this country has been by adults who can afford health clubs and workout videos," Schwarzenegger explained to *Newsweek* interviewer Suzie Boss. "The inner cities have been left out, and our children have been left out. Without P.E., you take away the basic right of being physically fit," he added, bemoaning the decrease of physical education programs in public schools.

To promote his recommendations, Schwarzenegger coauthored a series of books on children's fitness. *Arnold's Fitness For Kids: A Guide to Health Nutrition and Exercise* consists of three volumes, each directed toward a specific age group. The guides emphasize play over competition and "provide sound advice for getting kids to stay in shape and eat wisely," affirmed a *Publishers Weekly* reviewer. While praising the book's technical relevance, the

If you have enjoyed the work of Arnold Schwarzenegger, you may also want to check out the following books and films:

Michael Crichton, *Jurassic Park*, 1990.
Joseph Finder, *The Moscow Club*, 1991.
David Morrell, *The Fifth Profession*, 1990.
Cliffhanger, 1993.
Die Hard, 1988.
Hard Target, 1993.
Lethal Weapon, 1987.

reviewer criticized the design, and characterized the line drawings employed throughout as "unprepossessing." Reviewing *Arnold's Fitness for Kids Ages Six to Ten*, Todd Morning of *School Library Journal* also found the illustrations generic and concluded that despite the author's appeal, the book's "lack of focus will deter many readers."

Schwarzenegger returned to the screen in Dutch filmmaker Paul Verhoeven's *Total Recall* (1990). Based on a story by science-fiction writer Philip K. Dick, the film takes place in 2084, and Quaid (Schwarzenegger), a construction worker bored with life on earth, longs to vacation on recently colonized Mars. When Quaid enlists the services of a company to implant memories of a fictional trip to Mars in his brain, the procedure backfires and Quaid discovers his memories have already been altered. In fact, he is not Quaid at all, but Hauser, an agent of the tyrant Cohaagen (Ronny Cox) who controls the supply of air on Mars. Hauser does not manage to sort this out immediately, however, and is compelled to journey to Mars, where the mystery unravels. At the time of its release one of the most expensive motion pictures ever produced, the $60 million *Total Recall* bursts with violence, gadgetry, and special effects. *Time* film critic Richard Corliss described the movie as a "mammoth, teeming fantasy vision on film." Other critics were more ambivalent; Jack Kroll of *Newsweek*, for instance, admitted that the altered memory/lost identity plot holds a certain appeal, "but ultimately mayhem beats memory to a pulp," he quipped, "which leaves only the aftertaste of movie blood."

Schwarzenegger again worked with director Ivan Reitman to show the gentler side of his film personality. In *Kindergarten Cop* Schwarzenegger took on the role of Kimble, a Los Angeles detective who tracks the estranged wife and son of a wanted criminal to Oregon. At this point, his search is frustrated because no one can identify the wife and child. Kimble is forced to go undercover as a kindergarten teacher in the hope that he will find some clue to the son's identity. Kimble is overwhelmed by the task of managing a classroom full of five-year-olds. After adopting an authoritarian tone, Kimble lets up and develops a genuine rapport with the children. What makes the classroom scenes so much fun, asserted a *Rolling Stone* reviewer, "is Schwarzenegger's obvious delight in acting silly." Ralph Novak of *People* also gave Schwarzenegger high marks for his performance as a teacher, characterizing Kimball's relationship with the children as "irresistible" and added that the actor "is witty, charming, subtle, tough and most impressive—a Cary Grant with pecs." Schwarzenegger himself felt that his acting had reached a new level of maturity in the film. "I loved *Kindergarten Cop*," Schwarzenegger told Pat H. Broeske of *Interview*. "It was one of the few times when I could look at a movie of mine and say that I think my performance was good. I believed myself in it, and that's hard for me to do," he confessed.

Mega-star of Mega-buck Movies

Schwarzenegger revisited the role of the Terminator in *Terminator 2: Judgment Day*. *Terminator* director James Cameron directed this sequel, which elaborates on the premise of the first film. John Connor (Edward Furlong), the destined leader of the human resistance during the so-called "machine wars," is now a young teenager. In a interesting twist on the first film, the Terminator is sent back in time to protect John from a second, more technologically advanced terminator, the T-1000 (Robert Patrick). As a result of her previous encounter with the Terminator, John's mother, Sarah (Linda Hamilton) has been incarcerated in a mental institution. With the help of his cyborg protector, John manages to free his mother, and the trio set out to halt the chain of events that will lead to nuclear apocalypse. Throughout, they must contend with the dogged T-1000, whose liquid metal composition makes it impervious to harm.

Terminator 2 was reportedly produced on a budget of $100 million, making it, in 1991, the most expensive film ever produced. In addition to the requisite chase scenes and explosions, the film

introduced audiences to the startling visual effect of "morphing," or computer-animated shape changing. This technology allowed the T-1000 to assume an array of shapes and textures. Schwarzenegger's grisly makeup for the film's final sequences also reached new heights of realism. Battered by the T-1000, by the end of the film Schwarzenegger's Terminator is missing an arm, a knee, and half of his face. The application of the make-up took five hours, Schwarzenegger reported in *Interview*. Other than superior visuals, however, some critics felt the movie had little to offer. Considering it inferior to the original *Terminator*, Richard Corliss of *Time* described the film as a "humongous, visionary parable that intermittently enthralls and ultimately fails." The critic noted, however, that the actor's role in *Terminator 2* "establishes Schwarzenegger as a stolid icon with a sense of humor."

Although it was also a budget-busting adventure, Schwarzenegger's next film, *Last Action Hero*, subverted the expectations and assumptions of the action-film genre. Schwarzenegger plays Jack Slater, an action movie hero idolized by young Danny Madigan (Austin O'Brien). When a theatre projectionist gives Danny a magic ticket, he finds that he is able to slip into the action on the movie screen. Thus transported to Jack Slater's fictional, onscreen world, Danny teams with Jack to foil the plans of a mobster played by renowned actor Anthony Quinn. What distinguishes the film from straight-ahead action films is the sense of the absurd it levels on itself. "Jack's environment is a disturbing place to live—at once overblown and undernourished," remarked *New Yorker* reviewer Anthony Lane. "The good always triumph here, waging their brutal victories under a flawless sky; it looks like Oz with Uzis." As Slater and his world appear increasingly artificial, Danny becomes disenchanted with his hero. With aid of the magic ticket, Danny brings Slater back to the real world. Here, they see Schwarzenegger the actor attending the premiere of the new Jack Slater movie. Suddenly the very existence of Jack Slater is called into doubt. One of the villains from the Slater film has managed to escape into reality as well, and by the film's conclusion it is clear that he finds the world offscreen, where the bad guys often win, much more to his liking.

Nation reviewer Stuart Klawans found *Last Action Hero* convoluted and cumbersome, but credited the film's ironic sense of humor with at least challenging the audience's notions of heroism. "In fact," wrote Klawans, "the movie all but mocks you for having bought a ticket. That's better than rude—its a provocation." Critic David Ansen of *Newsweek* reasoned that in its attempt to satirize the action-film genre, *Last Action Hero* "fatally outsmarts itself." "The film is garish, loopy, and much too long," Lane concluded, "but it's an honorable failure: it suffers from a surfeit of invention, not a dearth."

In 1994, Schwarzenegger was reunited with co-star Danny DeVito and director Ivan Reitman in *Junior*. In the role of Dr. Alex Hesse, Schwarzenegger played a self-absorbed geneticist conducting research on a super-fertility drug. When Hesse loses funding for his research before the drug can be tested, he is persuaded by a friend, Dr. Larry Arbogast (DeVito), to try the drug on an unlikely volunteer: himself. Arbogast steals a frozen human egg which Hesse fertilizes and injects into himself. Coupled with the fertility drug, this causes Hesse to become pregnant. The egg Arbogast steals, however, belongs to scientist Diana Reddin, played by British actress Emma Thompson. As his pregnancy advances, Hesse and Reddin are drawn into an odd romantic relationship. "When the Big Guy starts showing, and begins to get that radiant glow, *Junior* hits its mellow, endearing comic stride," wrote *Newsweek*'s Ansen.

Jim Cameron's *True Lies* offered Schwarzenegger the role of an American spy who not only deals swift punishment to the enemy, as *New Republic* critic Stanley Kauffmann observed, but has "James Bond characteristics: suavity and erudition." Fashionable, speaking several languages, knowledgeable about Persian art, and a skilled dancer, Schwarzenegger's Harry Tasker leads a dual existence: he is an operative in a covert branch of intelligence, but his family thinks he's a computer salesman whose work requires frequent travel. Frustrated by neglect, Tasker's wife, Helen (Jamie Lee Curtis), flirts with a used car salesman who seduces women by pretending to be a spy. Harry becomes enraged when he suspects his wife is cheating, and in testing her loyalty, gets Helen involved in the action of his real job. After Harry's identity is revealed, the couple spends the remainder of the movie preventing terrorists from detonating an atomic weapon. Although the film faced controversy offscreen, accused of stereotypical depictions of Arab terrorists and a sexist treatment of Helen, audiences and many critics found *True*

Lies absorbing entertainment. "Cameron's script is often ingenious and always original," wrote Ralph Novak of *People*.

In 1996 Schwarzenegger returned to the basics in *Eraser*, an action-thriller in which he portrays John Kruger, a top-notch agent in the federal witness protection program whose specialty is helping witnesses assume new identities by "erasing" evidence of their old ones. Kruger is assigned to protect Lee Cullen (Vanessa Williams) who discovers a secret plot inside the U.S. government to illegally export an advanced weapons system known as the Rail Gun. While guarding his witness, Kruger survives a nail bomb explosion, an alligator attack at a New York City zoo, and a death-defying leap from an airplane. Filmed at a reported price of $120 million, *Eraser* is "good action fun, with spectacular stunts and special effects . . . and high energy," according to Roger Ebert in the Chicago *Sun-Times*. Richard Corliss, reviewing the film in *Time*, stated that *Eraser* "could have been a fiasco; instead, it smartly remythologizes this indispensable Hollywood icon." He concluded, "for the first time in a while, [Schwarzenegger's] character is as solid as he is."

Arnold Schwarzenegger rose from the impoverished village in Austria where he spent his boyhood to become the greatest bodybuilder in the history the sport; from there he became one of the most widely known film stars in the world. Throughout, his fervent desire to rise to the top has fueled his ascent, and his willingness to pursue opportunities far afield has ensured his success. He is both the Terminator and the caretaker of children's physical well-being. Schwarzenegger is, as Elizabeth L. Bland of *Time* said, "the most unlikely and inevitable star of Hollywood's global era."

■ Works Cited

Ansen, David, "Spinning Wheels in the Windy City," *Newsweek*, July 4, 1988, p. 58.

Ansen, David, "Bang, Bang, Kiss, Kiss," *Newsweek*, June 28, 1993, pp. 64-65.

Ansen, David, "Arnold Proves He's Bigger Than Ever," *Newsweek*, November 28, 1994, p. 66.

Review of *Arnold's Fitness for Kids: A Guide to Health, Exercise and Nutrition*, *Publishers Weekly*, April 12, 1993, p. 65.

Bland, Elizabeth L., "Box-Office Brawn," *Time*, December 24, 1990, pp. 52-55.

Boss, Suzie, "Hey, Kids, Get Physical!" *Newsweek*, August 27, 1990, pp. 62-64.

Corliss, Richard, "Mind Bending on Mars," *Time*, June 11, 1990, p. 85.

Corliss, Richard, "Half A Terrific Terminator," *Time*, July 8, 1991, p. 55-56.

Corliss, Richard, "Arnold, Back to Basics," *Time*, July 1, 1996.

Ebert, Roger, review of *Eraser*, *Sun-Times* (Chicago), June 21, 1996.

Johnson, Brian D., review of *Twins*, *Maclean's*, December 19, 1988, p. 48.

Kauffmann, Stanley, "Dishing It Out," *New Republic*, September 5, 1994, pp. 34-35.

Review of *Kindergarten Cop*, *Rolling Stone*, January 24, 1991, pp. 42-43.

Klawans, Stuart, review of *Last Action Hero*, *The Nation*, July 19, 1993, pp. 115-16.

Kroll, Jack, "Thanks for the Memories," *Newsweek*, June 11, 1990, p. 62.

Lane, Anthony, "Reality Check," *New Yorker*, July 5, 1993, pp. 94-97.

Morning, Todd, review of *Arnold's Fitness for Kids Ages Six to Ten: A Guide to Health Exercise and Nutrition*, *School Library Journal*, August, 1993, p. 183.

Novak, Ralph, review of *Kindergarten Cop*, *People*, January 14, 1991, p. 12.

Novak, Ralph, review of *True Lies*, *People*, July 25, 1994, p. 17.

Rafferty, Terrence, "Terminated," *New Yorker*, June 18, 1990, pp. 91-92.

Schickel, Richard, "Double the Pleasure," *Time*, December 12, 1988, p. 82.

Schwarzenegger, Arnold, "A Secret Tragedy," *Newsweek*, May 21, 1990, p. 9.

Schwarzenegger, Arnold, interview with Pat H. Broeske, *Interview*, July, 1991, p. 85.

Travers, Peter, review of *Red Heat*, *People*, June 20, 1988, p. 17.

Zehme, Bill, "Big Shot," *Rolling Stone*, August 22, 1991, pp. 38-42, 79.

■ For More Information See

BOOKS

Butler, George, *Arnold Schwarzenegger: A Portrait*, Simon & Schuster, 1990.

Conklin, Thomas, *Meet Arnold Schwarzenegger*, Random House, 1994.

Doherty, Craig A. and Katherine M. Doherty, *Arnold Schwarzenegger: Larger Than Life*, Walker & Co., 1993.
Flynn, John L., *The Films of Arnold Schwarzenegger*, Carol Publishing Group, 1995.
Green, Tom, *Arnold!*, St. Martin's, 1987.
Lipsyte, Robert, *Arnold Schwarzenegger, Hercules in America*, HarperCollins, 1993.

PERIODICALS

Nation, July 16, 1988, pp. 66-8.
New Republic, August 12, 1991, p. 28-9.
New York, June 18, 1990, pp. 68.*

—*Sketch by David P. Johnson*

Randy Shilts

■ Personal

Born August 8, 1951, in Davenport, Iowa; died of Acquired Immune Deficiency Syndrome (AIDS), February 17, 1994, in Guerneville, CA; son of Bud (a prefabricated housing salesman) and Norma (a homemaker). *Education*: University of Oregon, B.S., 1975. *Hobbies and other interests*: Gardening, walking, golden retrievers.

■ Addresses

Agent—Fred Mill, 2237 Union St., San Francisco, CA 94123. *Office—San Francisco Chronicle*, 901 Mission St., San Francisco, CA 94103.

■ Career

Journalist and broadcaster. KQED-TV, San Francisco, CA, correspondent for *Newsroom* and City Hall correspondent for *Ten O'Clock News*, 1977-80; KTVU-TV, Oakland, CA, reporter, 1979-80; *San Francisco Chronicle*, San Francisco, staff reporter, 1981-87, national correspondent, 1988-94.

■ Awards, Honors

Winner of numerous journalism awards while a student at the University of Oregon; Media Alliance Award for outstanding nonfiction author, 1982; Gay Academic Union Award for outstanding journalist, 1982; special citations from the San Francisco Board of Supervisors, 1982 and 1987; Silver Medal, Commonwealth Club, 1987, for best nonfiction author of the year; Outstanding Communicator Award, Association for Education in Journalism and Mass Communication, 1988; special citation from the office of the mayor of San Francisco, 1988; Outstanding Achievement Award, Parents and Friends of Lesbians and Gays, 1988; named outstanding author by the American Society of Journalists and Authors, 1988; American Medical Association's John P. McGovern Award Lectureship in Medical Writing, 1989; named University of Oregon Outstanding Young Alumnus, 1993; California Public Health Association's Outstanding Print Media Award, 1993.

■ Writings

The Mayor of Castro Street: The Life and Times of Harvey Milk, St. Martin's, 1982.
And the Band Played On: Politics, People, and the AIDS Epidemic, St. Martin's, 1987, new edition, Penguin, 1988.
Conduct Unbecoming: Gays and Lesbians in the U.S. Military, Vietnam to the Persian Gulf, St. Martin's, 1993.

Author of foreword for *Long Road to Freedom: The Advocate History of the Gay and Lesbian Movement,* edited by Mark Thompson, St. Martin's, 1994. Contributor of articles to periodicals, including *New York Times, Esquire, Christopher Street, New West, Village Voice, Columbia Journalism Review, Washington Post, Los Angeles Herald Examiner,* and *San Francisco Examiner.*

■ Adaptations

And the Band Played On was released on audiotape in 1988 by Simon & Schuster, and was adapted into a film by the Home Box Office (HBO) cable television network in 1993, rebroadcast on NBC in March, 1994; *Conduct Unbecoming* is being adapted into a made-for-TV movie by HBO; *The Mayor of Castro Street* is being adapted into a feature movie by Warner Brothers.

■ Sidelights

Although he had only written three books when he died in 1994 at age forty-two, Randy Shilts had already helped "set the standard" by which gay journalism is judged, according to Robert B. Marks Ridinger in *Gay and Lesbian Literature.* When Shilts joined the reporting staff of the *San Francisco Chronicle* in 1981, he was the first openly gay journalist at a major American daily newspaper. Over the next thirteen years, Shilts reported on the spread of Acquired Immune Deficiency Syndrome (AIDS)—the disease that killed him—with a tenacity that won respect from friends and foes alike. "I'm part of a new generation of gay reporters who are open about those very things that oldline newspapers discreetly hushed up," Shilts told Patricia Holt of *Publishers Weekly* in a 1982 interview. "On the one hand, it meant everything to me that I could prove myself as an objective reporter in the eyes of professional colleagues, straight or gay. But on the other hand, I was a controversial figure in the gay community because I refused to promote gay activism in the midst of covering hard news."

Shilts, the third of six sons, was born in Davenport, Iowa, but grew up in Aurora, Illinois. Most articles written about his early life have suggested his family life was a model of lower middle-class, conservative respectability. But his friend Katie Leishman, a correspondent for *Atlantic Monthly,*

has said there was a dark side to the story. "Randy was a master of disassociation," Leishman wrote in a *New York Times* article after Shilts' death. "Nearly every day his drunken mother forced him into the bathroom, made him take down his pants and then whipped him, and if he cried, whipped him again. He taught himself not to cry, so effectively that for many years he forgot how. . . ." Shilts bore the psychological scars all his life. He also suffered with migraine headaches and a variety of addictions. Writing was his way of coping, or as Leishman put it, "the only anesthesia that lasted."

Shilts, an indifferent student in high school, enrolled at Aurora College in 1969. His conservative politics and personal beliefs changed radically when he got involved in anti-Vietnam War protests. As a result, Shilts moved to Oregon in 1970 to "become a hippie." After attending Portland Community College, in 1973 he began studying journalism at the University of Oregon, where he was managing editor of the student newspaper. Shilts also "came out of the closet" at a time when such public pronouncements were a rarity. Underscoring the point, Shilts organized the Eugene chapter of the Gay People's Alliance, and in his senior year ran unsuccessfully for student president under the slogan, "Come Out for Shilts." Predictably, there was a price to be paid for such militancy. Despite graduating in 1975 at the top of his class, Shilts could not find a job in Oregon. He attributed this to homophobia, as he told David Ellis in a 1993 *People* magazine interview.

Career Blossoms in San Francisco

Shilts' first job was as the northwest correspondent for a California-based gay and lesbian magazine called the *Advocate.* During the three years he wrote for that publication, Shilts moved to San Francisco. In 1977, he was hired as a freelance reporter by San Francisco television station KQED, the local PBS affiliate. Two years later, he began covering civic politics as well as life in the Bay area's growing gay and lesbian community for Oakland television station KTVU. "It was a wonderful time to be a reporter," Shilts told Garry Wills in a 1993 *Rolling Stone* interview. "The whole gay thing was just exploding on Castro Street . . . [and] there was the excitement, too—seeing a lot of young gay people like myself, people who are open and who are committed to showing a

new way to be alive, that you didn't have to live in fear and trepidation all the time."

Through his work Shilts met Harvey Milk, a controversial and flamboyant gay rights advocate who had won a seat on San Francisco's board of supervisors in 1977. Milk's life and political career were cut short when he and San Francisco mayor George Moscone were assassinated on November 27, 1978. The next day, Shilts got a call from Michael Denneny, an editor with the gay magazine *Christopher Street* and the book publisher St. Martin's Press, asking him to write a cover story about Milks for *Christopher Street.* When he did, the reaction was so positive that Denneny suggested Shilts do a biography of Milks for St. Martin's.

As Shilts explained to Holt in his *Publisher's Weekly* interview, "[Milk's story] . . . was to a large extent the story of the gay movement in San Francisco and, ultimately, the nation. His death came at one of those rare times when the forces of social change collide with human events, and that's what I wanted to write about." Shilts saw Milk as a man of contradictions: a brilliant politician who was also at times immature, petty, and shallow. *The Mayor of Castro Street: The Life and Times of Harvey Milk*, was published in 1982, shortly after Shilts was hired as a reporter by the *San Francisco Chronicle.* Shilts had once told John Weir from the gay magazine *Out,* "I don't consider myself an activist or an advocacy journalist. I feel that prejudice . . . [against homosexuals] is born less out of malice than out of ignorance, and that if you just inform people . . . you can do more to erase prejudice than [you can by engaging in] any other kind of action." Gays who expected Shilts to promote their causes branded him a "gay Uncle Tom" when they read his warts-and-all biography of Milk and his *Chronicle* articles in which he criticized the practice of "outing"—forcing public figures to reveal their sexual preferences—and reported frankly on the dangers of San Francisco's bathhouses. In particular, Shilts condemned the kind of anonymous, casual sex that spread AIDS.

The Mayor of Castro Street garnered critical approval. Christopher Schemering in the *Washington Post Book World* stated that in addition to being a first-rate biography and a study of San Francisco's gay life, Shilts' book "functions equally well as an investigative piece on the mechanics of big-city

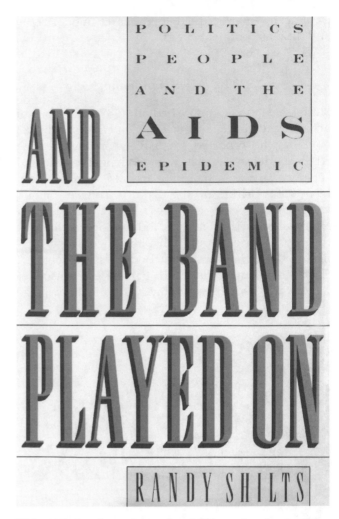

This 1987 book explores the failure of a host of institutions, including the mass media and gay community leaders themselves, to recognize and deal in time with the AIDS epidemic.

government in all its expedient, back-biting splendor." Elizabeth Mehren in the *Los Angeles Times* pronounced *The Mayor of Castro Street* to be "one of the first avowedly gay nonfiction books to be accepted—embraced, even—by the mainstream press and public." Mehren's assessment was overly optimistic, for few mainstream national publications reviewed *The Mayor of Castro Street.* One exception was the New York-based *Village Voice,* whose critic Richard Goldstein said the book was a "taut and teeming biography," and Shilts was "one of several gay journalists who are challenging a professional property based more on bigotry than on any discernible concern for truth." While initial assessments of *The Mayor of Castro Street* in the gay press were negative, that has now changed; in 1994 the book was hailed by Ridinger in *Gay and Lesbian Literature* as a landmark book

in that it "marks the beginning of modern gay and lesbian political biography."

The AIDS Epidemic

Shilts' next book, published in 1987, grew out of his work at the *San Francisco Chronicle*. From 1983 onwards, he reported exclusively on the growing AIDS epidemic, which was no longer considered "a gay story and therefore trivial," as Shilts told Jean Latz Griffin of the *Chicago Tribune*. Shilts's work and his own gay lifestyle left him sad and angry at what he felt was indifference to the disease by America's public health officials and politicians. "AIDS wasn't somebody else's problem," Shilts told Jim Miller and Pamela Abramson of *Newsweek*. "I live every day with the knowledge

CONDUCT UNBECOMING
GAYS & LESBIANS IN THE U.S. MILITARY
RANDY SHILTS
author of AND THE BAND PLAYED ON

Based on over a thousand interviews and official documents, Shilts's investigation of lesbians and gays in the military reveals thirty years of relentless persecution and individual heroism.

that friends will be dead in five years. I had to write the book, or go crazy." What Shilts did not say was that he, himself, was carrying the human immunodeficiency virus (HIV), the semen-and-blood-transmitted killer that destroys the body's ability to ward off infection and leads to AIDS. Shilts learned he was HIV positive the day he wrote the final page of *And the Band Played On*. He had been tested a year earlier but asked not to be told the results, for fear it would influence his reporting.

Shilts was one of the first journalists to investigate the AIDS epidemic. The theme of his book was as controversial as it was disturbing: he charged AIDS spread as rapidly as it did because at first no one took the disease seriously. Shilts said the government, media, scientific and medical communities, blood bank operators, and gay rights advocates all had their own reasons for ignoring or denying the threat. As a result of their negligence, AIDS became the worst public health disaster of modern times. Shilts made his case by recounting how and when the disease spread; he did so by focusing on the experiences of AIDS victims (one of whom was movie star Rock Hudson), health care workers, politicians, leaders of the gay and heterosexual communities, and journalists. Shilts also made headlines by publicly identifying a gay French-Canadian airline flight attendant as "Patient Zero," the first person to transmit the disease in North America.

Given the seriousness of his message and the public indifference to a disease that was still widely seen as a "gay problem," Shilts biggest worry was no one would read his book. He was astounded when *And the Band Played On* became an international bestseller and he became "the world's first AIDS celebrity," as one of his friends put it. The work also drew critical praise. Christopher Lehmann-Haupt of the *New York Times* saluted it as "a heroic work of journalism in what must rank as one of the foremost catastrophes of modern history." Daniel S. Greenberg, writing in the *Nation*, commented, "Shilts occasionally dwells on trivialities; he favors overly florid passages and grants excessive credence to unsupported gossip. But this is otherwise a solid journalistic performance, sure to be a durable study of the AIDS debacle." Greenberg's criticisms were echoed by those who disagreed with aspects of the book's angry message. For example, Nicholas Wade, writing on the editorial page of the *New York Times*,

criticized Shilts for applying "withering hindsight to society's shortcomings, almost none to its successes."

Shilts explained in a 1989 *Esquire* article that he wrote *And the Band Played On* in the hope he could "alter the performance of the institutions that had allowed AIDS to sweep through America unchecked." In that, he was frustrated, despite the book's commercial success. "The bitter irony is, my role as an AIDS celebrity just gives me a more elevated promontory from which to watch the world make the same mistakes in the handling of the AIDS epidemic that I had hoped my work would help to change," he said. "Never before have I succeeded so well; never before have I failed so miserably."

Homosexuals and the Military

Shilts wanted to follow up on the success of *And the Band Played On* by writing the "definitive" work on homophobia in America. It was his agent Fred Hill who suggested he investigate the difficulties faced by gays and lesbians in the U.S. military. Supported by an advance of almost $1 million, Shilts traveled the country interviewing more than 1,100 men and women who had served in the military since the Vietnam War. He also used the Freedom of Information Act to gain access to more than 15,000 pages of information. The physical effort took a toll on his health. In August 1992, after three years of drug therapy, Shilts fell ill with AIDS-related pneumonia. Four months later, on Christmas Eve, one of his lungs collapsed. He was forced to dictate the final three chapters of the book from a hospital bed. Shilts' knew he was dying, yet he forged ahead with renewed determination after President Bill Clinton pledged during the 1992 election campaign to lift the military's ban on homosexuals if he was elected.

Shilts revealed he had AIDS in February 1993, just a few weeks before publication *of Conduct Unbecoming: Gays and Lesbians in the U.S. Military, Vietnam to the Persian Gulf*. In the last two decades alone, Shilts claimed, more than 16,000 homosexuals were ruthlessly expelled from the armed forces. "It's very Stalinesque," he told interviewer Jeffrey Schmalz of the *New York Times*. "I think even people who support the ban would be flabbergasted if they knew what was being done to enforce it." Shilts was right. The massive book

If you enjoy the works of Randy Shilts, you may also want to check out the following books and films:

Marion Dane Bauer, *Am I Blue?: Coming Out from the Silence* (short stories), 1994.
Mike Hippler, *Matlovich: The Good Soldier*, 1989.
Troy D. Perry and Thomas L. P. Swicegood, *Profiles in Gay and Lesbian Courage*, 1991.
Richard Preston, *The Hot Zone*, 1994.
Longtime Companion, Samuel Goldwyn, 1990.

quickly made the *New York Times* bestseller list, generated much public discussion, and attracted many positive reviews. Jean Palmer of *KLIATT* praised *Conduct Unbecoming* as "comprehensive, clear, a truly landmark history." Historian John D'Emilio, writing in the *Nation*, commented that "Shilts's narrative is shocking," adding "Everything about the stories he recounts is offensive—deeply so—and their implications are dangerous." Even the usually hostile gay press had positive things to say about Shilts's work. A reviewer for the *Advocate* pronounced the book to be of "profound historical significance." On the other hand, several conservative publications and members of the military establishment denounced *Conduct Unbecoming*. In a response to the work published in the *Wall Street Journal*, John Lehman, secretary of the Navy during the Ronald Reagan administration, argued that the "loathing of the military and his genuine ignorance of its ways" by Shilts and other "zealots" exemplified "the schizophrenia of the radical gay movement."

In the spring of 1993, Shilts told Ellis in his *People* interview, "To me [AIDS] is no different than having high blood pressure or some other life-threatening illness. But in our culture, AIDS has this melodramatic veneer to it." Despite the brave words, Shilts was too ill to work. Nonetheless, on May 1, 1993, Shilts held a commitment ceremony with his partner, a film student named Barry Barbieri. Shilts also continued trying to write and act as an advisor of the scripts for film versions of *The Mayor of Castro Street* and *Conduct Unbecoming*. He could not. Shilts died on February 17, 1994. *San Francisco Chronicle* editor William German, quoted in the *Los Angeles Times*, stated, "The entire world has reason to honor Randy Shilts for

his . . . relentless investigation that helped us all become aware of a global epidemic."

■ Works Cited

Review of *Conduct Unbecoming: Gays and Lesbians in the U.S. Military, Vietnam to the Persian Gulf, Advocate,* June 15, 1993, p. 32.

D'Emilio, John, "All That You Can Be," *Nation,* June 7, 1993, pp. 806, 810, 812.

Ellis, David, "Writer of Wrongs," *People,* April 26, 1993, pp. 73-76.

Goldstein, Richard, "What He Did for Love," *Village Voice,* March 23, 1982, p. 40.

Greenberg, Daniel S., "Unhealthy Resistance," *Nation,* November 7, 1987, pp. 526-28.

Griffin, Jean Latz, *Chicago Tribune,* November 1, 1987, p. 5.

Holt, Patricia, "Randy Shilts," *Publishers Weekly,* March 19, 1982, pp. 6-7.

Lehman, John, "Sad Story of Gays in the Military," *Wall Street Journal,* May 18, 1993, p. A-16.

Lehmann-Haupt, Christopher, review of *And The Band Played On: Politics, People, and the AIDS Epidemic, New York Times,* October 26, 1987.

Leishman, Katie, "The Writing Cure," *New York Times,* March 5, 1994, p. 23.

Mehren, Elizabeth, review of *The Mayor of Castro Street: the Life and Times of Harvey Milk, Los Angeles Times,* March 25, 1982.

Miller, Jim, and Pamela Abramson, *Newsweek,* October 19, 1987, pp. 92-93.

Palmer, Jean, review of *Conduct Unbecoming: Gays and Lesbians in the U.S. Military, Vietnam to the Persian Gulf, KLIATT,* November, 1994, p. 38.

Ridinger, Robert B. Marks, "Randy Shilts," *Gay and Lesbian Literature,* edited by Sharon Malinowski, St. James Press, 1994.

Schemering, Christopher, review of *The Mayor of Castro Street: the Life and Times of Harvey Milk, Washington Post Book World,* April 2, 1982.

Schmalz, Jeffrey, interview with Randy Shilts, *New York Times,* April 22, 1993, p. 1.

Shilts, Randy, "Talking AIDS to Death," *Esquire,* March, 1989, pp. 123-124, 126, 128, 130, 132, 135.

Wade, Nicholas, "AIDS, in Harsh Review," *New York Times,* November 10, 1987, p. 34.

Warren, Jennifer, and Richard C. Paddock, "Randy Shilts, Chronicler of AIDS Epidemic, Dies at 42," *Los Angeles Times,* February 18, 1994, p. 1.

Weir, John, interview with Randy Shilts, *Out,* August/September, 1993, p. 45.

Wills, Garry, interview with Randy Shilts, *Rolling Stone,* September 30, 1993, pp. 46-9, 122-23.

■ For More Information See

BOOKS

Contemporary Authors, New Revision series, Volume 45, Gale, 1994, pp.399-401.

Contemporary Literary Criticism, Volume 85, Gale, 1995, pp. 318-346.

PERIODICALS

Economist, December 5, 1987, pp. 99-100.

Journal of American Studies, August, 1989, p. 339.

Los Angeles Times, October 9, 1987.

Los Angeles Times Book Review, May 2, 1993, pp. 4, 11.

New Republic, December 20, 1993, pp. 17-35.

Newsweek, February 28, 1994, p. 36.

New York Review of Books, September 23, 1993, pp. 18-23.

New York Times, April 21, 1993, Section C, p. 20; February 18, 1994, p. D-17.

New York Times Book Review, November 8, 1987, p. 9; May 30, 1993, pp. 2, 22.

Observer, November 7, 1993, p. 21.

School Library Journal, April, 1988, p. 123.

Scientific American, October, 1988, pp. 148-51.

Time, October 19, 1987, pp. 40, 45.

Tribune Books (Chicago), May 30, 1993, pp. 5, 10.

■ Obituaries

BOOKS

Contemporary Authors, Volume 144, Gale, 1995, pp. 407-408.

PERIODICALS

Chicago Tribune, February 20, 1994, p. 10.

New York Times, February 18, 1994, p. D17.

Times (London), February 21, 1994, p. 17.

Washington Post, February 18, 1994, p. B7.*

—*Sketch by Ken Cuthbertson*

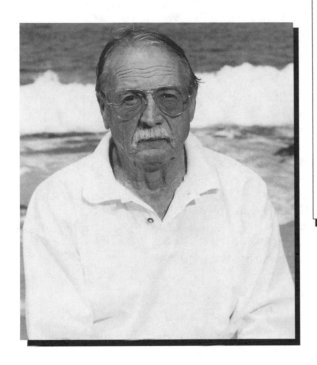

Theodore Taylor

■ Personal

Also writes as T. T. Lang; born June 23, 1921, in Statesville, NC; son of Edward Riley (a molder) and Elnora (Langhans) Taylor; married Gweneth Goodwin, October 25, 1946 (divorced, 1977); married Flora Gray Schoenleber (a library clerk), April 18, 1981; children: (first marriage) Mark, Wendy, Michael. *Education:* Attended Fork Union Military Academy, 1939-40, U.S. Merchant Marine Academy, Kings Point, NY, 1942-43, and Columbia University, 1948; studied with American Theatre Wing, 1947-49. *Politics:* Republican. *Religion:* Protestant. *Hobbies and other interests:* Ocean fishing, foreign travel.

■ Addresses

Home—1856 Catalina St., Laguna Beach, CA 92615. *Agent*—Gloria Loomis, Watkins Loomis Agency, Inc., 150 East 35th St., Suite 530, New York, NY 10016.

■ Career

Portsmouth Star, Portsmouth, VA, cub reporter, 1934-39, sports editor, 1941-42; *Daily News,* Wash-

ington, DC, copyboy, c. 1942; National Broadcasting Co. (NBC) Radio, New York City, sportswriter, 1942; *Sunset News,* Bluefield, WV, sports editor, 1946-47; New York University, New York City, assistant director of public relations, 1947-48; *Orlando Sentinel Star,* Orlando, FL, reporter, 1949-50; Paramount Pictures, Hollywood, CA, publicist, 1955-56; Perlberg-Seaton Productions, Hollywood, story editor and associate producer, 1956-61; freelance press agent for Hollywood studios, 1961-68; writer, 1961—; Twentieth Century-Fox, Hollywood, writer, 1965-69. Producer and director of documentary films. *Military service:* U.S. Merchant Marine, 1942-44; U.S. Naval Reserve, active duty, 1944-46, 1950-55, became lieutenant. *Member:* Academy of Motion Picture Arts and Sciences, Writers Guild, Authors League of America, Mystery Writers of America, Society of Children's Book Writers and Illustrators.

■ Awards, Honors

Commonwealth Club of California Silver Medal, 1969, Jane Addams Children's Book Award, Women's International League for Peace and Freedom (returned, 1975), Lewis Carroll Shelf Award, Southern California Council on Literature for Children and Young People Notable Book Award, California Literature Medal, and Best Book Award from University of California, Irvine, all 1970, all for *The Cay; Battle in the Arctic Seas* was selected one of *New York Times* Outstanding Books of the Year, 1976; Spur Award for Best Western for Young

People, Western Writers of America, and Commonwealth Club of California Silver Medal for the best juvenile book by a California author, both 1977, both for *A Shepherd Watches, a Shepherd Sings*; Southern California Council on Literature for Children and Young People award, 1977, for body of work; George G. Stone Center for Children's Books Recognition of Merit Award, 1980, for body of work; Young Reader Medal from the California Reading Association, 1984, for *The Trouble with Tuck*; Jefferson Cup Honor Book from the Virginia Library Association, 1987, for *Walking up a Rainbow*; American Library Association (ALA) Best Book Award, 1989, for *Sniper*, 1992, for *The Weirdo*, and 1993, for *Timothy of the Cay*; California Reading Association Young Reader Medal, 1992, for *Sniper*; Edgar Allan Poe Award, Mystery Writers of America, and New York Public Library Award for Best Book, both 1992, both for *The Weirdo*; Maryland Reading Association Best Young Adult Book Award, 1995, for *Sniper*; ALA Best Books for Young Adults citation and Scott O'Dell Award, both 1996, both for *The Bomb*.

■ **Writings**

FICTION FOR JUVENILES

The Cay, Doubleday (Garden City, NY), 1969.
The Children's War, Doubleday, 1971.
The Maldonado Miracle, Doubleday, 1973.
Teetoncey, illustrated by Richard Cuffari, Doubleday, 1974.
Teetoncey and Ben O'Neal, illustrated by Cuffari, Doubleday, 1975.
The Odyssey of Ben O'Neal, illustrated by Cuffari, Doubleday, 1977.
The Trouble with Tuck, Doubleday, 1981.
Sweet Friday Island, Scholastic, Inc. (New York City), 1984.
Walking up a Rainbow: Being the True Version of the Long and Hazardous Journey of Susan D. Carlisle, Mrs. Myrtle Dessery, Drover Bert Pettit, and Cowboy Clay Carmer and Others, Delacorte (New York City), 1986.
The Hostage, illustrated by Darrell Sweet, Delacorte, 1988.
Sniper, Harcourt (San Diego), 1989.
Tuck Triumphant, Doubleday, 1991.
The Weirdo, Harcourt, 1992.
Maria, Harcourt, 1992.
Timothy of the Cay, Harcourt, 1993.
The Bomb, Harcourt, 1995.

NONFICTION FOR JUVENILES

People Who Make Movies, Doubleday, 1967.
Air Raid—Pearl Harbor! The Story of December 7, 1941, illustrated by W. T. Mars, Crowell (New York City), 1971.
Rebellion Town: Williamsburg, 1776, illustrated by R. Cuffari, Crowell, 1973.
Battle in the Arctic Seas: The Story of Convoy PQ 17, illustrated by Robert Andrew Parker, Crowell, 1976.
(With Louis Irigaray) *A Shepherd Watches, a Shepherd Sings*, Doubleday, 1977.
H.M.S. Hood vs. Bismarck: The Battleship Battle, illustrated by A. Glass, Avon, 1982.
The Battle of Midway Island, illustrated by Andrew Glass, Avon (New York City), 1983.
Battle in the English Channel, illustrated by A. Glass, Avon, 1983.
Rocket Island, Avon, 1985.

NOVELS FOR ADULTS

The Body Trade, Fawcett (New York City), 1968.
The Stalker, D. I. Fine, 1987.
Monocolo, D. I. Fine, 1989.
To Kill the Leopard, Harcourt, 1993.

OTHER

The Magnificent Mitscher (biography), Norton (New York City), 1954.
Fire on the Beaches, Norton, 1957.
(With Robert A. Houghton) *Special Unit Senator: An Investigation of the Assassination of Senator Robert F. Kennedy*, Random House (New York City), 1970.
(With Kreskin) *The Amazing World of Kreskin*, Random House, 1974.
Jule: The Story of Composer Jule Styne, Random House, 1979.
(With Tippi Hedren) *The Cats of Shambala*, Simon & Schuster (New York City), 1985.

Author of television plays "Tom Threepersons," *TV Mystery Theater*, 1964, "Sunshine, the Whale," and "The Girl Who Whistled the River Kwai," 1980; author of screenplays *Night without End*, 1959, *The Hold-up* and *Showdown*, both Universal, both 1973, *Diplomatic Immunity*, 1989, and numerous documentary films. Also author of books under the pseudonym T. T. Lang. Contributor of

short stories and novelettes to magazines, including *Argosy*, *Ladies' Home Journal*, *McCall's*, *Redbook*, and *Saturday Evening Post*.

Taylor's manuscripts are included in the Kerlan Collection, University of Minnesota.

■ Adaptations

The Cay was adapted as a television film starring James Earl Jones, NBC-TV, 1974, and as a filmstrip, Pied Piper Productions, 1975; *The Trouble with Tuck* was adapted as a filmstrip, Pied Piper Productions, 1986; *Timothy of the Cay* and *The Hostage* have been recorded on audio cassette, Recorded Books, 1996.

■ Work in Progress

Rainbow's End, a collection of short stories for boys; *Naughty, Naughty Knifework*, for adults.

■ Overview

"I believe that a writer should constantly feed his fires by being on the go, doing different things, seeking new experiences," Theodore Taylor once noted. Putting that philosophy into practice in his own life, Taylor has served as a newspaperman, magazine writer, and movie publicist, managed a prize fighter, worked as a merchant seaman, been a naval officer, and spent time in Hollywood as both a production assistant and a documentary filmmaker. Inspired by these varied vocations, as well as by the many locations—from Japan, Taiwan, and Hong Kong to most of the European countries—in which he has lived and worked at one time or another, Taylor has crafted several award-winning novels for young adults, as well as acclaimed works of nonfiction that draw on both the author's strong grasp of U.S. naval history and his ability to share that vivid sense of understanding and enthusiasm with his readers.

The author was born in the rural town of Statesville, North Carolina, the youngest of six children born to Edward and Elnora Taylor. He described his early childhood in an essay in the *Something about the Author Autobiography Series* (*SAAS*) as "one short happy adventure, knowing and caring little about what was going on in the

outside world simply because there was so much going on in my inside world. . . . In terms of material wealth, we had very little, but there was a richness in the surroundings that money could never buy."

These rural southern roots would form the background for several of Taylor's books: for example, the Carolinas are used as the backdrop for his "Hatteras trilogy," a work of historical fiction that features the adventures of Wendy Appleton, a mute English girl found shipwrecked on an island off the coast of South Carolina in the late 1890s. The series includes *Teetoncey*, *Teetoncey and Ben O'Neal*, and *The Odyssey of Ben O'Neal*, all of which describe the growing romantic relationship between Wendy and her rescuer, a young man who is called "Teetoncey," or dunce, by his fellow villagers because of his desire to go to sea.

"Statesville, in the heart of the Piedmont area of North Carolina, red-earth flatlands before the western rises of the Blue Ridges, had about five thousand inhabitants when I was born," recalled Taylor. "County seat of Iredell, it was centered in an agriculture economy, mainly: cotton, tobacco, corn, some orchards; truck farms. There was a brickyard and a foundry, where my father worked; knitting mills provided most of the jobs. It was a nice, God-fearing, Waspish town of the upper South, related in some ways to 'Altamont,' Thomas Wolfe's town of Asheville, up in the Blue Ridges. Some of the people of *Look Homeward, Angel*, as I remember them, could probably have been found in Statesville." But there were other memories, equally vivid and exciting to an impressionable young boy, but darker. He recalls being between five and six years old, and watching "the Ku Klux Klan riding by on horses one night, carrying pine knot torches; of a Model-T Ford, driven by a bootlegger, its rear end sagging with tins of booze, racing up Center Street toward the railroad station, laying a smokescreen, followed by cops in a black touring car."

As a boy, Taylor was more entranced by the action of World War I than with his studies: "I spent a lot of time drawing Fokkers and Spads and Sopwith Pups and Scouts in aerial battles; looping artillery fire into the Flanders trenches. When I should have been listening to the teacher I filled sheets of paper with war scenes." This fascination, also revealed in many of Taylor's books, would continue throughout his career, making him

Taylor (foreground) in 1946 after diving near Bikini Atoll, the setting for his 1995 historical novel, *The Bomb*.

an acknowledged authority on the U.S. military history of the early twentieth century.

Early in 1934 Taylor moved to Cradock, Virginia, where he began his writing career at the age of thirteen as a cub reporter for the Portsmouth *Evening Star.* "Until school began I explored. I highly recommend exploration to young and would-be writers. I followed the Norfolk & Western tracks down to the river, often hopping the slow coaljacks for a ride, to watch the small freighters that chugged down the Elizabeth toward North Carolina on the inland waterway; to see tankers unloading on the South Norfolk side. I followed the streetcar track on foot into Portsmouth and explored the waterfront, spending hours at the Isaac Fass fishing docks watching the boats unload. I watched the side-wheeler ferries, still coal-burners, plying the mile or so across to Norfolk. There was an all-encompassing excitement to this waterfront activity, so different from the flatlands of the Piedmont, and I was caught up in it."

But something happened in the spring of 1935 that would change Taylor's life forever. "I was offered a chance to write a sports column, . . . a type-written page and a half of copy, for the *Portsmouth Star.* . . . For this, I was to receive fifty cents." The eager Taylor immediately said yes. "I remember studying the sports pages of the *Star* and the larger *Norfolk Virginian-Pilot,* just to see how the stories were written," he recalled of his first days as an honest-to-goodness reporter, "then placing them down by the typewriter for constant referral. . . . After laboring all morning and up to mid-afternoon on the page and a half, I nervously rode the streetcar to Portsmouth clutching my first story, mentally and probably physically crossing fingers that it would be accepted." It was, although the newspaper's editor later commented, "Ted Taylor was the rawest recruit we ever had."

Taylor left his home in Virginia at the age of seventeen and moved north to join the staff of the Washington *Daily News* as a copyboy. By the age of nineteen he was working as an NBC network sportswriter. During World War II, he joined the United States Merchant Marine, "having no desire to slog around in army mud nor any great desire for navy discipline." He also became a member of the U.S. Naval Reserve and for almost a year and a half served as a seaman aboard a gasoline tanker in the Atlantic and Pacific Oceans

and on a freighter plying the seas of Europe before becoming third-mate on two other ships. Returning stateside in 1944, Taylor was called up by the Navy as an ensign aboard the USS *Draco,* a cargo attack vessel in the Pacific. "Following the Japanese surrender, I heard about Operation Crossroads, the nuclear experiment at Bikini to see the bomb go off. Unfortunately, but typically, my ship, the USS *Sumner,* was ordered home before the big blast." Characteristically, his personal experience of this hotly debated military action would continue to haunt Taylor for many years but would ultimately find an outlet in his writing.

In the Korean War, Taylor also saw active duty as a naval officer; during his entire military career, he served a total of five years at sea in both the Atlantic and Pacific Oceans. His experiences at sea during the war form the basis for several of his fiction and nonfiction books. *"Battle in the Arctic Seas* (1976) is the result of wartime experience," he explained. "I sailed in convoys, was both fascinated and overwhelmed by them—this great family of ships at sea, moving as a single unit, performing like horses in a drill team. The drama was always incredible: the gathering together, the weighing of anchor, departure and forming-up; the escorts thrashing about; sometimes a U-boat attack, and then another type of drama. I'd always wanted to do a story about the most famous convoy of World War II, and PQ 17 qualified in every way. It is humanly impossible to tell as much as possible by use of a single ship, the *Troubador,* and her unique crew."

In *Battle in the English Channel* (1983) Taylor tells the story of the 1942 episode in the English Channel when a group of German ships were able to successfully elude both British naval and air forces while en route from France to Germany. In the conclusion, Taylor states its central theme: "Operation Fuller failed because of the command structure and not from lack of individual effort on the part of those who had to go out and fight."

While serving as a lieutenant in the navy during the Korean War, Taylor wrote his first book, *The Magnificent Mitscher,* a biography of Admiral "Pete" Mitscher, a carrier group commander during World War II. A year after its publication, Taylor moved to Hollywood where he worked as a press agent, and later as a story editor and associate producer. He subsequently produced docu-

mentary films throughout the world and wrote books.

Using his war experiences, Taylor's second book, *Fire on the Beaches,* told the story of the ships that fled from German submarines along the East Coast during the war, "ships like the Cities Service tanker, SS *Annibal,* the one I'd served on. I stopped off in New York to research *Fire on the Beaches* at the shipping companies and then in Washington at Coast Guard headquarters. One morning at the latter I was reading accounts of ships that were sunk along the Eastern seaboard and down in the Caribbean, over in the Gulf of Mexico, when I came across a paragraph that described the sinking of a small Dutch vessel. An eleven-year-old boy survived the sinking but was eventually lost at sea, alone on a life raft." Taylor was struck by this small drama; its irony

Taylor (left) with author Gary Paulsen in Minnesota in 1988 after running a dog team.

would haunt him for several years, until it germinated and grew into the novel *The Cay.*

In 1966, after working for over a year on the film *The Sand Pebbles,* Taylor began work on his first book for younger readers. "My own children were interested in how motion pictures were made," he recalled, "and I thought others might be, too. *People Who Make Movies* was quickly sold to Doubleday and I was astonished some two years later, after the book began circulating in schools, to receive mail from young readers. More than three thousand responded to that book, most seeking Hollywood careers. . . . In writing for adults, I'd probably received a dozen letters.

"Two years later, I decided to go ahead with the long-brewing story of the boy on the life raft in the Caribbean. A few days after returning home from Florida, I rolled fresh paper into the typewriter. Three weeks later *The Cay* was completed and the printed version is little different from the first draft." Although Taylor would note that *The Cay* was "the quickest and easiest book I've ever written," he also acknowledged that over ten years of thought and reflection also greatly contributed to the ease with which the work was written.

The Cay is a two-character story about an eleven-year-old boy, Phillip, and a seventy-year-old black Caribbean seaman named Timothy who are stranded on a raft after their boat is torpedoed by German submarines in 1942. The two eventually land on a cay, or coral island. There, the boy, who was raised with a racist outlook and who has lost his sight, learns to trust the old man; knowing he is ailing, Timothy trains the lad to fend for himself, thus ensuring his survival and rescue after the old man's death. Taylor dedicated the book to the dream of Dr. Martin Luther King, "which can only come true if the very young know, and understand."

After its publication in 1969, *The Cay* received numerous awards, was translated into nine languages, and was adapted into a successful film for television. It also received a great deal of critical praise: the relationship between Timothy and Phillip was described by Marilyn Singer in *School Library Journal* as "a hauntingly deep love, the poignancy of which is rarely achieved in children's literature"; while Charles W. Dorsey, writing in the *New York Times Book Review,* declared that Taylor "skillfully developed the perenially popular cast-

away plot into a good adventure story. . . ." However, it also attracted hostile criticism from some reviewers, such as Albert V. Schwartz who called it "an adventure story for white colonists—however enlightened—to add to their racist mythology," in a 1971 article in *Interracial Books for Children*. Attacks also came from representatives of the Interracial Council on Children's Books, who exerted enough pressure to ban the novel in several libraries. Five years after Taylor received the esteemed Jane Addams Book Award, he was requested to return it.

For his own part, the author noted that the charges of racism levelled at his novel were largely supported by isolated passages in *The Cay*, "usually descriptive of the black character, Timothy; then the broader contention that the white character, the boy Phillip, was not changed by his experience with the seventy-year-old West Indian. Needless to say," Taylor contends in a letter to the editor he submitted to *Top of the News*, "passages in any book can be underlined and utilized for whatever purpose the reader chooses. That purpose does not always coincide with what the writer had in mind; nor always with the total meaning; nor always with the majority of the readers." Taylor added that he did not believe that he had written a racist novel: "The goal was to the contrary. Directed primarily toward the white child (thinking that the black child did not need to be told much about prejudice), I hoped to achieve a subtle plea for better race relations and more understanding. I have reason to believe that I partially achieved that goal, despite acknowledged omissions and . . . flaws."

Like the "Teetoncey Trilogy" and *The Cay*, the majority of Taylor's stories for young readers are tales of adventure whose survival heroes are young people challenged by the intrusion of the unfamiliar. He alternates between nonfiction and fiction, with one book very often leading to another. "In the early seventies I'd come across a clipping from the *Fresno Bee* about a Basque shepherd who sang to his sheep," Taylor recalled in *SAAS*. "I sensed a story in this San Joaquin Valley man and after rereading the clipping in 1975, made contact with him. *A Shepherd Watches, a Shepherd Sings*, for Doubleday, resulted. In addition to extensive use of taped interviews for a book of this type I also independently do extensive research. That time, on sheep. Much to my surprise I learned that sheep were being driven

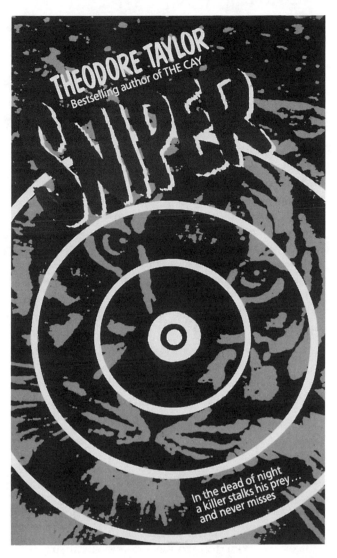

In this 1989 thriller, Ben Jepson must combat a mysterious sniper who has targeted the animals on his family's zoological preserve.

across the United States from as far away as Vermont in the early 1850s to feed the gold miners of California. That bit of information became a novel, *Walking up a Rainbow*, published in 1986 by Delacorte."

One night in 1974, Taylor was dining with a friend and his stepson, a lawyer from San Francisco. "During the course of the meal, [the stepson] said, 'Okay, you wrote a story about a blind boy in *The Cay*; now let me tell you a story about our blind dog.' Whenever someone says, 'Let me tell you a story,' I listen but ninety-nine times out of a hundred the listening is for naught. This time Tony Orser's story became a short story for *Ladies' Home Journal*, published in 1977, then a tele-

play, . . . ; finally, *The Trouble with Tuck* was published by Doubleday in 1981." The story of a blind Labrador retriever who eventually learns to maneuver with the help of a guide dog named Daisy, *The Trouble with Tuck* was popular with many young animal lovers.

"I often work on three [books] at once, switching from No. 1 to No. 2 if I write myself into a hole. An adult suspense novel, *The Stalker*, sprang from an episode of CBS's *60 Minutes*." In similar fashion, Taylor's 1987 young adult novel *The Hostage* was inspired by a front-page article he read in the *Los Angeles Times* and imaginatively transformed into a fourteen-year-old boy's predicament as he is forced to weigh environmental and personal moral concerns against his family's economic well-being after he and his father capture a killer whale and contemplate selling the animal to a California marine park.

■ Update

In recent years, Taylor has built upon his characteristic themes of survival and maturation through both sequels to earlier novels and new works of young adult fiction. Through such works as *Timothy of the Cay*, a continuation of his controversial 1969 novel *The Cay*, historically grounded fictions like *The Bomb*, and the popular action novel *Sniper*, elements of suspense intermingle with Taylor's young protagonists' attempts to make mature choices in order to survive life-and-death predicaments. These later novels continue to show Taylor to be a talented spinner of edge-of-your-seat adventure yarns.

In 1993's *Timothy of the Cay*, Taylor links past with future, juxtaposing the attempts of Phillip Enright, the blind protagonist of the earlier novel, to regain his sight with the Caribbean-born sailor Timothy's early years as a cabin boy. Following each character in alternating chapters—Phillip's story is narrated in the first person while Timothy's reads as a laudatory historical account—*Timothy of the Cay* answers many questions left in the minds of readers of the previous novel by covering two time periods: the years before the two find themselves shipwrecked on the tiny island, and the months immediately after Phillip's rescue. Taylor explores the same social and racial prejudices that characterized his earlier novel, while also highlighting the similarities between

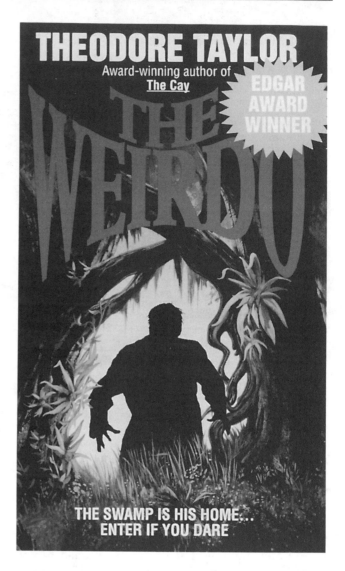

A disfigured teen and a student join forces to find a killer hiding in a wildlife refuge in this 1991 work.

Phillip's brave decision to endure a high-risk operation that may restore his sight and young Timothy's struggle against both prejudice and poverty in his determination to captain a ship of his own. Although noting that the novel's attempt to deal with the subject of racial prejudice tends to cause gaps and imbalances in the story line, Stephanie Zvirin noted in *Booklist* that Taylor "also manages some moving moments of introspection and quiet heroism as well as an occasional snatch of the same wild drama that fired *The Cay*."

In another sequel, *Tuck Triumphant*, published in 1991, the tail-wagging Labrador hero of *The Trouble with Tuck* returns with lead dog Daisy in tow to help fourteen-year-old Helen cope with the arrival

of an adopted brother. Her new sibling sends Helen on a roller-coaster of emotions as she shifts from disappointment over the young Chok-Do's being a rambunctious six-year-old rather than a cuddly baby, confusion over the orphaned boy's deafness, and finally, love and sadness when she realizes that he may be sent to a private boarding school. Praised by *Voice of Youth Advocates* reviewer Donna Houser as "a beautiful, poignant story of two special dogs and a lonely, deaf little boy," *Tuck Triumphant* echoed Taylor's earlier efforts as a children's author.

Imaginative Fiction of High Adventure

Taylor's abilities as a writer have continued to transcend genres; while *Tuck Triumphant* and *Timothy of the Cay* were primarily character studies, other novels have combined equally realistically drawn characters with much more highly imaginative, suspense-filled storylines. 1989's *Sniper* features Ben Jepson, a young man who faces down danger in an effort to save the animals held in his family's privately held zoological preservation. Located in the California landscape familiar to readers of Taylor's work, the Los Coyotes Preserve where Ben and several animal handlers live contains such exotic animals as lions and tigers. When Alfredo, whom Ben's parents have left in charge of the preserve while they are away covering an assignment for *National Geographic*, becomes seriously injured in a car accident, Ben finds himself in charge. Unfortunately, his increased duties at the preserve soon include fighting for his life as a mysterious sniper armed with a night-scoped rifle begins a guerrilla-like attack on all the inhabitants of the preserve. Aided by an African veterinarian, a pair of Spanish-speaking animal handlers, and his girlfriend, Ben must make decisions that will decide the fate of both the animals and his family's life work.

Published in 1992, Taylor's *The Weirdo* went on to win that year's Edgar Allan Poe award for best young adult mystery. In the novel, seventeen-year-old Chip Clewt, a survivor of an airplane accident that occurred when he was seven and left the left side of his body disfigured, has fled with his recovering-alcoholic father to a small cabin deep in the wilderness of North Carolina's Powhatan Swamp wildlife refuge. Encountering Tom Telford and his assistant, Samantha Sanders, two students doing field work on the native black

bear population, he decides to help them in their efforts to track and tag the bears. The tagging project—intended to help influence state authorities to extend the ban on hunting that has protected the bears for the past four years—runs afoul of the desire of several local hunters, who decide to hunt the young people down. Telford mysteriously disappears. In addition to portraying Chip's maturation and realization that he can transcend his physical handicap, Taylor highlights environmental issues through Samantha's mixed feelings about her own beliefs and her respect for her father, who is a devout hunter. "Murder, suspense, and intrigue abound, as does a hint of romance, but the environmental message is a clear and realistic one," explains Frances Bradburn in *Wilson Library Bulletin*. While noting that the author ultimately sides with wildlife preservationists, "Taylor is also careful to present the native population's desire—even need—to preserve a way of life that

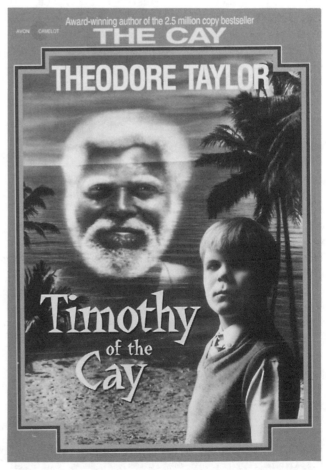

This 1993 sequel to *The Cay* alternates Philip's attempts to recover his sight with Timothy's history on the seas.

has been a part of the eastern North Carolina/ Virginia heritage for generations. Pitting 'bad' hunters against 'good' environmentalists is a trap that Taylor will not allow himself to spring."

To Kill the Leopard, an action novel for adults published by Taylor in 1993 that has its roots in his experiences during World War II, was followed a year later by *Sweet Friday Island.* Taking place on the Sea of Cortez, which separates Baja California from Mexico, this adventure novel finds spunky fifteen-year-old Peg and her father vacationing on what they believe to be the uninhabited island of Viernes Dulce—Sweet Friday Island. Expecting to spend their annual "father and daughter only" vacation swimming, loafing, and exploring the craggy island terrain, and undeterred by the hostile reception they received at the Mexican border, the two campers suddenly find their tenting holiday transformed into a fight for their lives after docking on the remote island brings them face to face with a hostile but invisible enemy who punctures their raft, drains their supply of drinking water, and makes off with Peg's father's medical kit. Without insulin, he soon lapses into a diabetic coma and Peg is left to match wits with the enemy, knowing the lives of both she and her father hang in the balance.

Reaping the Bitter Harvest of Technology

Taylor earned resounding critical praise for still another award-winning effort, 1995's *The Bomb.* Set against the backdrop of the 1945 U.S. liberation of Japanese-occupied Bikini Atoll—a coral island in the Western Pacific located 2,200 miles from Hawaii—this poignant story of human perseverance and, ultimately, tragedy finds an echo in the current debate over nuclear weapons testing around the globe. Like his neighbors, *The Bomb's* fourteen-year-old protagonist Sorry Rinamu is grateful to the United States after the departure of their liberating forces, and feels a sense of security as life on his tropical island returns to normal. However, when the "helpful" U.S. Army forces return to his home a year later and announce that they will be "temporarily" relocating island residents in order to conduct tests of their latest atomic bomb in the Bikini lagoon, Sorry and his Uncle Abram are convinced, rightly, that such a weapon will certainly destroy their home; the residents of this quiet island will be left without a home. Their efforts to convince their neighbors

If you enjoy the works of Theodore Taylor, you may want to check out the following books and films:

Eric Campbell, *The Place of Lions,* 1991.
Jean Craighead George, *On the Far Side of the Mountain,* 1990.
Welwyn Wilton Katz, *Whalesinger,* 1991.
John Neufeld, *Edgar Allan,* 1968.
Free Willy, Warner Bros., 1993.

that all the plants and animals on their homeland will be destroyed fall on deaf ears, and Uncle Abram dies in the process. Left alone with the realization of impending disaster, Sorry attempts to fight for his native homeland on his own, realizing too late that one person from an insignificant country cannot influence the actions of a superpower.

Taylor ends his moving fiction with an epilogue documenting the actual results of the U.S. government's destruction of Bikini Atoll and its impact on the lives of the villagers. Much of this information was based on the author's personal experiences in the mid-1940s, when he served as a U.S. Navy ensign during Operation Crossroads; while aboard the *USS Sumner* Taylor was involved with relocating the inhabitants of a similar small island in preparation for nuclear weapons testing. He described the navy's plan in an article accompanying his novel: "Almost one hundred unmanned warships would gather in the atoll's lagoon for two 'shots' [bomb detonations]—one aerial, one undersea. Navy officials wanted to know if the ships would survive the cataclysmic force of nuclear explosions. Animals would take the place of human crews on the target ships. Goats would be tethered on the open decks; guinea pigs and five thousand rats would be inside the ships, along with cancer-prone white mice. . . . All would be exposed to radiation." More than fifty years later, the once-beautiful Bikini Atoll is still poisoned by radioactive fallout from Operation Crossroads.

Promoting Models of Self-Reliance

Throughout his long career as a writer, Taylor has shared his wide-ranging life experience and interests with young readers, making them both en-

tertaining and insightful. "Every story I have written is about real people and stems from real-life events," he told Norma Bagnall in an interview in *Language Arts*. "They include kids who have figured out things for themselves because kids like that really exist. I think they serve as models; I *hope* they serve as models, models of self-sufficiency and self-reliance." And as an author, Taylor also serves as a model. "Long ago I learned about discipline and have no trouble going to my office about eight-thirty each morning," he noted in his *SAAS* essay, describing the personal writing regimen that has allowed him this success. "With a half-hour off for lunch, I work until four-thirty; sometimes five. I do this seven days a week except during football season. September to Super Bowl Sunday. During this grunt-grind period on the gridiron, I work only five days weekly—*without guilt*. Otherwise, I feel enormous guilt if I don't work. Precious hours going to waste."

■ Works Cited

Bagnall, Norma, "Theodore Taylor: His Models of Self-Reliance," in *Language Arts*, January, 1980, pp. 86-91.

Bradburn, Frances, "Middle Books," in *Wilson Library Bulletin*, September, 1992, pp. 93-94.

Dorsey, Charles W., review of *The Cay*, New York Times Book Review, June 29, 1969, p. 26.

Houser, Donna, review of *Tuck Triumphant*, in *Voice of Youth Advocates*, October, 1991, pp. 232-33.

Schwartz, Albert V., 'The Cay': Racism Still Rewarded," in *Interracial Books for Children*, Volume 3, number 4, 1971, pp. 7-8.

Singer, Marilyn, review of *The Cay*, School Library Journal, September, 1969, p. 162.

Taylor, Theodore, letter to the editor, *Top of the News*, April, 1975, pp. 284-88.

Taylor, Theodore, *Battle in the English Channel*, Avon, 1983.

Taylor, Theodore, essay in *Something about the Author, Autobiography Series*, Volume 4, Gale, 1987.

Taylor, Theodore, "On Writing *The Bomb*" (press release), Harcourt, 1995.

Zvirin, Stephanie, review of *Timothy of the Cay*, in *Booklist*, September 15, 1993, p. 153.

■ For More Information See

BOOKS

Gleason, Virginia L., "Theodore Taylor," *Twentieth-Century Young Adult Writers*, St. James Press, 1994, pp. 637-39.

Twentieth-Century Children's Writers, 3rd edition, St. James Press, 1989, pp. 953-54.

PERIODICALS

ALAN Review, spring, 1996.

Christian Science Monitor, May 6, 1988; January 25, 1989, p. 13.

Growing Point, January, 1991, pp. 5447-51.

Horn Book, October, 1974, p. 145; December, 1975, p. 596; April, 1982, p. 170; February, 1984, p. 79; January, 1990, p. 72.

Junior Bookshelf, December, 1994, p. 239.

Los Angeles Times Book Review, June 21, 1987, pp. 3, 8.

New York Times Book Review, September 17, 1967, p. 34; November 3, 1968, p. 53; July 11, 1971, p. 8; January 9, 1972, p. 8; October 6, 1974, p. 8; October 24, 1976, p. 43; November 15, 1981, pp. 54, 69; March 6, 1983, p. 30.

Saturday Review, August 19, 1967, p. 35; June 28, 1969, p. 39; August 21, 1971, p. 27; October 16, 1971, p. 57.

School Library Journal, November, 1984, p. 139; July, 1990, p. 27; March, 1991, p. 196.

Time Educational Supplement, June 10, 1983, p. 22.

Times Literary Supplement, October 30, 1970, p. 1258.

Top of the News, November, 1971.

Voice of Youth Advocates, June, 1984, p. 111; February, 1985, p. 333; December, 1985, p. 336; June, 1986, p. 83; April, 1988, p. 30; June, 1990, pp. 93-94; June, 1992, p. 104; June, 1994, p. 94; April, 1996, p. 30.

Washington Post, May 26, 1979.*

—Sketch by Pamela Shelton

Frances Temple

unteer in Sierra Leone, West Africa, 1965-67; VISTA volunteer in health services and low-income housing, central Virginia, 1970-74; writer of teaching methodologies.

■ Personal

Full name, Frances Nolting Temple; born August 15, 1945, in Washington, DC; died of a heart attack, July 5, 1995, in Geneva, NY; daughter of Frederick (a diplomat, teacher and farmer) and Lindsay (Crumpler) Nolting; married Charles Temple (a professor of education and writer), July 19, 1969; children: Anna Brooke, Jessica, Tyler. *Education:* Attended Wellesley College, 1963-65; University of North Carolina, B.A. (English and African studies), 1969; University of Virginia, M.Ed., 1976. *Hobbies and other interests:* Crafts (pottery and quilts), playing and writing music.

■ Addresses

Home—112 William St., Geneva, NY 14456.

■ Career

Writer of books for young readers, 1990-95. Children's Hours School, Geneva, NY, first and second grade teacher, 1983-95. Peace Corps vol-

■ Awards, Honors

Jane Addams Children's Book Award, Hungry Minds Books of Distinction award, and recommended book citation, National Council of Teachers of English, all 1993, all for *Taste of Salt*; Best Book for Young Adults citation, American Library Association (ALA), Best Books citation, *School Library Journal*, and Notable Book in the Field of Social Studies citation, Children's Book Council, all 1993, all for *Grab Hands and Run*; Best Books for Young Adults and Top of the List citations, both ALA, Best of the Best Editors' Choice citation, *Booklist*, and 100 Best Books of the Year citation, New York Public Library, all 1994, all for *The Ramsay Scallop*; 100 Best Books of the Year citation, New York Public Library, 1994, for *Tiger Soup*.

■ Writings

FICTION

Taste of Salt: A Story of Modern Haiti, Orchard Books, 1992.
Grab Hands and Run, Orchard Books, 1993.
The Ramsay Scallop: A Novel, Orchard Books, 1994.

(Adaptor and illustrator) *Tiger Soup: An Anansi Story from Jamaica* (picture book), Orchard Books, 1994.

Tonight, by Sea, Orchard Books, 1995.

The Beduin's Gazelle, Orchard Books, 1996.

ADULT EDUCATIONAL

(With Ruth Nathan, et al) *Classroom Strategies That Work: An Elementary Teacher's Guide to the Writing Process*, Heinemann, 1989.

(With Charles Temple and Nathan) *The Beginnings of Writing*, 3rd edition, Allyn & Bacon, 1992.

Also contributor to *Writers in the Classroom*, edited by Nathan, Christopher Gordon, 1991, and *Stories and Readers*, edited by C. Temple and Patrick Collins, Christopher Gordon, 1992.

■ Sidelights

Frances Temple, author of award-winning books of contemporary and medieval history, began fiction writing on a dare. A primary school teacher and education writer, Temple was challenged by one of her students. "I always did a lot of writing," Temple told *Something about the Author* (*SATA*) in an interview. "And when teaching I would also write in class during free-writing periods, and then the kids and I would share what we wrote. But one of my students complained that I never finished anything I started. I was always telling my students that they had to finish theirs, but I wasn't practicing what I preached. So one summer I sat down and wrote a book. It was an exercise in self-discipline. I never really expected to publish it."

That first book, finished in 1987, was *The Ramsay Scallop*, ultimately published in 1994 and an ALA Best Books for Young Adults pick. "I didn't know I had written a juvenile," Temple said. "I didn't really think of it at the time. I like to include people of all ages in my books and I sent it out to some adult publishers who thought it might do better as a young adult title, but frankly most editors told me there was little chance for a book taking place seven hundred years ago and filled with such information as how to build a cathedral." But the writing experience had transformed Temple: she saw stories in the world around her and in quick succession wrote manuscripts dealing with contemporary life and young people living through extraordinary perils: in *Grab Hands and Run* Temple tells the story of a family from El Salvador as they flee to Canada, and in *Taste of Salt* she tells a story of modern Haiti with "gritty realism and vivid island setting," according to Shannon Maughan in *Publishers Weekly*. The realism was no accident: Temple blended meticulous research and familiarity with many parts of the world with a deep and abiding sense of fairness and belief in other humans. These are some of the most important tools in the writer's kit, and Temple, though coming to writing late, developed them throughout her life.

Born in Washington, D.C., with a father in the diplomatic service, Temple spent the first nine years of her life in the idyllic surroundings of a farm in Virginia. She and her three sisters "spent days at a stretch in make-believe," she told *SATA*. "My sisters and I slept four in the same room. My older sister made up stories every night, the continuing adventures of Wally and Rachel, who had threaded necks and could trade heads. I couldn't think of stories. I planned to be a firefighter when I grew up." Schooled at home until the fourth grade, Temple learned to read from the comic strips with the help of her mother. Books figured largely in her life, "but I think I just skipped over children's books and went right to adult titles," Temple explained in her interview. "I remember loving C. S. Lewis and *The Forsyte Saga*. I also remember staying with my grandmother once in Virginia. She was very involved in the civil rights movement. And I was sitting in her home reading a Nancy Drew mystery. She took it away and gave me [South African Alan Paton's] *Cry the Beloved Country* to read instead. I think that was a pivotal moment for me."

An International Perspective

Then at age nine, Temple moved with her family to Paris, France. "We moved away from our farm to a hotel and were expected to wear dresses and speak French," Temple told *SATA*. "At school, we were not allowed to say anything unless we raised a hand first, were given permission, and then stood to speak. The nuns called me a barbarian." But it was an awakening for Temple; this was most definitely not Kansas—or Virginia. "My best friend in France lived in a half-ruined castle. Her mother was paralyzed; we carried her in a litter

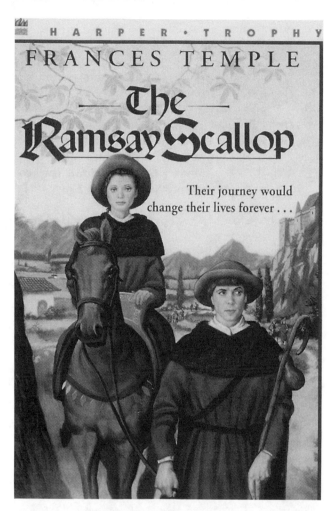

FRANCES TEMPLE

The Ramsay Scallop

Their journey would change their lives forever . . .

Written in response to a dare from Temple's students, this tale of two medieval adolescents relates what they learn about the world and themselves while on a prenuptial religious pilgrimage.

through long hallways and up staircases hung in tapestries, pretending she was the Queen," Temple wrote in the *Seventh Book of Junior Authors and Illustrators.* The family stayed five years in France and then came a posting to Vietnam, just prior to the large American military buildup there. "Our Vietnamese school was damaged by a bomb," Temple recalled. "The nuns sent us to help in an orphanage. When school reopened I kept working at the orphanage because I liked being with the children and was needed: to mop, to spoon out oatmeal, once to hold a sick baby while it died. That was like saying good-bye to the whole world."

These years provided Temple not only with a big picture and a global view, but also established in her a sense of compassion and fairness—the abil-

ity to see the world's problems on the individual, human level. Throughout the family's time in France and Vietnam the girls would periodically return to the United States, to their grandmother's home, for vacations. But out of high school, Temple returned on her own to Wellesley College. "It was pretty strange coming back to the U.S. then," Temple told *SATA* in her interview. "This was at the time of the Kennedy assassination and things were in turmoil here. Also, most of the people I'd known in Vietnam were either dead or in hiding." She lasted two years before she set off again, this time as a Peace Corps volunteer to West Africa in Sierra Leone, where she assisted a midwife. "We walked on footpaths through bushy woods," Temple recalled, "from one village to another. At each village we met with the women who were pregnant and admired all the new babies, checking for health problems. At night we sat around and traded news and stories. The midwife, Jeneba, gave women advice. I helped carry her gear and gifts: vitamins, scissors, live chickens." Temple also learned about tribal life, living with the Mende tribe. "It was an amazing experience to live in a small village," she noted in her interview. "There is a completely shared life and no one is left out of anything, yet they manage to keep some private part to themselves, some private thoughts." She was also fascinated by the relationship of the local crafts—iron work and pottery—to the religion. It was a theme that she would explore later in her writing career.

Temple returned to the United States in 1968 and finished her undergraduate degree at the University of North Carolina, assisting in the formation of an African studies program by helping to build the curriculum of French-speaking black writers. These included not only writers from Africa, but from Haiti—another connection that would play out later in her writing. "I loved being in a big public university," Temple said. "I got to know the States finally and also became involved in the later stages of the civil rights movement." Temple graduated in English and African studies and also got married. The next four years were spent as a volunteer with VISTA and in completing her master's degree in education. She was living again on a farm in Virginia, began teaching school, and also started a family. "When our children were little, I told them stories at night," Temple told *SATA.* "Sitting on the floor in the dark, listening to them breathe, I found that there are just two hard parts to making up stories: the first is

getting started, the second is stopping." In the early 1980s Temple and her family moved to up-state New York, where her husband took a faculty position and where she continued to teach in primary school. The stories she told her children at night continued to be simply that: bedtime tales. But she did coauthor texts on process-writing and classroom strategies. Then came her students' challenge to finish one of her projects and the first of her book-length efforts.

Interest in Social Justice Spurs Writing

Temple's first fiction publication came about through a work-study semester she and her husband spent in the Dominican Republic in 1990. They heard about a military fire-bombing of a boys' shelter in neighboring Haiti and she decided that it was time people in the United States really took a look at what was happening in Haiti, which was struggling to evolve into a democracy after years under the grip of a dictatorship. Her interest in the country went back to her college years when she was helping to create an African studies curriculum, but there was nothing academic about what was occurring in Haiti. "I had gotten to know a lot of young Haitians," Temple explained in her *SATA* interview. "They would come cane-cutting in the Dominican Republic, and I listened to them, to their stories and I got interested in what was going on in Haiti. When [Jean-Bertrand] Aristide was elected it was the result of a real populist movement. I came to see that if people here in the United States could understand how important that movement was, we wouldn't want to see it overthrown."

The result was *Taste of Salt: A Story of Modern Haiti*, the story of a street urchin, Djo, whom Father Aristide gathers together with others to give a chance for a different life. It is also the story of the young girl Jeremie, who has been educated at a convent school. The two meet at a hospital, where Djo is near death after being beaten by the ruler Duvalier's thugs, the *Tonton Macoute*. Aristide has sent Jeremie to get Djo's story on tape, but while Djo is in a coma, she relates her own story. Through a blending of the two tales, a realistic portrayal of life in Haiti emerges. The reader learns of Djo's difficult life living in a shelter with other street children. At one point he is kidnapped and sent to the Dominican Republic, where he is forced to work in the cane fields for three years.

The novel ends as Aristide is elected president. Told heavily in dialect, *Taste of Salt* is intended to give a sense of both the great hope and helplessness that the people of Haiti have experienced. The title comes from voodoo lore, in which a pinch of salt can give a zombie a sense of self-awareness and an escape from his predicament. The day Temple finished the novel, however, Aristide was deposed by a military coup and forced into an exile that was to last until the restoration of the elected government in 1994.

This timely first novel earned Temple widespread critical praise; "an excellent first effort," wrote Kathryn Havris in *School Library Journal*. Similarly,

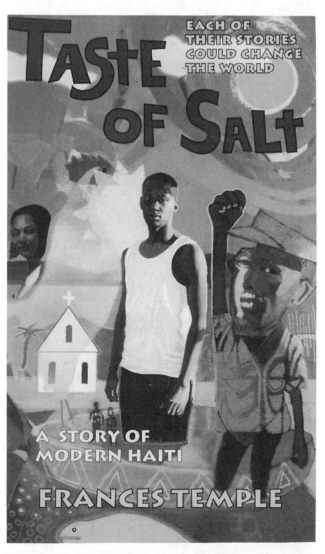

Winner of the 1993 Jane Addams Award, this story revolves around the dreams of three people: a priest, a victim of a firebombing, and a convent-educated girl who believe in a new Haiti.

Horn Book contributor Nancy Vasilakis called the work "a deeply felt, provocative statement of human courage by an exciting new author." A *Publishers Weekly* critic thought that "Djo's extraordinary experiences and circumstances shed harsh light on a people in crisis," while *Bulletin of the Center for Children's Books* editor Betsy Hearne noted that Temple "handles with unobtrusive ease" such intricacies as changing viewpoints, flashbacks, and "the blend of political and personal, the balance of romance and violence." *Booklist*'s Hazel Rochman also added to the chorus of favorable assessments: "The combination of dramatic action, romantic interest, and vivid storytelling will grab even the most apolitical of teens," the reviewer commented. A recipient of a Jane Addams and a Hungry Mind Books of Distinction award, *Taste of Salt* proved an auspicious publishing debut for Temple. "My indication that the book worked," Temple said in her *SATA* interview, "was when I was invited to talk with a local ninth grade class—many of them African Americans—about the book. I was filled with trepidation, wondering how the black kids would react to this white lady writing in the voice of young black men and women in Haiti. But they loved the book and were excited about the characters."

For her next two publications, Temple went back to projects she had already written. "Our home in Geneva is not far from the Canadian border," Temple told *SATA*. "Canada was the goal of many refugees from Latin America and our family became involved in the Sanctuary movement. We had a family of three stay with us for five months: a mother and two young children. The father had been killed in El Salvador." It was the experiences of this family that largely inspired the writing of *Grab Hands and Run*, a novel about a young Salvadoran boy named Felipe, his sister Romy, and their mother Paloma. Felipe has overheard his activist father Jacinto tell Paloma that if anything should happen to him, if he should disappear or if the police should come for him, that the rest of the family should "grab hands and run." That is exactly what comes to pass, and their subsequent journey to Canada—one of the few countries in the Western Hemisphere that would take El Salvadorans as political refugees—is full of high adventure, of bribes and luck and deceptions of immigration officials. Like her novel of Haiti, *Grab Hands and Run* is a realistic portrayal of political realities compellingly told through the eyes of a young protagonist.

"I just loved that family," Temple said in her interview. "In the five months they were with us, we grew very close. They lived life so intensely and had much to be depressed about, but were not depressed. Later I interviewed other refugees who came through to add to the story, but it is very much centered around that one family. I felt strange about creating an interior life for the young boy and sister and mother when I really couldn't know everything going on inside of the real people. I didn't want to be intrusive into their thoughts and feelings, but you can't avoid getting into feelings if you're doing a novel." In the end, the refugee family, by then settled in Canada, were pleased with their depiction and Temple shared the publisher's advance money with them so that they could return to El Salvador for a brief visit.

Once again, Temple had a winner. *Grab Hands and Run* not only garnered honors, but also an excellent critical reception. A *Kirkus Reviews* writer, for instance, commended the characterizations and language in the novel, finding it to be "well wrought, authentic, and compelling." Susan Knorr, reviewing the book in *School Library Journal*, felt that Felipe, whose perspective drives the narrative, "is a thoroughly believable and appealing character whose forced maturation will be deeply felt and remembered by readers." A *Voice Literary Supplement* critic likewise noted that Temple was "able to avoid the preachiness that often creeps into books set among human rights outrages" by viewing the action through Felipe's eyes.

Delving into the Past

For her third publication, Temple could finally go back to that first book she had written on a dare, a story set in 1300 in both England and the Iberian peninsula of Spain and Portugal. "I wrote *The Ramsay Scallop*," Temple explained in her *SATA* interview, "to understand the complete and total religious world view of the Middle Ages. I knew I wanted to set it before the Plague because I didn't want to have my main characters dying off because of it. And so setting it at the end of the Crusades seemed logical. That was such a turning point, such a turning away from militarism, though the people of the time didn't know it was the end of the Crusades. We now say the Crusades ended in 1298 with the fall of Acre, but the hostilities actually could have started up again

at any time." The story of reluctant marriage partners—fourteen-year-old Elenor of Ramsay and her fiance Thomas, fresh home from the Crusades—the book becomes a quest for moral and religious understanding when a wise priest suggests the pair go on a pilgrimage together to Spain before their wedding. What follows then is a picaresque novel of sorts, an episodic tale of a journey and the unexpected joys and adventures that such journeys served up seven hundred years ago. By the end of the book Elenor and Thomas have indeed come to know one another and are ready to accept their arranged marriage, and the reader knows a whole lot more about the medieval world than before setting out on Temple's journey.

"I'd been interested in the Pilgrim Way in Spain for a long time," Temple continued, "but it wasn't until my husband took a group of students to Spain that I got to explore the trail." Temple walked the paths of this ancient pilgrims' route and subsequently researched the period thoroughly, reading more than seventy books in En-

If you enjoy the works of Frances Temple, you may also want to check out the following books and films:

James R. Berry, *A Thief in the Village and Other Stories of Jamaica*, 1988.
Louise Moeri, *The Forty-Third War*, 1989.
Sharon Kay Penman's *Falls the Shadow*, 1988, and *The Reckoning*, 1991.
Judith Merkle Riley's *A Vision of Light*, 1989, and *In Pursuit of the Green Lion*, 1990.
The Killing Fields, Warner Bros., 1984.

glish, Spanish and French (both modern and medieval), and even uncovering a guidebook to the route from 1190 written by a priest. "The way I see it," Temple said, "there was something very egalitarian about those pilgrimages. Class and privilege fell away while the people were on those dusty paths, and normally, the society of 1300 was a rigidly stratified one. It's a rich time for study." Readers and reviewers felt so, as well. Kathy Broderick, writing in *Book Links*, noted that the book "is an intelligent, romantic and *ambitious* work rich in opportunities for middle school and junior high readers." Broderick also commented on the plethora of facts included about medieval

Europe, from religion to philosophy. The title of the book comes from the scallop badges that successful pilgrims receive once they reach their destination. Jane Langton wrote in the *New York Times Book Review* that "as Thomas and Elenor travel toward their distant goal there is a rich tapestry of events and, best of all, the sense of a long dusty road unwinding." A *Kirkus Reviews* writer thought that Temple describes the countryside with "singularly unpretentious beauty," and manages to recreate "medieval Europe at its best." The critic concluded that *The Ramsay Scallop* is "a throwback with a contemporary sensibility; an enchanting pilgrimage to self-realization, service, and love."

Versatility was a trademark for Temple, whose own interests were reflected in her writing. "I partly write to educate myself about various topics," Temple told *SATA*. "And I think kids can be interested in all kinds of things. What they're given mostly is psychodrama. But, just like adults, kids can be attracted to any situation, to any character who touches on universals. The way I look at it, when you read a book, you're trying on a different life. It frees you up from the person you are, to experiment with people you could be. One reason that kids are so disaffected from schools is that they see that their opinions are not really wanted. We need to turn that perception around. To make each voice needed. To bring kids back into the loop. I want to allow people to trust themselves to care, to sort out a position and believe. Not to be cynical. I don't want to use the schools to proselytize, but to teach kids to think."

Temple's books challenge young readers to think and to analyze. Her 1995 work *Tonight, by Sea* once again turns the spotlight on Haiti, this time recounting an individual tale of survival of the boat people who fled the island in the wake of the coup against Aristide. Temple "paints an affecting portrait of a proud, resourceful people trying to survive in the face of lawlessness and tyranny," Luann Toth noted in *School Library Journal*, while *Horn Book* reviewer Martha V. Parravano praised how the author "depicts life in Haiti in vivid detail and captures the musical cadences and rhythms of Haitian speech." Hazel Rochman, reviewing *Tonight, By Sea* in *Booklist*, described the work as a "docu-novel about the struggle for social justice," adding, "Temple gives a human face to the Haitian boat people."

Grab Hands and Run

BY FRANCES TEMPLE

Twelve-year-old Felipe, his mother, and his sister flee El Salvdor for Canada, braving the elements and authorities in their search for freedom.

A Promising Career Cut Short

Temple's next projects included two sequels to *The Ramsay Scallop*: historical novels set in North Africa in 1302 and in West Africa in 1304. "I want to do a set of books that look at the cultural heritage of this country," she explained in her interview. "To look at our roots. *Ramsay* was an examination of the European connection, of the Christian contribution. My North African book will look at Islam and I hope will erase some of the stereotypes we have of that religion. The whole style of writing of that book is influenced by the heavy use of illusion in Arabic. And with the West African book I am trying to look at African culture before it was disrupted by the slave trade. To examine how craft and religion work together with the forces of nature. Both the books have taken a terrific lot of research."

The first of these sequels, *The Beduin's Gazelle*, is set in the desert "sand sea" of the Middle East and follows the adventures of Halima and Atiyah, cousins who have been betrothed since birth. The two, members of a nomadic tribe, the Beni Khalid, are separated twice: first, by Atiyah's ruthless uncle Saladeen, who pressures Atiyah to study Islamic law at the university in Fez, and second, by a sheikh in the rival Shummari tribe who captures Halima after she becomes lost in a sandstorm. Atiyah rescues Halima with help from his fellow student Etienne, a French pilgrim who appeared in *The Ramsey Scallop*.

Critics applauded Temple's complex, vivid characters and swiftly moving story. Ellen Fader, writing in *Horn Book*, commended Temple's "recreation of the Bedouin culture, with its long tradition of storytelling and poetry and its capable women and children. . . ." In *Bulletin of the Center for Children's Books*, Betsy Hearne echoed those sentiments, remarking that *The Beduin's Gazelle* exhibits a "lively plot, with playful poetic passages attributed to Bedouin customs of versifying. . . ." A *Publishers Weekly* reviewer stated that the author "is at the top of her game here, deftly handling societal issues with a spirited style."

Unfortunately, the same day Temple mailed the final revisions to *The Beduin's Gazelle*, she suffered a heart attack while walking with her husband at Lake Geneva, New York, and died shortly thereafter. Her passing cut short a promising career; as friend and fellow author Cynthia DeFelice told David Falchek of the *Finger Lakes Times*, Temple had "developed tremendous stature in the area of children's literature in a short time." Anita Silvey, writing in *Horn Book*, stated that Temple "epitomized the finest in new voices in the children's book field." And after long years of teaching the writing process, Temple had finally come to see herself as a professional writer. As she revealed in her interview, "I'm always so gratified when kids in the schools I visit want to know what happened to one of my characters after the book was over. It means those characters were real for them. One of my goals is to make people question—to question, for example, what their responsibilities are in a democracy. But in the end, I do not want my characters to be puppets for my ideas. I want them to be real people with real emotions. My ultimate goal is to have people question what it means to be human."

■ Works Cited

Review of *The Beduin's Gazelle, Publishers Weekly,* March 25, 1996, p. 85.

Broderick, Kathy, review of *The Ramsay Scallop, Book Links,* November, 1994, pp. 17-19.

Fader, Ellen, review of *The Beduin's Gazelle, Horn Book,* May/June, 1996, p. 341.

Falchek, David, "Temple Introduced Children to Richness of Other Cultures," *Finger Lakes Times* (Geneva, NY), July 9, 1995.

Review of *Grab Hands and Run, Kirkus Reviews,* April 15, 1993, p. 537.

Review of *Grab Hands and Run, Voice Literary Supplement,* December, 1993, p. 27.

Havris, Kathryn, review of *Taste of Salt, School Library Journal,* September, 1992, p. 280.

Hearne, Betsy, review of *Taste of Salt, Bulletin of the Center for Children's Books,* November, 1992, pp. 65-66.

Hearne, Betsy, review of *The Beduin's Gazelle, Bulletin of the Center for Children's Books,* March, 1996, p. 244.

Knorr, Susan, review of *Grab Hands and Run, School Library Journal,* April, 1993, pp. 143-44.

Langton, Jane, review of *The Ramsay Scallop, New York Times Book Review,* August 28, 1994, p. 20.

Maughan, Shannon, "Flying Starts of 1992: Frances Temple," *Publishers Weekly,* December 28, 1992, pp. 27-28.

Parravano, Martha V., review of *Tonight, by Sea, Horn Book,* July/August, 1995, p. 462.

Review of *The Ramsay Scallop, Kirkus Reviews,* March 15, 1994, p. 405.

Rochman, Hazel, review of *Taste of Salt, Booklist,* August, 1992, p. 2005.

Rochman, Hazel, review of *Tonight, By Sea, Booklist,* March 15, 1995, p. 2005.

Silvey, Anita, "The Intelligent, the Witty, the Brave," *Horn Book,* September-October, 1995, p. 518.

Review of *Taste of Salt, Publishers Weekly,* June 22, 1992, p. 65.

Temple, Frances, in a telephone interview with J. Sydney Jones conducted for *Something about the Author,* May 31, 1995.

Temple, Frances, comments in *Seventh Book of Junior Authors and Illustrators,* edited by Sally Homes Holtze, H. W. Wilson, 1996, pp. 319-21.

Toth, Luann, review of *Tonight, by Sea, School Library Journal,* April, 1995, p. 158.

Vasilakis, Nancy, review of *Taste of Salt, Horn Book,* November/December, 1992, pp. 730-31.

■ For More Information See

PERIODICALS

Booklist, May 1, 1993, p. 1596; January 15, 1994, p. 869; March 15, 1994, p. 1348; June 1, 1994, p. 1799; August, 1994, p. 2047.

Bulletin of the Center for Children's Books, April, 1993, p. 132; April, 1994, p. 271; September, 1994, p. 26-27; April, 1995, p. 287.

Kirkus Reviews, August 1, 1992, p. 994; August 15, 1994, p. 1140.

Publishers Weekly, April 12, 1993, p. 64; July 4, 1994, p. 61; April 3, 1995, p. 63.

School Library Journal, May, 1994, p. 135; August, 1994, p. 152.

Voice of Youth Advocates, December, 1992, p. 286; June, 1993, p. 95; April, 1994, p. 31; June, 1994, p. 721.*

—Sketch by J. Sydney Jones

Acknowledgments

Acknowledgments

Grateful acknowledgment is made to the following publishers, authors, and artists for their kind permission to reproduce copyrighted material.

JANE AUSTEN. Austen, Jane, portrait by Cassandra Austen. Reproduced by permission of National Portrait Gallery, London/ Beechey, Sir William. From the cover of *Emma*. Penguin Books, 1985. Reproduced by permission of Colonel Lane Fox./ Tibbles, Jean-Paul. From the cover of *Pride and Prejudice*. Puffin Classics, 1995. Abridgement copyright © Penguin Books, 1995. All rights reserved. Reproduced by permission of Jean-Paul Tibbles./ From the cover of *Sense and Sensibility*. By Jane Austen. Tor, 1995. All new material in this edition copyright © 1995 by Tom Doherty Associates, Inc. All rights reserved. Reproduced by permission./ Portrait of Austen home at Chawton.

MARION DANE BAUER. Bauer, Marion Dane, photographs by Ann Goddard. Both reproduced by permission of Ann Goddard./ Conway, Michael. From the cover of *On My Honor*. By Marion Dane Bauer. Copyright © 1986 by Marion Dane Bauer. Cover illustration by Michael Conway. Used by permission of Dell Books, a division of Bantam Doubleday Dell Publishing Group, Inc./ Underwood, Beck. From the cover of *Am I Blue?: Coming Out from the Silence*. Harper Trophy. Copyright © 1994 by Marion Dane Bauer. Cover art © 1994 by Beck Underwood. Cover copyright © 1995 by HarperCollins Publishers. Cover design by Steve Scott. Reproduced by permission.

JORGE LUIS BORGES. Borges, Jorge Luis, photograph by Harold Mantell. Reproduced by permission./ di Giovanni, Norman Thomas. From the jacket of *Six Problems for Don Isidro Parodi*. By Jorge Luis Borges and Adolfo Bioy-Casares, translated by Norman Thomas di Giovanni. E. P. Dutton, 1981. Copyright © 1980, 1981 by Jorge Luis Borges, Adolfo Bioy-Casares, and Norman Thomas di Giovanni. All rights reserved. Used by permission of the publisher, E. P. Dutton, an imprint of New American Library, a division of Penguin USA./ McMullan, James. From the cover of *The Aleph and Other Stories, 1933-1969*. By Jorge Luis Borges, edited and translated by Norman Thomas di Giovanni. E. P. Dutton, 1978. Copyright © 1970 by Jorge Luis Borges and Norman Thomas di Giovanni. Used by permission of the publisher, E. P. Dutton, an imprint of New American Library, a division of Penguin USA./ Braren, Ken. From the jacket of *Selected Poems, 1923-1967*. By Jorge Luis Borges, edited and translated by Norman Thomas di Giovanni. Delacorte Press/Seymour Lawrence, 1972. English translation, introduction and notes copyright © 1972 by Norman Thomas di Giovanni. Reproduced by permission of Delacorte Press/Seymour Lawrence, a division of Bantam Doubleday Dell Publishing Group, Inc./ Kuhlman, Gilda. From the cover of *Labyrinths, Selected and Other Writings*. By Jorge Luis Borges, edited by Donald A. Yates and James E. Maurois. New Directions, 1964. Copyright © 1962, 1964, renewed 1992 by New Directions Publishing Corporation. Reproduced by permission of the publisher.

ROBBIE BRANSCUM. Beilby, Ted and Rick Eissler. From the jacket of *Old Blue Tilley*. By Robbie Branscum. Macmillan, 1991. Copyright © 1991 by Macmillan Publishing Company, a division of Simon & Schuster, Inc. Copyright © 1991 by Ted Lewin. Reproduced by permission of Ted Beilby./ Watts, Patricia Parcell. From the jacket of *The Girl*. By Robbie Branscum. Harper & Row, Publishers, 1986. Jacket art © 1986 by Patricia Parcell Watts. Jacket © 1986 by Harper & Row, Publishers, Inc. Reproduced by permission of HarperCollins Publishers, Inc./ Gladden, Scott. From the book cover of *The Murder of Hound Dog Bates*. By Robbie Branscum. Puffin Books, 1995. Cover illustration copyright © 1995 by Scott Gladden. Used by permission of Viking Penguin, a division of Penguin Books USA Inc./ From the jacket of *Old Blue Tilley*. By Robbie Branscum. Simon & Schuster, 1991. Copyright © 1991 by Ted Lewin. Reproduced by permission of Ted Beilby.

JOSEPH BRUCHAC. Bruchac, Joseph, photograph by Michael Greenlar. Reproduced by permission./ Bruchac, Joseph. Photograph of the Bruchac home. Reproduced by permission./ Jacob, Murv. From the cover of *Flying with the Eagle, Racing with the Great Bear: Stories from Native North America*. By Joseph Bruchac. Bridgewater Books, 1993. Text copyright © 1993 by Joseph Bruchac. Illustrations copyright © 1993 by Murv Jacob. All rights reserved. Reproduced by permission of the publisher./ Green, Ann E. From the cover of *Dawn Land*. By Joseph Bruchac. Copyright © 1993 Joseph Bruchac. Cover illustration copyright © 1992 Murv Jacob. All rights reserved. Reproduced by permission.

LOIS MCMASTER BUJOLD. Bujold, Lois McMaster (holding a book), photograph by David Dyer-Bennet. Reproduced by permission./ Bujold, Lois McMaster (at age seventeen), photograph. Reproduced by permission./ Morrissey, Dean. From the cover of *Vorkosigan's Game: The Vor Game Borders of Infinity*. Guild America Books, 1990. Copyright © 1990 by Lois McMaster Bujold. All rights reserved. Reproduced by permission of Dean Morrissey./ Gutierrez, Alan. From the cover of *Brothers in Arms*. By Lois McMaster Bujold. Baen, 1989. Copyright © 1989 by Lois McMaster Bujold. All rights reserved. Reproduced by permission./ Gutierrez, Alan. From the cover of *Falling Free*. By Lois McMaster Bujold. Baen, 1988. Copyright © 1988 by Lois McMaster Bujold. All rights reserved. Reproduced by permission./ Hickman, Steven. From the cover of *Barrayar*. By Lois McMaster Bujold. Baen, 1991. Copyright © 1991 by Lois McMaster Bujold. All rights reserved. Reproduced by permission.

Jacket illustration copyright © 1984 by Jon Weiman. All rights reserved. Reproduced by permission of Jon Weiman./ Steirnagle, Michael. From the cover of *Memoirs of a Bookbat*. By Kathryn Lasky. Harcourt Brace & Company, 1994. Copyright © 1994 by Kathryn Lasky Knight. Jacket illustration copyright © 1994 by Michael Steirnagle. Reproduced by permission of Michael Steirnagle./ Hyman, Trina Schart. From an illustration in *The Night Journey*. By Kathryn Lasky. Puffin Books, 1981. Text copyright © Kathryn Lasky, 1981. Illustrations copyright © 1981 by Trina Schart Hyman. All rights reserved. Used by permission of Viking Penguin, a division of Penguin Books USA Inc.

MYRON LEVOY. Levoy, Myron, photograph. Reproduced by permission./ Raymond, Larry. From the cover of *Pictures of Adam*. By Myron Levoy. Beech Tree, 1986. Copyright © 1986 by Myron Levoy. Reproduced by permission of Beech Tree Books, an imprint of William Morrow and Company, Inc./ Connor, Mona. From the cover of *Alan and Naomi*. HarperTrophy, 1977. Copyright © 1977 by Myron Levoy. Cover Art copyright © 1991 by Mona Conner. Cover copyright © 1991 by HarperCollins Publishers. All rights reserved. Reproduced by permission.

CHRIS LYNCH. Lynch, Chris, photograph by Jeff Thiebauth. Reproduced by permission./ Burke, Phillip. From the cover of *Iceman*. By Chris Lynch. HarperTrophy, 1994. Copyright © 1994 by Chris Lynch. Cover copyright © 1995 by Phillip Burke. Cover copyright © 1995 by HarperCollins Publishers. Cover design by Steve Scott. All rights reserved. Reproduced by permission./ LaCava, Vince. From the cover of *Mick*. By Chris Lynch. HarperTrophy, 1993. Copyright © 1996 by Chris Lynch. All rights reserved. Reproduced by permission./ Burke, Phillip. From the cover of *Shadow Boxer*. By Chris Lynch. HarperTrophy, 1993. Copyright © 1993 by Chris Lynch. Cover copyright © 1995 by Philip Burke. Cover copyright © 1995 by HarperCollins Publishers. Cover design by Stefanie Rosenfield. All rights reserved. Reproduced by permission.

KIT PEARSON. Pearson, Kit, photograph by Russell Kelly. Reproduced by permission.

TERRY PRATCHETT. Pratchett, Terry, photograph. Reproduced by permission./ McPheeters, Neal. From the cover of *Diggers*. By Terry Pratchett. Delacorte, 1991. Copyright © 1989 by Terry and Lyn Pratchett. Jacket illustration copyright © 1991 by Neal McPheeters. All rights reserved. Used by permission of Delacorte Press, a division of Bantam Doubleday Dell Publishing Group, Inc./ Player, Stephen. From an illustration derived from *Discworld*. By Terry Pratchett. Copyright © 1994 by Mamelok Press Ltd. Reproduced by permission of Terry Pratchett./ Kidd, Tom. From an illustration in *Wyrd Sisters*. By Terry Pratchett. ROC, 1988. Copyright © by Terry and Lyn Pratchett. All rights reserved. Reproduced by permission of Penguin USA./ Sweet, Darrell K. From the cover of *Witches Abroad*. By Terry Pratchett. Copyright © 1991 by Terry and Lyn Pratchett. Reproduced by permission of Darrell K. Sweet.

FAITH RINGGOLD. Ringgold, Faith, photograph by C. Love. © Faith Ringgold Inc. Reproduced by permission of Faith Ringgold./ Ringgold, Faith, "The Letter" in *Faith Ringgold: A 25 Year Survey*. FAMLI, 1990. © 1990 Faith Ringgold Inc. Reproduced by permission of Faith Ringgold./ Ringgold, Faith, "The Flag is Bleeding" in *Faith Ringgold: A 25 Year Survey*. FAMLI, 1990. © 1990 Faith Ringgold Inc. Reproduced by permission of Faith Ringgold./ Ringgold, Faith, "Dancing on the George Washington Bridge" in *Faith Ringgold: A 25 Year Survey*. FAMLI, 1990. © Copyright Fine Arts Museum of Long Island. Reproduced by permission of Roy Eaton.

ARNOLD SCHWARZENEGGER. Schwarzenegger, Arnold, photograph. AP/Wide World Photos. Reproduced by permission./ Movie still from *Junior*. Reproduced by permission of Universal Pictures.

RANDY SHILTS. Shilts, Randy, photograph by Jerry Bauer. © Jerry Bauer./ Shilts, Randy. From the cover of *Conduct Unbecoming: Gays & Lesbians in the U.S. Military*. St. Martin's Press, 1993. Copyright © 1993 by Randy Shilts. All rights reserved. Reproduced with permission of St. Martin's Press, Incorporated./ Shilts, Randy. From the cover of *And the Band Played on: Politics, People, and the AIDS Epidemic*. St. Martin's Press, 1987. Copyright © 1987 by Randy Shilts. All rights reserved. Reproduced with permission of St. Martin's Press, Incorporated.

THEODORE TAYLOR. Taylor, Theodore, photograph by John Graves. Reproduced by permission of Theodore Taylor./ Taylor, Theodore (with two other gentlemen), photograph. Reproduced by permission./ Taylor, Theodore and Gary Paulsen, photograph. Reproduced by permission of Theodore Taylor./ From the cover of *Timothy of the Cay*. By Theodore Taylor. Avon Books, 1993. Copyright © 1993 by Theodore Taylor. Reproduced by permission of Avon Books, New York, a division of William Morrow and Company, Inc./ From the cover of *The Weirdo*. By Theodore Taylor. Avon Books, 1991. Copyright © 1991 by Theodore Taylor. Reproduced by permission of Avon Books, New York, a division of William Morrow and Company, Inc./ From the cover of *Sniper*. By Theodore Taylor. Avon Books, 1989. Copyright © 1989 by Theodore Taylor. Reproduced by permission of Avon Books, New York, a division of William Morrow and Company, Inc.

FRANCES TEMPLE. Temple, Frances, photograph. Reproduced by permission of Jan Regan Photography./ Temple, Frances. From the jacket of *Grab Hands and Run*. Orchard Books, 1993. Copyright © 1993 by Frances Nolting Temple. Jacket illustration © 1993 by Frances Nolting Temple. Reproduced by permission of Orchard Books, New York./ Jenkins, Leonard. From the cover of *Taste of Salt*. By Frances Temple. HarperTrophy, 1992. Copyright © 1992 by Frances Nolting Temple. Cover Art © 1994 by Leonard Jenkins. Cover copyright © 1994 by HarperCollins Publishers. Cover design by Stefanie Rosenfield. All rights reserved. Reproduced by permission./ Leister, Bryan. From the cover of *The Ramsay Scallop*. By Frances Temple. HarperTrophy, 1994. Copyright © 1994 by Frances Nolting Temple. Cover copyright © 1994 by Bryan Leister. Cover copyright © 1995 by HarperCollins Publishers. All rights reserved. Reproduced by permission.

Cumulative Index

Author/Artist Index

The following index gives the number of the volume in which an author/artist's biographical sketch appears.